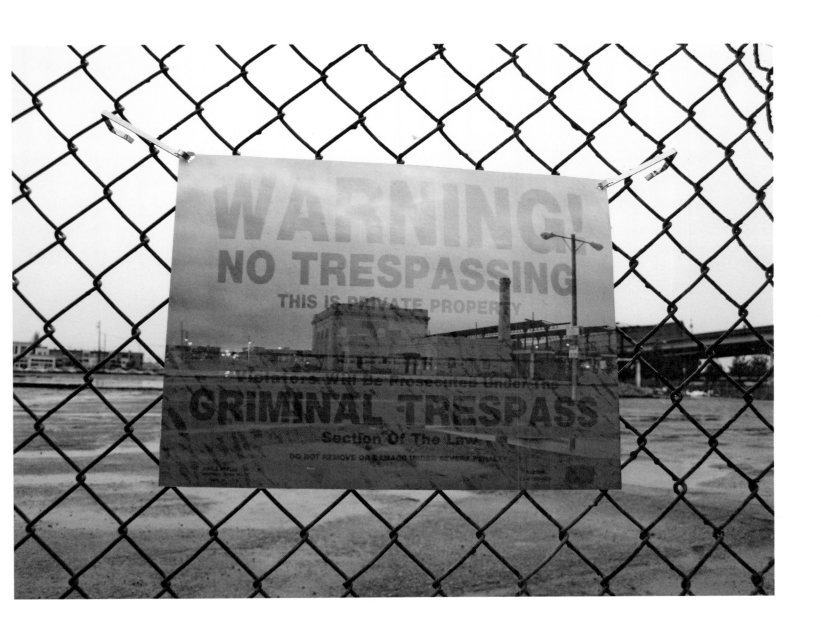

TRES

A HISTORY OF UNCOMMISSIONED URBAN ART

EDITED BY ETHEL SENO

BY CARLO MCCORMICK
IN COLLABORATION WITH
WOOSTER COLLECTIVE'S
MARC & SARA SCHILLER

ADDITIONAL TEXTS BY
BANKSY, ANNE PASTERNAK,
AND J. TONY SERRA

PASS

TASCHEN

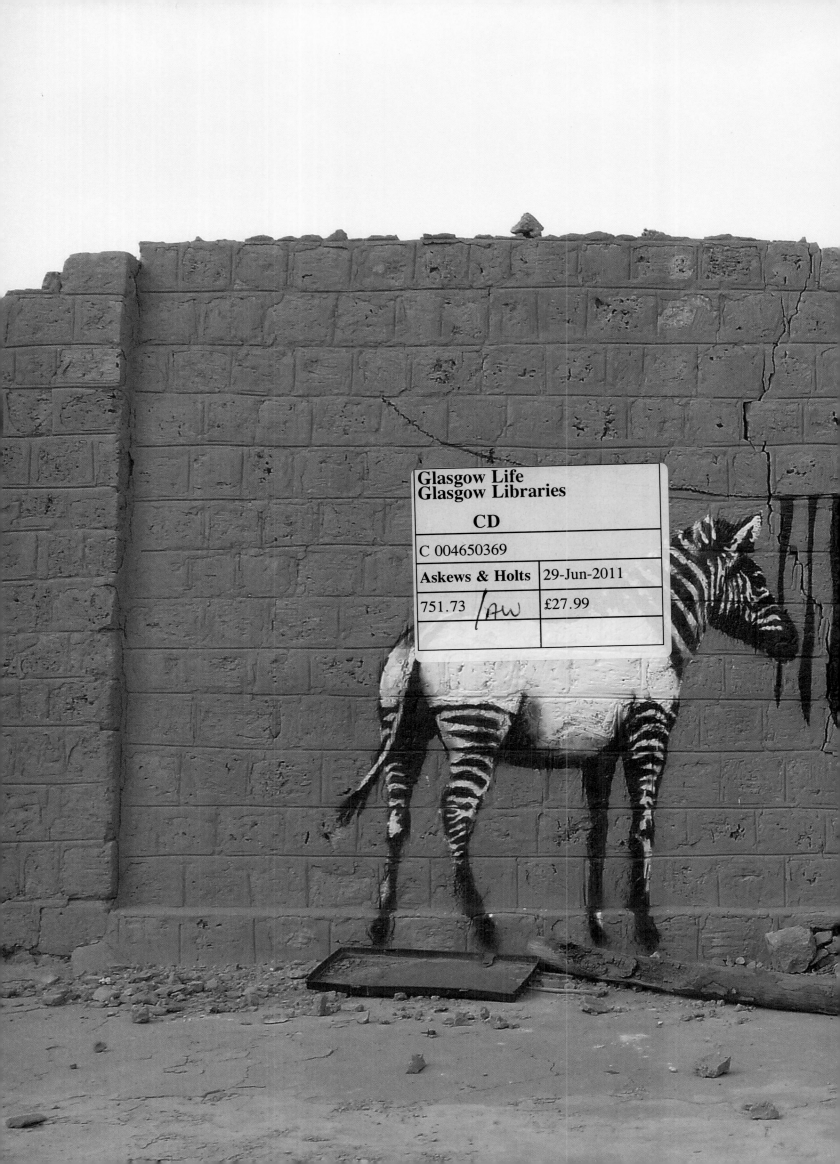

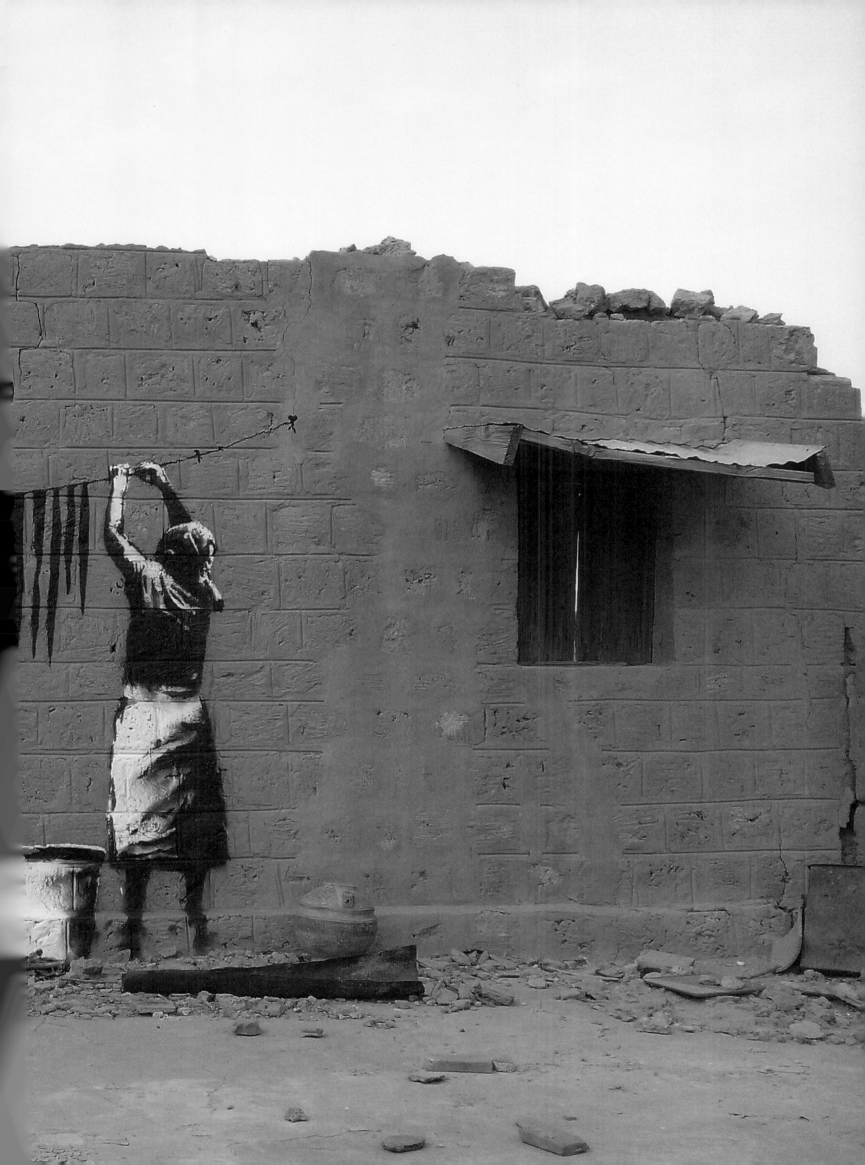

"My one regret in life is that I have never climbed over a fence."

—Queen Mary

I was 16 years old when I first trespassed onto some railway tracks and wrote the initials of the graffiti crew (of which I was the only member) on a wall. Afterwards the most incredible thing happened—absolutely nothing. No dogs chased me, no thunderbolt from God shot down to punish me, and my mum didn't even notice I'd been gone. That was the night I realized you could get away with it.

That was also the night I discovered that beyond the "No Entry" sign everything happens in higher definition. Adrenalin sharpens your eyesight, each little sound becomes significant, your sense of smell seems more acute, and tramps shit everywhere.

To some people breaking into property and painting it might seem a little inconsiderate, but in reality the 30 square centimeters of your brain are trespassed upon every day by teams of marketing experts. Graffiti is a perfectly proportionate response to being sold unattainable goals by a society obsessed with status and infamy. Graffiti is the sight of an unregulated free market getting the kind of art it deserves. And although some people might say it's all a big waste of time, no one cares about their opinion if their name isn't written in huge letters on the bridge into town.

—BANKSY, 2010

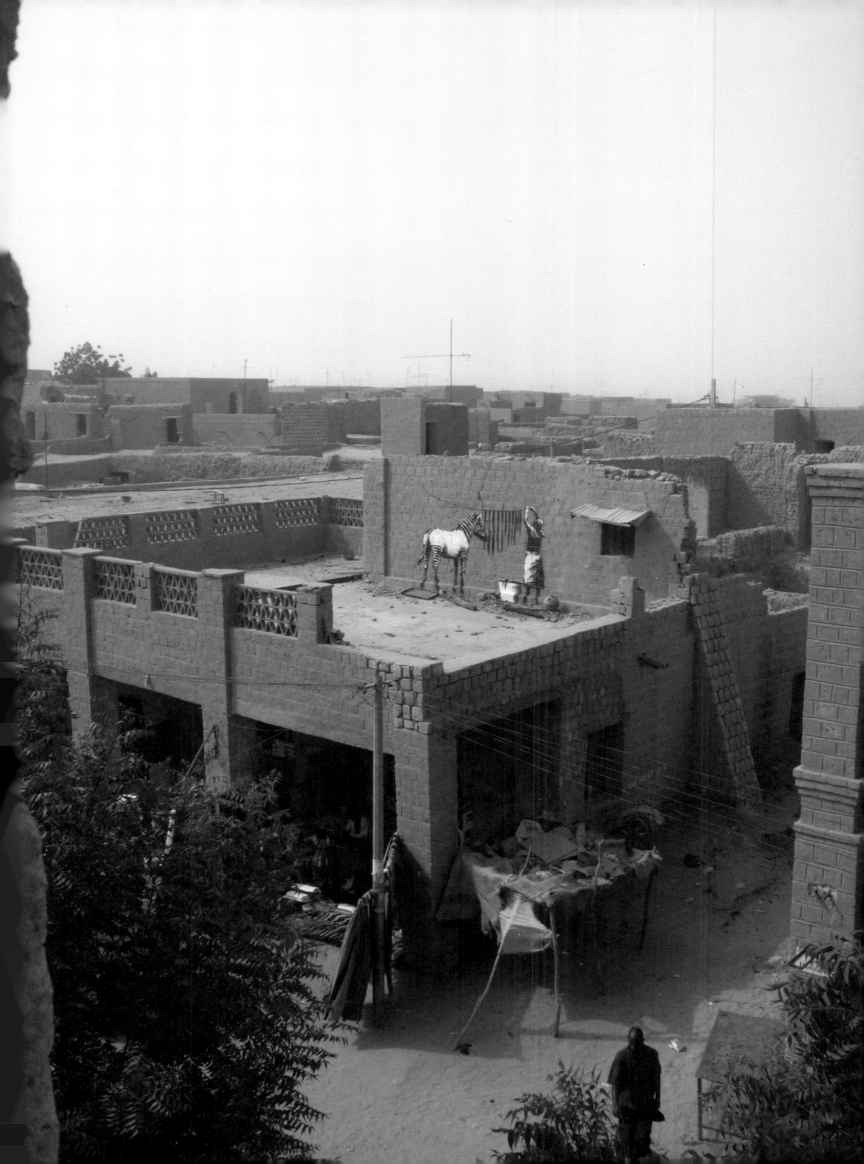

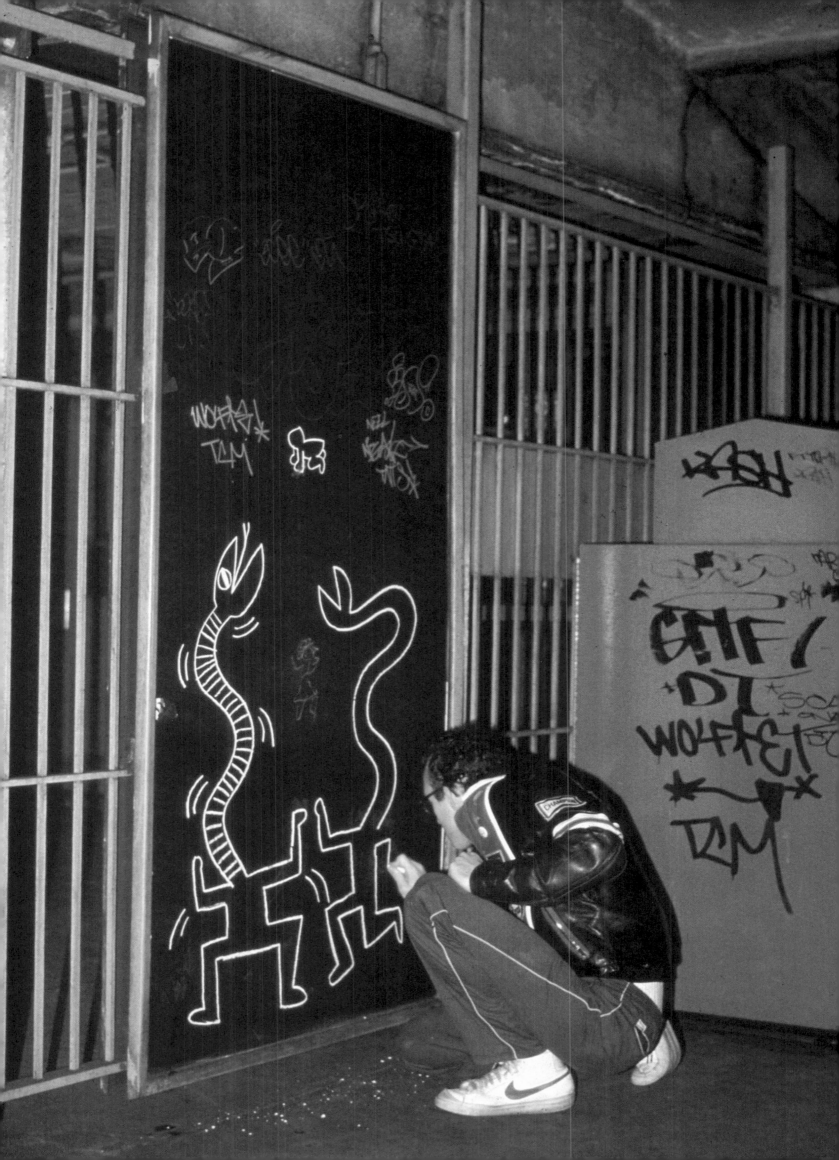

CITY VIEW

That first moment you notice a stencil on the pavement, a sticker on the back of a mailbox, or a metal sculpture attached to a street sign, you are suddenly transported into another world—to a vibrant subculture that infiltrates and eradicates the monotony of daily life. Your commute to work, or that short trip to the store, now becomes an adventure as you search for creativity in unexpected places.

The artists featured in this book work freely in the city streets, often anonymously, ignoring what the outside world thinks. They give away their art for free, bucking the pressures of commerce that govern both museums and galleries. Working outdoors, they have just minutes to create a piece or risk the threat of arrest. These magical, ephemeral pieces they leave for us to enjoy may last for minutes or sometimes days, constantly changing with the weather, or altered by a fellow artist, or removed by an angry building owner. Climbing high or going underground into tunnels to place their work, these artists are often motivated by the danger inherent in putting up the piece.

It is the interplay between the urban environment and the artists who see the city as one giant canvas that captivates the imagination. Never before have we seen public art reach such a scale as we now see with the works of Blu, or become so pervasive as we see with Shepard Fairey's, or so copied as that of Banksy, or so delicate as that of Swoon.

Instilled in these artists is the concept that images and ideas are there to be co-opted, manipulated, and then transferred freely

"With each piece of free public art, they reclaim a part of the city that has been sold off to advertisers."

around the world. Street artists bemoan the rapid disappearance of public space. The idea that a company can buy the side of a building, the realization that billboards are reproducing like rats, and that publicly funded art is often the result of watered-down compromises, eats away at the street artist's soul. With each piece of free public art, they reclaim a part of the city that has been sold off to advertisers.

Many people are too quick to view street art through the lens of vandalism. They mistakenly believe that the artists are taking beautiful buildings and defacing them. And yet, most street artists work in neglected neighborhoods and place their work on "forgotten" buildings. They look for the rundown building with paint chipping off, with weeds growing out of the sidewalk. Their motivation is to beautify these buildings and to create something truly special. They believe that the art adds something to the city, creating an energy that enhances eroding buildings. If you put a piece of art on a vapid advertisement that is plastered all over town—does the community disagree with your efforts? If you beautify a rotten door, does its inhabitant not applaud you?

Over the years, technology has played a critical role in the rapid development of unauthorized public art. The affordable digital camera means that every piece can now be documented and shared, encouraging other artists to go higher, bigger, and better. Technology has also allowed these artists to be multifaceted. Gone are the days when you were considered only a photographer or only an illustrator. Today's street artists are sketching and

blowing their images up on copy machines; they are photographers by documenting their work, and they are sculptors as they case the city streets to determine what building is appropriate for their piece.

An art movement has never before gone through so many iterations so quickly. The Internet, combined with the digital camera, has allowed artists to see work from around the world overnight. They can react to the pieces, ask questions via email, see comments that admirers or critics are making, and incorporate all of this into the piece they make the next day. Sharing their stories, a strong community has developed that pushes each artist to develop materials that can withstand the weather, to identify locations that will make more impact, and to continue to push forward their ideals.

Overwhelmingly, it is the strong sense of community that characterizes this group of artists. An unwritten code has emerged that binds them together. It can be as simple as offering a bed, couch, or floor to a traveling artist. Or the willingness to work on a group piece. Or perhaps being there in a time of need, offering up a marker or a can of spray paint. As admirers and urban inhabitants, we are brought into this community in a silent, steady manner every time we are surprised by seeing a new piece, and as we daily search for more unauthorized public art. The viewer knows that the city is alive and that the artist cannot live without making this art. Ultimately, it is a shared view of the world and the belief that small acts can make a difference that will be identified with this movement.

WHERE ANGELS DARE TO TREAD

"From the prefix tres *(beyond) and* passer *(to pass), the original meaning of* trespass *was all about transgression, offense, and sin."*

Society, as the collective condition that strives for order in a vain effort to defy the entropy of being, is a construction of boundaries. As much as it is expected of artists to follow the rules like anyone else, the license we grant creativity is ultimately about giving artists some tacit permission to constantly stretch, challenge, and, if need be, defy this unending accumulation of boundaries. Someone has to do it, and while it can also be anticipated of the criminals, crazies, and children, we seemingly prefer it from an artist's hand. Just as the other is needed to establish the self, the best way to know the limits is to have something or someone pressing up against them, like an itch may remind us of the skin in which we are contained.

The act of going too far, of crossing the proverbial line, is what we call trespass. One of those delightful words for which we can thank the French, from the prefix *tres* (beyond) and *passer* (to pass), the original meaning of *trespass* was all about transgression, offense, and sin, as its use in the Bible will remind us. It took until the middle of the 15th Century for *trespass* to acquire the meaning of "unlawful entry," as it was first recorded in the forest laws of the Scottish Parliament. We can thus appreciate its longstanding, almost erotic proximity to *transgression*, which indeed only begins after *trespass* becomes more a matter of law than of morality.

As much as our complaint against trespassing may now be of a criminal nature, all too often in the heat of a culture war the dispute starts to smack of moral outrage. So deadly is its stench of corruption, in fact, we don't just blame the culprits but levy judgment on any

who can stand its rancor. Viewing it as a sign of blight and malignant decay, we are even intolerant of those who would tolerate it. When it comes to something like graffiti, it would seem the abiding ethos of a community's well-being is so dangerously at stake that punishment could be appropriate for the store that sells the paint, the unsuspecting parent, or even property owners who do not properly eradicate the sign of their own victimization.

For whatever reasons the Scots may have seen to restrict the terms under which individuals could enter their forests, we can be sure that the very fact that entry became against the law means that there was cause, if not custom, for going there in the first place. If we feel compelled to delineate some places as off-limits, we could at least recognize that wherever we put such limits there will be an inverse attraction. That is the nature of taboo.

I am reminded of a conversation I had many years ago with the radical Tuli Kupferberg. Knowing that he was one of the very few in the United States to actively oppose the Korean War long before his band The Fugs became one of the most outrageous anti–Vietnam War provocateurs of the '60s, I wanted to know the source of his immense countercultural spirit. He cited that moment when they first put DO NOT WALK ON THE GRASS signs in Central Park. "To me it was an invitation," he explained. Born in 1923, a man whose jump off the Brooklyn Bridge was immortalized by fellow poet Allen Ginsberg in *Howl*, Kupferberg is certainly a pioneer explorer of our forbidden zones. Swap his sign for one that says NO TRESPASSING, and it

"Any gesture that has not been granted permission and yet commands public address needs to be understood primarily as a kind of discourse."

is impossible to count just how many have followed in those footsteps.

For those most concerned with the ill that trespassers represent, be they activists or artists, it might help to consider this: graffiti, protest, and aesthetic intervention all work in opposition to authority. Any gesture that has not been granted permission and yet commands public address—be it activist or avant-garde, mischief, vandalism, or fine art—needs to be understood primarily as a kind of discourse. Audience is everything, even in the coded language of graffiti, where the intended audience often remains a subcultural set of fellow practitioners. Communication is as fundamental to human nature as is mark making, and the primal embodiment of both impulses is registered in our earliest cave paintings. It is necessary to keep both in mind, as well as where this particular kind of art is created, to understand certain acts as inherently creative.

Because restrictions on free expression and movement will inherently be viewed by a segment of the population as an invitation, the act of trespass can be understood not simply as a challenge to the rules but also as a challenge to the authority upon which they are founded. When, as is so often the case, the artist's trespass is not merely private but directed at a larger audience, we might also find that what is being communicated intimately involves a provocation for others to question consensus reality. Street Art, taking its cues from both the recent lineage of graffiti and the more esoteric history of Modernism's assault on status-quo assumptions, screws with normative urban experience to allow for a broader questioning

of the way things are. This is the space of doubt and scrutiny in which uncommissioned public art operates.

Because we are not so interested here in the individual phenomena by which one kind of unsanctioned expression gains greater currency at one time or another, but rather in the nature of all these interventions in public space collectively, this book is not intended as a definitive history per se. Our story is not one to be told as a matter of chronology or neatly divvied up according to the well-established boundaries of genre. The vanity of our ambitions is to take in the larger picture, to question why so many different people throughout the ages have for seemingly very different reasons felt obliged to address public space in unsolicited fashions. We want to get at how this history of aesthetic interventions clusters around shared concerns and strategies. Nothing so formal as a map, this book is more an intuition, an empiric reading of the discrete ways in which motives and methodologies from different manner of cultural endeavor can inform one another.

OPPOSITE

Richard Hambleton
LOCATION New York City
DATE 1982
PHOTO Martha Cooper

PAGES 18–19

Lee Quinones
LOCATION New York City
DATE 1981
PHOTO Martha Cooper

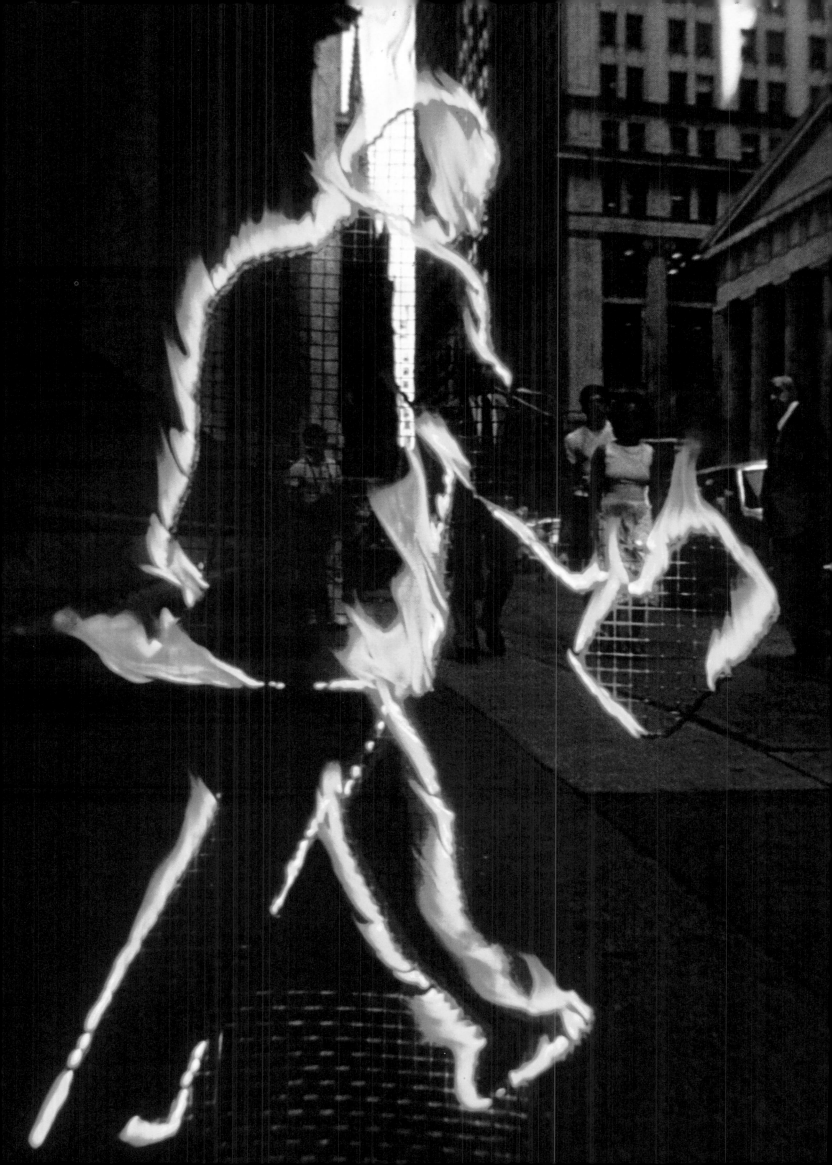

RULES OF THE GAME

"It is vital to understand how the uncommissioned intervention is a reflex against the hegemony of public space by the interests of the few over the psychological well-being of the many."

It is easy to conjure the flavor of mid-'70s New York, the atmosphere of wide-open lawlessness like a miasma in the air—the garbage strikes and blackouts; the first beats of the Hip-Hop Nation sounding from the school yards as Kool Herc, Afrika Bambaataa, and other pioneers hot-wired their systems into public service for spontaneous parties. Of course, the pervasive scent of Krylon paint was also in the air as the subway system was conquered by bold young turks with self-dubbed and fantastic names, speaking a postlinguistic language in their hyperstylized way of writing that defied all sociologies of youth, subculture, or deviance.

Such is the narrative most people would gladly receive in the cultural wake of rap's ascendancy and in urban youth marketing, which now plays a preeminent role in defining identity. It is, however, a reductive history that misses the wide-ranging display of transgression, terror, and territorial crisis that New York City felt in the critical spasms of the great white flight from desegregated urban neighborhoods. Not enough respect or remuneration has been awarded to those early style-master kings who ruled certain train lines at seminal times for us to want to diminish their place in any underground pantheon. But if you asked people who really ruled the twisted heart of this Gotham-on-the-skids, then it would have to be a diminutive aerialist from France named Philippe Petit.

Pointlessly heroic in the spirit of explorers like Edmund Hillary, absurdly daring in the way of American motorcycle acrobat Evel Knievel, and baring showmanship that P. T. Barnum would appreciate, Petit's tightrope walk in the summer of 1974 captured the imagination. His early-morning perambulations high above downtown New York, along a wire strung between the two Babel-esque towers of the World Trade Center, would not have commanded so much attention at that time had it not been, in the sum of its spectacle, an outlaw act. A primal trespass upon a structure still being built, it was for Petit an act of love perversely constituted as a transgressive gesture.

In the wake of 9/11, history has provided a healthy amnesia by which we can forget the public outcry protesting construction of the WTC as a neighborhood-destroying, light-blocking monumentality, as corporate and civic hubris and a grotesque expenditure of money at a time of widespread and dire fiscal woe. But beyond the patina of nostalgia, stench of death, and abiding sense of loss now inextricably associated with the towers, it is vital to understand how the uncommissioned intervention is a reflex against the hegemony of public space by the interests of the few over the psychological well-being of the many.

This ongoing frisson between the authority of property and the artists' subversive questioning of this privileged domain returned one last time to the WTC before their mortal erasure. In 2000 the Austrian collective Gelatin was given studio space in one of the buildings as part of a program sponsored by an arts organization called the Lower Manhattan Cultural Council. While the other artists in residency were busy making fine art and entertaining studio visits, Gelatin was working in a covert manner, planning and occasionally hauling odd bits of construction

material into their space, which they had sealed off from public view. The fruition of their labors occurred in a brief instant one morning when the window of their room was removed, and towering more than 100 stories above the city, a temporary balcony was installed for Gelatin to take its own Petit-esque foray into the sky. A perfect rupture in the hypothetical membrane that separates public and private space in the urban mindscape, it followed two of the most basic rules of the game: speed and secrecy.

As we consider the urgency and fearlessness with which creative types of every ilk have tackled the monolith of social control that is built into the superstructure of the urban experience, it is worth noting that no matter how whimsical or wily the expressions may be, the canvas is always fundamental to the work itself—be it an artery of transportation, a building structure, or the walls that separate individual and mass domains. It is easy to speak of graffiti and Street Art as the imposition of some personal will upon the public good. With an intrinsic

quest for fame and the proactive search for a broader audience, vandalism of this sort operates as a kind of activism—a defacement of the consensually established visage that vested interests hide behind to create the shiny illusion of an orderly, civilized, prosperous, and benevolent world. It not only bites the proverbial hand that feeds us but makes us collectively wonder exactly whose hand that is.

At its most apolitical, work done without permission in places that make others bear witness to the affront still embodies an intuitive rebellion against the assumption that the rules of property take precedence over the inherent rights of free use and self-expression. From the cave paintings left by primitive man through the proto-poster art of Martin Luther nailing up his proclamations in the early 16th Century, there are valuable precedents for the appropriation of public walls by individual ideologues that cannot be forsaken by the mere existence of mortar, brick, steel, and glass, nor whatever subsequent laws are constructed.

PAGE 20

Paolo Buggiani, *Wall Street*
LOCATION New York City
DATE 1981

LEFT

Martin Luther, Posting the 95 Theses
LOCATION Wittenberg, Germany
DATE 1517

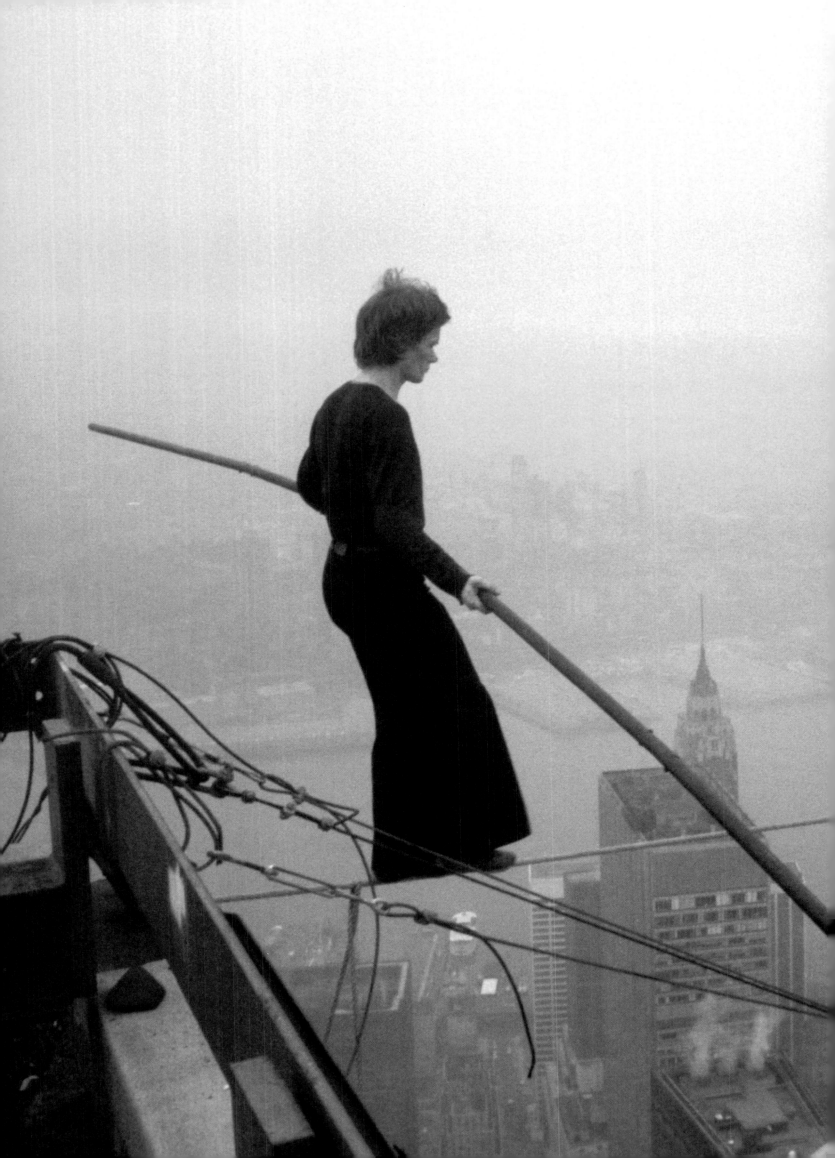

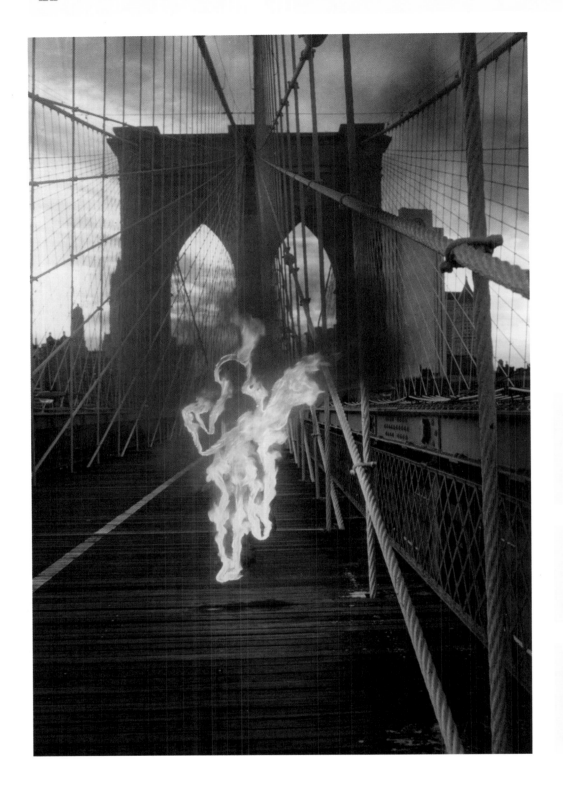

PAGES 24-25

Philippe Petit, *Le Coup*
LOCATION World Trade Center, NYC
DATE 1974
PHOTO Jean-Louis Blondeau

LEFT

Paolo Buggiani, *Minotaur*
LOCATION Brooklyn Bridge, NYC
DATE 1980

OPPOSITE

Richard Hambleton
LOCATION New York City
DATE 1980
PHOTO Franc Palaia

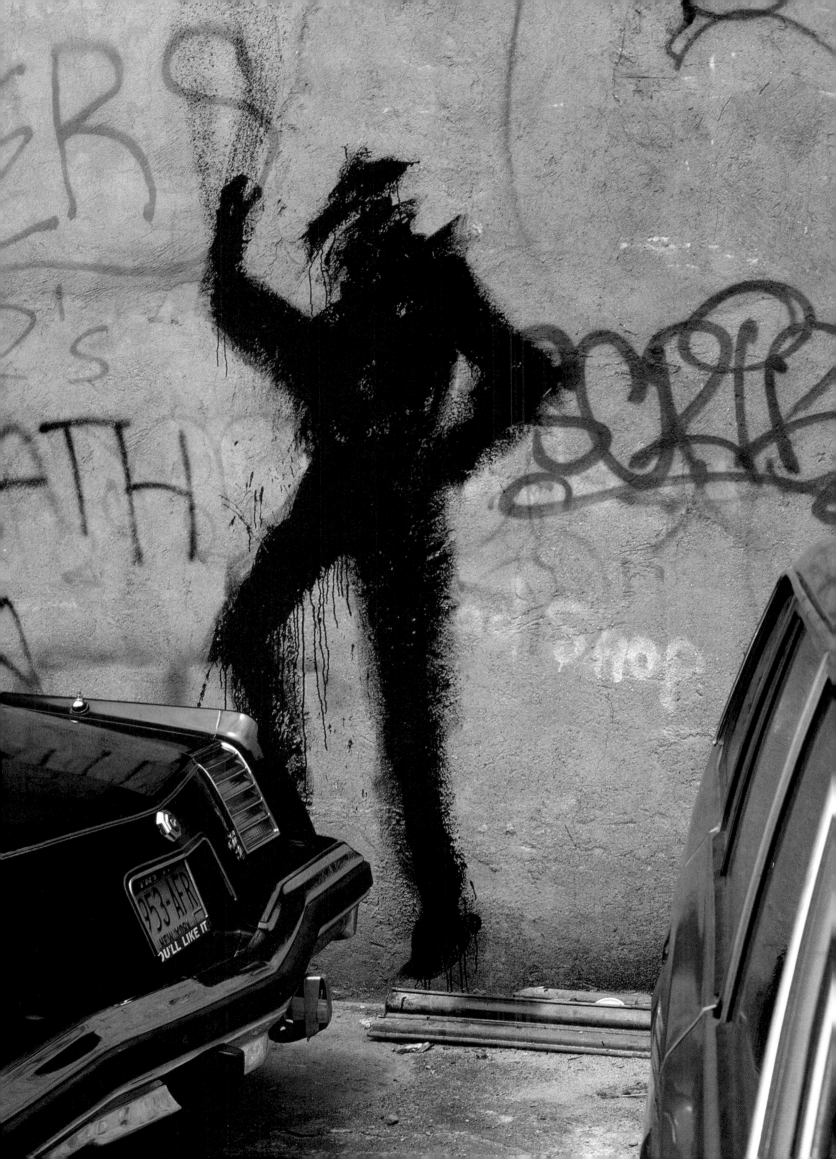

THESE ARE THE THOUGHTS THAT SET FIRE TO YOUR CITY...

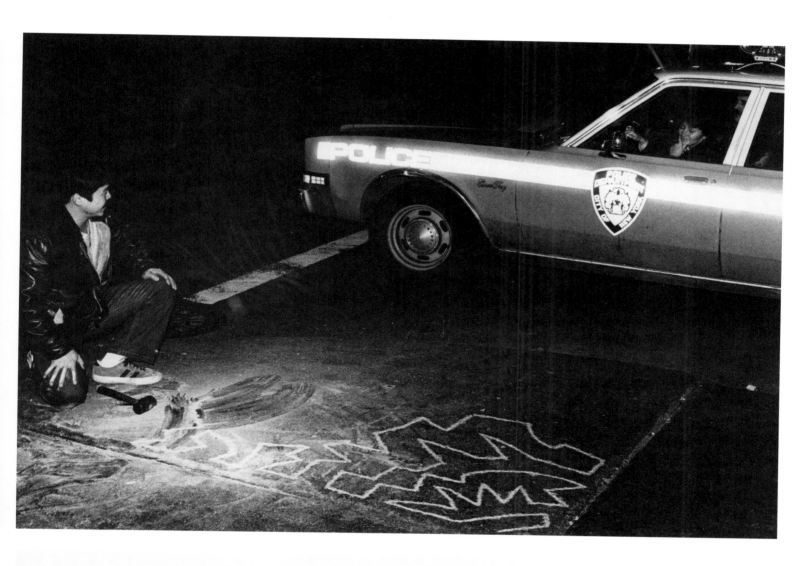

OPPOSITE

Joey Krebs the Phantom Street Artist
LOCATION Los Angeles, California
DATE 1993
PHOTO Anthony Friedkin

ABOVE

Ken Hiratsuka, *Fossil Line*
LOCATION New York City
DATE 1983
MEDIUM Chisel carving on sidewalk
PHOTO Toyo Tsuchiya

BELOW

Peter Missing
LOCATION Lower East Side, NYC
DATE C. 1990
PHOTO Clayton Patterson

Peter Missing's symbol, the upside-down martini glass, came to represent the anti-gentrification struggle in the 1980s and later. It is quite possible that this graffiti was not done by Peter Missing, but by a resistance-movement individual, likely an LES squatter. There are two main symbols here: Peter's anti-gentrification sign, and the N with a cross on one end and an arrow at the other, representing the squatter movement.
—Clayton Patterson

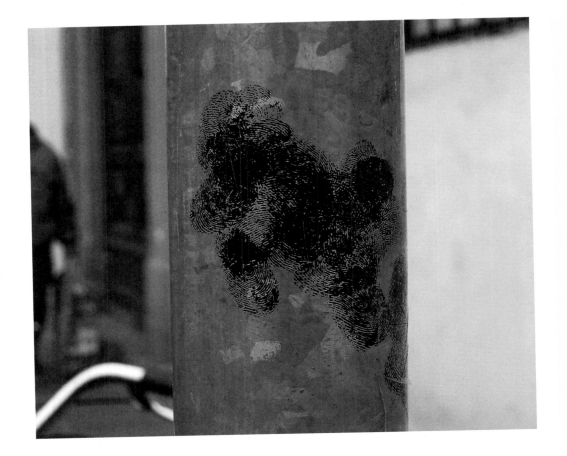

OPPOSITE

Krzysztof Wodiczko
LOCATION Victory Column,
Stuttgart, Germany
DATE 1983
MEDIUM Projection on 19th-Century
military monument
ARTIST NOTES During the 1983
national election campaign in West
Germany, the Christian Democratic
Party's proposal to deploy Pershing
2 missiles around major cities of
West Germany was a critical issue.

*Krzysztof Wodiczko projects large-
scale images onto the facades of
public buildings to incite and exam-
ine questions of power, violence,
and human rights. While many of
his projects around the world are
executed with permission/sponsor-
ship, the work pictured here is an
exception, along with his projection
of a swastika on the South African
embassy in London in 1985.*

PAGES 34-35
Ann Messner, *crosswalk*
LOCATION New York City
DATE 1977

ABOVE
Jeroen Jongeleen / Influenza,
Fingerprints as Corpus Delicti
LOCATION Florence, Italy
DATE 2002
MEDIUM Silkscreen on vinyl

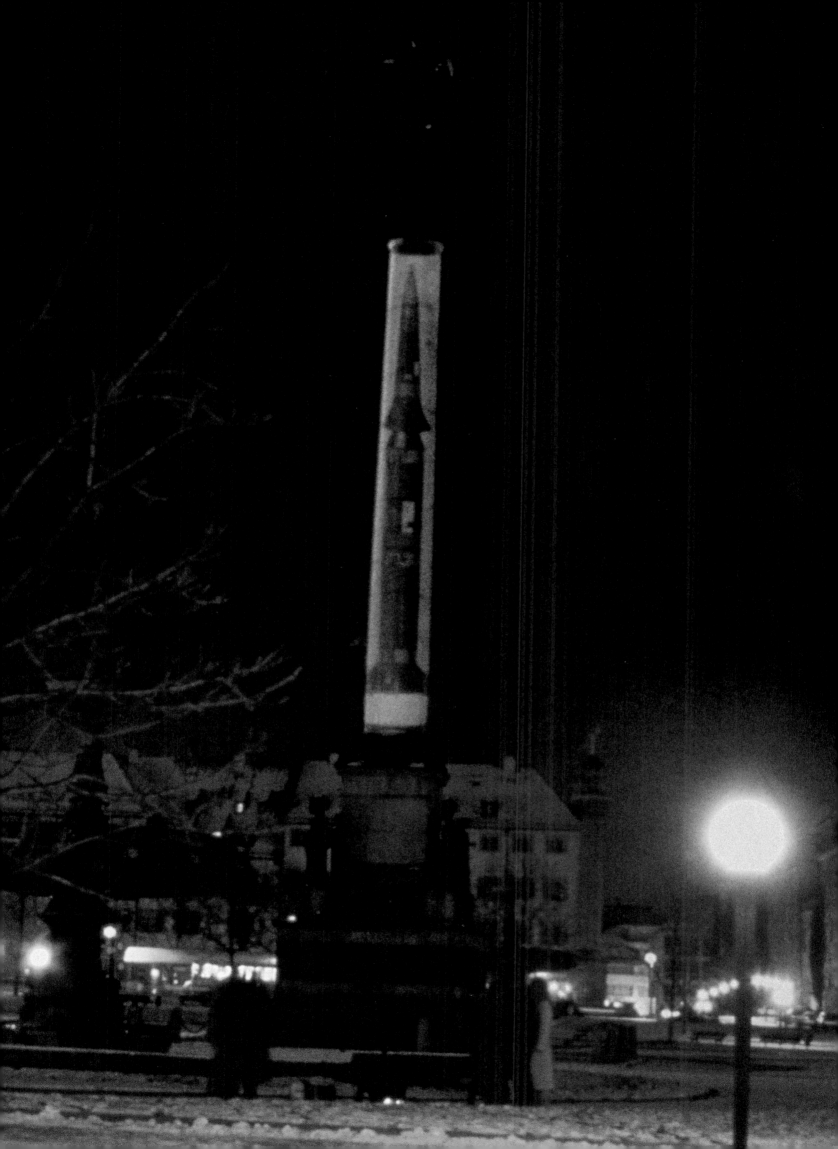

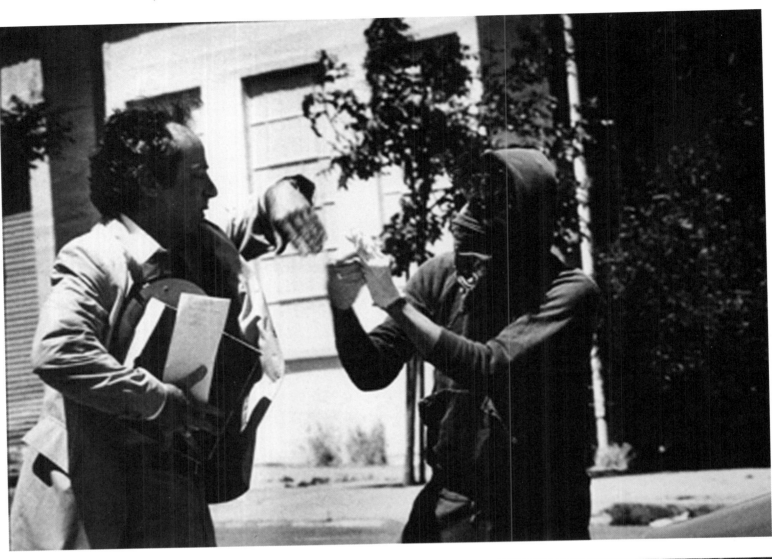

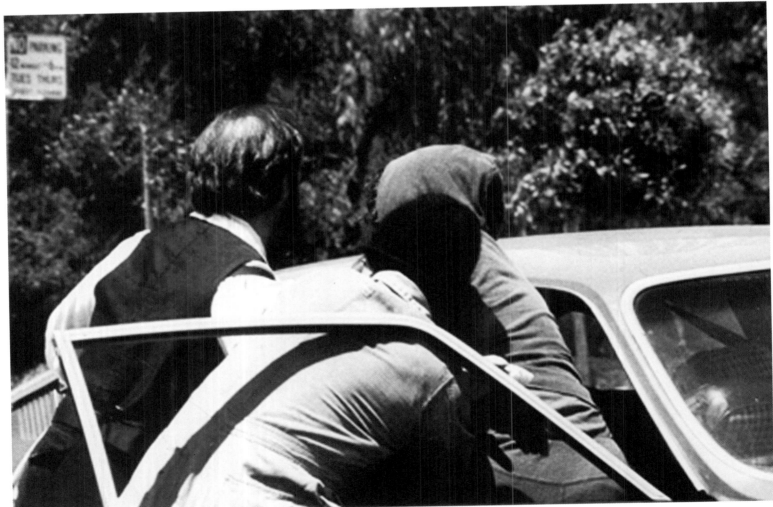

OPPOSITE

Tony Labat, *Kidnap Attempt*
LOCATION San Francisco, California
DATE 1978

Conceptual artist Tony Labat kidnapped the media-obsessed candidate for mayor of San Francisco, Lowell Darling, bringing performance art dangerously close to terrorism.

RIGHT

Hans Winkler and p.t.t.red,
p.t.t.red in Disneyland
LOCATION Anaheim, California
DATE 2001
ARTIST NOTES Slapping Mickey Mouse on the Fourth of July, 2001, after Desert Storm parade, and escaping to Tijuana, Mexico.

Conceptual artist Hans Winkler, along with collaborator Stefan Micheel (p.t.t.red), asked Mickey Mouse for his autograph on a piece of paper that contained a contract giving Winkler permission to hit Mickey Mouse, with slapstick results.

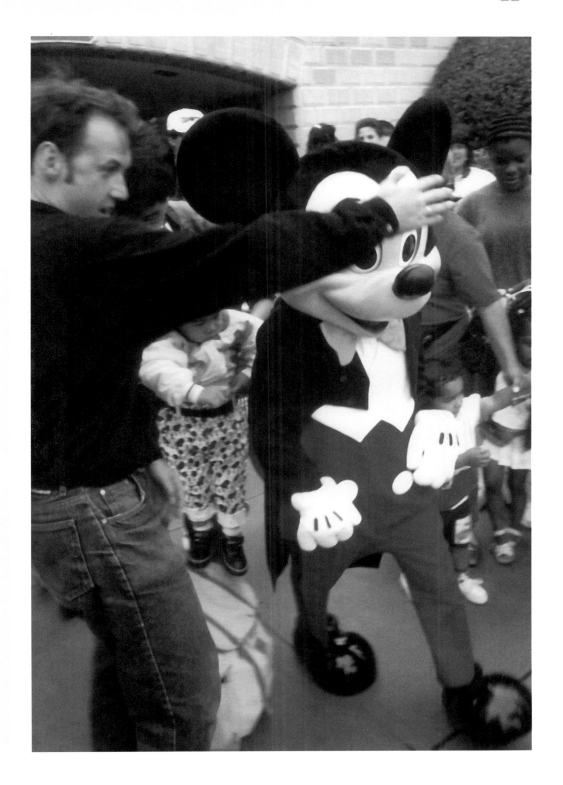

BELOW

Os Gêmeos
LOCATION São Paulo, Brazil
DATE 2008

After 20 years at the school
It's not hard to learn
All the cunning of their dirty tricks
It's not the way it has to be
 —from the song
 "Geração Coca-Cola"

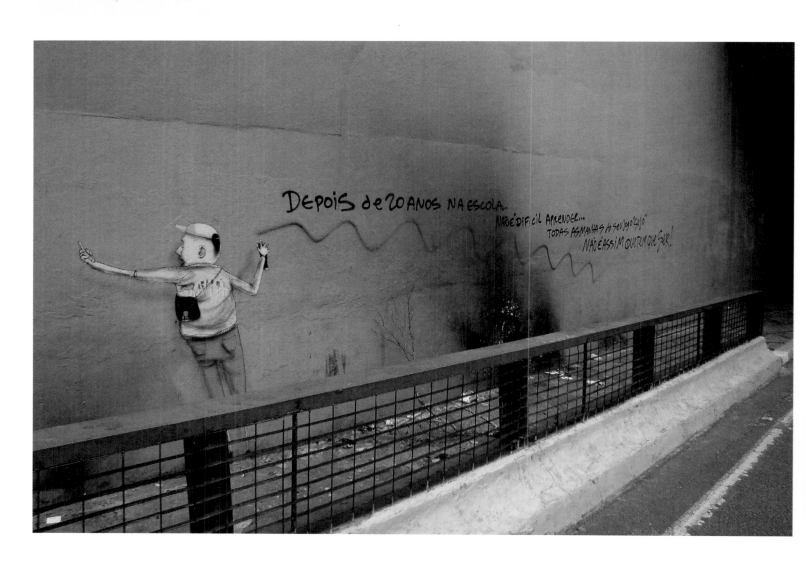

David Wojnarowicz
LOCATION Hudson River Pier, NYC
DATE 1983
PHOTO Ivan Dalla Tana

David Wojnarowicz remained ambivalent and antagonistic towards the art market until his untimely death in 1992, preferring to do much of his best work as guerilla actions. Pictured here: art from an abandoned pier along the West Side Highway that he took over with artists Mike Bidlo and Luis Frangella, and an early street stencil (circa 1980).

OPPOSITE

Nick Walker, *Mona Lisa*
LOCATION London, England
DATE 2007

BELOW

Guerrilla Girls, *Do Women Have To Be Naked To Get Into the Met. Museum?*
LOCATION New York City
DATE 1989

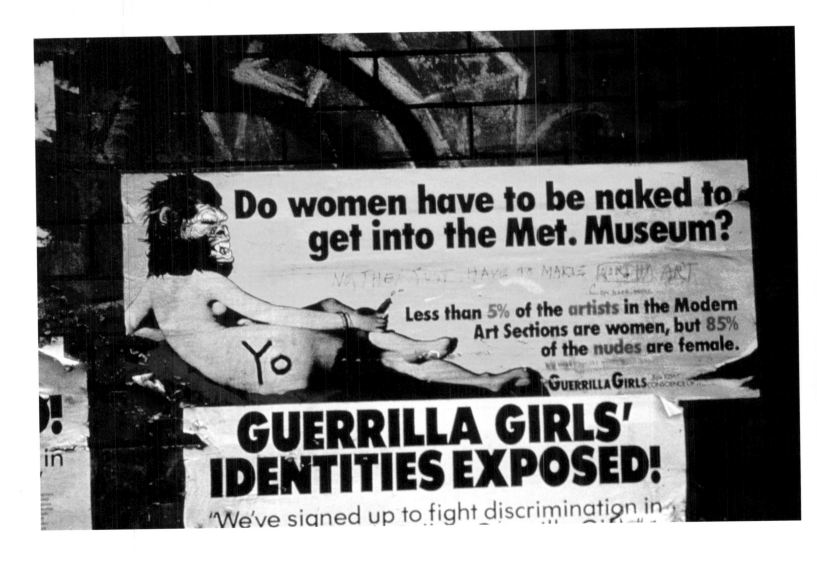

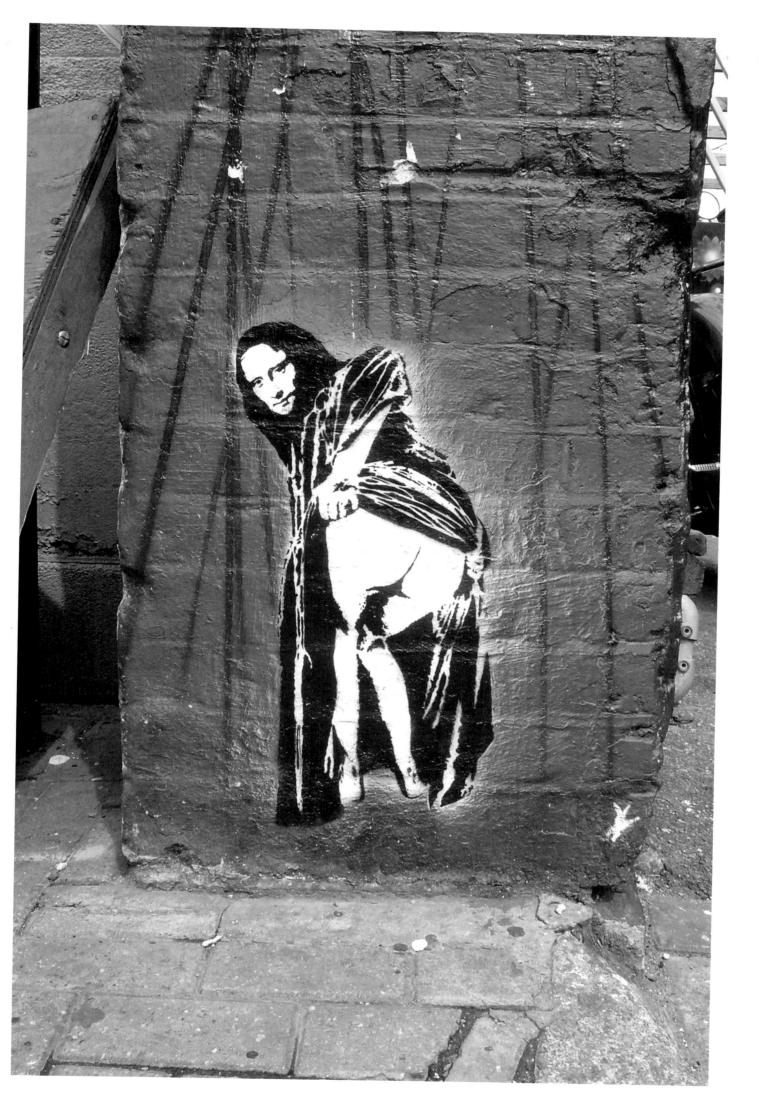

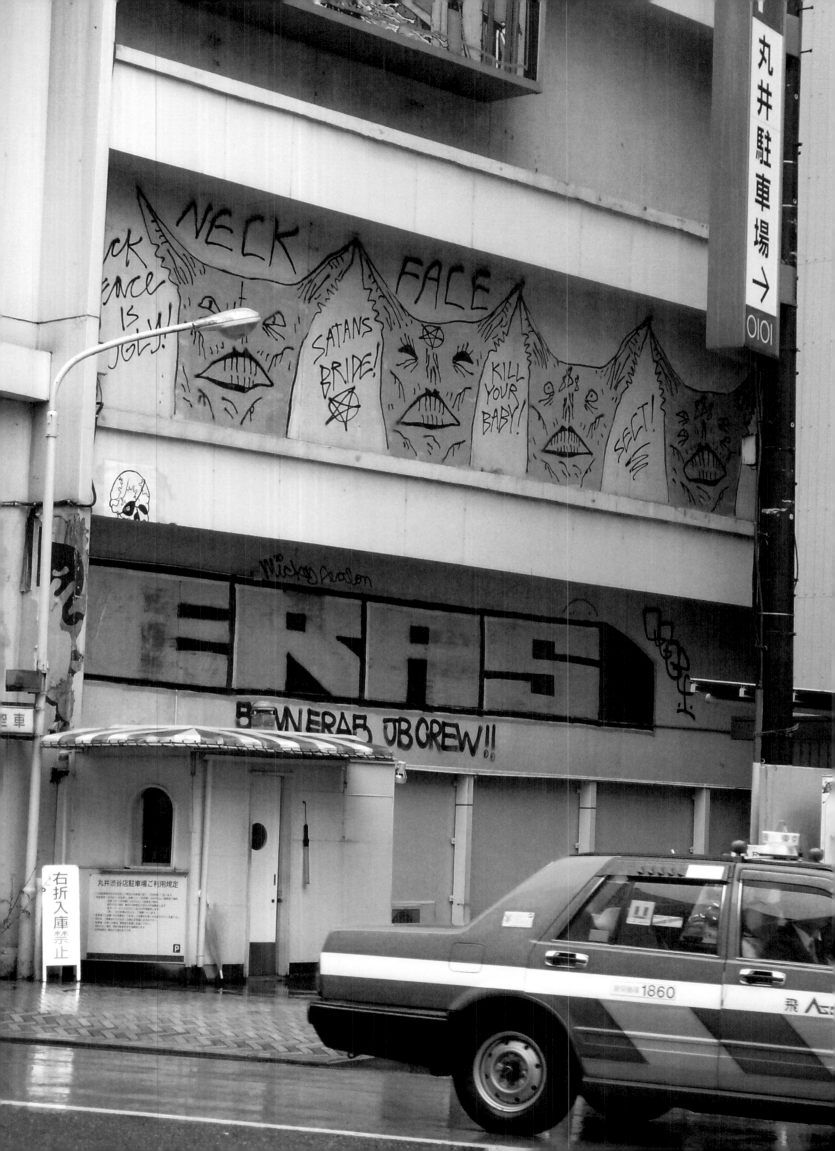

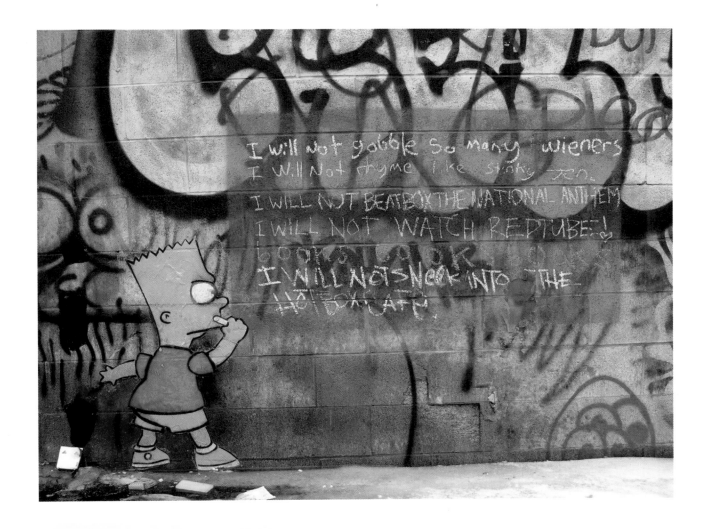

Posterchild, *Chalkboard Theme Week—Bart*
LOCATION Kensington Market, Toronto, Canada
DATE 2007

Chalk left by the artist near the wall was used by passersby who filled in the board

NeckFace
LOCATION Tokyo, Japan
DATE 2008
PHOTO Martha Cooper

JR, *28 Millimeters, Women Are Heroes*
LOCATION Morro da Providencia, Rio de Janeiro, Brazil
DATE 2008

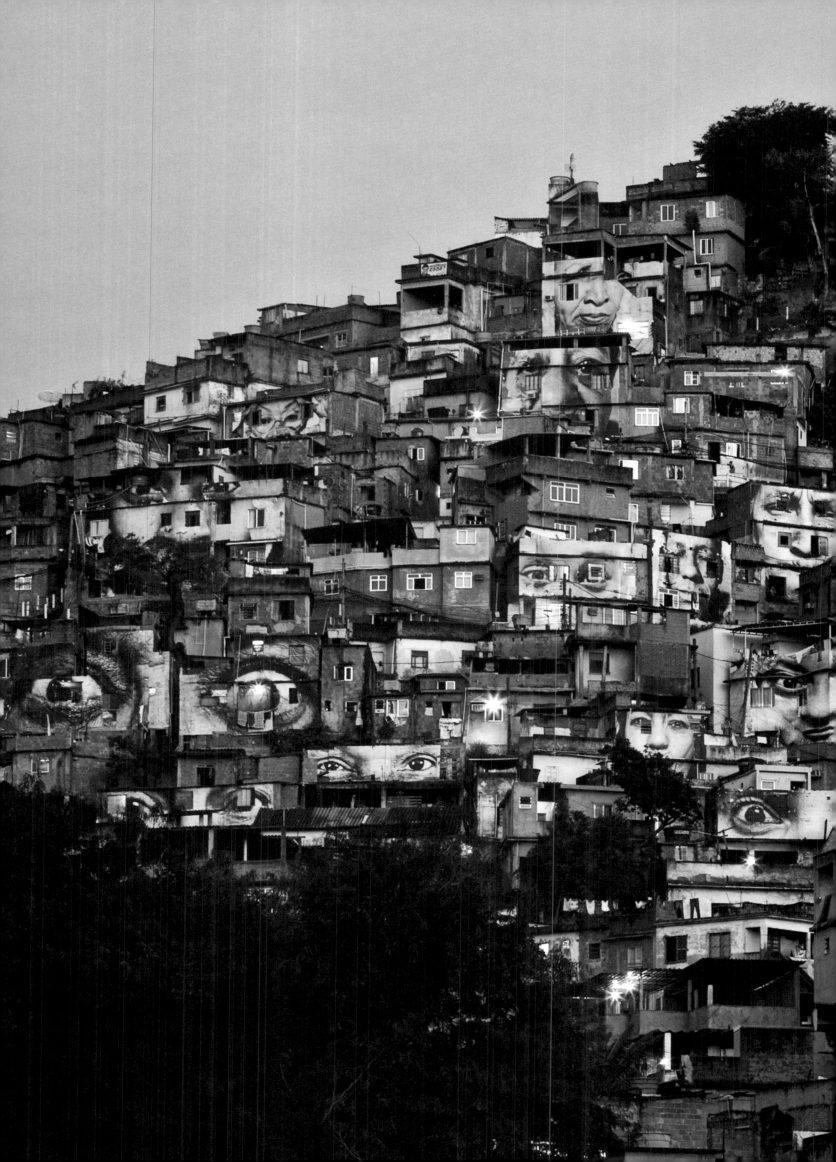

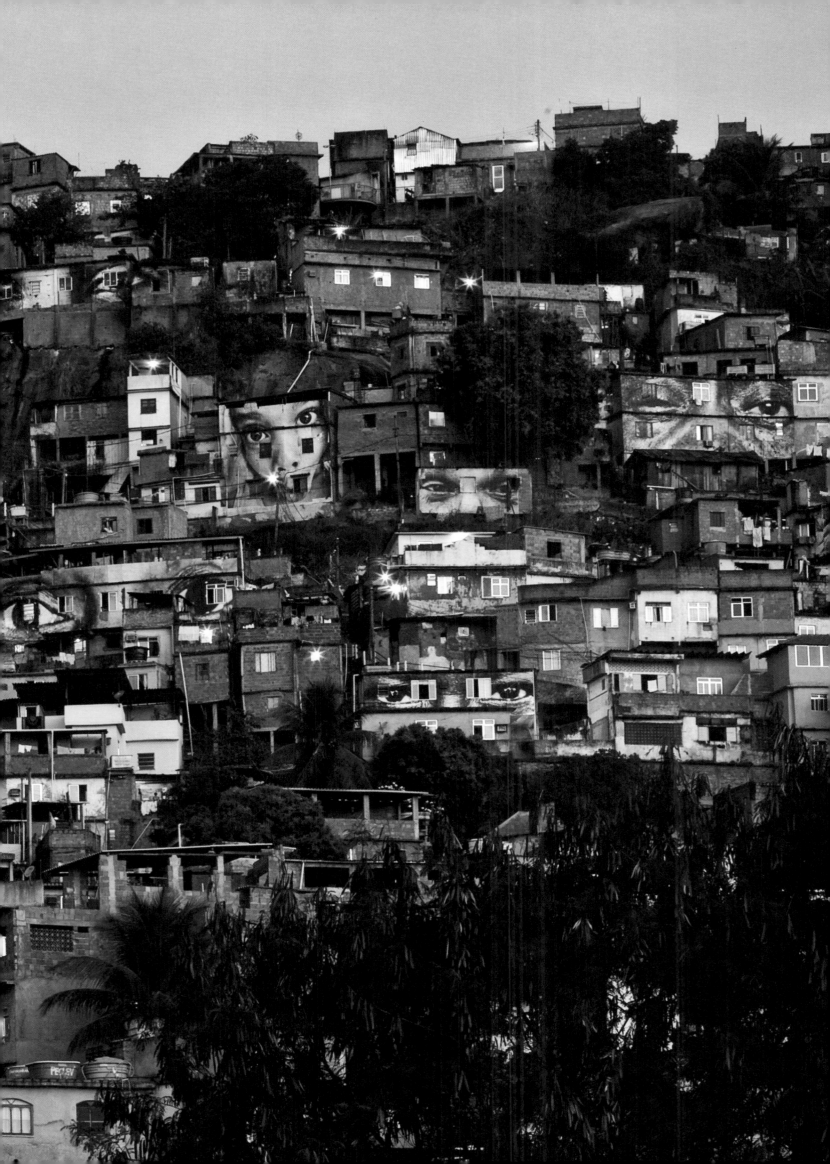

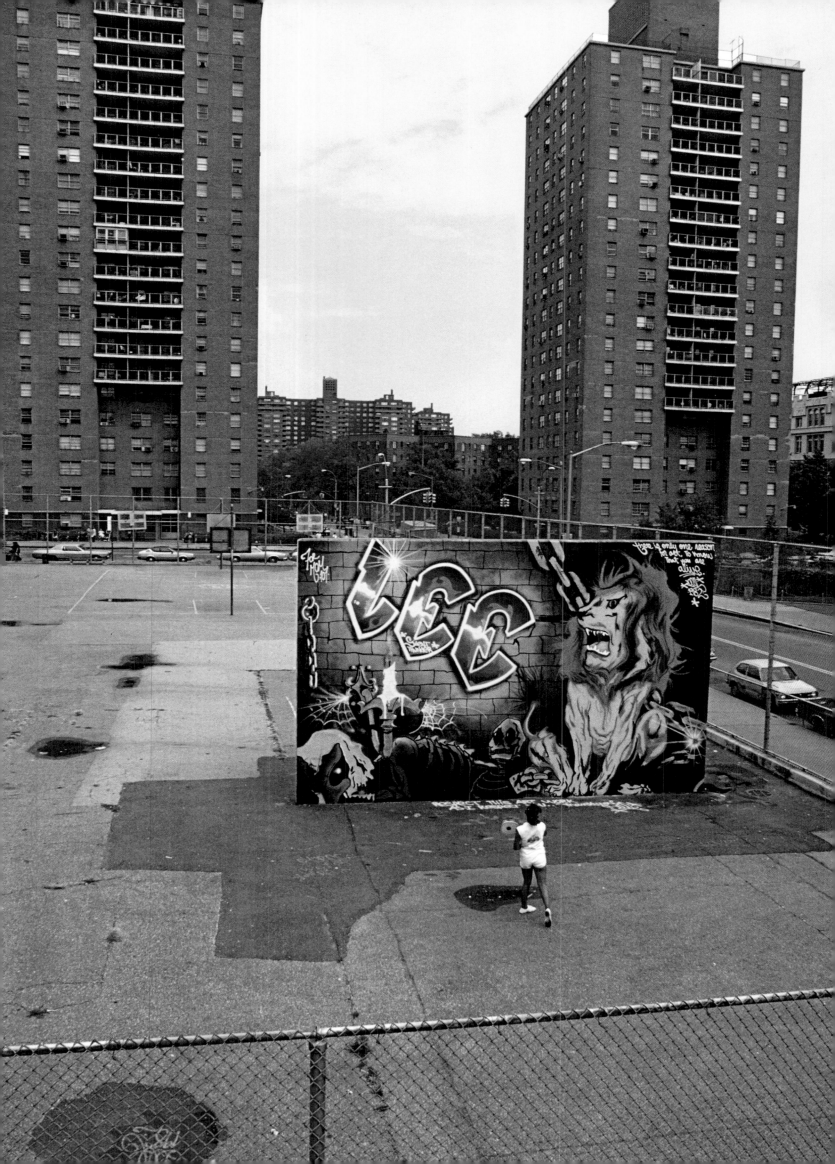

CONQUEST OF SPACE

Taking its name from the Latin term denoting a crude drawing or inscription scratched into a hard surface, graffiti is the oldest form of unsanctioned public art from which all aesthetic or radical statements made upon the geography of public space have evolved. A primary form of mark-making at its etymological and phenomenological root, graffiti embodies characteristics and modi operandi distinct from the creative, ideological, or most lowbrow impulses associated with it. Yes, something needed to be expressed with such urgency or spontaneity that the author felt compelled to disfigure and vandalize property—but ultimately the greatest taboo violated is the psychological dimension of space.

Like the drunken boor who stands too close, muttering nonsense with rancorous breath and flinging spittle in your face, graffiti is a social offense, outlawed and persecuted not because it is particularly dangerous or harmful but because it ignores the personal boundaries of the body politic. Artists who perpetrate their art on an unsuspecting and unwilling audience irritate most precisely by virtue of their presumption, a Duchampian conceit beyond the mere declaration, "This is art because I say it is"—no, they further assert that the sphere of others is a canvas of their own in a morally pernicious form of appropriation.

Touring like bands, traveling minstrels of mischief, street artists today no longer move in a loose patchwork of individuated provincialisms but with an ever-expanding matrix of migratory adventurers and world of sites—heavily frequented cultural capitals and exotic locations alike—where their art communicates to both the local audience and to one another. In part an extension of youth lifestyle updating Jack Kerouac's *On the Road* (1957), and surely akin to the way that travel has long been essential to artistic practice, be it the Grand Tour de rigueur for artists of the salon academy generations or the market-driven globalism of the contemporary art world, it is also indelibly informed by the deeper history of mark-making that has served our itinerant spirits as a way to conquer, tame, ritualize, familiarize, or personalize space.

With the same impulse as the British explorer George Mallory (1886–1924)—who, when asked why he would climb Mount Everest, responded, "because it's there"—those who trespass on a global stage do so with a remarkably predatory disposition. Like armies dying to capture a hill or astronauts dedicating lifetimes to get to some other territory, the invading forces feel compelled to mark, memorialize, and monumentalize the occasion with a flag. And because it is like the fetish around those footprints still left on the moon's surface or the blood spilt on some godforsaken bit of rock, whatever residual or documentary trace can suggest an afterlife beyond this temporal dimension carries the full aesthetic load. In mapping this kind of aesthetic territorialism, digital photography and video, in league with the Internet, have become as proximate to a tangible manifestation as this immaterialist ephemeral art can get. Like postcards, memorabilia, or the snapshots each tourist has taken before the same itinerary of cliché spots, they serve as tokens of place without which one would feel like he had never been there.

"Location is everything; context and content are ultimately the most measurable difference between what is written in the bathroom stall and...the Brooklyn Bridge."

If the conquest of space is at best a temporary negotiation, the role of public art is itself a dubious proposition. As a culture we do not do so well in differentiating between permanence and impermanence. We would like to believe in an ecology of gestures, the naturalist's mandate that the ideal way to hike into and occupy any wonder, natural or man-made, is to leave no trace—or rather, to counter the prevailing forces of time and neglect, to leave every space a little cleaner and more pristine than it was before. Yet we have made an emotional and cultural space as a society for the wonder that accompanies the individual within the universal.

However rabid tree huggers may feel about it, there is a quaint nostalgia of young love and dream of eternity expressed by heart-enclosed names carved into a tree. There is a surprising appeal in the curious legacy of socially inappropriate inscriptions: Lord Byron, the ultimate Romantic figure who set into our cultural lexicon the very idea of the untethered traveling adventurer-artist, carved his name into the Greek Temple of Poseidon; the great decadent and perverse bard Arthur Rimbaud perpetrated the self-same aggrandizement upon the Temple of Luxor. Both inscriptions add to the historical potency of the ancient, and it is the spontaneous, unmediated, and dedicated that gets the props. A folk art of proto-Lovemarks, significant for the public sharing of positivism, is accepted in the arrogant honor of the Romantics creating their own visitor sign-in book, the exuberance of declaring love for another, or perhaps the trans-generational mimetic of those Polynesian petroglyphs carved in concentric circles as

each family successively offered up the umbilical cords of their newborns to whatever god was looking after fertility in that culture.

Is our proclivity for marking territory a very human example of culture and the evolution of linguistic and visual communication, or closer to the way animals spray their urine to denote possession of a place? On one hand we will have to temper the aggressive tendencies of getting up and getting over as a pathological manifestation of ignorance and arrogance, yet on the other we must balance our fascination with the unmediated by owning up to the persistent power that the savage Other still exerts. It is dangerous for us to bestow a greater sense of authenticity on the primitive, yet it is at the root of our discourse, from Brassaï's remarkable photographs of poor kids scrawling their unsanctioned expressions on the rough walls of '50s Paris, through the subtle condescension within the poetics of Norman Mailer's seminal *Faith of Graffiti* text (1974). Certainly it was rarely discussed how graffiti, as a newly redirected fine-art form in the early '80s, was embraced both among American collectors and even more phenomenally in Europe, where it bore the further exoticism of seeming so fine an example of America's beloved capacity for transgression.

Location is everything; context and content are ultimately the most measurable difference between what is written in the bathroom stall and the profound bravado of more heroic feats like Smith and Sane's landmark subjugation of the Brooklyn Bridge, a move so balls-out it still stands out as the single greatest escalation within the graffiti wars. Authorship is of course

"As a cultural registration it takes its power from saying someone was here, regardless of whom."

key—would we bother to preserve anyone else's name but Byron's upon an iconic cultural cradle?—but as a cultural registration it takes its power from saying someone was here, regardless of whom. This may be less evident in the egocentric dialect that is graffiti as we commonly know it, but it is at the heart of where graffiti's explosion as a newly American cultural form comes from.

Others will offer their own idea of history, but as I remember it, before graffiti's remarkable genesis among inner-city youth, what we had was the perverse perpetration of an inherently insensitive inside joke: "Kilroy Was Here." Supposedly, according to the most believable

of the many urban myths associated with it, begun as a modest inscription by an inspector of bombs manufactured by the United States military in World War II, this graffiti slogan came to be found wherever our good-old-boy soldiers wanted to surprise and disquiet their enemies.

The spread of this discretely nationalist notion of America's global dominance from a war-based folk art to its wider populist currency may seem like a peculiar historical anecdote, but by our account it is the Rosetta Stone by which we should continue to read the impulse of putting your mark where it is otherwise thought not to belong. Why? Because in the human geography and mental geometry of space, *I was here*.

BELOW

Jean-Léon Gérôme, *Napoleon and the Sphinx*
LOCATION Egypt
MEDIUM Photogravure of painting

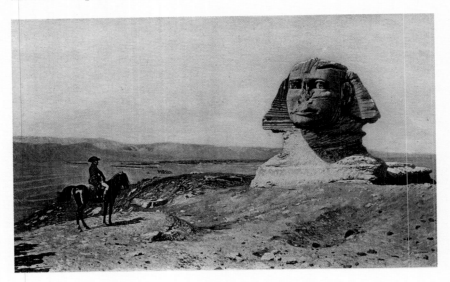

PAGE 48

Lee Quinones
LOCATION New York City
DATE 1982
PHOTO Martha Cooper

There is only one reason for art. To know that you are alive.
—Lee Quinones, 1982

OPPOSITE

Sane, Smith
LOCATION Brooklyn Bridge, NYC
DATE 1988

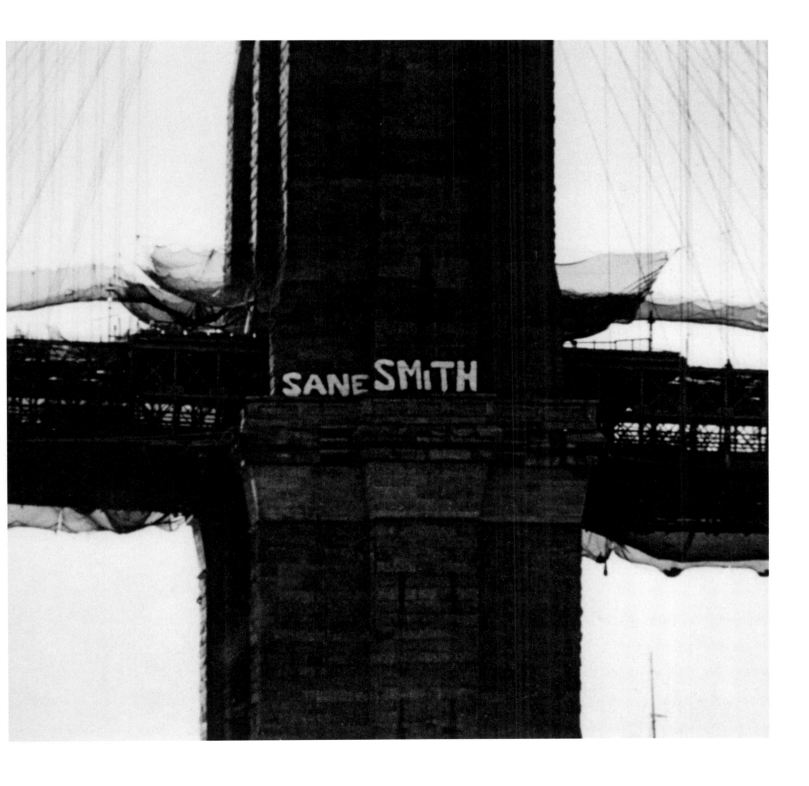

OPPOSITE

Sam3, *Sisifo*

LOCATION Campofelice di Roccella,
 Sicily, Italy
DATE 2008

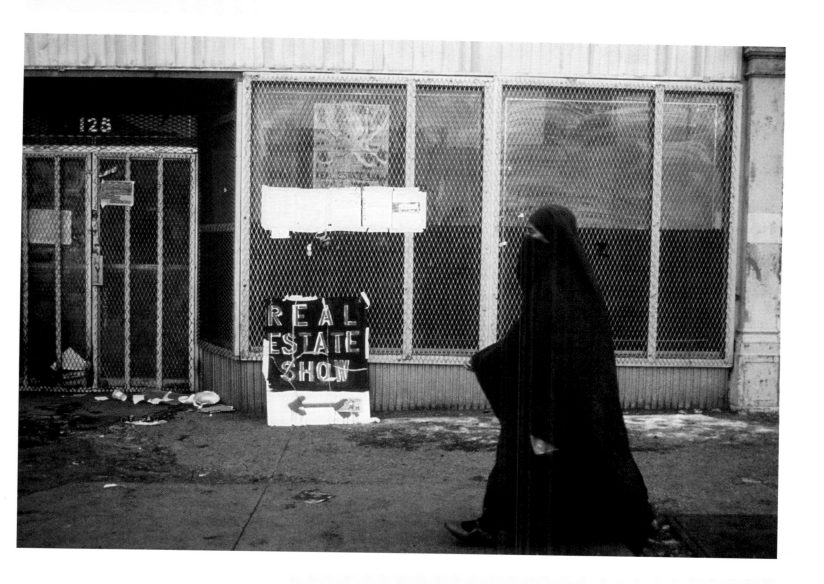

ABOVE

Real Estate Show

LOCATION Lower East Side, NYC
DATE 1980
PHOTO Ann Messner

The Real Estate Show was the occupation of an abandoned building along Delancey Street that began on New Year's Eve, 1980. The show was shut down by police, but the city eventually recapitulated by giving the organizers a vacant building nearby, which became the seminal alternative space ABC No Rio. That summer, the collective Colab would stage the epic takeover of a former massage parlor to create the Times Square Show, which launched a generation of artists including Tom Otterness and Jean-Michel Basquiat into public consciousness.

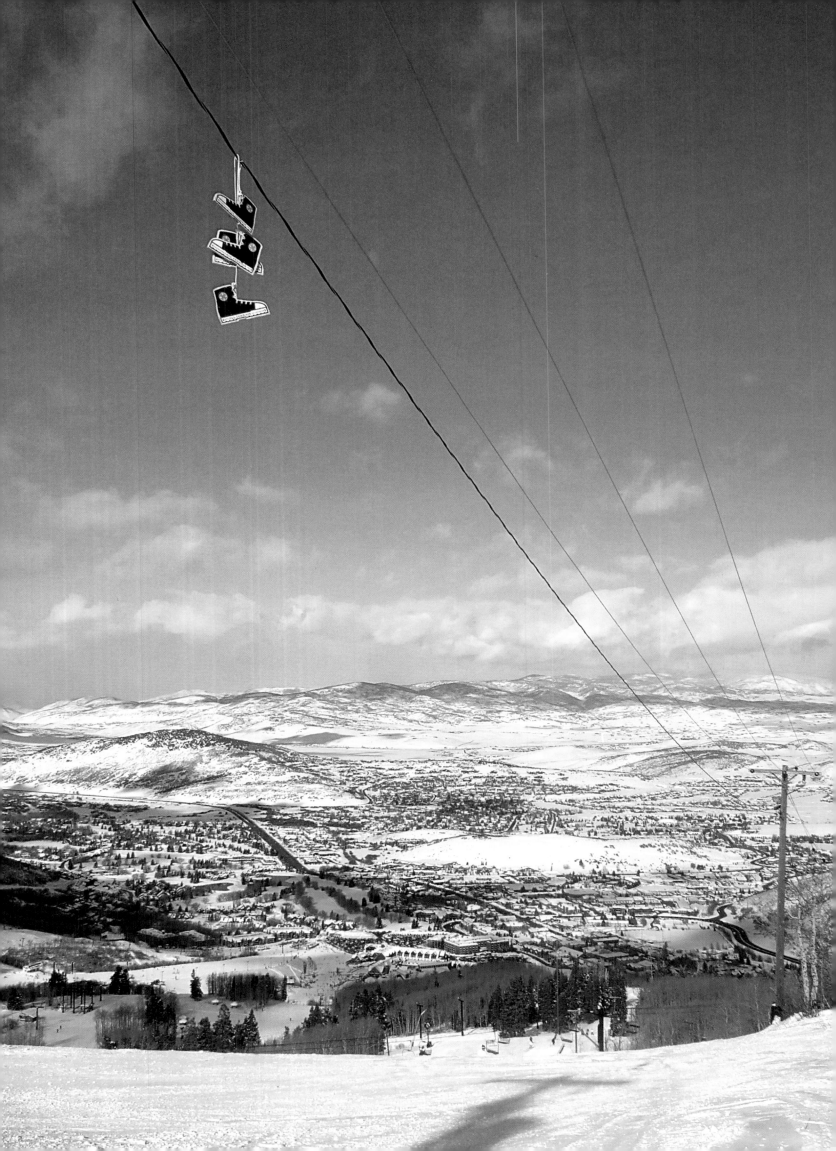

OPPOSITE

Skewville
LOCATION Salt Lake City, Utah
DATE 2007
MEDIUM Silk-screened wooden
 sneakers

BELOW

REVS / COST
LOCATION New York City
DATE 1992
MEDIUM Paint roller
PHOTO Jake Dobkin, 2007

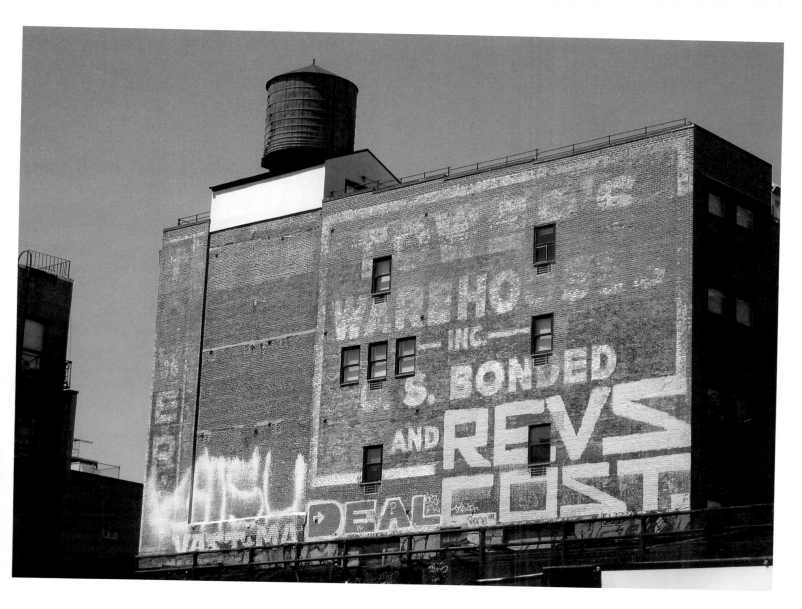

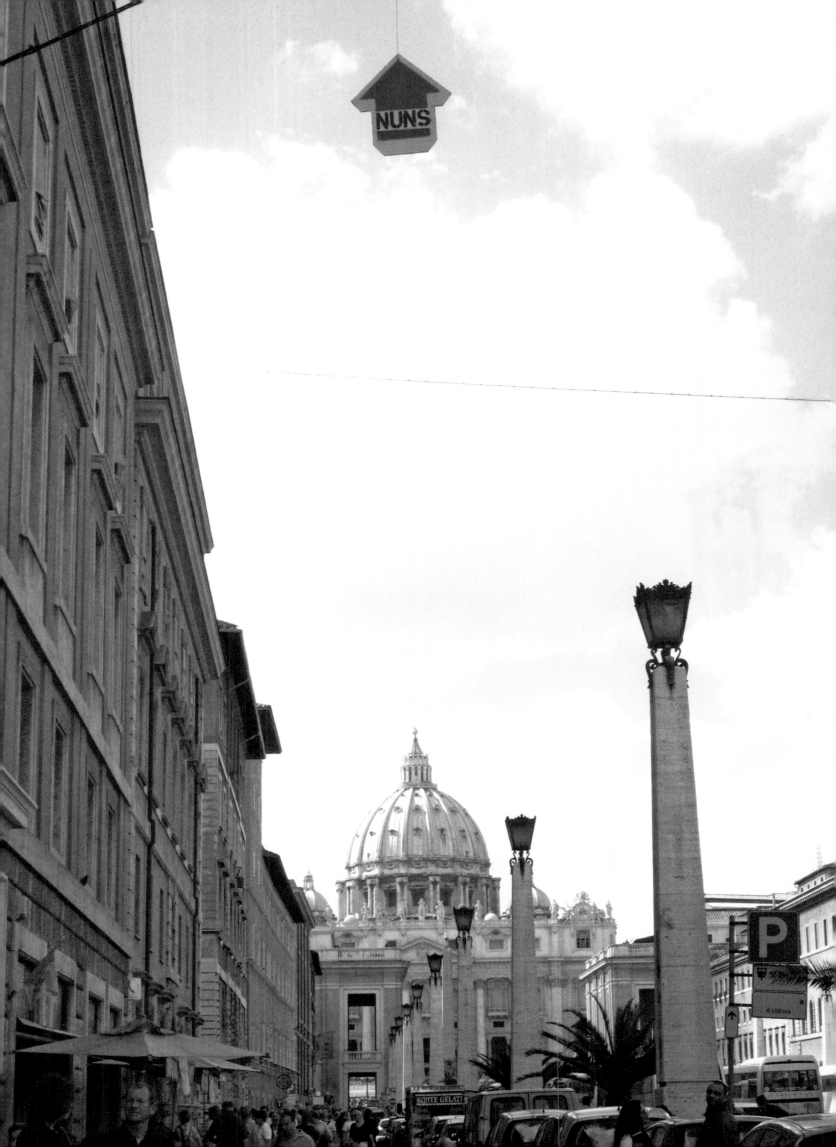

OPPOSITE

Above, *Nude/Nuns*
LOCATION Vatican City
DATE 2006
MEDIUM Wooden arrow mobile

NUDE appears on the other side of the mobile.

RIGHT

Skewville
LOCATION Hollywood, California
DATE 2004
MEDIUM Silk-screened wooden
 sneakers

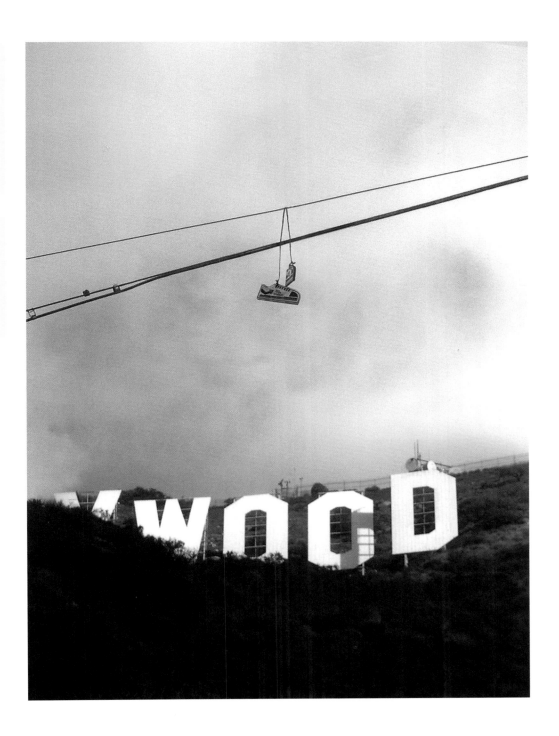

ABOVE

Cayetano Ferrer, *SP Mountain*
LOCATION San Francisco Peaks
 north of Flagstaff, Arizona
DATE 2006
MEDIUM Light projection on
 mountain
ARTIST NOTES Visible to maybe a few
ranchers and anyone who hap-
pened to be looking out from an
airplane above the site, this piece
is a simple blue square of light
projected onto an extinct volcano
called SP Mountain. I imagined it
as a site for a self-portrait.

OPPOSITE

Graffiti Research Lab, *Laser Tag*
LOCATION Brooklyn Bridge, NYC
DATE 2007
MEDIUM Projection

PAGES 62-63

Shepard Fairey / OBEY Giant,
MassPike Billboard
LOCATION Boston, Massachusetts
DATE 2009
PHOTO Geoff Hargadon

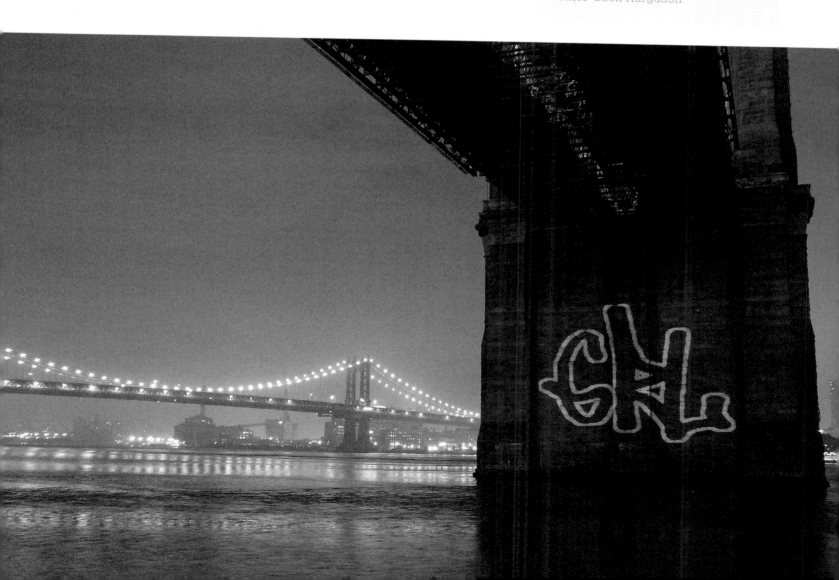

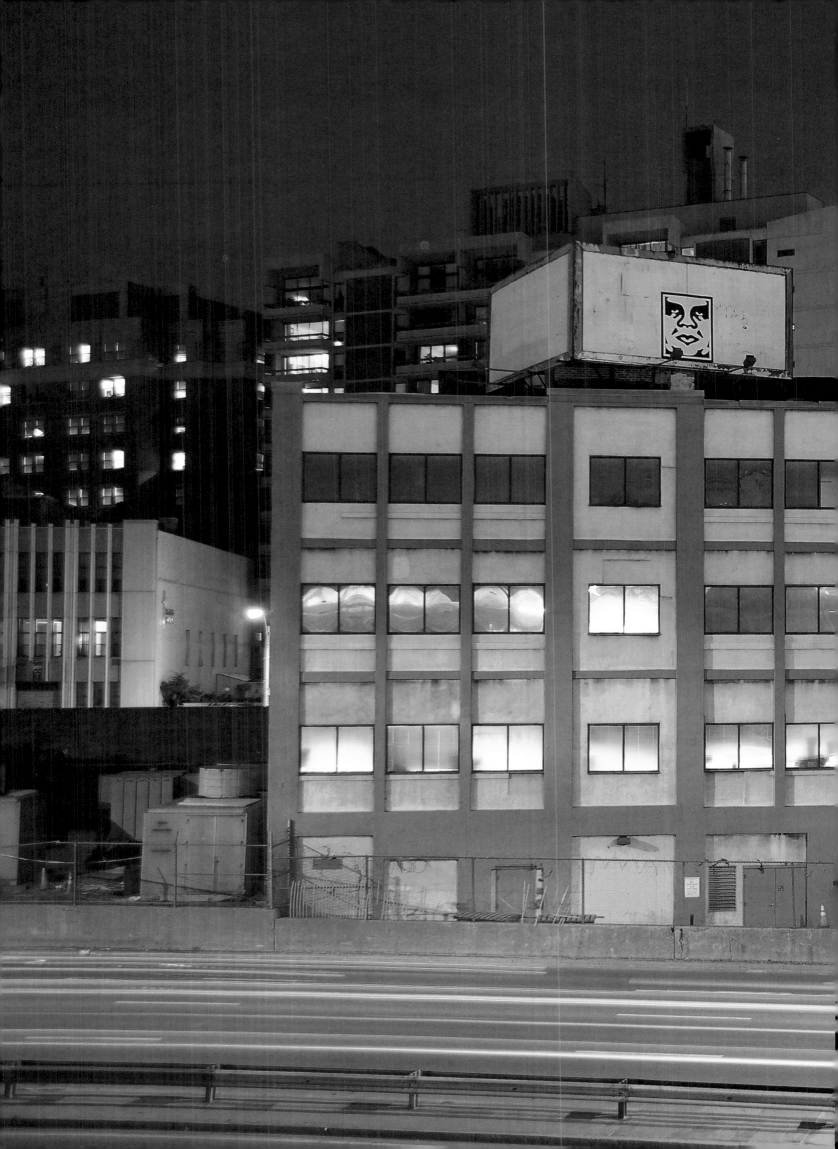

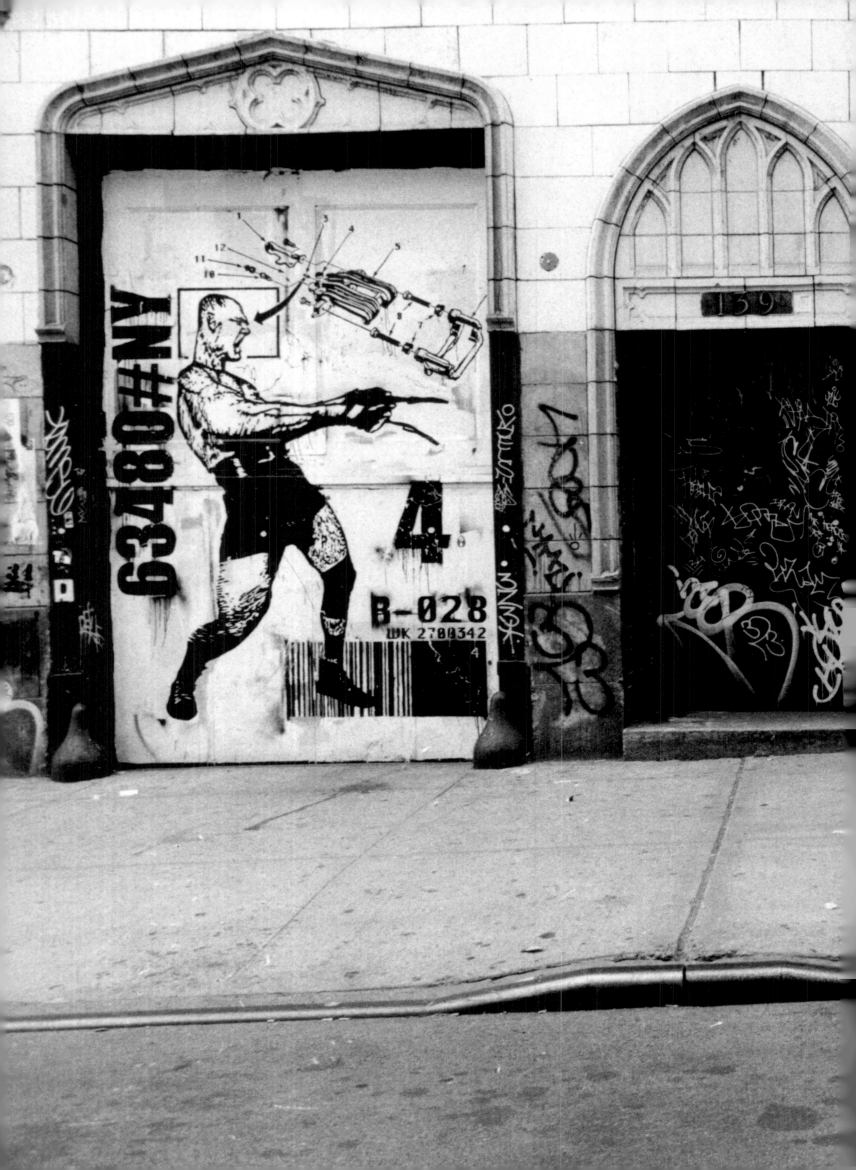

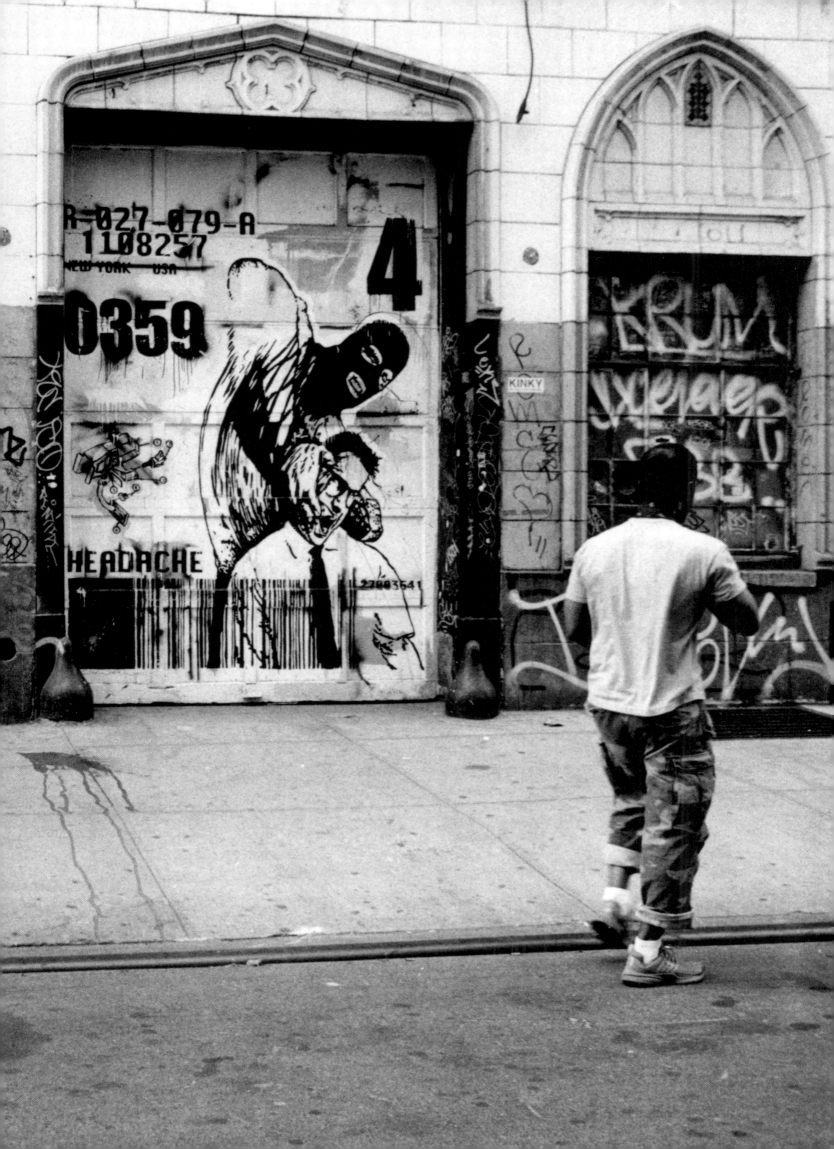

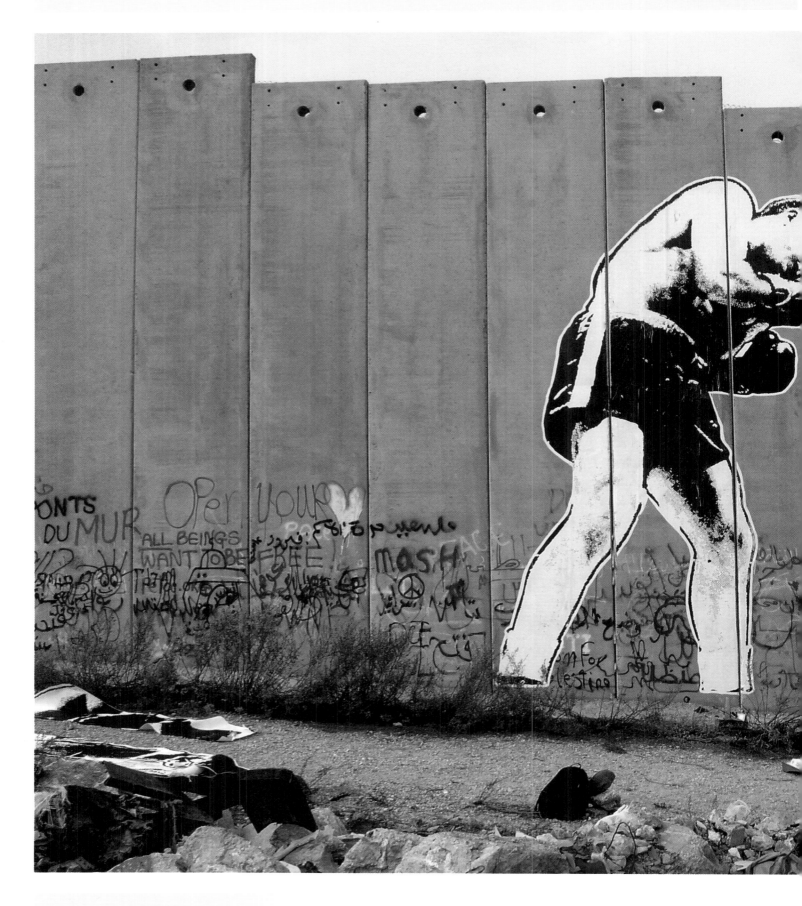

PAGES 64–65

WK
LOCATION Lower East Side, NYC
DATE 2001
PHOTO Francesca Magnani

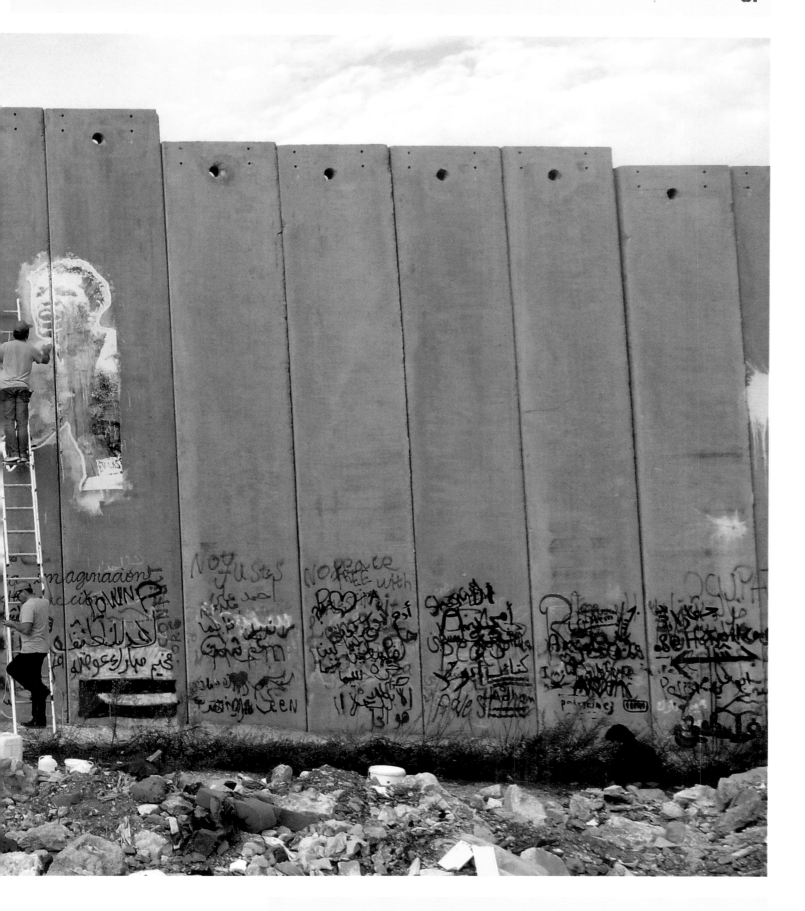

ABOVE

Faile, *Boxers*
LOCATION Israel–Palestine Wall,
 Palestine
DATE 2007

ARTIST NOTES We put this up for "Santa's Ghetto," to raise awareness as to what is happening between Israel and Palestine.

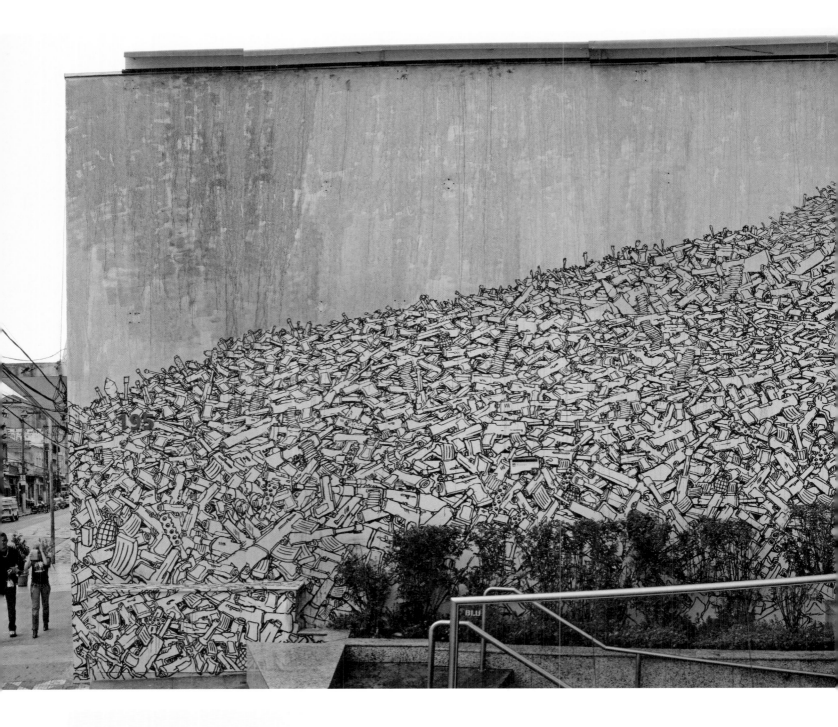

ABOVE

Blu
LOCATION São Paulo, Brazil
DATE 2007

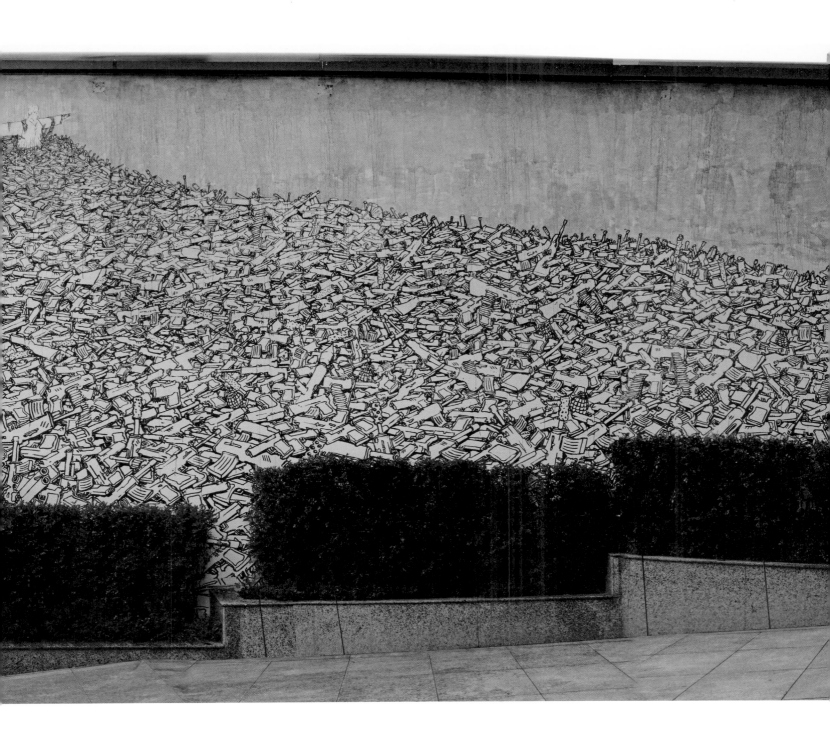

BELOW

D*Face, *Concrete Can Series*
LOCATION Covent Garden, London,
England
DATE 2008

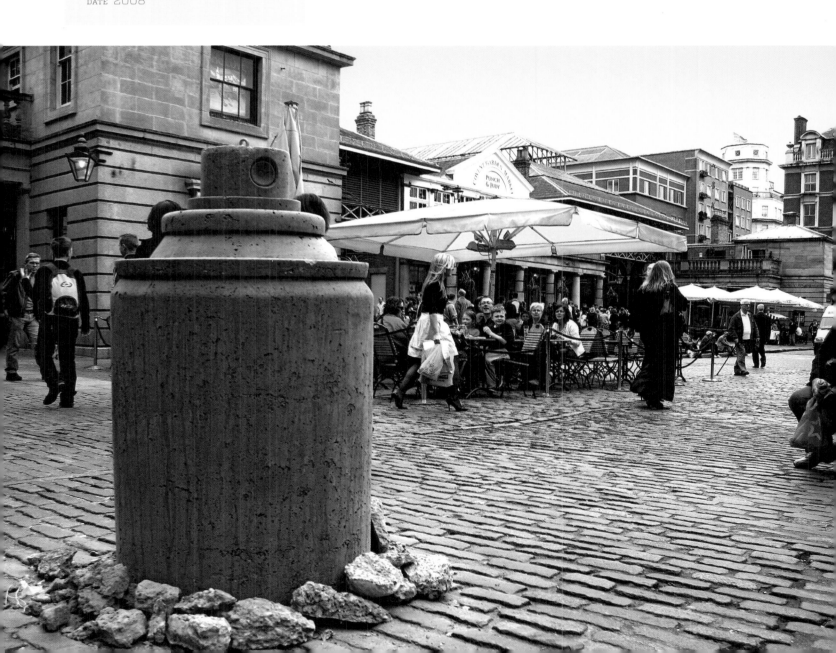

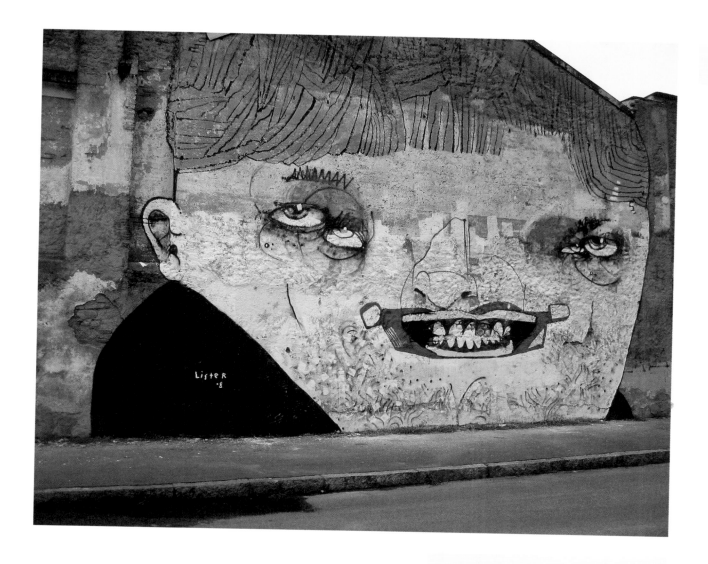

ABOVE

Lister, *Overtones of Decay*
LOCATION Milan, Italy
DATE 2008
MEDIUM Spray paint, acrylic
PHOTO Brent Kerr

PAGES 72–73

Invader
LOCATION Varanasi, India
DATE 2007
MEDIUM Ceramic tiles

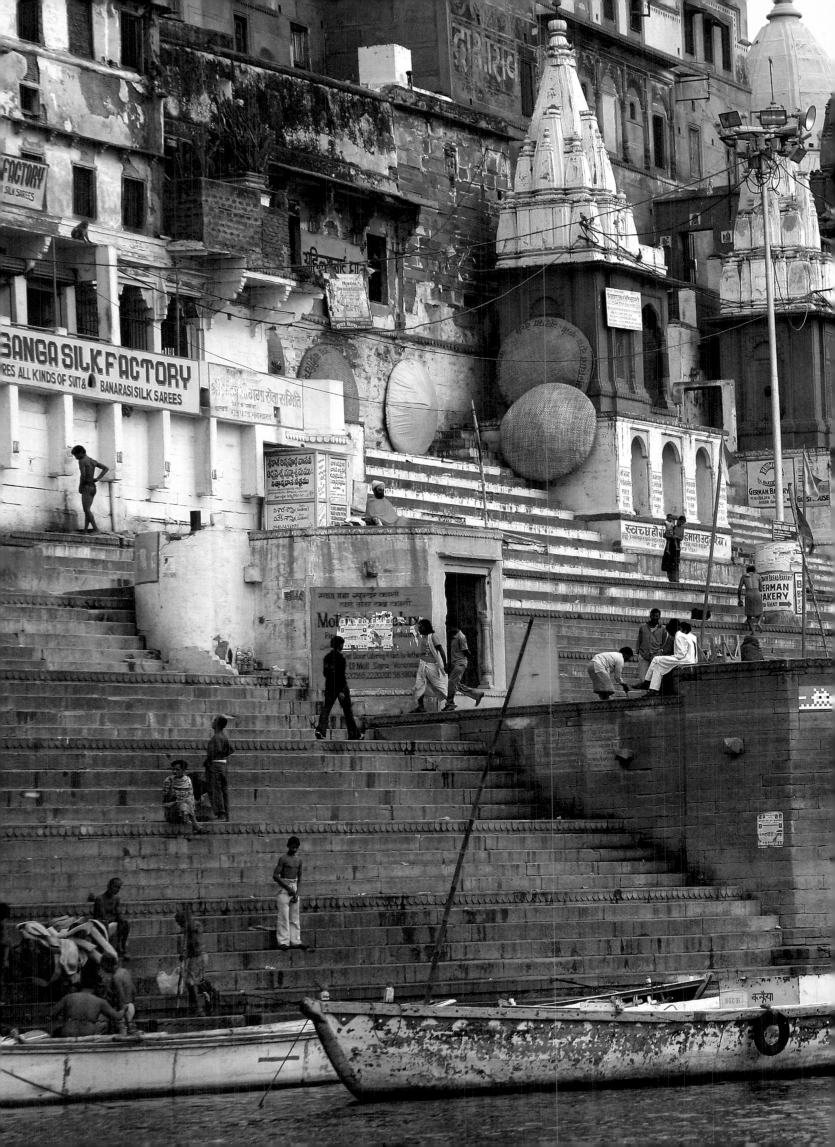

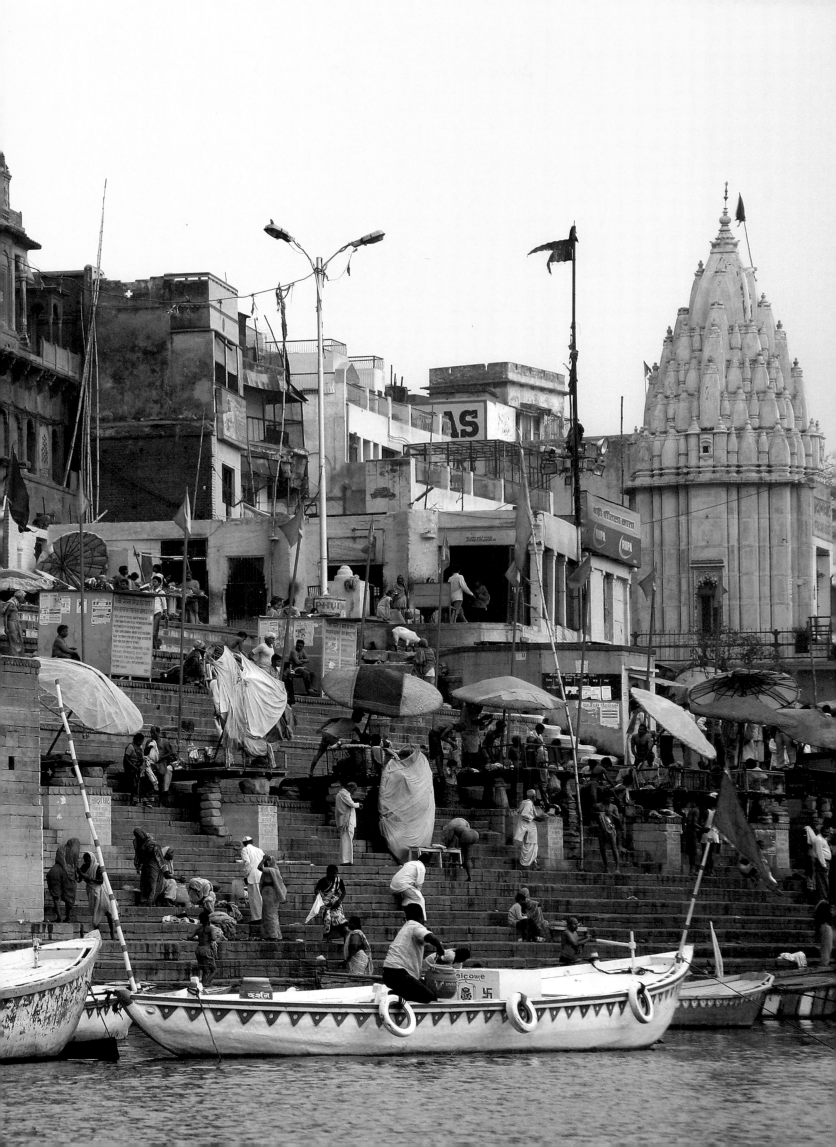

OPPOSITE, TOP

Filippo Minelli, *FACEBOOK*
LOCATION Bamako, Mali
DATE 2008

OPPOSITE, BOTTOM

Filippo Minelli, *MYSPACE*
LOCATION Phnom Penh, Cambodia
DATE 2007
ARTIST NOTES Writing the names of
anything connected with the 2.0 life
we are living in the slums of the third
world is to point out the gap between
the reality we still live in and the
ephemeral world of technologies.

BELOW

Filippo Minelli, *FLICKR*
LOCATION Phnom Penh, Cambodia
DATE 2007

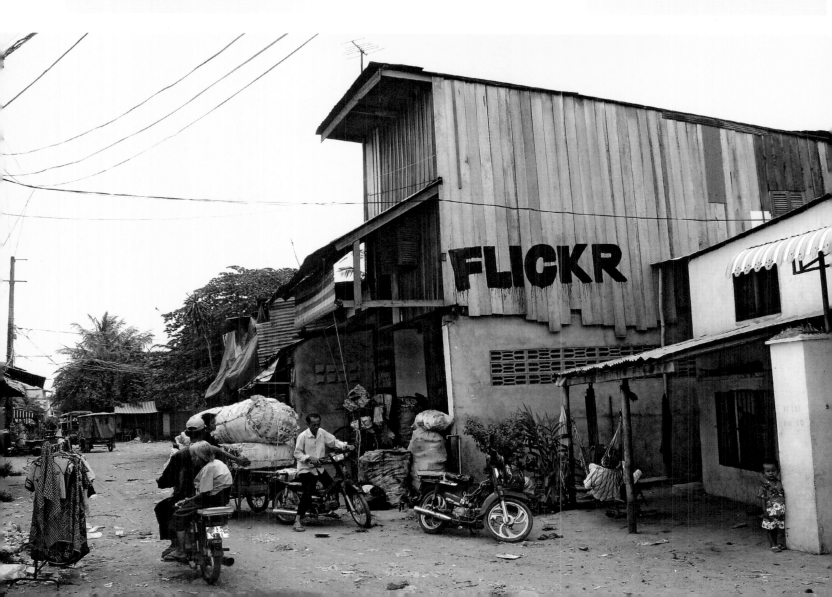

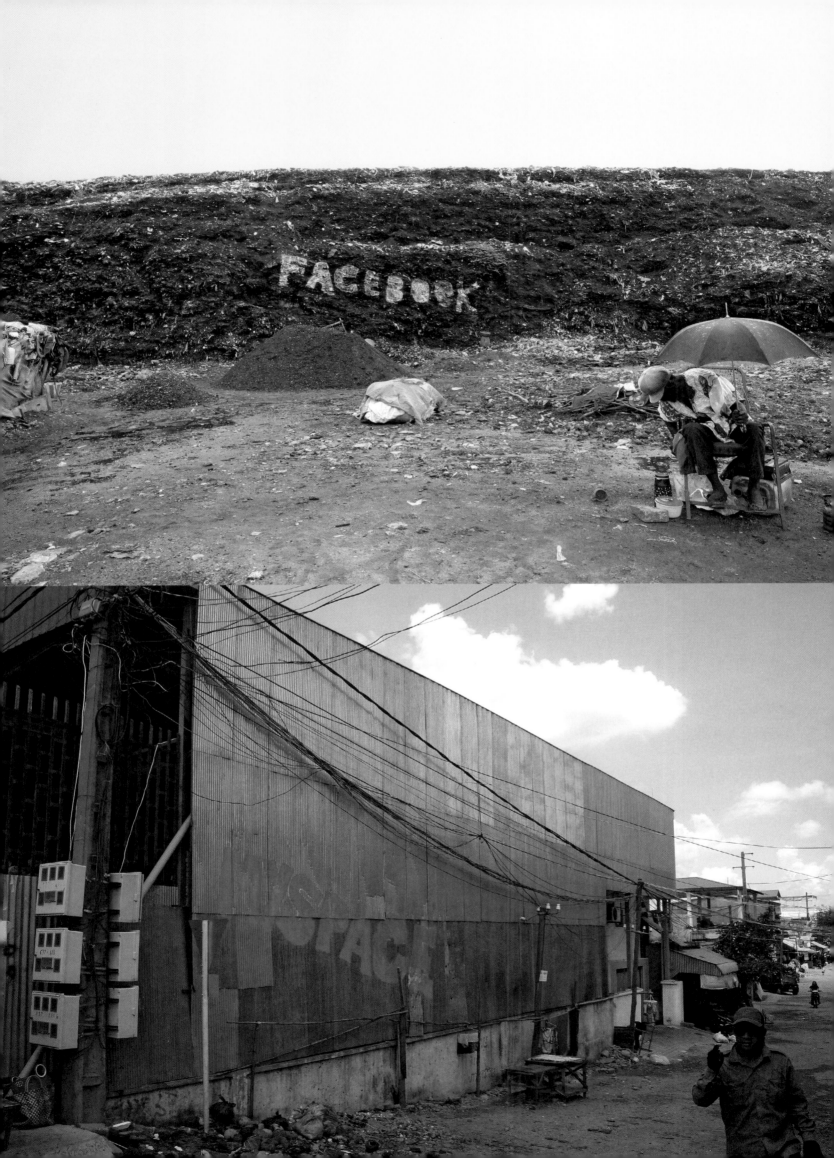

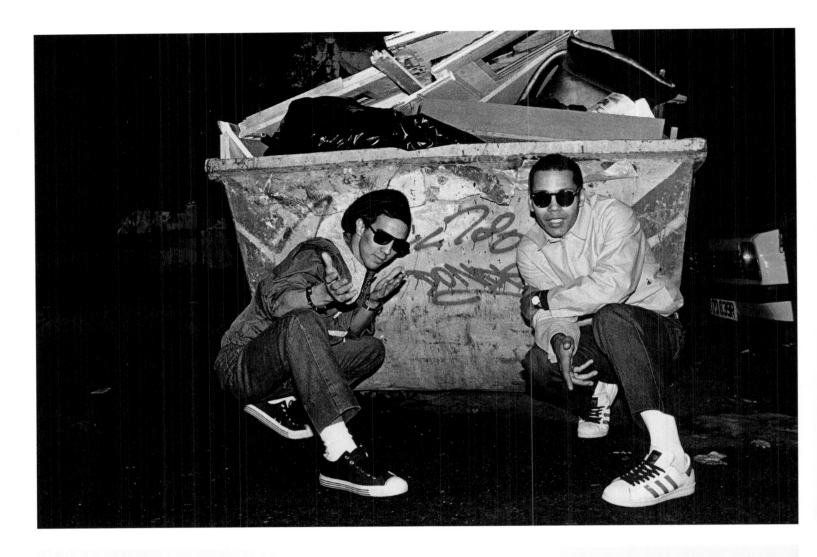

Futura and Dondi
LOCATION London, England
DATE 1982
PHOTO Janette Beckman

Part of the first tour of the then-emergent movement of Hip-Hop through Europe, which included Afrika Bambaataa and the Rock Steady Crew—the impact of graffiti artists like Futura 2000, Dondi White, and Fab Five Freddy immediately transformed post-punk England into a culture obsessed with this new urban vernacular.

Blade, *Dancing Ladies*
LOCATION Bronx, NYC
DATE 1975
ARTIST NOTES Created in the Esplanade Tunnel, the only underground train tunnel in the northeast Bronx, this is the train that inspired Lee Quinones to start writing.

PAGES 78-79

Tehching Hsieh, *One-Year Performance 1981-82, Outdoor Piece*
LOCATION New York City
DATE 1981

In a dauntingly epic year-long performance project, Tehching Hsieh lived for one entire year in New York City *without ever going inside. Amidst his other year-long performances of that era—which entailed impossible efforts like punching a time clock every hour on the hour or living entirely in a small cage—this may not seem quite so superhuman, save for the fact that 1981 delivered one of the worst winters in New York history.*

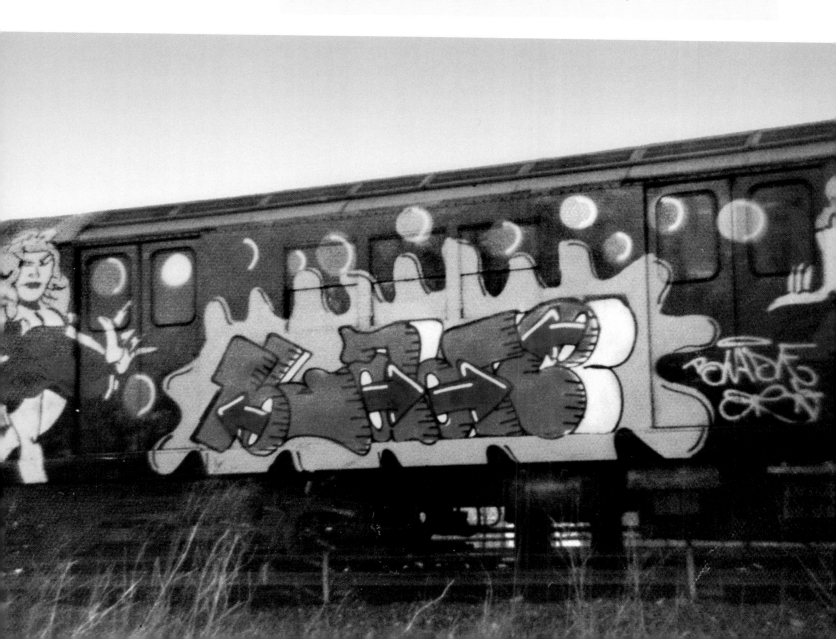

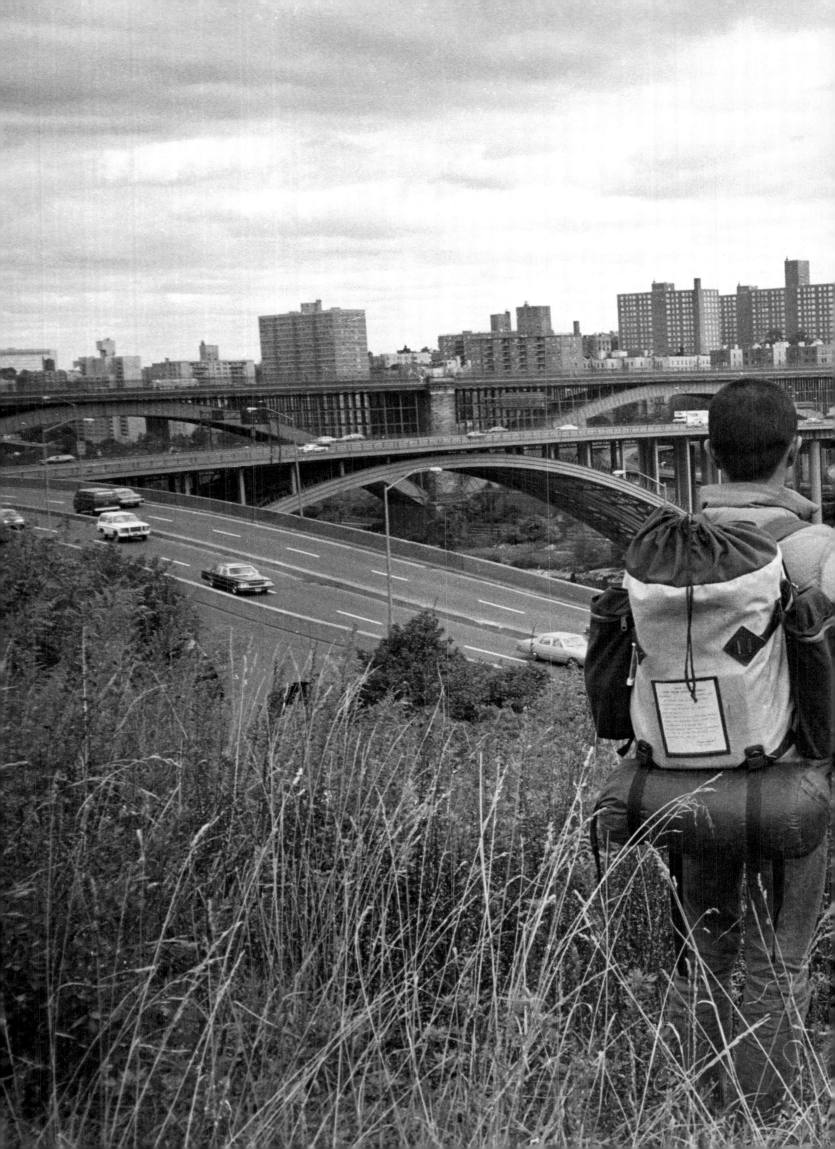

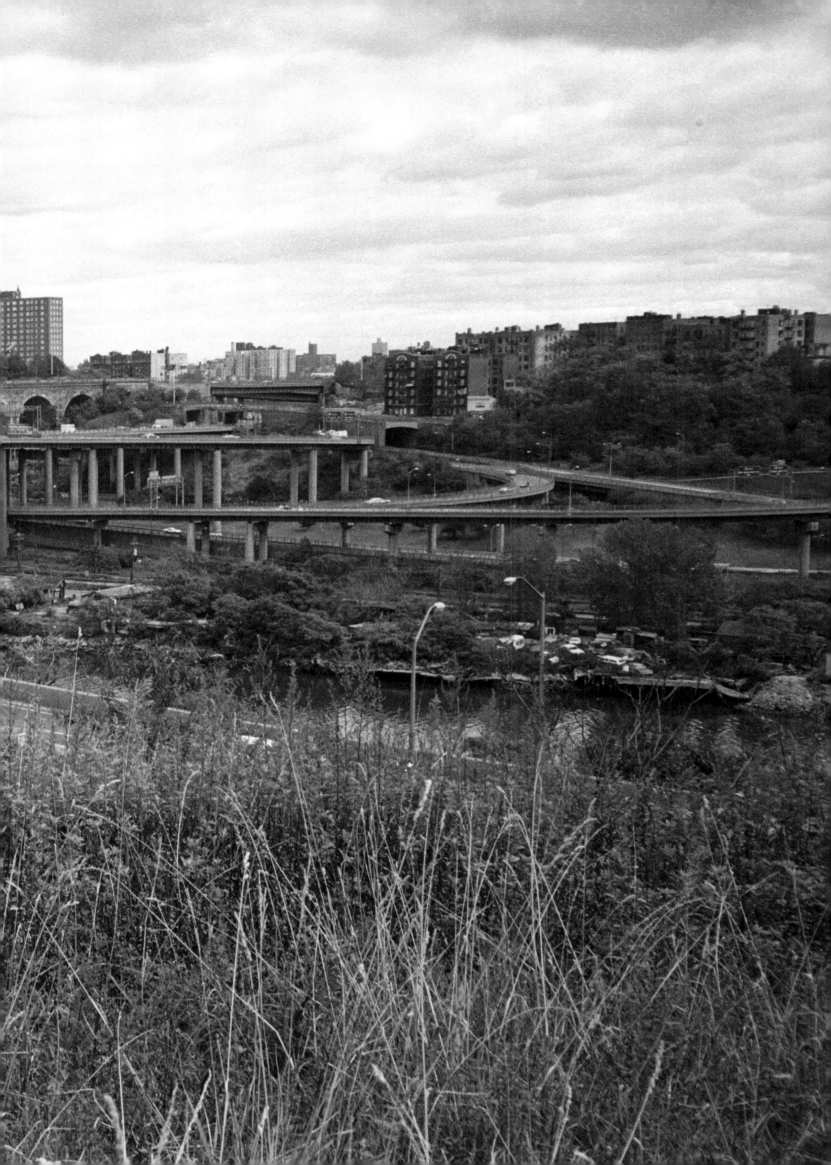

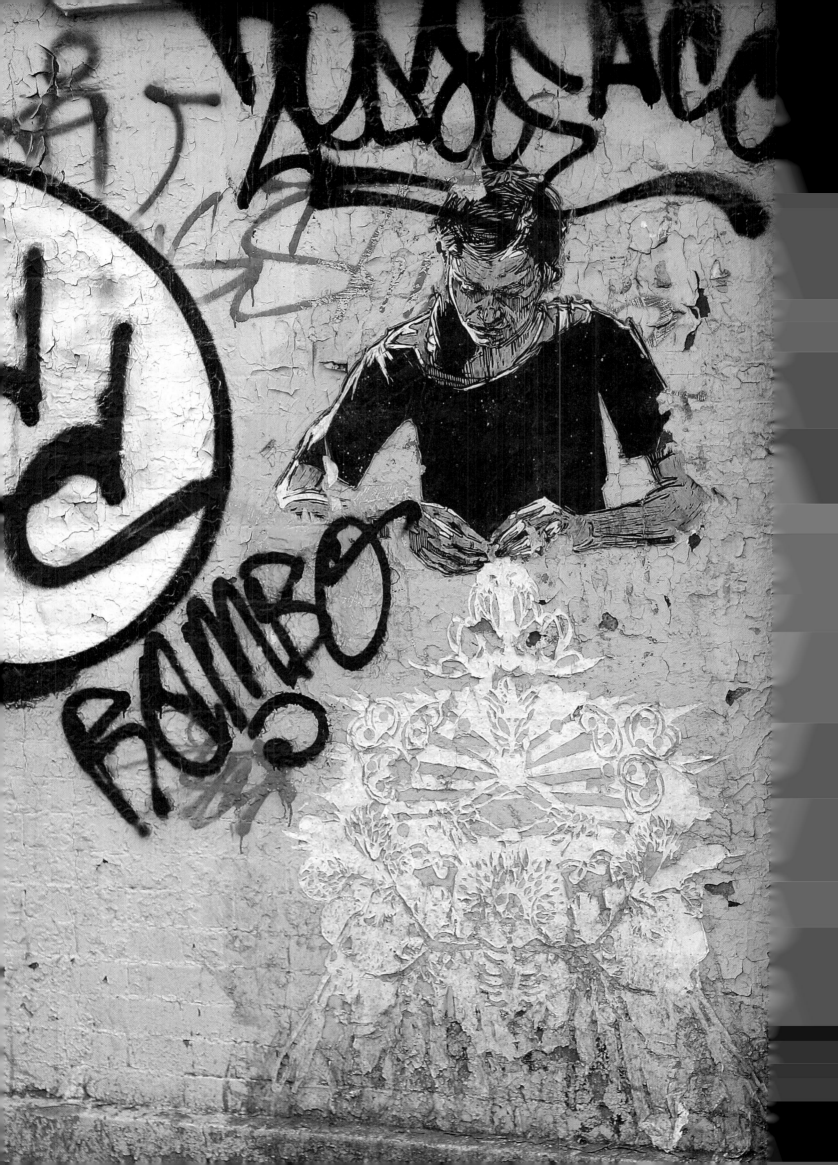

PUBLIC MEMORY PRIVATE SECRETS

"What is remarkable within the proliferation of Street Art today is that this most ephemeral of art forms is often driven deeply by our cultural need to memorialize."

If one considers how every town, small or large, feels obliged to occupy its most prominent squares, crossroads, and parks with unappealing statuary to forgotten figures and moments too vast to enumerate, it would not be presumptuous to presume that public art is all about the memorial and that we, the public, are obsessed with memory. A celebration of the worst of these monuments spread throughout the world could be a glorious competition of local and national pride as vested in the meta-banal. Why we need to remember—and more peculiarly why we need to secure the past in the most monumentally public form— may have less to do with the lessons of history than the construction of cultural identity. Either way, as a didactic or a mimetic, it is understandable how public art has over the centuries become debased.

Rather than critique the lousy ways bad art is sanctioned and supported by mediocre bureaucracies, we aim to locate how this tendency towards historical witness bears out even in less civic-minded gestures. This is as good a point as any to note that public space, whether bearing commissioned art or advertising or the free will of illicit auteurs, evinces a kind of *horror vacui*, an almost pathological dread of the blank slate of empty space that demands pseudoutilitarian ornamentation. If we view the surface of the city as a skin, the effect is ornate indeed: a heavily bombed area of graffiti, the look of '70s-era subway cars appears more mannered than the illustrated man from a carnival sideshow with the same sort of inked-up overkill that reminds us of the old tattoo adage that, like potato chips, a few are never enough.

The clustering of tags, the migratory pattern by which the presence of graffiti inspires more graffiti, may in fact prove at least one argument of the famed "broken window theory" that was embraced as a cause for zero tolerance towards graffiti in the '80s: it does seem to grow and multiply, and has been exploited as visual phenomenology by some young artists. Far more unfortunately, however, the same must be said of advertising in the public realm, and one can imagine that some places could eventually have so many markers, plaques, and statues that the past would subsume the present. It is like the discipline of garden design: the human hand in interface with the natural world, the ordered and disciplined giving way at times to a more raucous heath.

What is remarkable within the proliferation of Street Art today is that, rather than an affront to the past that was made emblematic when Grant's Tomb in New York was so overridden by graffiti vandalism that it became a media symbol of urban decay, this most ephemeral of art forms is often driven deeply by our cultural need to memorialize. Beyond the most obvious example of memorial walls, graffiti-styled murals done in the spirit of roadside shrines, which in countless cities have spawned into a kind of urban folk art, many artists have turned to the temporality of outdoor work as a medium to make absence evident.

This is surely the cause of the Ghost Bikes movement begun in the United States (2003), where the deaths of bike riders who have been hit by motorists are given creative and political symbol through the maintenance of a white

painted bicycle at the fatal landmark. Even without the direct corollary to death, there is a poignant mortality at work in the poetics by which our mark-making today so often acts as surrogate for the passing of that which has otherwise not made a physical mark. It is an emotional registration—not a landmark, but a remark—a way of conjuring peoples and places that, in the city's perpetual pursuit of empiric progress, get eradicated or displaced from a community.

Drawn by economic necessity to the margins of our cultural metropolises, artists' sensitivities have been exposed for many decades to the physical and human face of abandonment. It is within these marginal spaces of rapid change—at one time a matter of white flight and socioeconomic deterioration, now more likely renewal and gentrification—that artists forge the interstice between public memory and more private, secretive worlds. When David Wojnarowicz began painting on an abandoned West Side New York pier in the early '80s and unintentionally turned that bit of disused property into a much-hyped canvas for artists from all over and international fashion-magazine photo shoots, it was more than just a grand place to work—it was the residual memory vessel for the then-vanishing demi-world of gay cruising and anonymous sex.

Also long gone from the face of New York, their only vestigial trace in a permanent installation in the stairwell of the Whitney Museum, are the mesmerizing little worlds built by the artist Charles Simonds in the early '70s around SoHo and downtown Manhattan. Constructed on the sills and sides of buildings like ancient adobe dwellings, Simonds' miniature clay cityscapes proffered Lilliputian worlds of idyllic primitivism on an endearing dollhouse scale for a time and place where so humanizing a presence truly had a cathartic potency. It is not so far a stretch to find the same kind of fantasy and empathy woven into and out of ad hoc communities in the figurative work recently emerging from Bushwick to Berlin to Brazil.

This trope of making visible what has otherwise gone unnoticed and is fleeting in its disappearance, like ZEVS' paintings of shadows on the streets, inhabits our cities in flux with a population of old souls and transients whose very presence offers the comfort of generational neighborhood lore. When Richard Hambleton created his famous shadow figures on the streets decades ago they were implicitly threatening, lurking forms that made visceral our urban paranoia. Today, when you pass a figure by an artist like Swoon, the effect has the familiarity of an old neighbor you have not seen for a long while. This is the planned garden of chaotic nature to which we referred earlier: people are the flowers that must spring through the cracks in the dehumanized sidewalk. It is the quintessential literary metaphor of *A Tree Grows in Brooklyn* (1943) that charted a coming of age in the same Williamsburg neighborhood where so many street artists have plied their trade as the new shoot that grows from a felled tree. No, it is not all nostalgia or full of love, but let us take into account a propensity in urban expressions towards Arcadian ideals and intimate fantasies harbored within the private spaces of an all-too-public domain.

Mass-mediated, declaratory, crowded, and in your face, the city may be the best place to keep the kinds of secrets that need to be shared. This is the über-forest where if the proverbial tree must be felled, no matter how taciturn or transgressive the act, there exists a larger mind's eye, a Hitchcockian *Rear Window*, to bear witness. Surely the best cartographer of that slippery slope between public and private spaces, Vito Acconci, in his performance work of the late '60s, goes right to the frisson between individual autonomy and city life with the criminal-minded discretion of the contemporary urban vandal. Bordering on the perverse, Acconci not only made public art of telling secrets, he inhabited the authoritative gaze of surveillance with his *Following Piece* (1969), where for a month he picked individuals at random to follow, sometimes for many hours, until they entered a private place where he would not be allowed. As an oddity in a general consideration of public art, it is worth following the piece's arc along the path of anonymity and accountability that weaves through the modern world. It brings to mind at once the long lineage of work that conceptual and political artists have done along our geo-political borders and the youthful vernacular of urban artists seeking a private mode of discourse within public space.

Much in the same way that genres of popular music can only be intelligently read by an initiate few, graffiti art's strength lies in its ability to communicate with itself in plain sight of a mass audience that could not, or would not, hope to decipher it. Just as there are many for whom all heavy metal or all rap sounds indistinguishable, for most of the population graffiti is simply din to be blocked out, urban noise of little consequence and as aggravating as the horns and exhaust of automotive congestion. This notion of a coded language offers the sort of disjunction that is critical to any definition of subculture, and is why we would argue that, however much it may grow or diminish in popularity and public perception, graffiti will continue to maintain its own underground status, perhaps distinctly from Street Art.

But what happens when it truly does go underground, if the tree does not fall but simply ducks its head under the forest floor; it may have an audience, but at what point does it stop being "public" art? That is a question that would surround so vague and hypocritical a term as *public space*. The odd cul-de-sac of expressions we locate in the graffiti tunnels such as REVS' infamous diaries, the Freedom Tunnel, Zezão's epic underground anthropologies in São Paulo, or Adams and Itso setting up secret sanctuary within the nooks and crannies of Copenhagen, only serve to show that this is among the many subversive ways in which such unsanctioned work questions and resists our most primary assumptions.

I am reminded of discovering that one of the Billboard Liberation Front artists whose '70s work in San Francisco is not only central to the history contained here but epitomizes the radical instincts of dissent that cannot be tamed by any art academy, is also involved in a curious subculture of urban explorers. Because this practice is steadfast in leaving as little trace as possible, it is not included among the

"Mass-mediated, declaratory, crowded, and in your face, the city may be the best place to keep the kinds of secrets that need to be shared."

glorious pictures before you, but the idea that there are legions out there whose recreational pursuit is the conquest of major urban landmarks is inspiring to say the least; and all the more so in this age of terrorist dread. Sleeping a night atop, say, the Golden Gate Bridge may not have the spectacle of Petit's walk in the clouds or the bohemian vigor of John Sloan and Marcel Duchamp camping in Stanford White's Washington Square Park Arch in 1917 and declaring the Village an independent nation, but it describes in terms perhaps too pure for art what *trespass* really means, and just why it is so valuable an act in our culture.

Above the secrets and beyond the memory it is magical-thinking wish fulfillment that brought us to draw in the caves of Lascaux, inspired college kids to build their own towering Statue of Liberty for their occupation of Tiananmen Square, and accounts for much of the immense visual whimsy in this book. It is the iconoclasm that puts Napoleon before the Sphinx, topples the statues of fallen leaders in a rush of adrenaline some call freedom, provokes the likes of Bruce High Quality Foundation to tackle public sculptures, and accounts for innumerable schoolboy pranks where some small town's beloved landmark goes missing or grows an unseemly appendage. It is all about not heeding that PLEASE DO NOT WALK ON THE GRASS sign and going where we are not supposed to because it's there.

PAGE 80

Swoon, *Allison the Lace Maker*
LOCATION New York City
DATE 2005
MEDIUM Linoleum block print, cut paper

BELOW

Vito Acconci, *Following Piece*
LOCATION New York City
DATE 1969.

Vito Acconci's performance works from the late '60s still rank among the most arch actions ever taken in the name of art. Following Piece involved the artist not simply as creator or participant but as viewer, choosing to follow a random pedestrian each day, sometimes for many hours at a stretch, until they left public space and entered some private space.

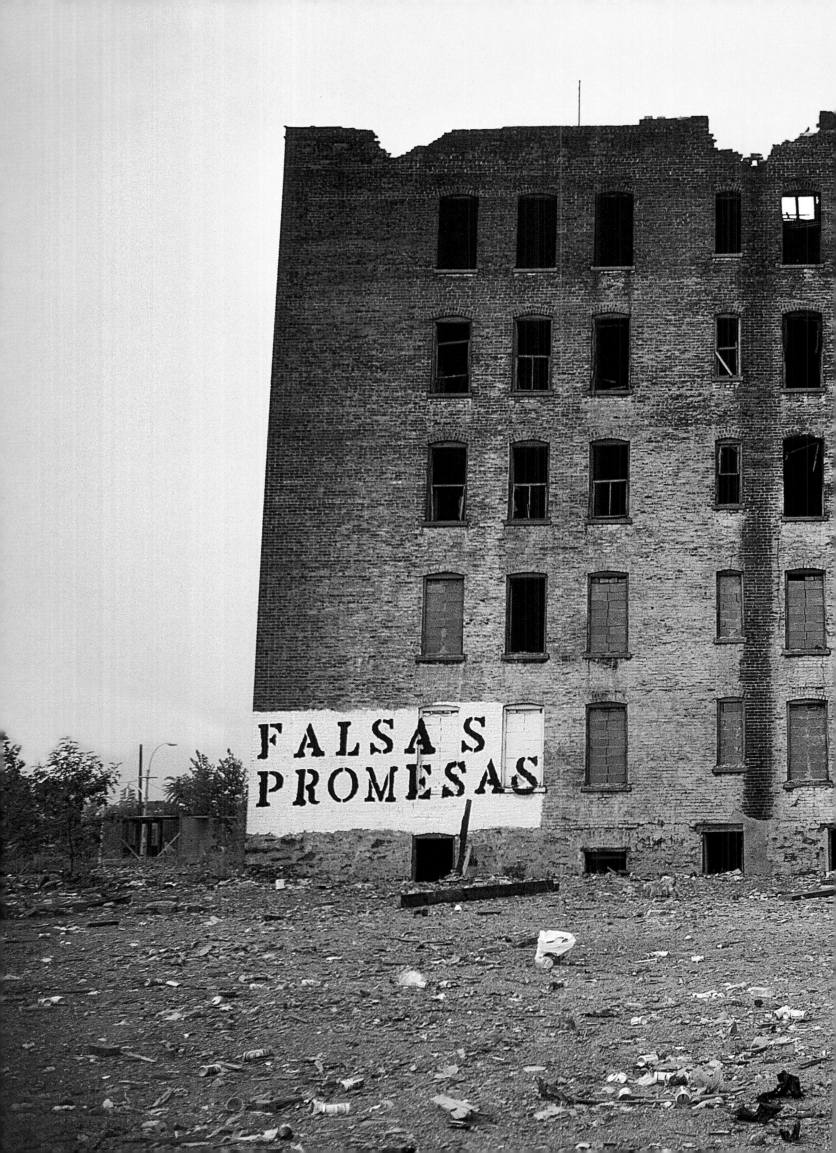

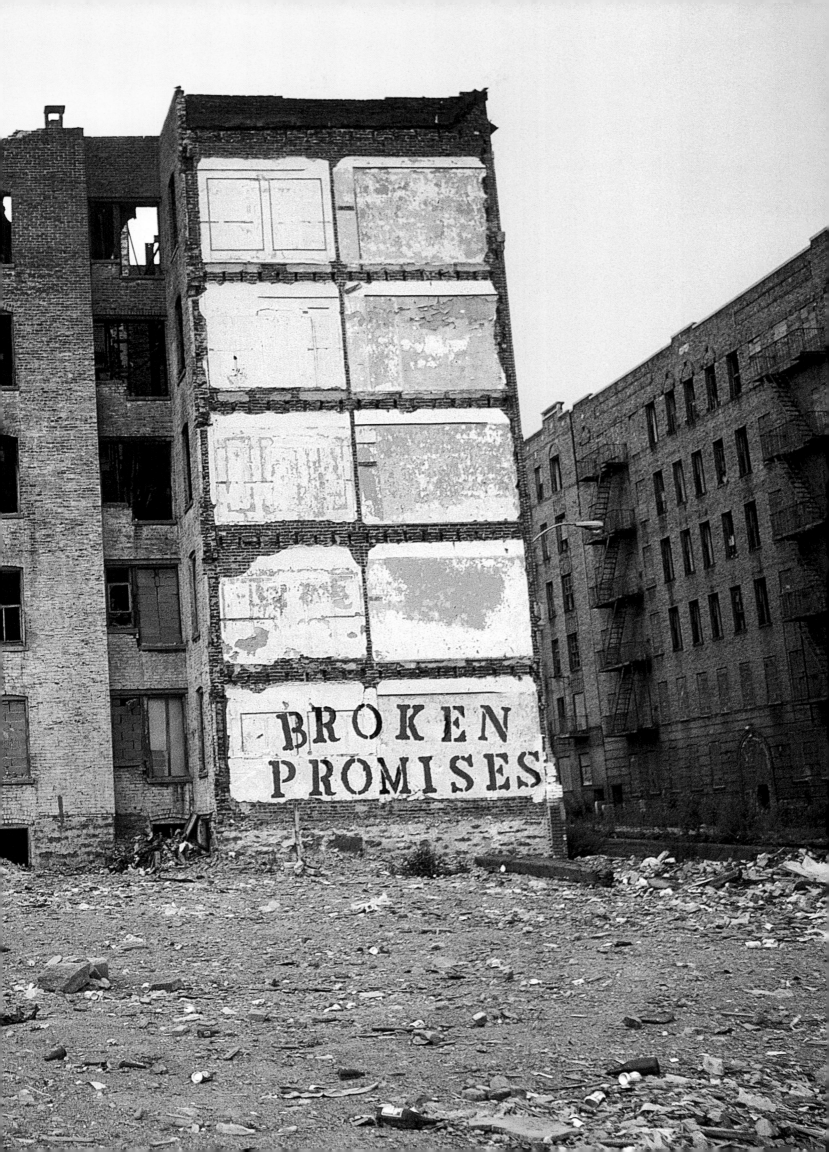

John Fekner, *Broken Promises/*
Falsas Promesas
LOCATION South Bronx, NYC
DATE 1980

An urgent semaphore along the
critical fault line of urban decay,
John Fekner's Broken Promises
mural became an instant national
photo-op backdrop as myriad poli-
ticians, including then-president
Ronald Reagan, activists, and civic
leaders loved it as the definitive
site to speak on the problems fac-
ing inner cities.

SEQUENCE, RIGHT

Adams & Itso, *København H*
LOCATION Copenhagen, Denmark
DATE 2008
MEDIUM Adhesive vinyl
ARTIST NOTES We had two trains
running with this text, in Danish
and English.

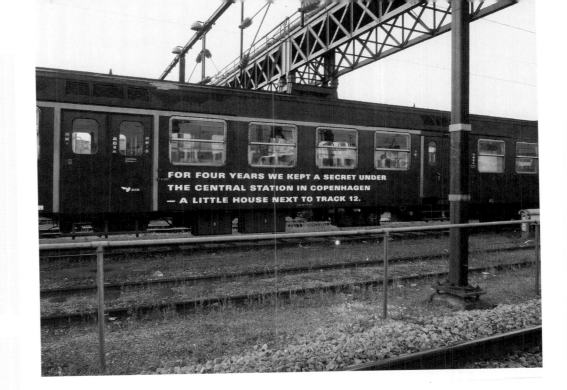

FOR FOUR YEARS WE KEPT A SECRET UNDER THE CENTRAL STATION IN COPENHAGEN — A LITTLE HOUSE NEXT TO TRACK 12.

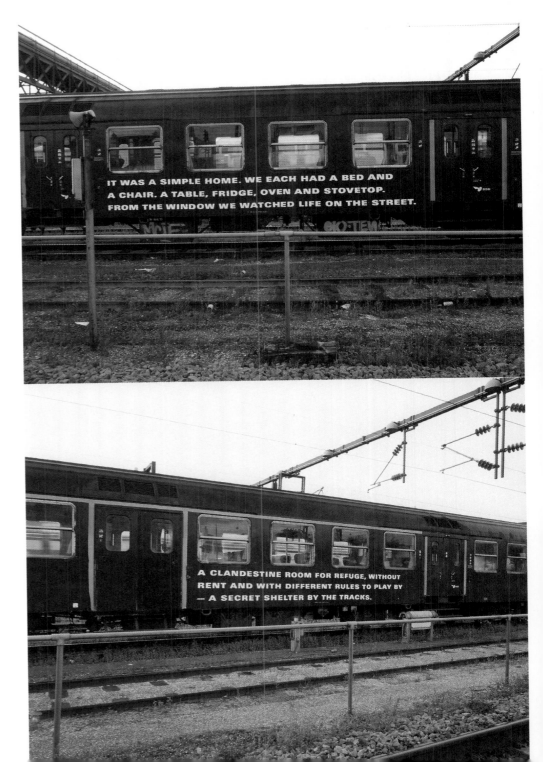

IT WAS A SIMPLE HOME. WE EACH HAD A BED AND A CHAIR. A TABLE, FRIDGE, OVEN AND STOVETOP. FROM THE WINDOW WE WATCHED LIFE ON THE STREET.

A CLANDESTINE ROOM FOR REFUGE, WITHOUT RENT AND WITH DIFFERENT RULES TO PLAY BY — A SECRET SHELTER BY THE TRACKS.

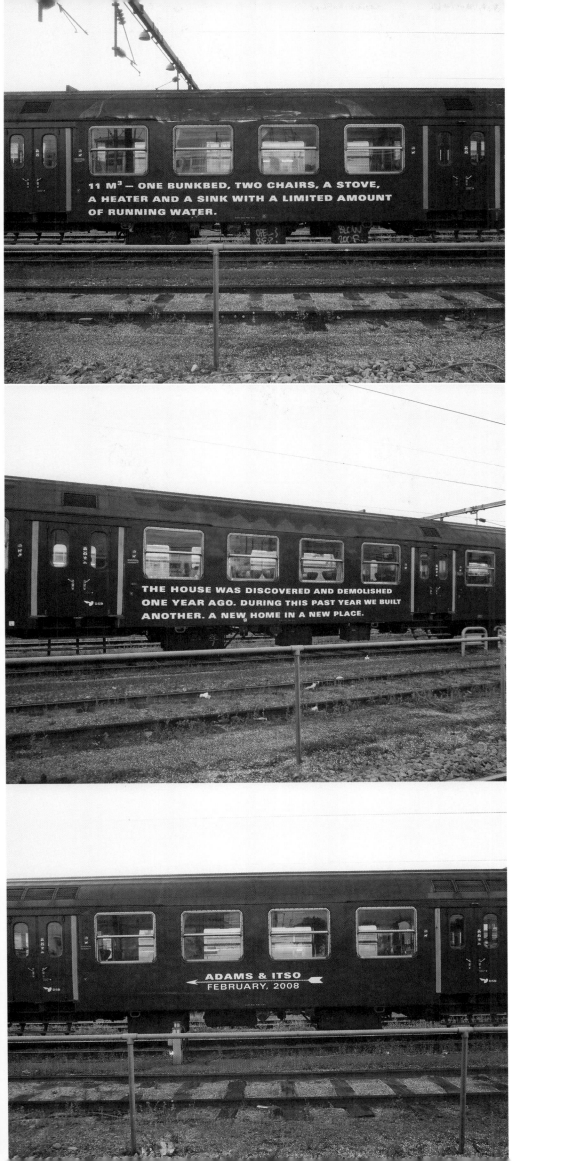

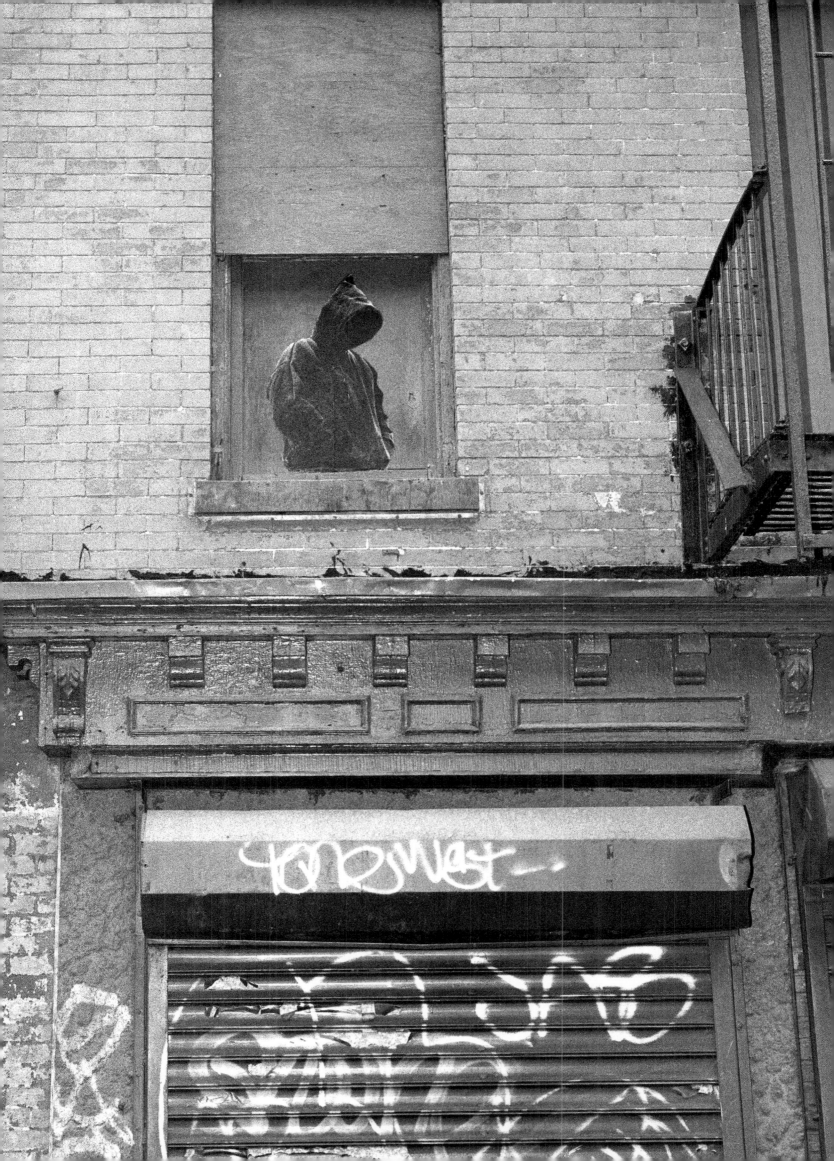

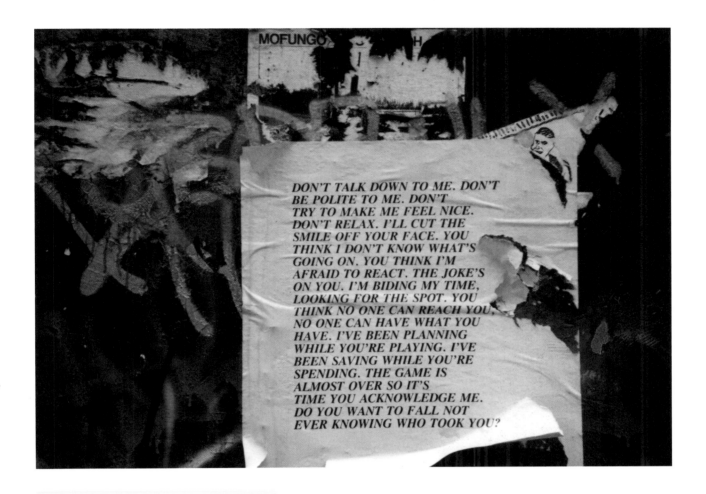

DON'T TALK DOWN TO ME. DON'T BE POLITE TO ME. DON'T TRY TO MAKE ME FEEL NICE. DON'T RELAX. I'LL CUT THE SMILE OFF YOUR FACE. YOU THINK I DON'T KNOW WHAT'S GOING ON. YOU THINK I'M AFRAID TO REACT. THE JOKE'S ON YOU. I'M BIDING MY TIME, LOOKING FOR THE SPOT. YOU THINK NO ONE CAN REACH YOU, NO ONE CAN HAVE WHAT YOU HAVE. I'VE BEEN PLANNING WHILE YOU'RE PLAYING. I'VE BEEN SAVING WHILE YOU'RE SPENDING. THE GAME IS ALMOST OVER SO IT'S TIME YOU ACKNOWLEDGE ME. DO YOU WANT TO FALL NOT EVER KNOWING WHO TOOK YOU?

OPPOSITE

Dan Witz, *The Hoody Project*
LOCATION Lower East Side, NYC
DATE 1997
MEDIUM Silkscreen poster on
 boarded-up window

ABOVE

Jenny Holzer, *Inflammatory Essays*
LOCATION New York City
DATE 1983
MEDIUM Offset printing on colored
 paper

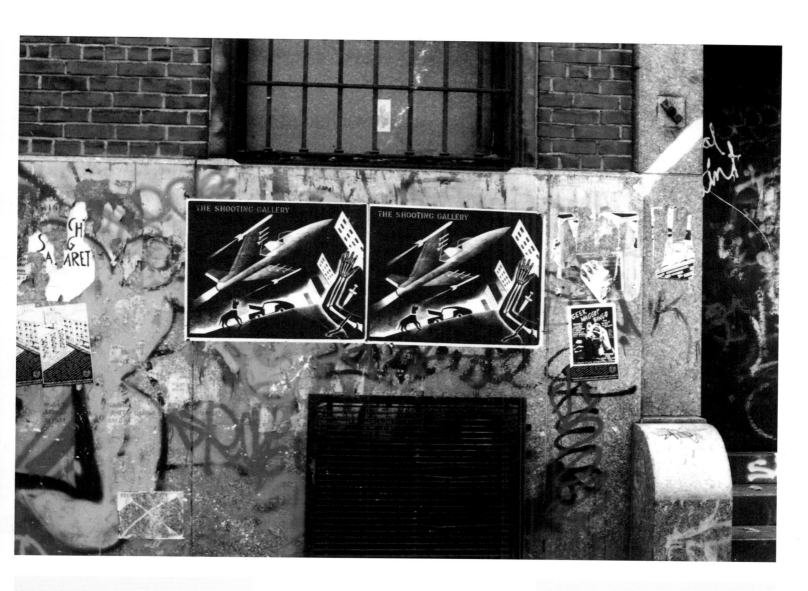

OPPOSITE

Ernest Pignon-Ernest,
La Commune
LOCATION Paris, France
DATE 1971
MEDIUM Serigraphies
ARTIST NOTES For the centenary
of the Paris Commune in 1971,
I pasted several hundred silk-
screens in places that retained the
memory of tragic historical events
related to the French revolution
and struggle for freedom.

ABOVE

Anton van Dalen, *The Shooting
Gallery*
LOCATION East Village, NYC
DATE 1983
ARTIST NOTES The street posters
The Shooting Gallery were put up
along Avenue B in 1983 to address
the heroin economy and its devas-
tating effect on the community.

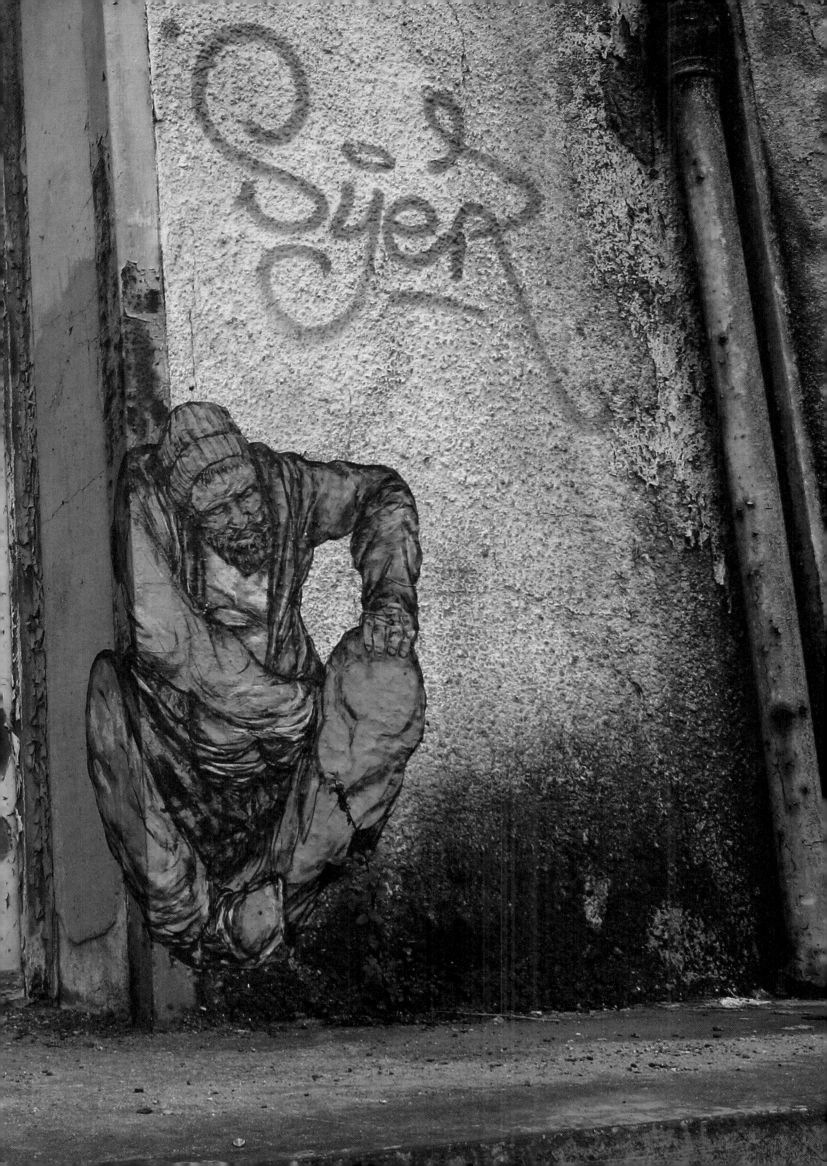

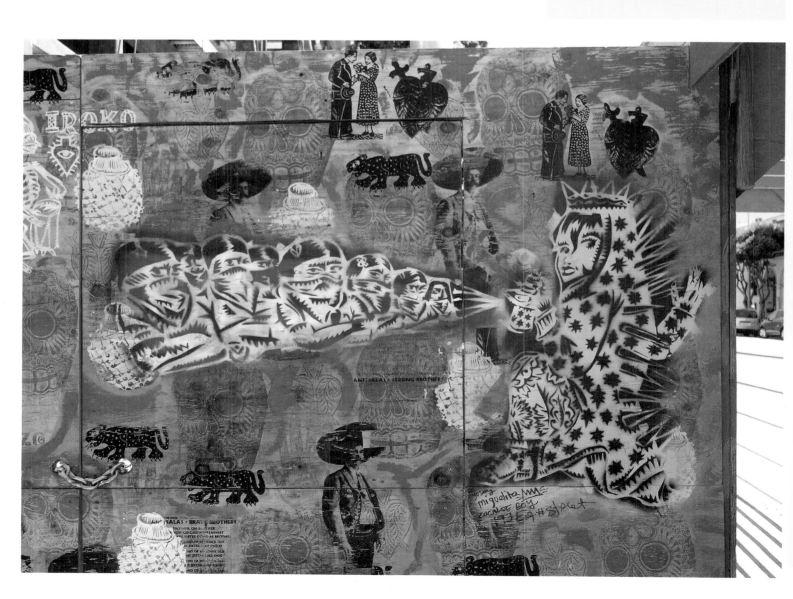

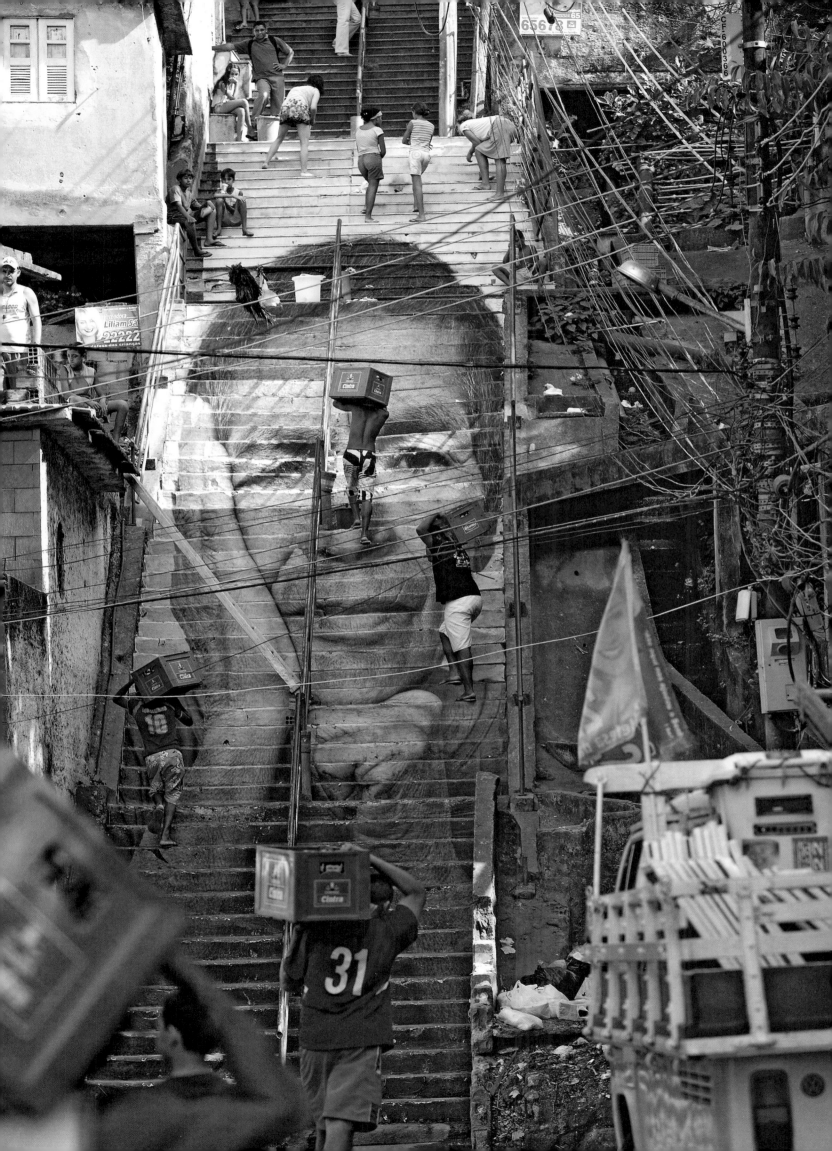

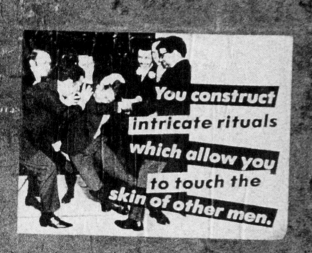

PAGES 98-99

Barbara Kruger
LOCATION New York City
DATE 1982

BELOW

Barbara Kruger
LOCATION New York City
DATE 1998

OPPOSITE

Ernest Pignon-Ernest, *Pieta for the AIDS Generation*
LOCATION Durban, South Africa
DATE 2002

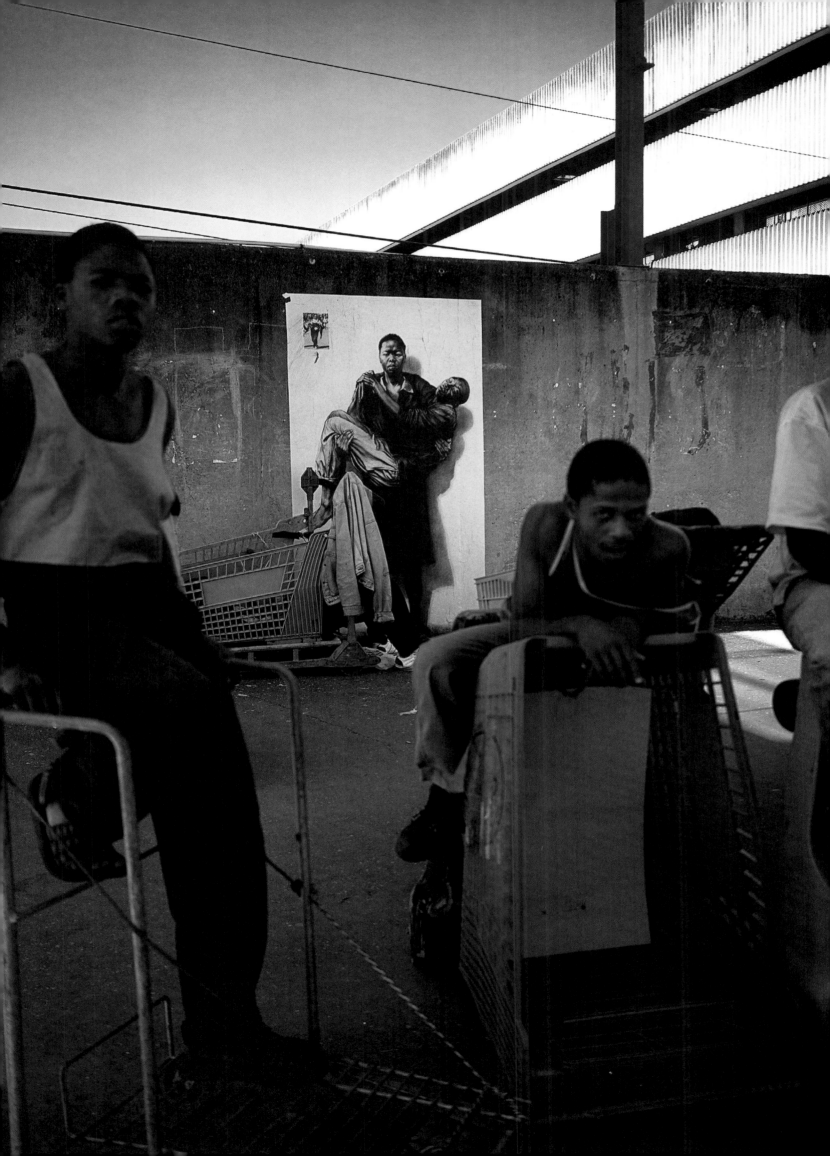

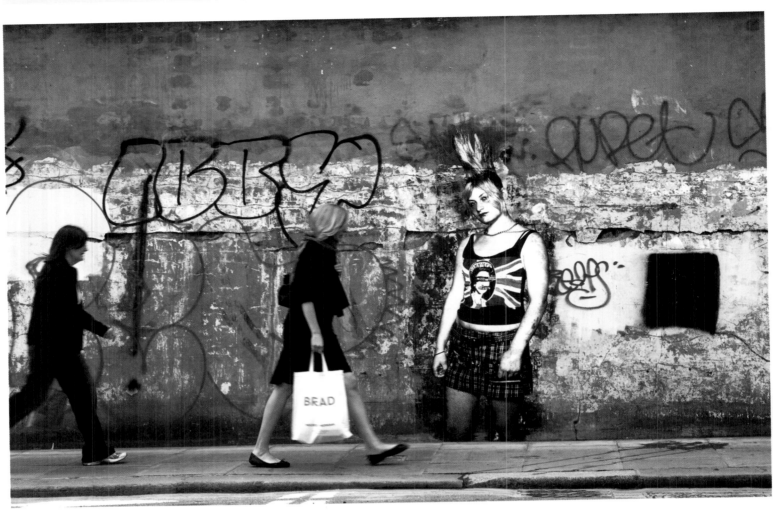

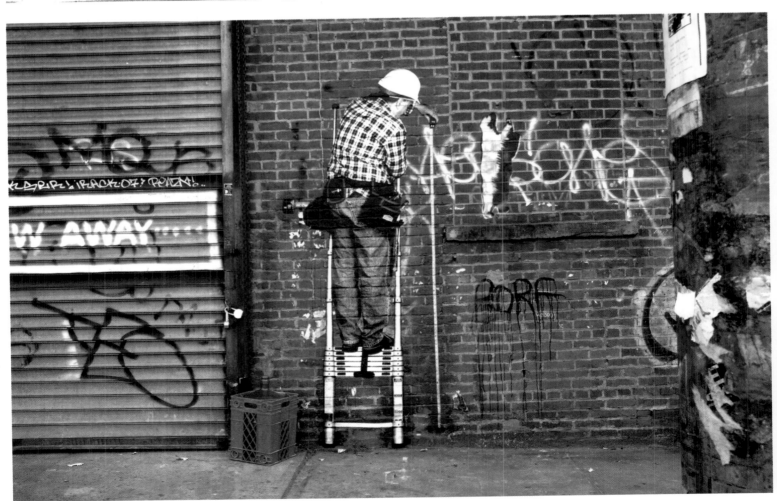

OPPOSITE, TOP

Dan Bergeron, *Laura Heale*
LOCATION London, England
DATE 2007
MEDIUM Photo, wheatpaste

OPPOSITE, BOTTOM

Dan Bergeron, *Working Man—
The Measurer*
LOCATION Brooklyn, New York
DATE 2007
MEDIUM Photo, wheatpaste
ARTIST NOTES This is a portrait of my
dad for my memory, and a charac-
ter interacting with his surround-
ings for everyone else.

BELOW

C215, *Lying Nina*
LOCATION New Delhi, India
DATE 2008
MEDIUM Stencil
PHOTO Christian Guemy

Portrait of the artist's daughter

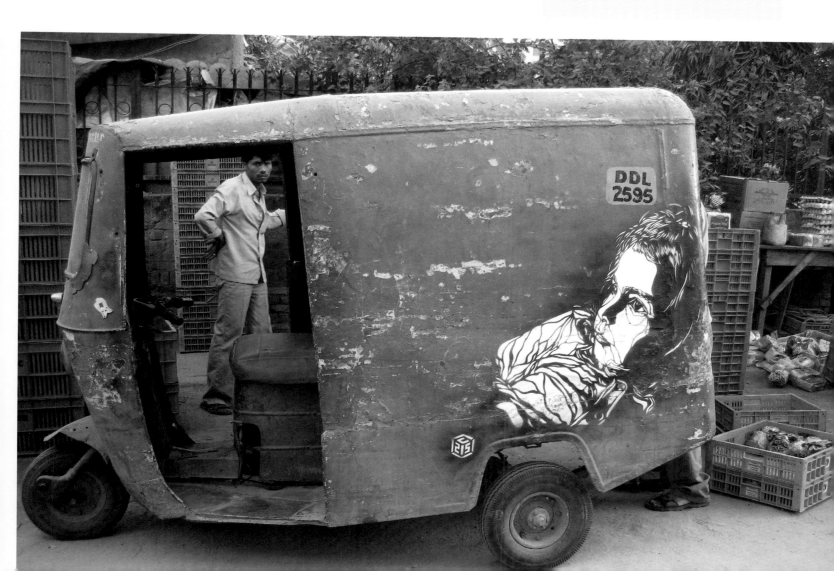

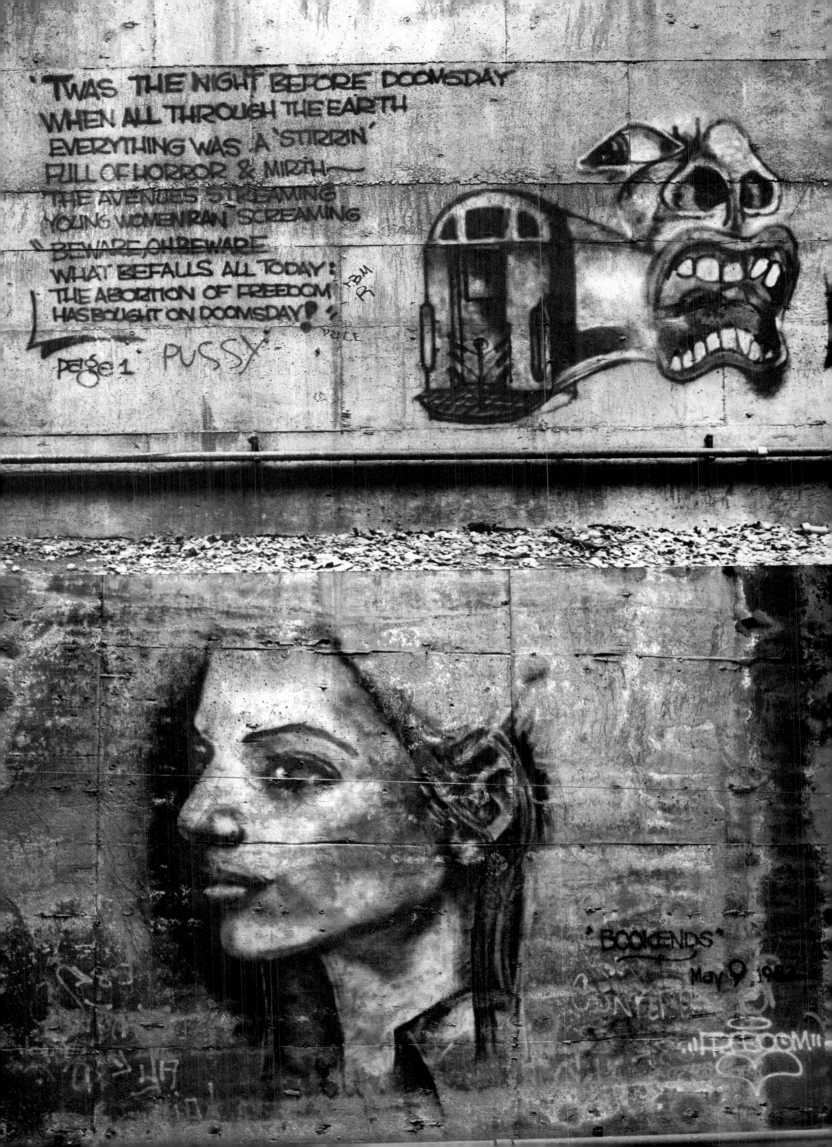

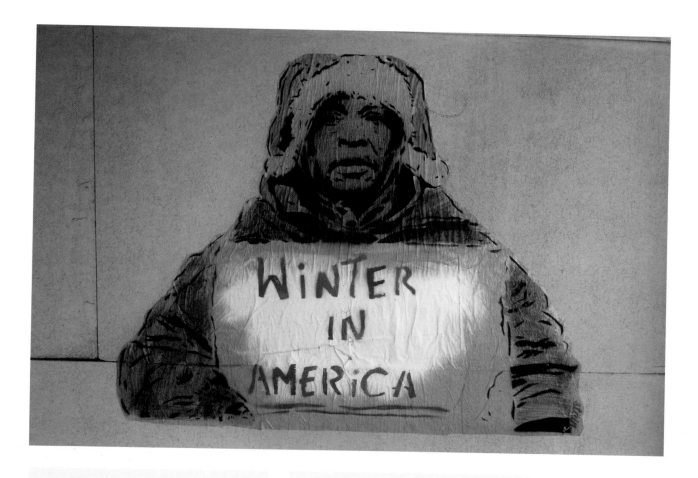

OPPOSITE

Freedom, *Page 1 / Bookends*
LOCATION Freedom Tunnel, NYC
DATE 1982
PHOTO Lisa Kahane

Built by master planner Robert
Moses in the 1930s as a train
tunnel, but soon disused with
the advent of the automobile and
otherwise isolated by its location
in Riverside Park, the Freedom
Tunnel remains one of the revered
iconic landmarks in the history
of graffiti. This cavernous space
once housed hundreds of people in
its subterranean shanty town and
afforded committed graffiti artists
a rare opportunity to work for long
durations on a single work. It has
retained its name for the artist
Chris "Freedom" Pape, whose monu-
mental murals took root there.

ABOVE

Chris Stain, *Winter in America*
LOCATION Baltimore, Maryland
DATE 2006
ARTIST NOTES The piece was inspired
by Gil Scott-Heron, whose lyrics
for "Winter in America" are a cri-
tique of America's history from its
inception to the present.

OPPOSITE

Elbow-Toe, *Cassandra*
LOCATION London, England
DATE 2006
MEDIUM Woodblock print
ARTIST NOTES Cassandra was a tragic
Greek character that could see the
future but no one would listen to
her; I would place her in neighbor-
hoods where gentrification was
taking place.

BELOW

Zezão
LOCATION Caboçu de Baixo Tunnel,
São Paulo, Brazil
DATE 2009

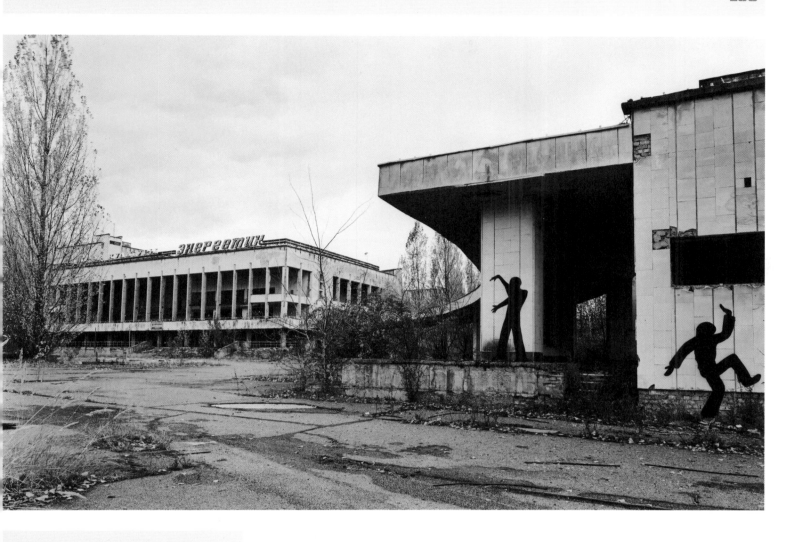

Tobias Starke, *Dialogue*
LOCATION Pripyat, Ukraine
DATE 2005

Kim Köster, *Laufende Atomreak-*
toren (operating nuclear reactors)
LOCATION Pripyat, Ukraine
DATE 2005

Konstantin Danilov, *Untitled*
LOCATION Pripyat, Ukraine
DATE 2005

Pripyat, Ukraine, the industrial
city that housed Chernobyl's
workforce, has been an abandoned
radioactive no-go zone since the
reactor disaster on April 26, 1986.

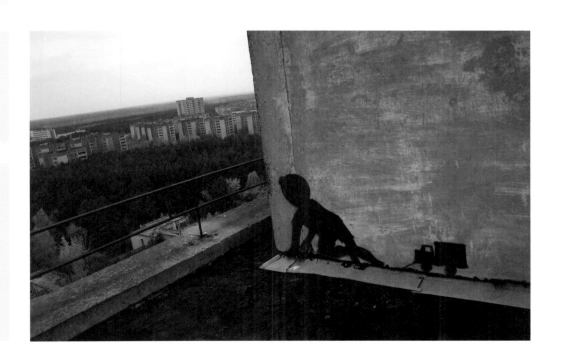

PAGES 110–111

ABOVE

Group Material, *DA ZI BAOS, Democracy Wall*

LOCATION Union Square, NYC
DATE 1982
PHOTO Andres Serrano

"Dazibao" is Chinese for the "large-scale posters" that were used in the democracy-wall movement in China—a traditional form of social written dialogue occurring in public squares. We tailored the concept and made a version using statements we got from interviewing people on the street about a number of social issues that were relevant to the site of Union Square and current events.
 —Julie Ault

The Bruce High Quality Foundation, *Public Sculpture Tackle*

LOCATION New York City
DATE 2007

OPPOSITE

Paul Harfleet, *The Pansy Project— Fuck Off and Die Faggots!*

LOCATION Tottenham Court Road, London, England
DATE 2007

Paul Harfleet revisits city streets planting pansies as close as possible to where he has experienced verbal homophobic abuse. He titles the location after the abuse received.

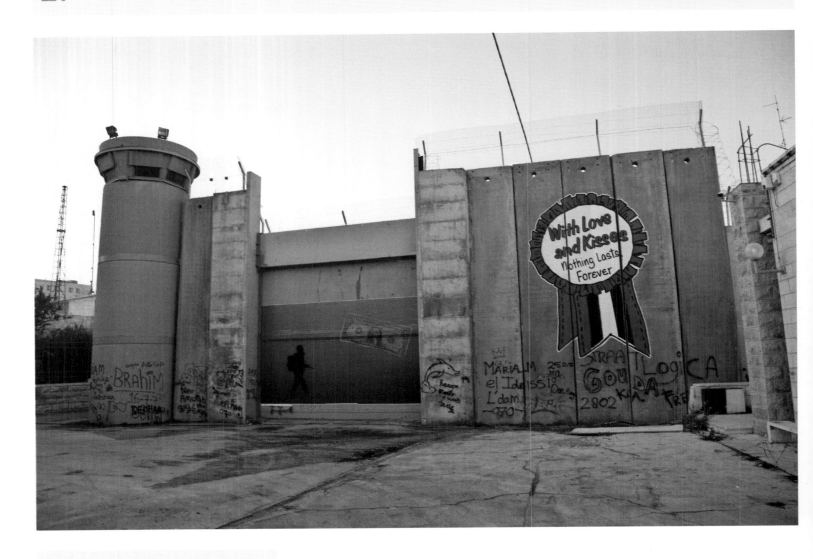

Faile, *Nothing Lasts Forever*
LOCATION Israel–Palestine Wall,
 Palestine
DATE 2007

BELOW

Monochrom, *Nazi Petting Zoo*
LOCATION Vienna, Austria
DATE 2008
PHOTO Raimund Appel

A nation that to this day has never come to terms with its Nazi past, Austria—in particular its capital, famed for its zoo—was the site of this mock attraction where visitors were given the dubious pleasure of visiting and petting conveniently forgotten savages.

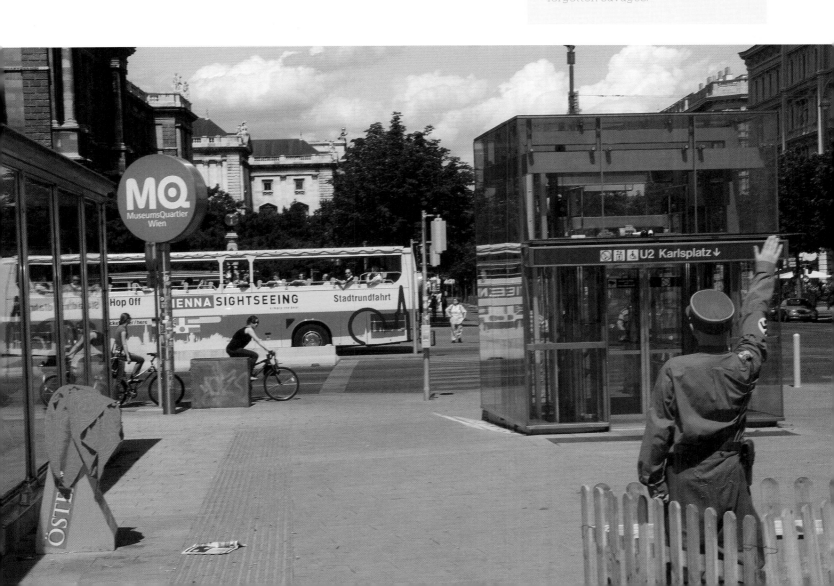

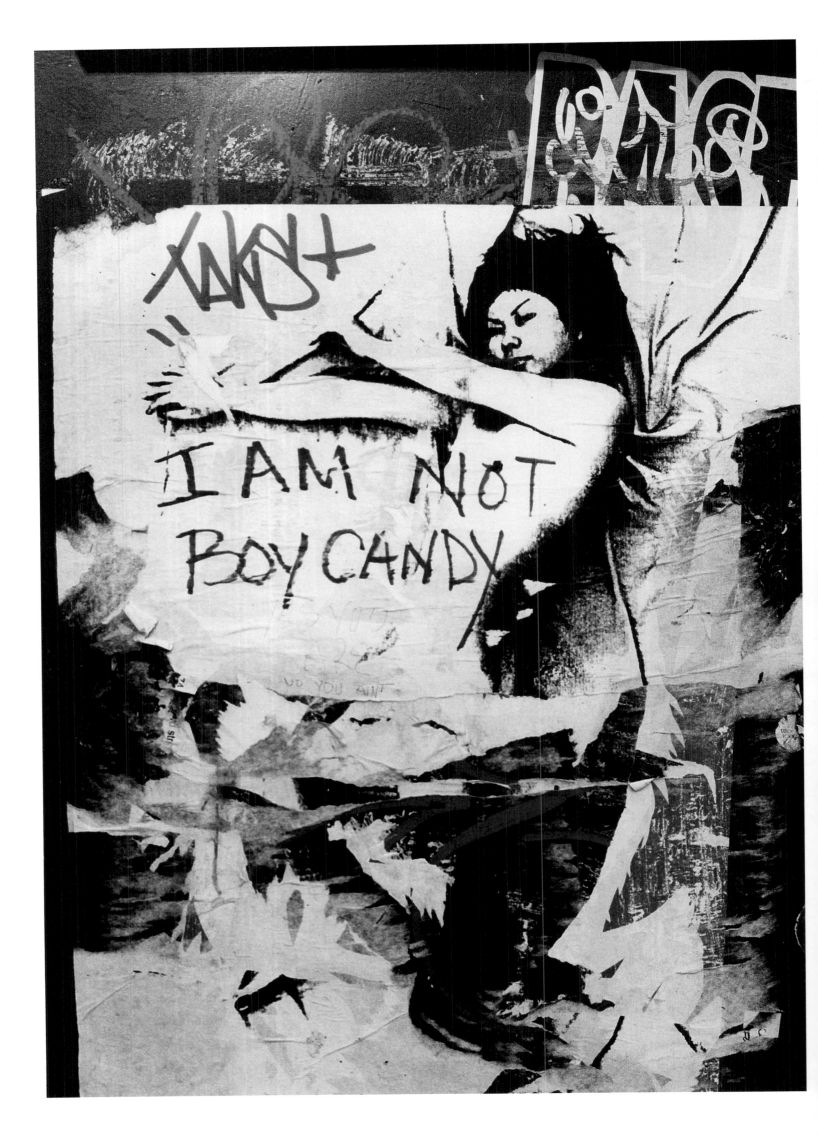

OPPOSITE

Aiko, *A Girl Series*
LOCATION New York City
DATE 2000
MEDIUM Wheatpaste
ARTIST NOTES I arrived in New York City in 1997. As a member of the Faile, I posted hundreds of my self-portrait sleeping on the streets of Lower Manhattan. By doing this I found a way to communicate with the city and random strangers. I fell in love with Street Art, and New York City became my best friend.

BELOW

Tom Otterness
LOCATION New York City
DATE 1977
ARTIST NOTES I had just joined Colab in 1977. NYC was a wreck and nearly bankrupt. I lived in a room directly across from a large concrete wall near the Bowery. Homeless men camped there, built fires, and sold used clothes off the fence. Working with international sign symbols, making what I thought were visual sentences, I would put up something, then watch how the men in front took to it or not. The project was a kind of ongoing nonverbal exchange.

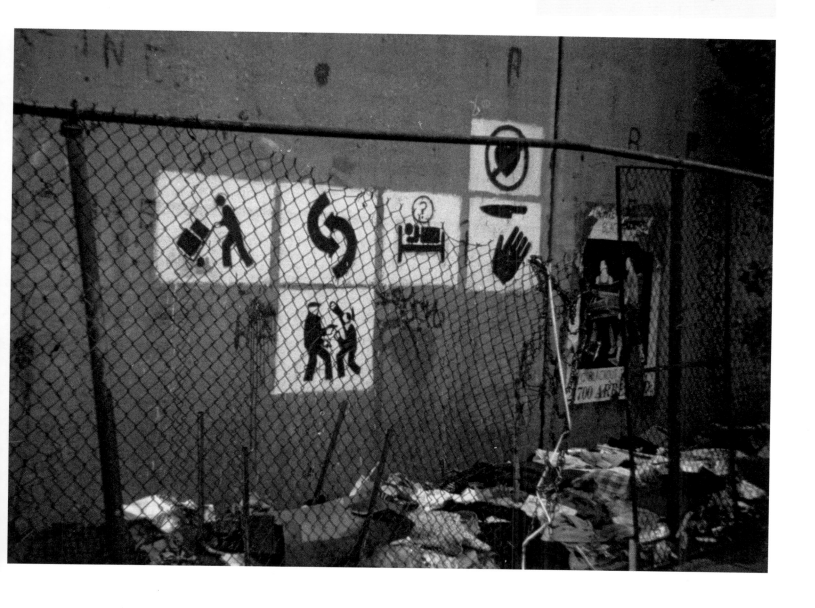

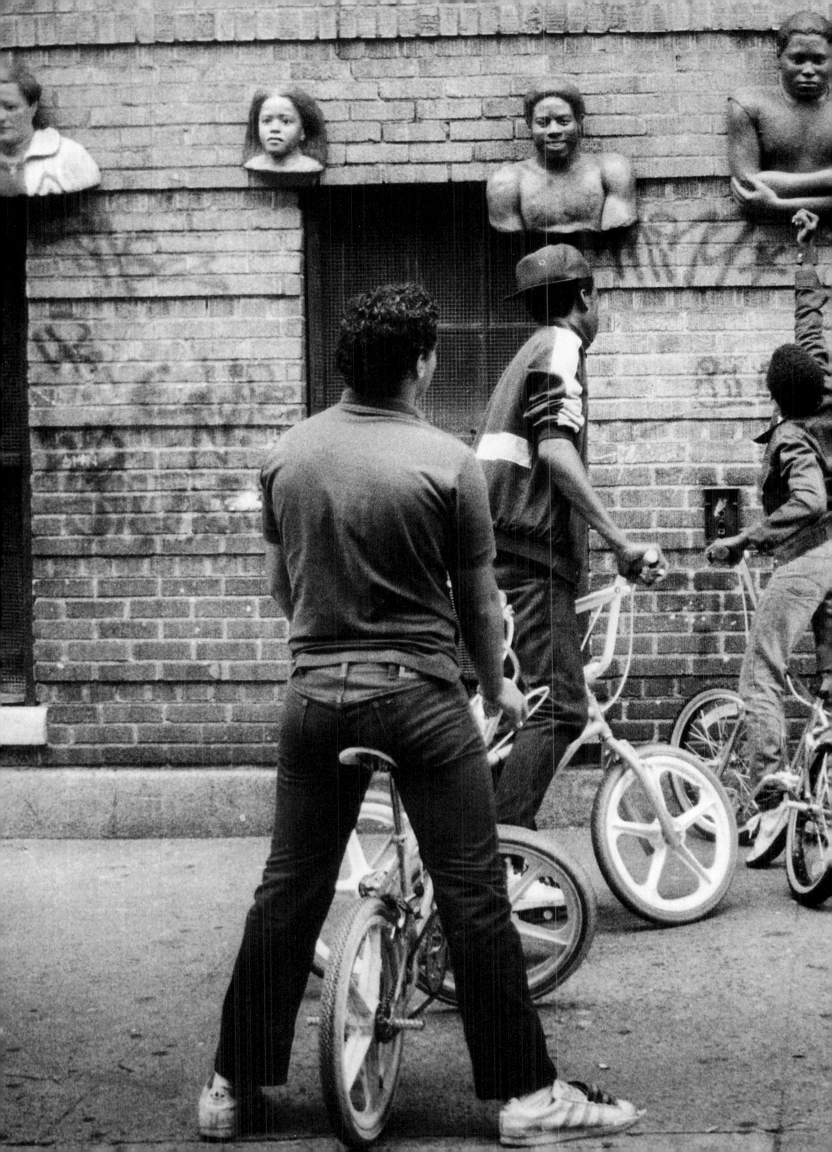

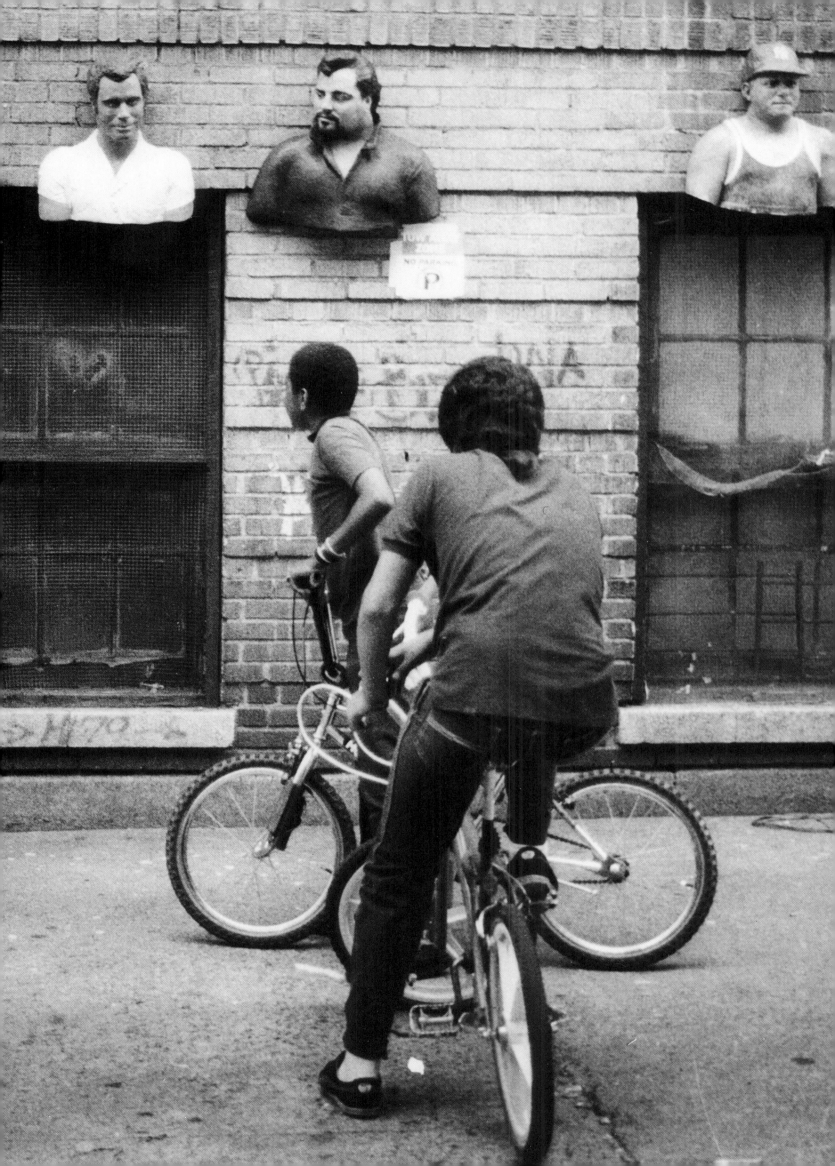

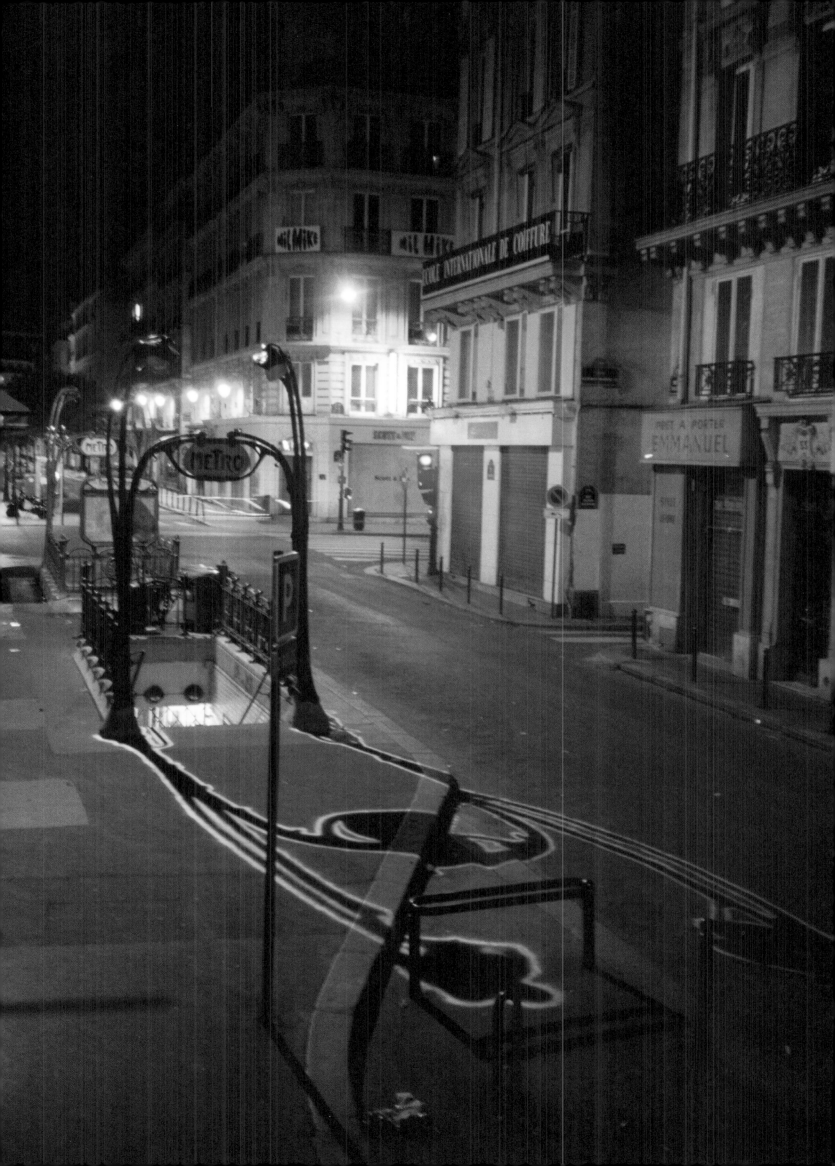

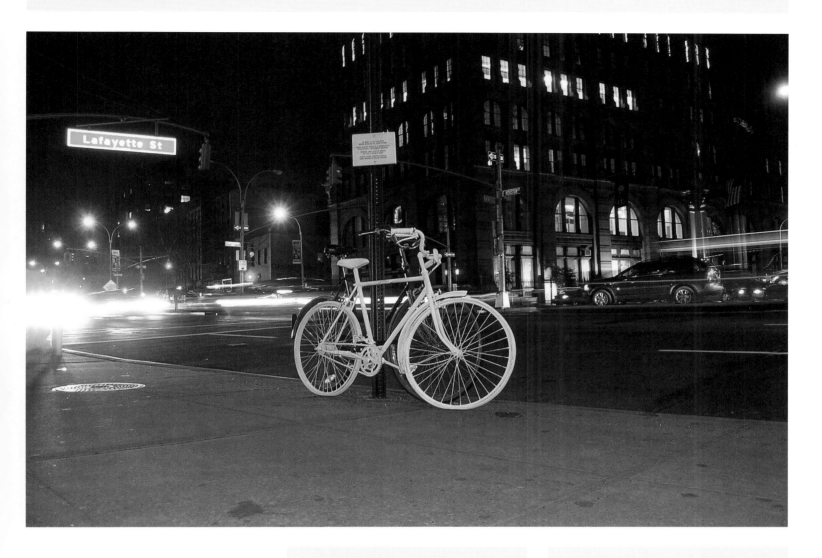

OPPOSITE

ZEVS, *Electric Shadows, Subway*
LOCATION Paris, France
DATE 2000

ABOVE

Ghost Bike Project, *Unknown Cyclist 2005*
LOCATION New York City
DATE 2005
PHOTO Kevin Caplicki

PAGES 118–119

John Ahearn & Rigoberto Torres, *Walton Ave*
LOCATION Bronx, NYC
DATE 1985
PHOTO Ivan Dalla Tana

John Ahearn has long given image and presence to generations of local residents normally excluded from public representation since setting up his studio in the South Bronx in the '70s and subsequently moving it to Harlem. Widely recognized for his commissioned work in public spaces, Ahearn continues to present his busts of ordinary people in and for the community in which he lives and works each year.

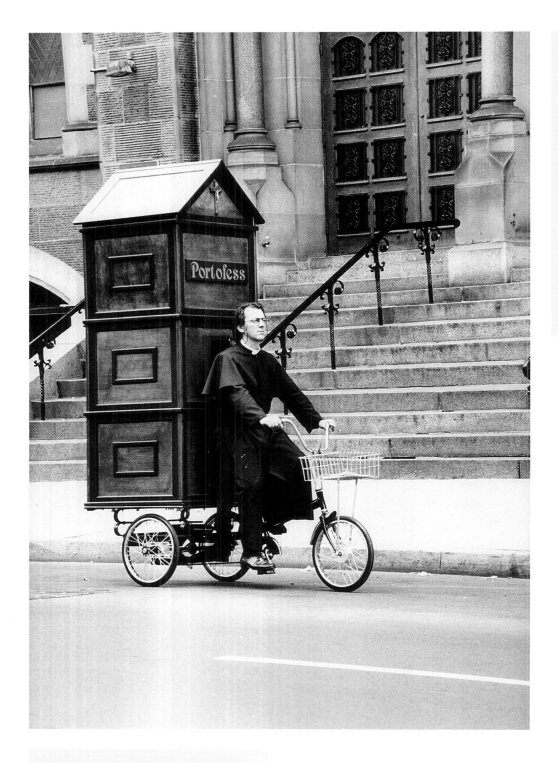

OPPOSITE

Alex Grey, *Private Subway*
LOCATION Red Line, Boston,
 Massachusetts
DATE 1974
ARTIST NOTES I took an hour-long
ride on the subway going from
one end of the line to the other
with a self-portrait in the ad
slot above my seat. The entire
year from June 1974 to June
1975, I examined polarities
through performances that led
from this rational/intuitive
hemispheric split haircut, to the
North Magnetic Pole, to finally
resolving the opposites through
an LSD-induced mystical
experience.

ABOVE

Joey Skaggs, *Father Anthony
Joseph (aka Joey Skaggs)
peddling Portofess: Religion on
the move for people on the go*
LOCATION New York City
DATE 1992

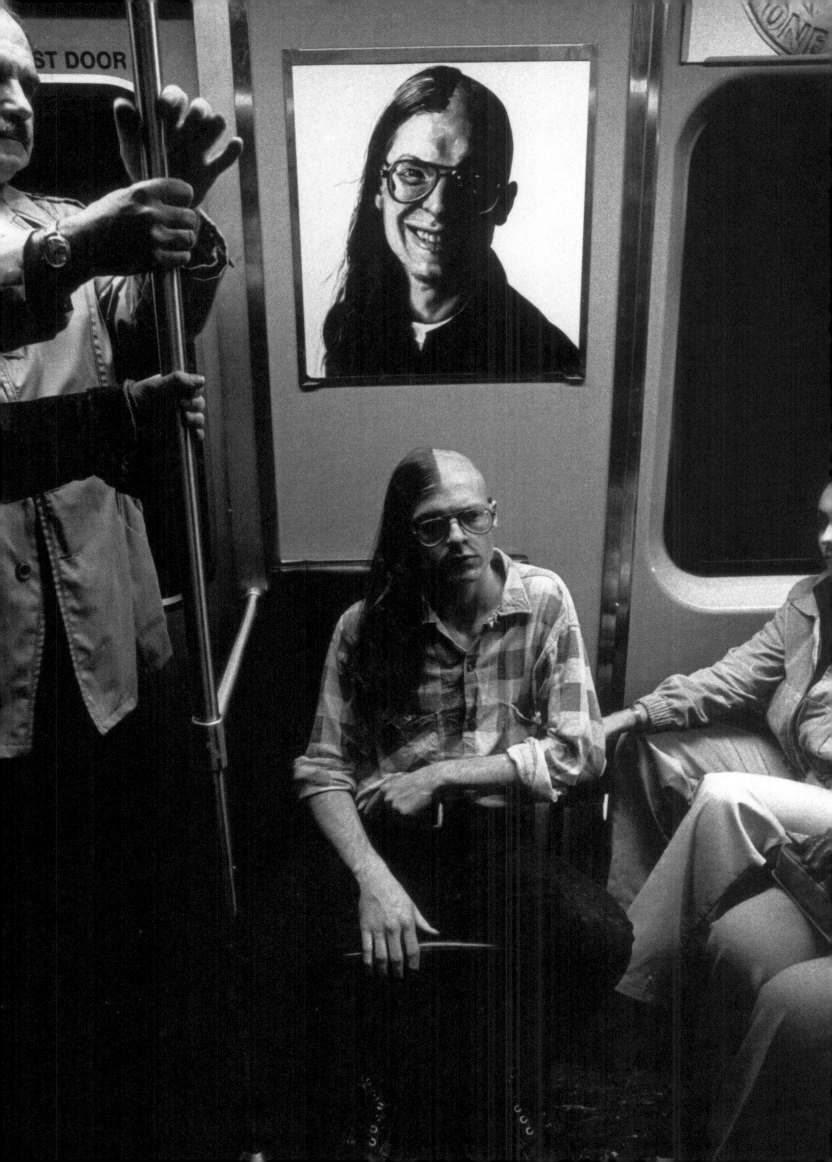

ABOVE

Blek le Rat, *Reflecting Florence Aubenas*
LOCATION Paris, France
DATE 2005
PHOTO Sybille Prou

Florence Aubenas, a French journalist who worked for the French newspaper Libération, *was taken hostage in Iraq on January 5, 2005, along with her translator Hussein Hanoun Al-Saadi. Blek pasted posters of Florence all over Paris, in places she used to go, in order to remind people and to attract the attention of the media towards her release. Florence and Hussein were freed on June 11, 2005.*

OPPOSITE

Graziano Cecchini
LOCATION Trevi Fountain, Rome, Italy
DATE 2007
PHOTO Antonio Amendola

The dye intervention was claimed by FTM Futurist Action 2007, which said it aimed to turn this "grey bourgeois society into a triumph of color."

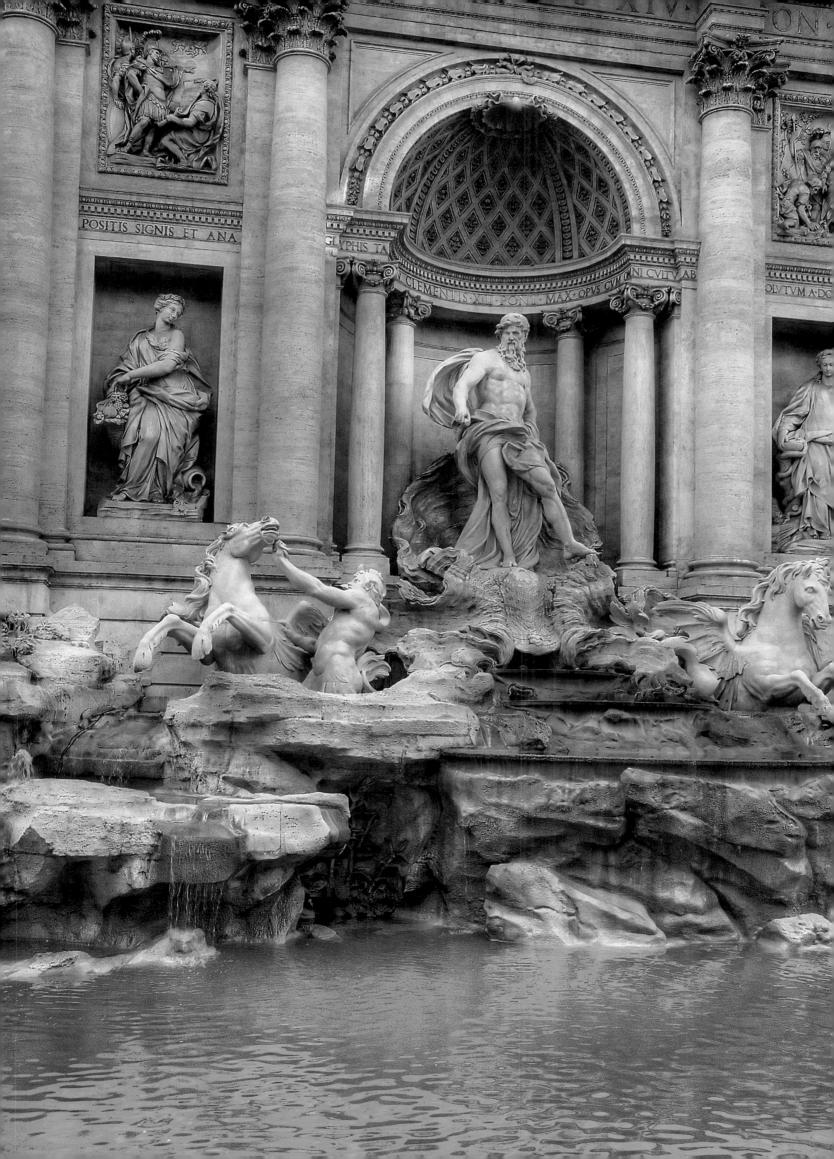

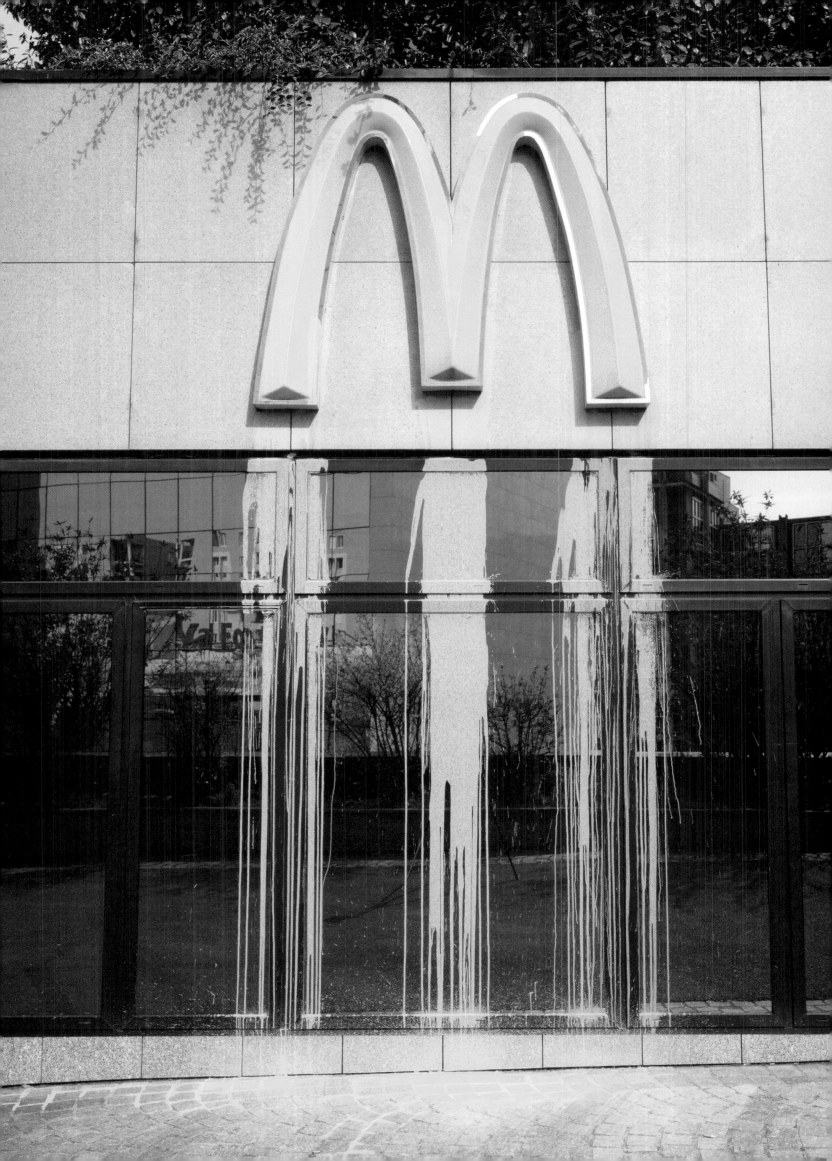

DEVIANT SIGNS
FREE ART
+ CONTRA
CONSUM
4 ERISM

One of the most salient features of graffiti is its approximation of branding. At its most basic level, the tag mimics the ideographic compression, repetition, and saturation that we would expect of corporate logos and marketing campaigns. As a matter of practicality an artist's tag must be fluent, fluid, flexible enough to be put up anywhere, quickly, under any conditions, and maintain that most primary of marketing directives: instant recognition. Self-taught, intuitive, and mastered through a convergence of trial and error with rote, there is something unique about the way a young writer first learns and ultimately takes authorship over his or her tag.

There is not merely a formalist measure at work in tagging, but a psychological dimension endemic to the creation and perception of the name. A graffiti writer's name is significantly more than just an alias. A nom de plume as well as a nom de guerre, it constitutes the basis for a total transformation, like a cape to a superhero; different from a given name, it is a name taken not simply to avoid prosecution but to create an other, a super-surrogate that defines and embodies a new identity. And this is just how it works on many aficionados: it catches our eye, we wonder what or who it is, we track it, and we come to know it. Getting up, by these terms, is really about fame, and by the same quotients of style and audience awareness, a graffiti writer's quest for audience recognition flies or fails much as any consumer ad campaign.

Visually sophisticated and savvy by any standard, urban youth culture has developed its voice, its ironies, and its infatuations, with an uncanny capacity to hack mainstream culture for its own means. The modus operandi is symbiotic and satiric, aggressive but torn by ambivalence in its appropriation of a dominant culture that is highly adaptable in its terms of co-option. Resistance is part of the hegemony, but far from futile, it is all the more vital. Following the collapse of their genre in the art market, the redirection of graffiti artists towards commercial design enterprises—most stunningly with the rise of street-wear in the early '90s—is the epitome of how the underground's relationship to the mainstream is a brilliant catastrophe of simultaneous success and failure. Considering that example as a significant forerunner for how successive generations have come to navigate this difficult terrain, it is not inconsequential that much of street-wear's early visual language was a parodist riff on preexisting corporate come-ons.

These external confrontations and internal contradictions between creativity and the systems of support it needs to sustain itself are neither new nor particular to the interventions we are considering. They are, however, all the more dramatic for a medium that, based on the street, is all about making art free for everyone. In a consumer-based economy, the idea of giving anything away for nothing and making fun of the machinations of seductions that compel us to over-identify with commodities may well be the truly offensive crime committed here. It is important to understand the distinctions between purely reactive gestures and expressions that are more mediated or aesthetic. What the decision of an artist to abandon the sanctified safe space of the art world for the open arena of the social polyglot has in common with

"In a consumer-based economy, the idea of giving anything away for nothing and making fun of the machinations of seductions that compel us to over-identify with commodities may well be the truly offensive crime being committed here."

the obstructions of activism, vandalism of graffiti, or visual play of contemporary street art is an inherent scrutiny, if not rejection, of the ways in which everything from ideas and feelings to property, space, and material objects are bought, sold, and controlled.

Insofar as we gladly accept the premise that mark-making, as a personal expression of self and social form of communication, is a prominent characteristic of all unsanctioned public art as old as mankind, it is also worth looking at the way that centuries of social evolution have deeply affected the terms of engagement. For whatever model history may present of this primary impulse to make our mark, it only goes so far in explaining the how and why of graffiti—and fraught as it is with the cultural condescension of primitivism and outsider art, it might be used with a little more caution at that. No, if we are honest enough to admit that these deeds are not simply creative acts but destructive ones as well, then we might just understand how the exponential rise and global spread of graffiti, post-graffiti, and Street Art is addressing an endemic shift in our relationship as individuals to the body politic, and most importantly, the social architecture of economy and politics that has been built around us.

To begin with we should make note of when we began to notice. That is, if the etymology of *graffiti*—coined in the mid-19th Century following the discovery of scribbling on the walls of ancient Pompeii—tells us that the act is indeed quite old, it says something that our recognition and recording of it is relatively recent. In deference to the many old-school writers out there

who would never let a mere matter of age deter them from getting up every now and then, let us say that most everything under consideration in *Trespass* is an expression of youth and better tracked a social phenomenon rather than an art movement in any formal sense.

Before, when children were to be seen and not heard, one could hardly expect anyone to notice much of what they said, let alone if their mode of address was scratching on a wall or a drawing on the pavement. But if, as we have previously noted, the impetus for this expression to reach a critical mass came from the young American soldiers of World War II, the postwar explosion of youth culture is crucial to the conspicuous place that these kinds of transgressions now have in our physical and psychological landscape. In a way unprecedented and still very much pronounced, youth was invested with an almost fetishistic power. At once dominant in terms of music, fashion, and style, the young have been simultaneously embraced and reviled as the key demographic and signifier of what's happening. What previously had been easily dismissed as juvenilia would henceforth be hotly debated as the contentious and critical issue of juvenile delinquency. The patina of fine art and free expression, it turns out, is better cover for such mischief than the excuse of youthful indiscretion.

Presupposing that the insistent need for kids to find some mode of expression is a constant, what has changed is not merely the degree of attention we are paying them, it is how their expressions convey a different relationship to their environs. I suspect that some of these

"To play in public space is to break the rules, to trespass one's own emotions and sensibilities upon what is otherwise meant to be anonymous, functional, and boringly quotidian."

differences account for the friction that exists today between graffiti writers and street artists, manifest when the former will dismiss the latter as people who have not paid their proper dues, who do not know what it means to get beat up, robbed, chased down electrified tunnels, or jailed for their art. As is often the case with youth, attitudes are part and parcel of lifestyles, but as a matter of personal observation one of the most telling determinants of what art will be made is the artists' gut-level relationship to the canvas. Most startling is the ebb and flow between those who see themselves as inherently improving, even beautifying their environment, and those whose rebellious anger provokes them to fuck things up. Both, however, are reactions to the widespread commercialization and commodification of public space. It was one thing when kids ran amok in abandoned and decaying cities for their own amusement, but it is quite another matter when the surfaces being attacked are advertisements—and these days those are just about everywhere, which is precisely the point.

From the mediations of the spectacle launched by the Situationists and the ridiculing modifications of San Francisco's Billboard Liberation Front through the ad-buster critiques that aesthetic terrorists have launched upon the marketplace with mock ads, perverse product drops, and electronic sign hacking, imitation—far from a form of flattery—is a deliberate strategy of ironic inversion, the appropriation of a dominant language by the disenfranchised to turn the hypocrisy and lies back on their purveyors. Far from being entirely political or polemical, much of this questioning of consensus reality takes place in absurdist whimsy.

To play in public space is to break the rules, to trespass one's own emotions and sensibilities upon what is otherwise meant to be anonymous, functional, and boringly quotidian. To create carnivalesque ruptures in the mundane or meaningful is the subversive role of the clown, whether it is Shepard Fairey spinning out an elaborate campaign featuring a deceased wrestler that promotes no product but rather elaborates the industry of persuasion by which we allow the empty promise of what we consume to define who we are, or any number of artists working in the streets today, including Leon Reid, Darius and Downey, or Roadsworth, to name a few. There is a potent point of convergence where fine art, by imitating life as a farce, approximates the travesty and tragedy of our bottom-line being with the same acerbic edge wielded by anarchist street theater, the situational comedy incidents enacted by performance artists, or the business-suited hoaxes of The Yes Men. All the world is indeed a stage, and it is just a matter of enterprising individuals to take over the role of director to improvise a new reality.

OPPOSITE

Abbie Hoffman, Jerry Rubin
LOCATION New York Stock Exchange, New York City
DATE 1967

Abbie Hoffman (left) and Jerry Rubin set five-dollar bills on fire; from the spectators' gallery more than a dozen hippies threw dollar bills onto the floor of the New York Stock Exchange. They said they were making a "love gesture."

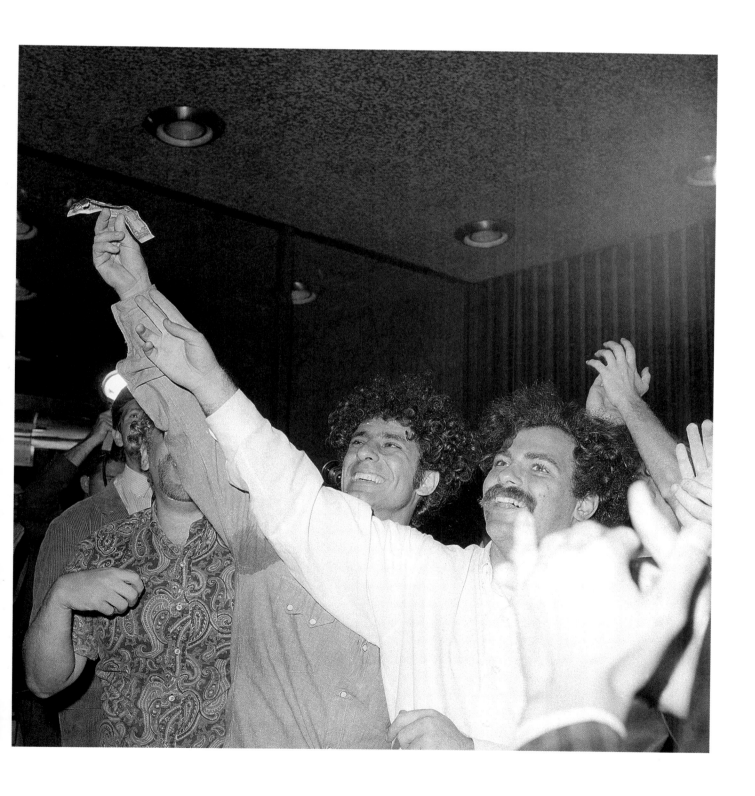

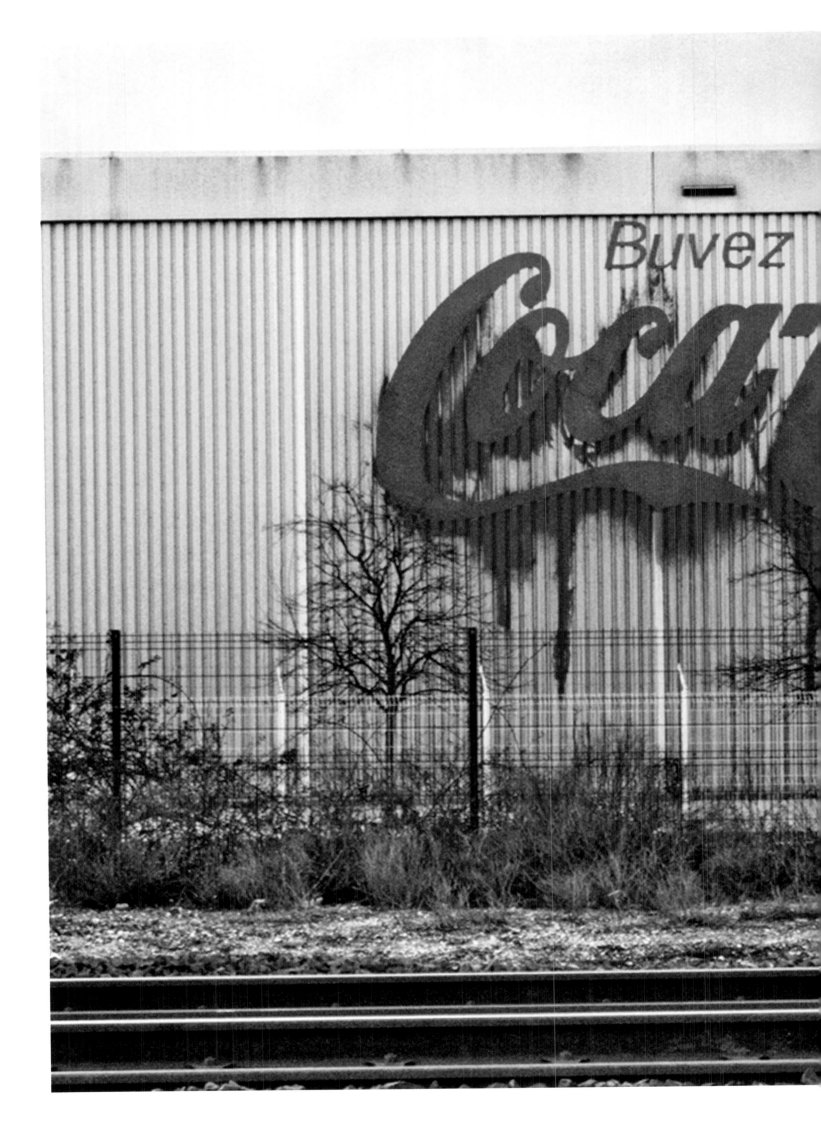

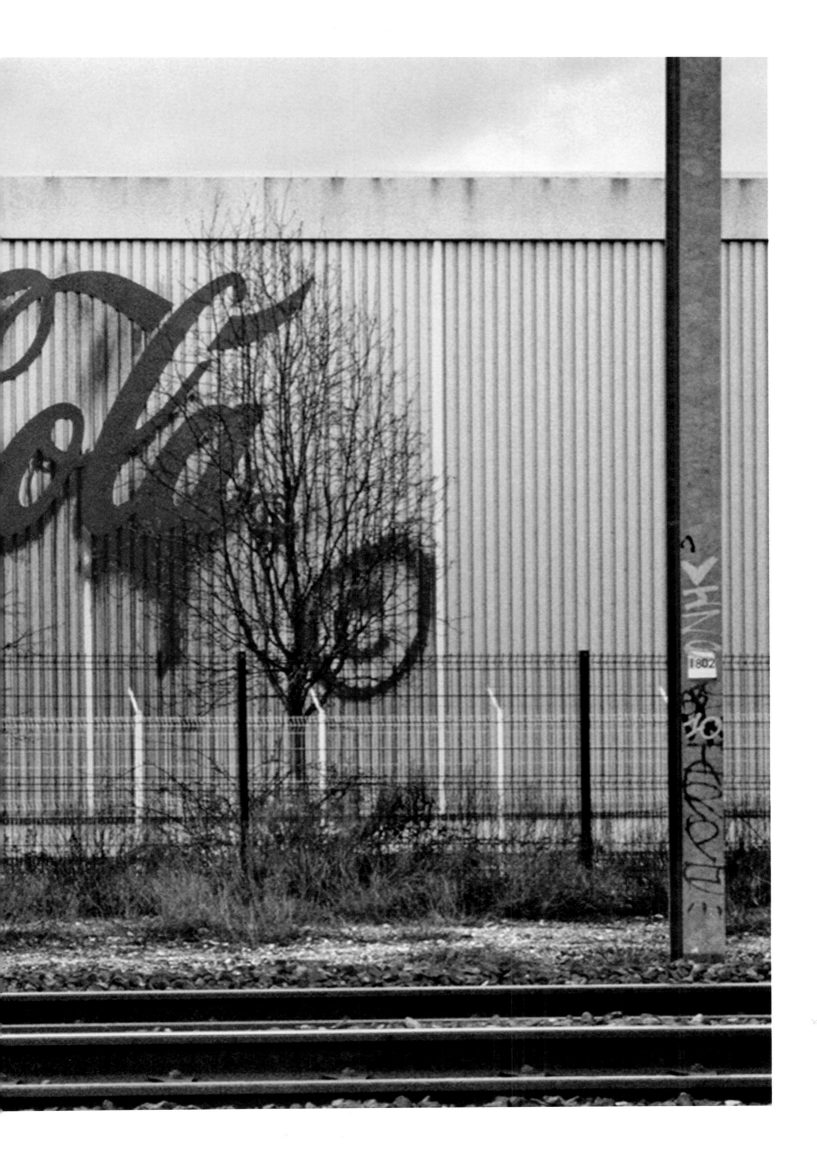

OPPOSITE

KAWS
LOCATION New York City
DATE 1998

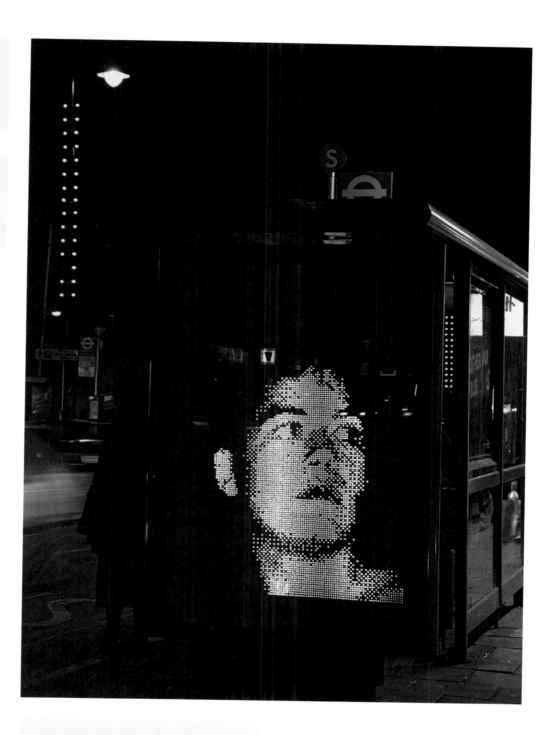

ABOVE

CutUp
LOCATION London, England
DATE 2006
MEDIUM Wood
ARTIST NOTES Created by drilling
thousands of holes in a wooden
board, the image is activated by
the light of the bus shelter.

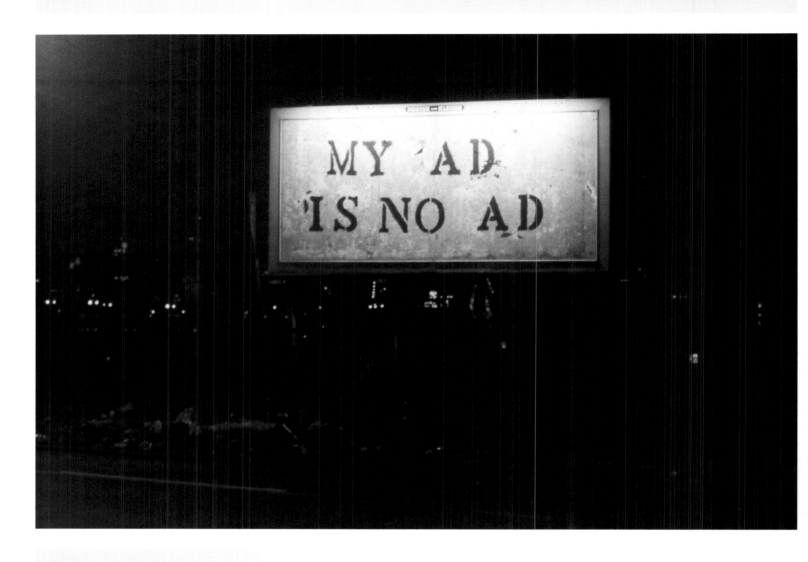

ABOVE

John Fekner, *My Ad Is No Ad*
LOCATION Sunnyside, NYC
DATE 1980

OPPOSITE

DC Gecko, *Hypocrisy (night time)*
LOCATION Madrid, Spain
DATE 2008
MEDIUM Advertising

PAGES 140–141

Skullphone, *Clear Channel Digital Billboard*
LOCATION Los Angeles, California
DATE 2008
PHOTO Curtis Kulig

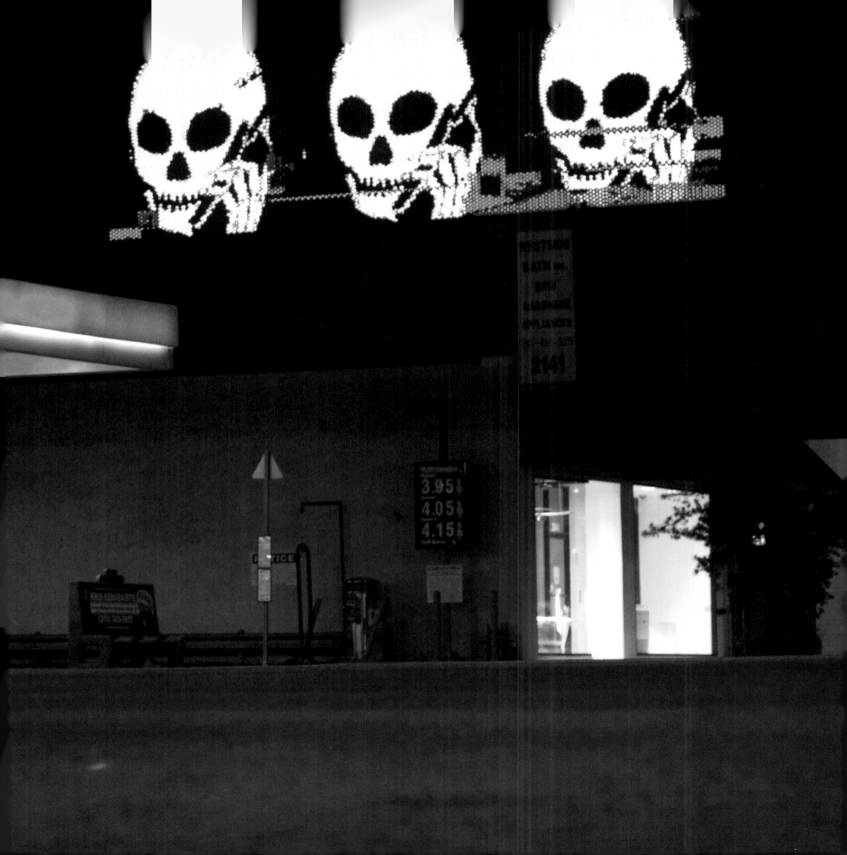

BELOW

Billboard Liberation Front, *Shit Happens*

LOCATION San Francisco, California
DATE 1989
ARTIST NOTES Prior to their improvement and liberation, these billboards read: HITS HAPPEN / NEW X-100

Our ultimate goal is nothing short of a personal and singular billboard for each citizen. Until that glorious day for global communications when every man, woman, and child can scream at or sing to the world in 100Pt. type from their very own rooftop; until that day we will continue to do all in our power to encourage the masses to use any means possible to commandeer the existing media and to alter it to their own design.
—The BLF Manifesto by
Jack Napier, John Thomas

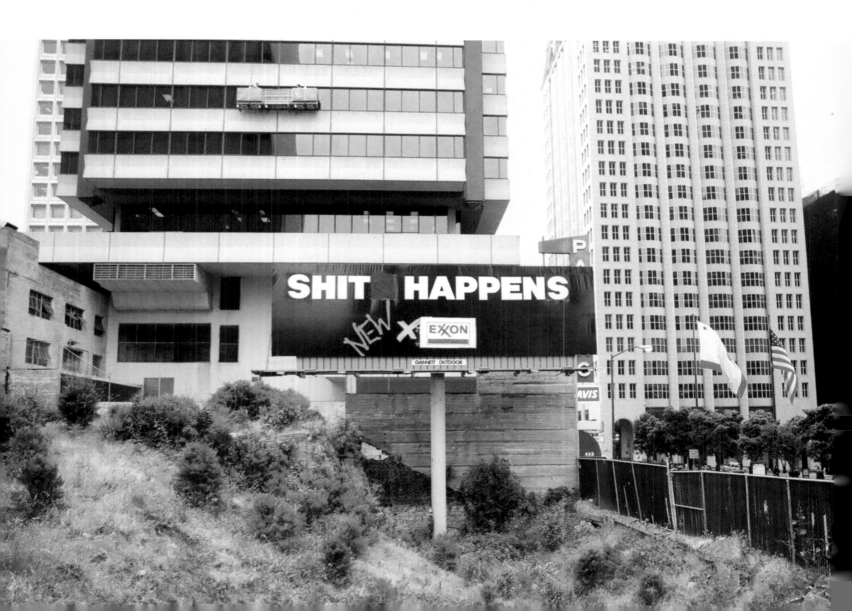

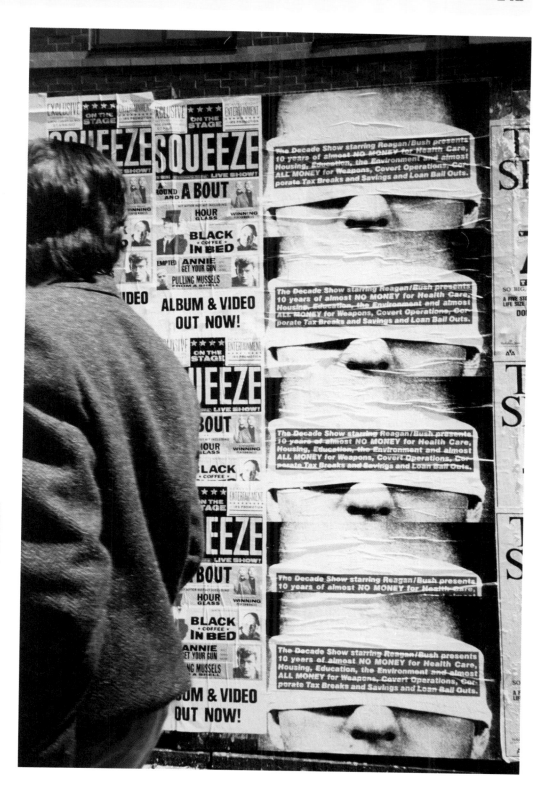

RIGHT

Barbara Kruger
LOCATION New York City
DATE 1990
MEDIUM Poster for *The Decade
Show: Frameworks of Identity
in the 1980s*

*Poster reads: The Decade Show,
starring Reagan/Bush, presents
10 years of almost NO MONEY for
Health Care, Housing, Education,
the Environment and almost
ALL MONEY for Weapons, Covert
Operations, Corporate Tax Breaks,
and Savings-and-Loan Bailouts.*

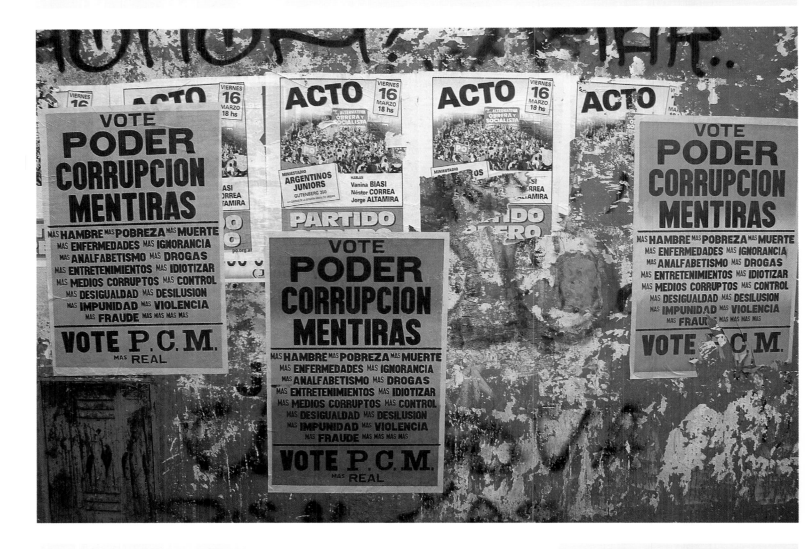

Vómito Attack, *Vote Power,*
Corruption and Lies
LOCATION Buenos Aires, Argentina
DATE 2007

Posters were put up during
electoral times in the city.

PAD/D, *Not for Sale / Art for the*
Evicted
LOCATION East Village, NYC
DATE 1984
PHOTO Gregory Sholette

"Guggenheim Downtown" is written
above this outdoor exhibit parodying
the explosive East Village art scene
and calling artists to take a stand
against real-estate speculation.

PAGES 146–147

The Bruce High Quality Foundation, *Rentstrike! (Shea Stadium)*
LOCATION New York City
DATE 2007

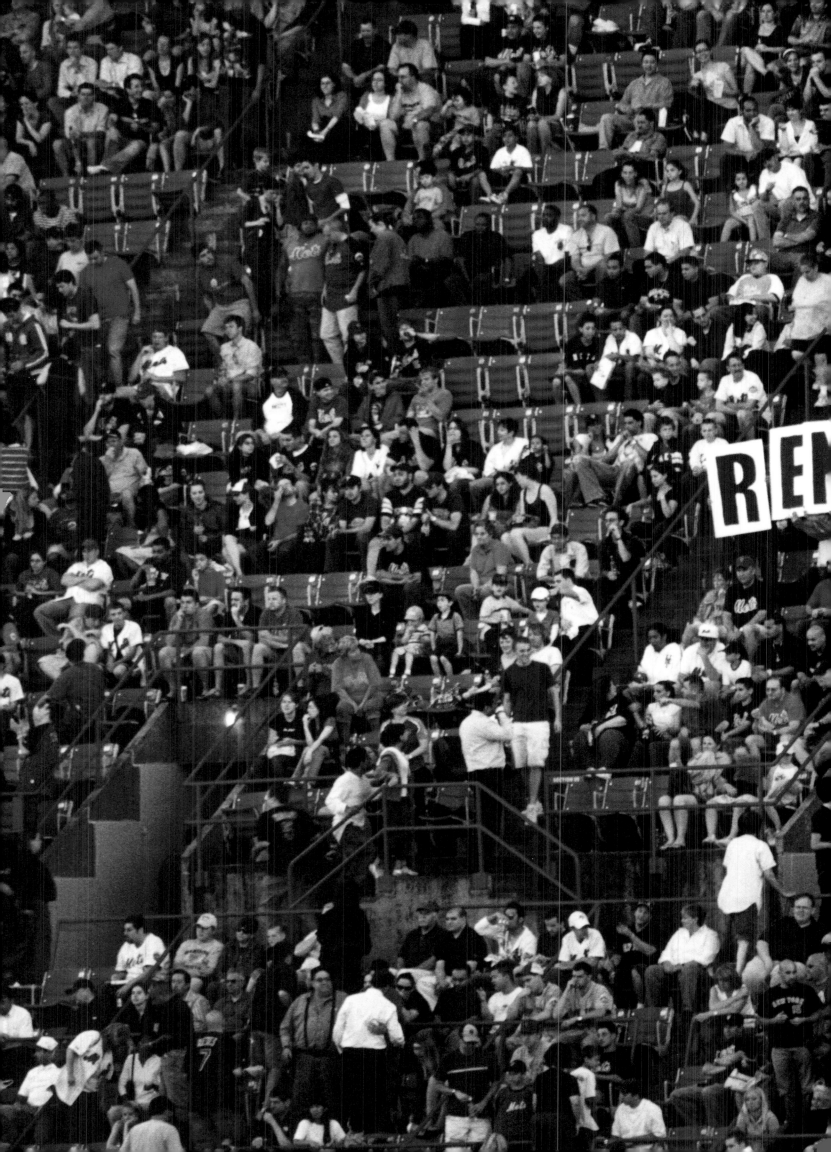

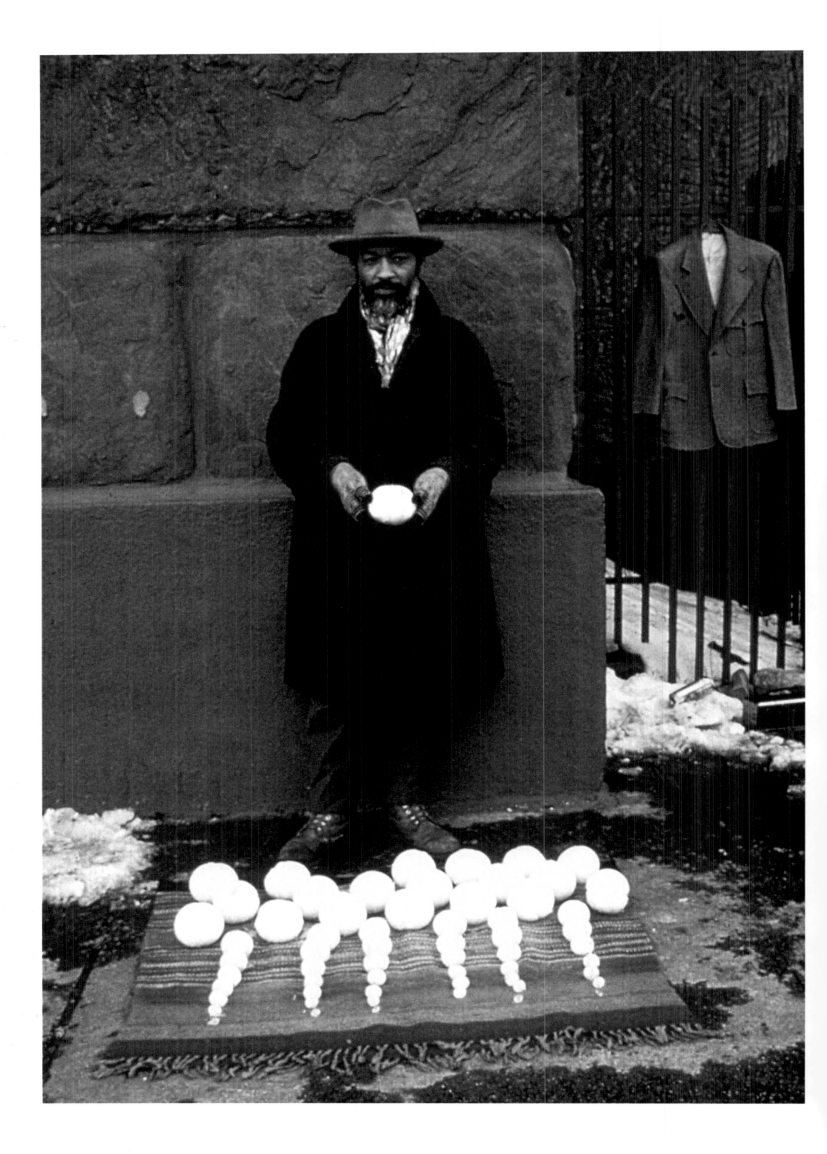

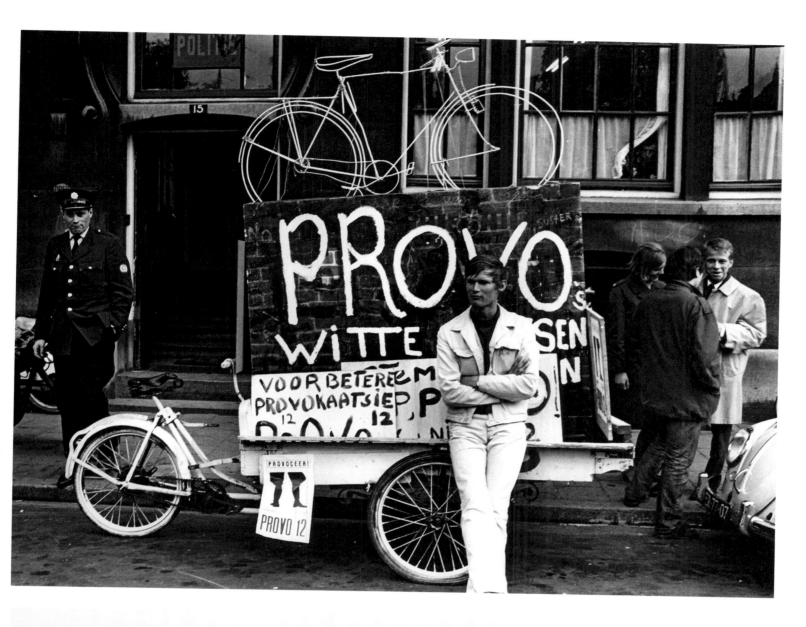

David Hammons, *Blizzard Ball Sale*

LOCATION Cooper Square, NYC
DATE 1983
PHOTO Dawoud Bey

David Hammons' conceptual and performance-based work of the '70s and '80s brought an unprecedented level of poetic metaphor to political art. Positioning himself alongside the usual menagerie of street vendors, Hammons' act of selling snowballs—priced according to size—at once made mockery of art-market machinations and confronted unsuspecting viewers with the inherently absurd problematic of an African American male proffering worthless projectiles as commodities.

Provo/Bernhard de Vries, *White Bicycles* campaign

LOCATION Amsterdam, Netherlands
DATE 1966
PHOTO Cor Jaring

Active in Holland from 1965 to 1967, the Provo movement was a radical mixture of hippies, anarchist-aligned activists, and artists inspired by the rise of Happenings. White Bicycles was a plan to improve the economy of public transport in Amsterdam by providing free white bikes for public use. Though the artists fell far short of their proposed goal of 20,000 bikes, this idealistic project was an international inspiration that also had a profound and lasting impact on the lifestyle choices of the Dutch people.

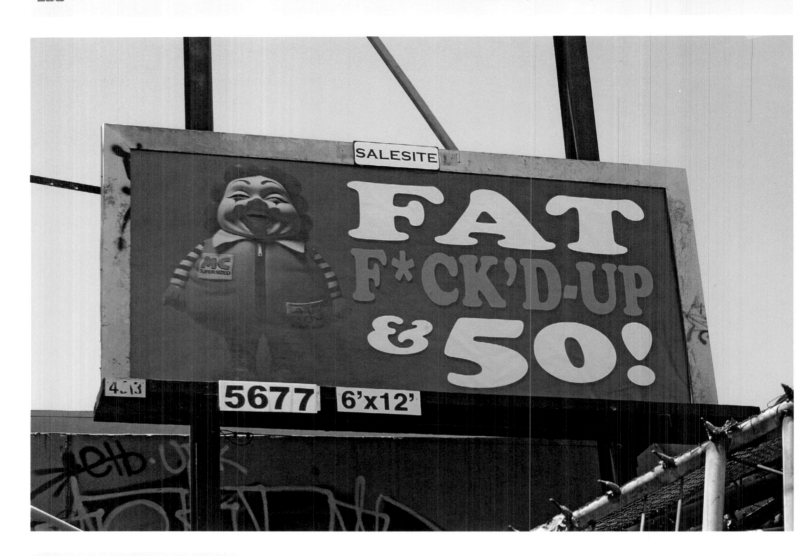

ABOVE & OPPOSITE

Ron English,
*Fat, F*ck'd-Up & 50!*
To Serve Man
LOCATION San Francisco, California
DATE 2005, 50th Anniversary of
McDonald's

Ron English has a complicated mythology around his character MC Supersized, who is basically Ronald McDonald if he actually ate the food at McDonald's. In a nutshell: Fifty years ago aliens came to earth to scope out a possible food source. They found humans too scrawny and created a self-replicating fattening mechanism called the fast-food franchise that addicted humans to salt and fat. Fifty years later the aliens would return to harvest the now deliciously fattened population …

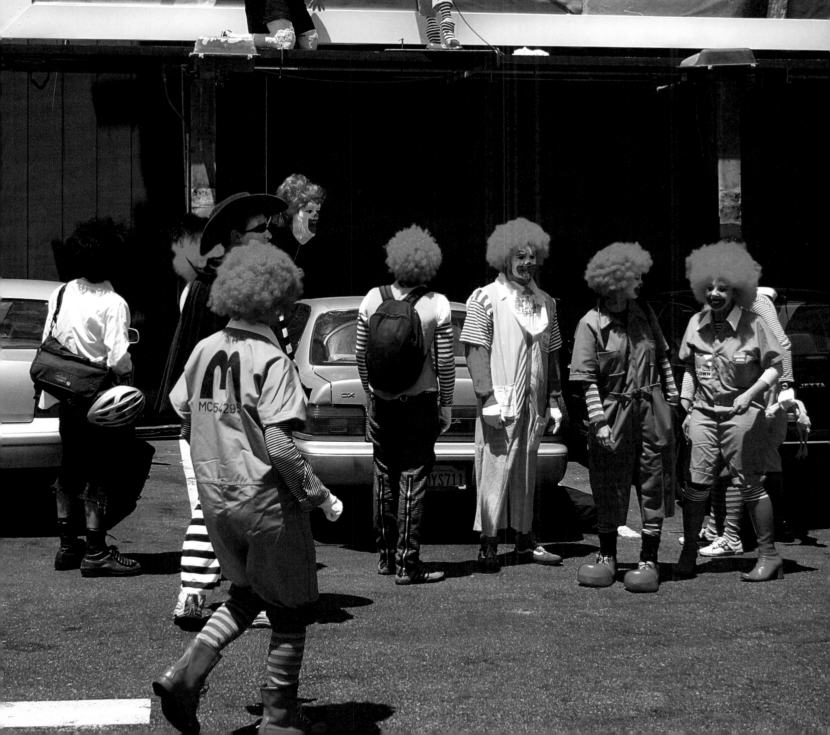

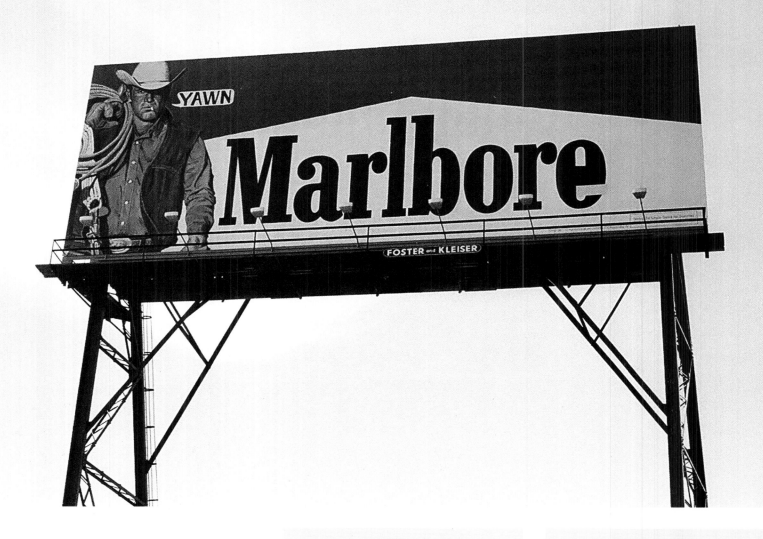

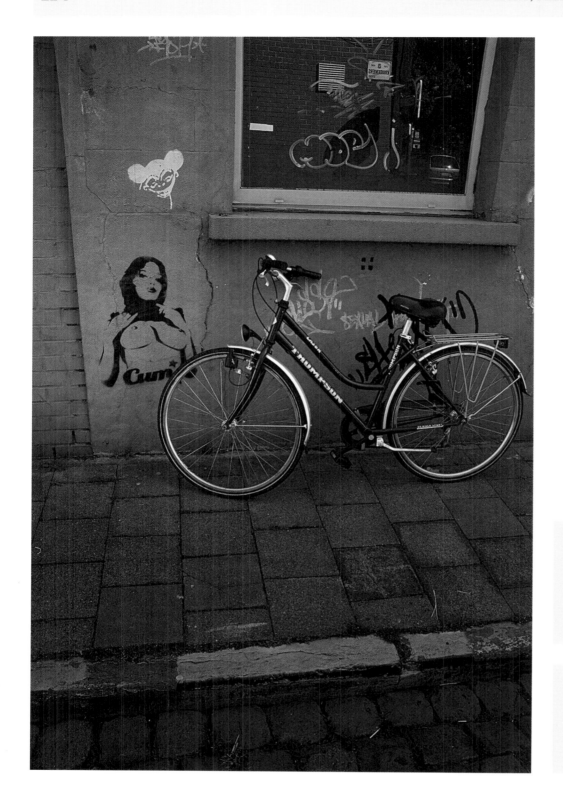

LEFT

Cum*
LOCATION Ghent, Belgium
DATE 2006
MEDIUM Stencil
PHOTO Steven De Volder

OPPOSITE

Jeroen Jongeleen / Influenza
LOCATION Manchester, England
DATE 2004
MEDIUM Stencil

PAGES 156–157

Shepard Fairey
LOCATION Philadelphia,
 Pennsylvania
DATE 1996
PHOTO Adam Wallacavage

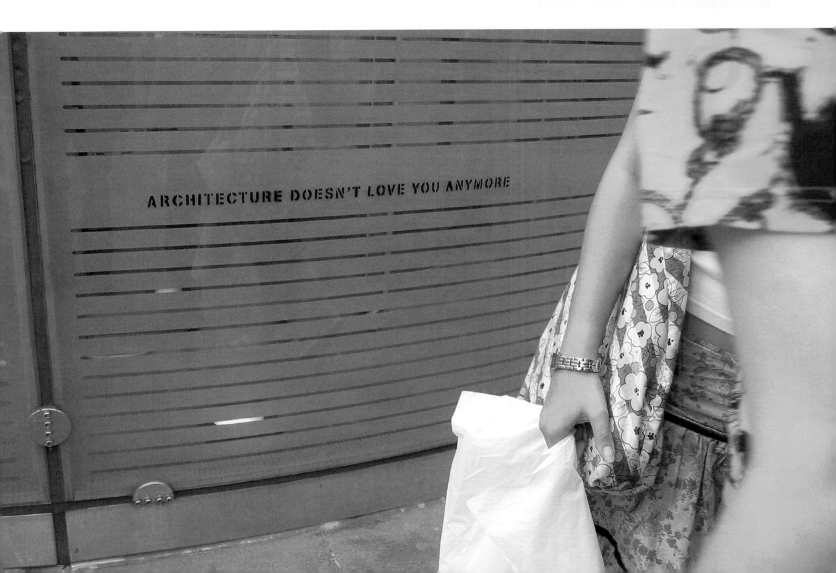

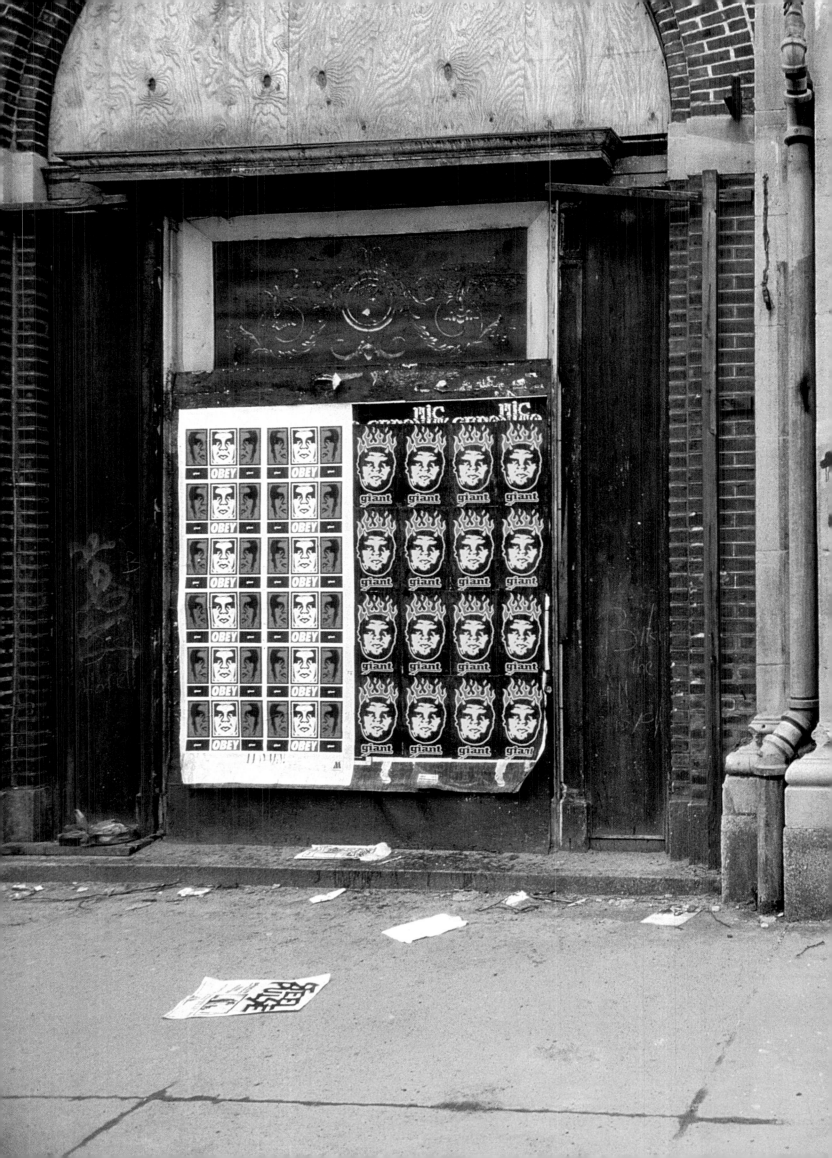

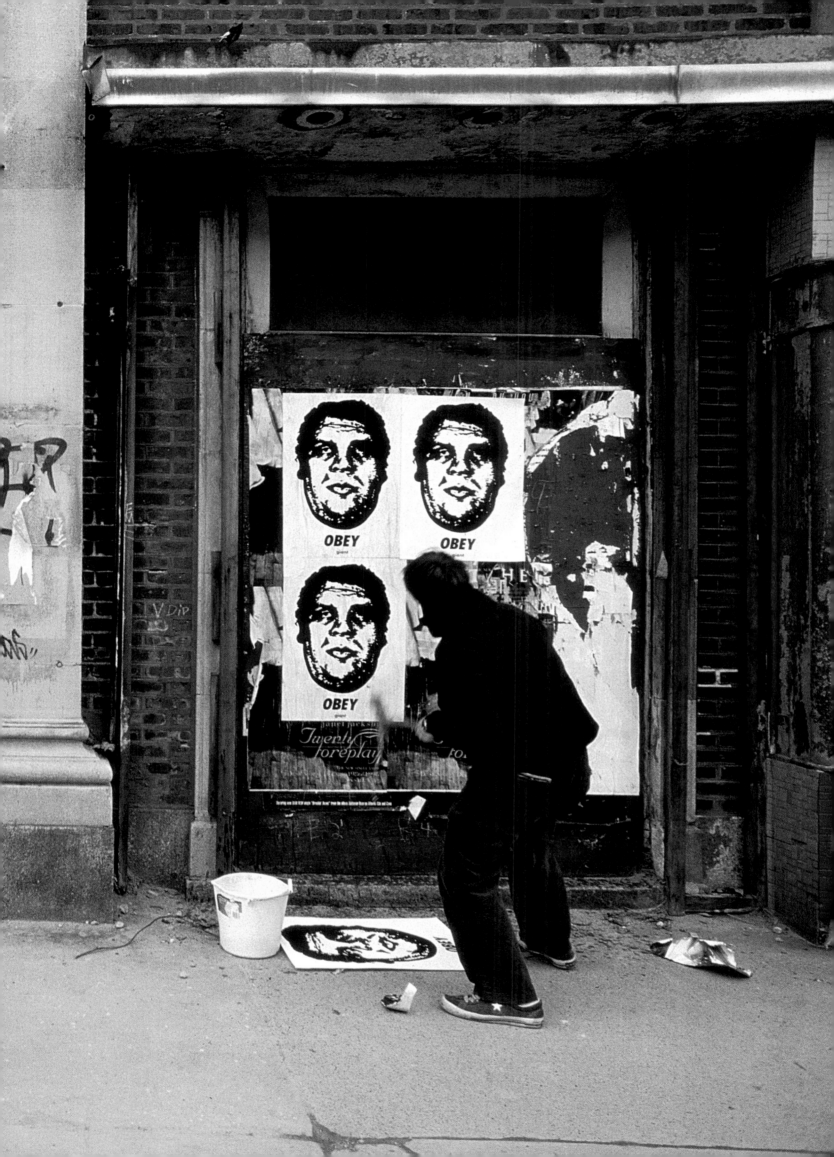

BELOW

Laura Keeble, *Idol Worship*
LOCATION Southend, Essex, England
DATE 2007
MEDIUM Polystyrene, plaster,
 spray paint

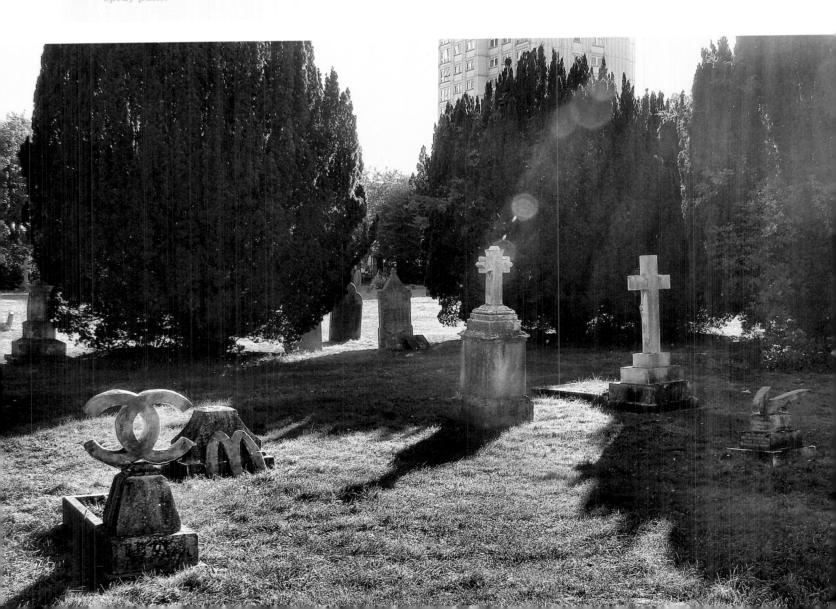

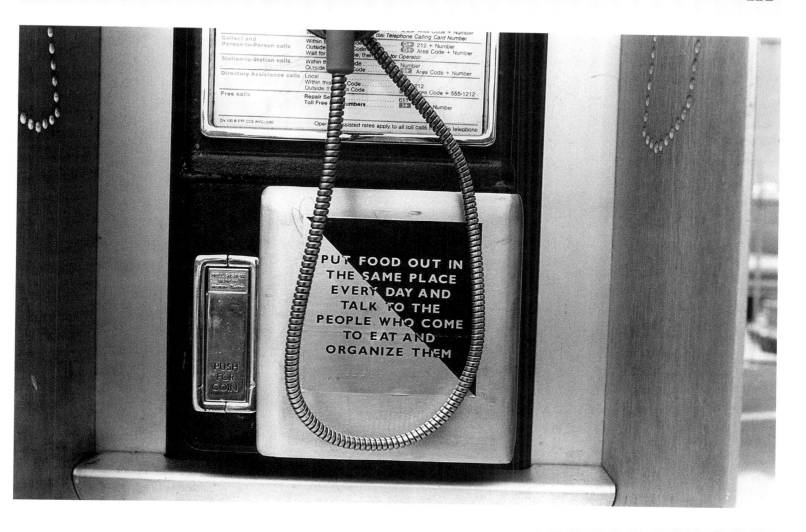

ABOVE

Jenny Holzer, *Survival*
LOCATION New York City
DATE 1983
MEDIUM Offset print on silver
 sticker
PHOTO Mike Glier

Text from Survival, *1983–1985*

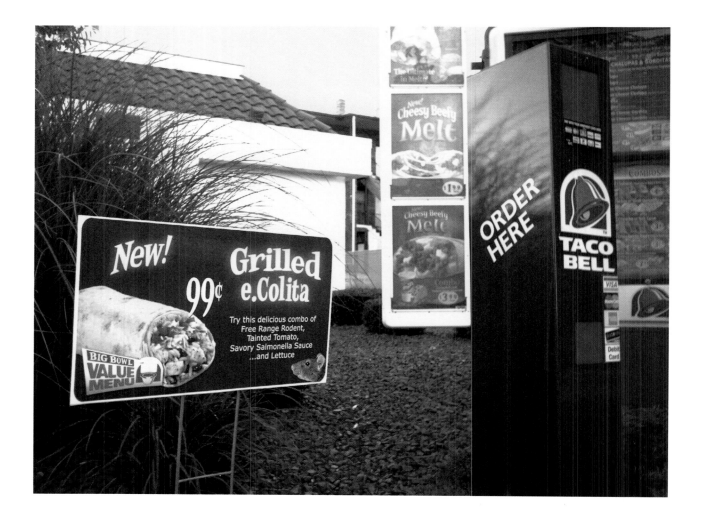

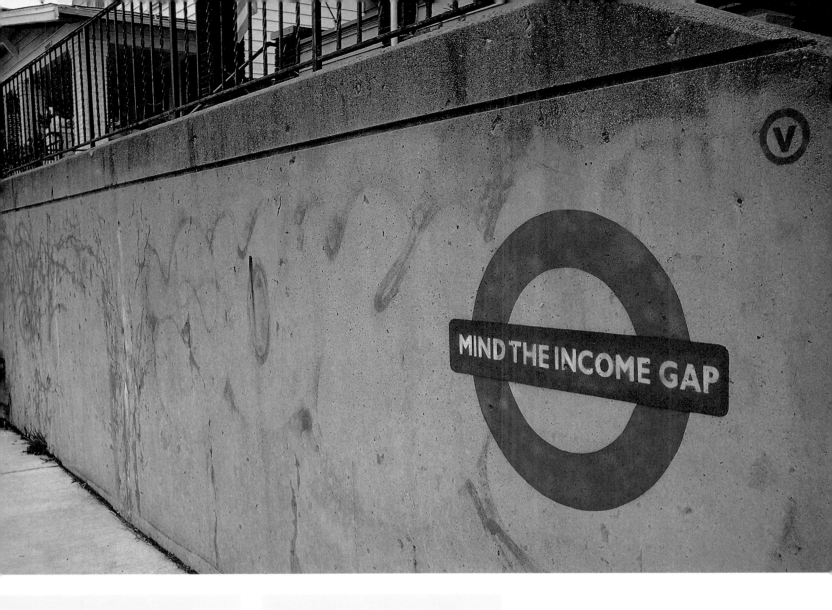

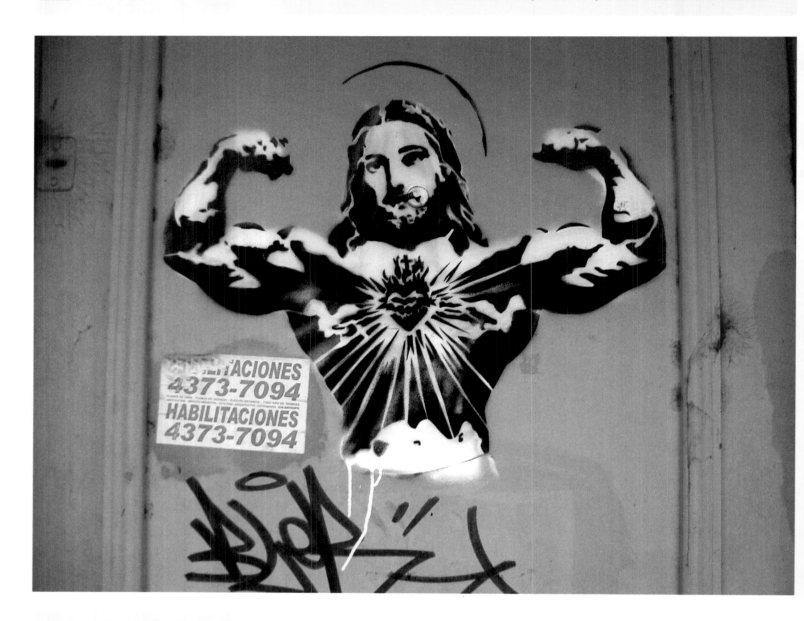

bs.as.stencil, *Mighty Jesus*
LOCATION Buenos Aires, Argentina
DATE 2008
MEDIUM Stencil and spray paint
PHOTO Doble G

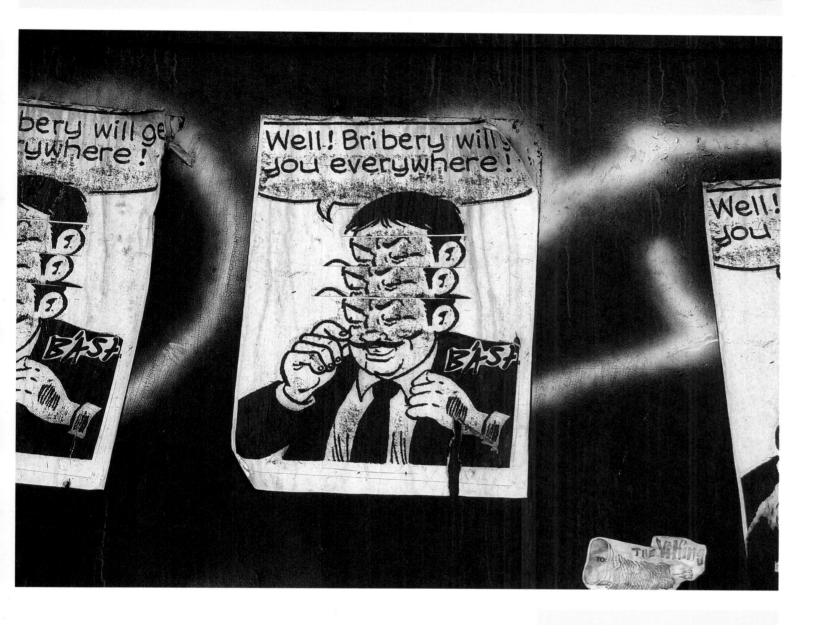

ABOVE

Bast
LOCATION New York City
DATE C. 2002
PHOTO Jake Dobkin

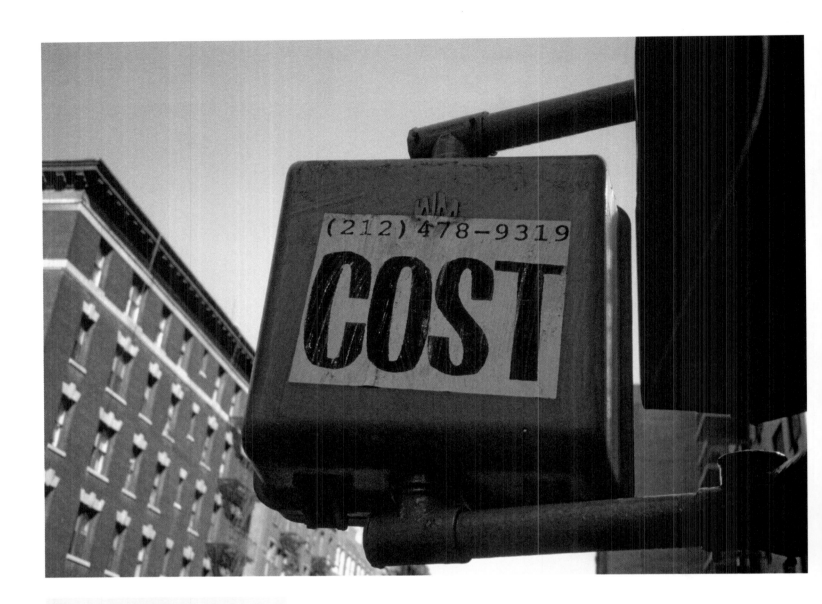

COST

LOCATION New York City

DATE 1992

MEDIUM Wheatpaste on back of
traffic signal

BELOW

The Decapitator, *Untitled 23*
LOCATION London, England
DATE 2008
MEDIUM Stickers on billboard

PAGES 166–167

Bast, Aiko & Faile
LOCATION New York City
DATE 2000
PHOTO Aiko

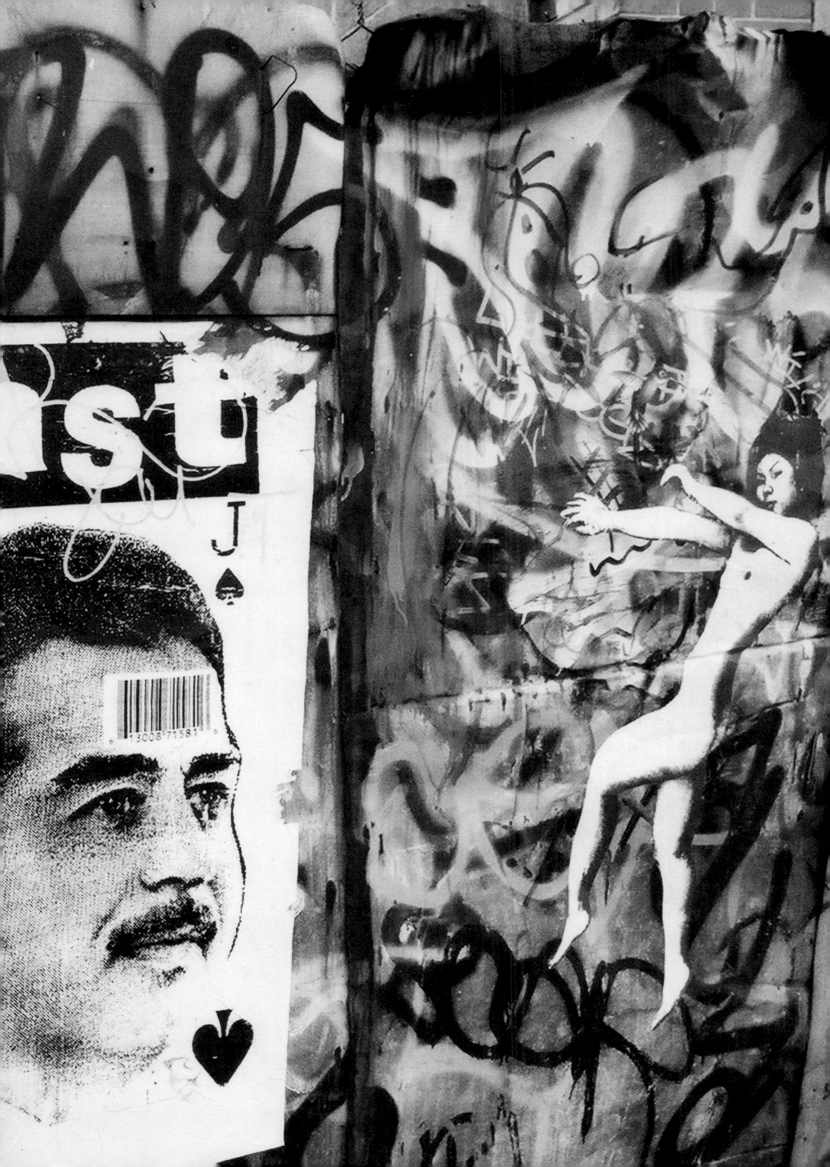

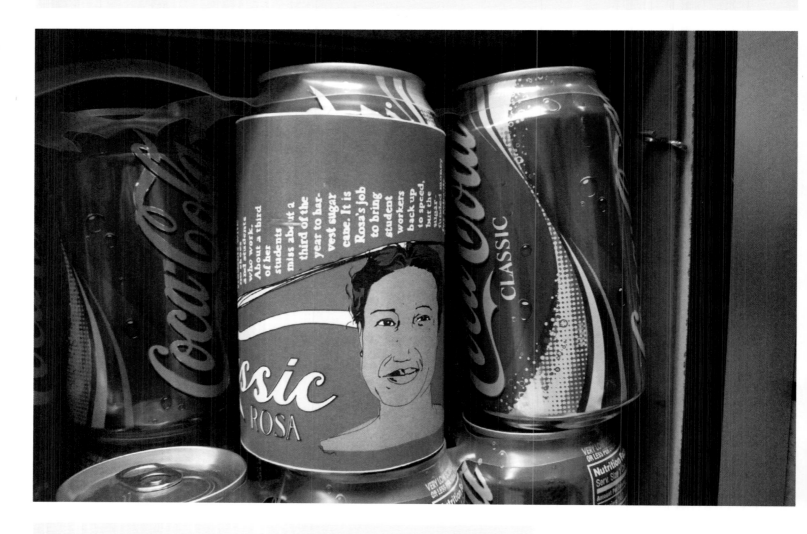

Amanda Eicher & Steve Lambert with the Anti-Advertising Agency, *PeopleProducts123—Classic Rosa*
LOCATION San Francisco Bay Area, California, and other states
DATE 2007
ARTIST NOTES PeopleProducts123 reconnects labor and products by featuring images and stories about the workers who make the products on sale. This improved packaging is placed in stores using a technique called "shopdropping," the opposite of shoplifting, in which items are clandestinely left in retail environments.

Ji Lee, *Bubbled Camel Ad*
LOCATION New York City
DATE 2007

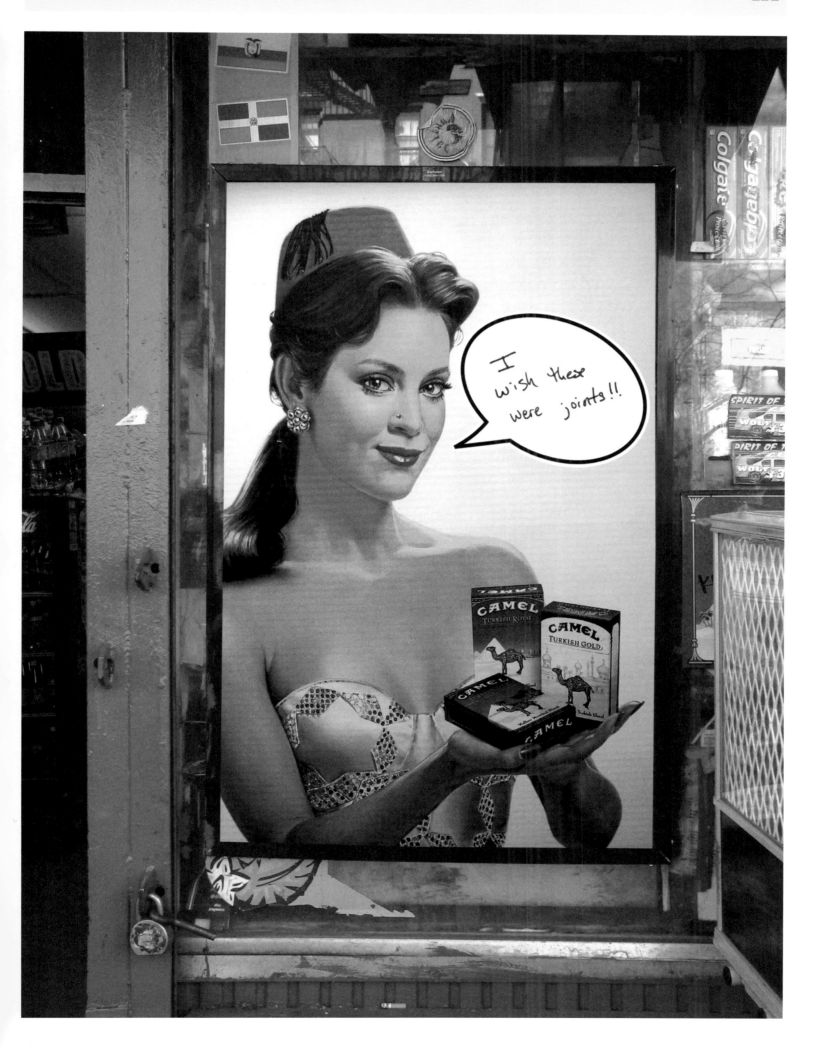

BELOW

Brave New Alps, *Nike the Ripper*
LOCATION Munich, Germany
DATE 2006
MEDIUM Wheatpaste on billboard

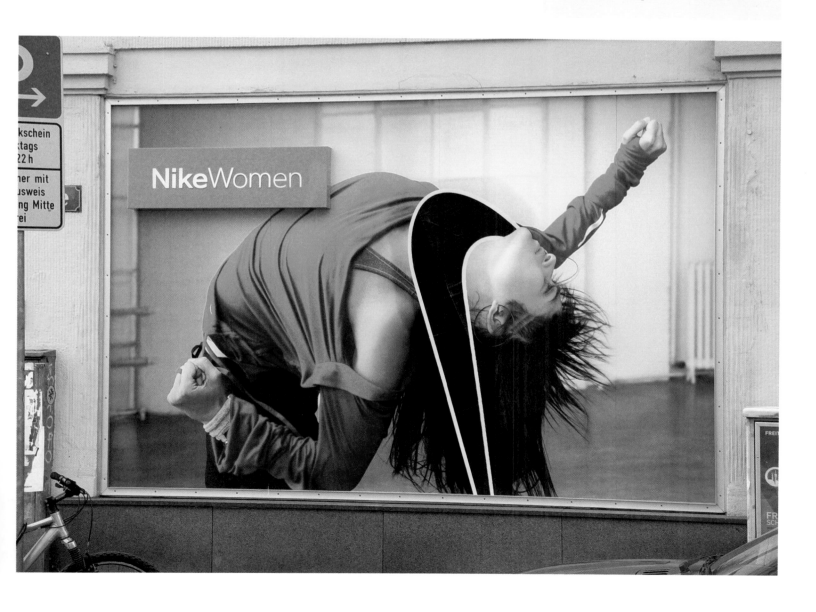

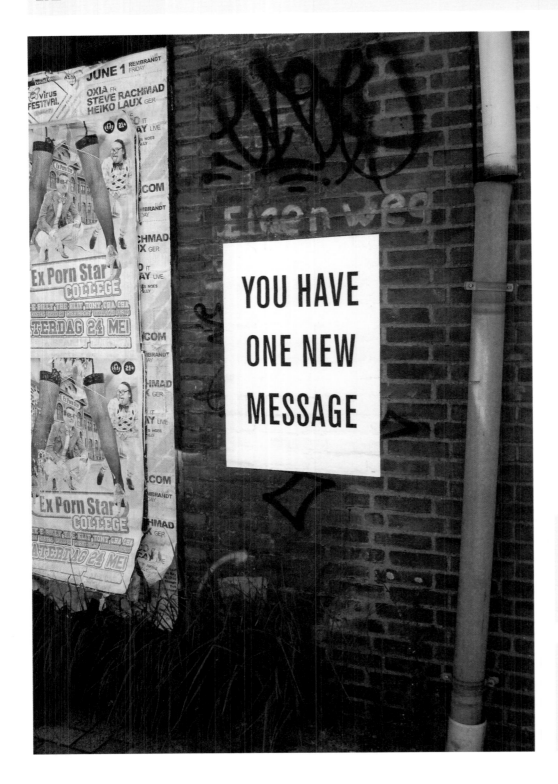

LEFT

Erosie, *One New Message*
LOCATION Eindhoven, Netherlands
DATE 2008
MEDIUM Poster, wheatpaste

OPPOSITE

Brad Downey, *Ignore This Sign*
LOCATION Marietta, Georgia
DATE 2004
MEDIUM Street sign, paint

PAGES 174–175

Thundercut, *Chinatown Walker*
LOCATION New York City
DATE 2007

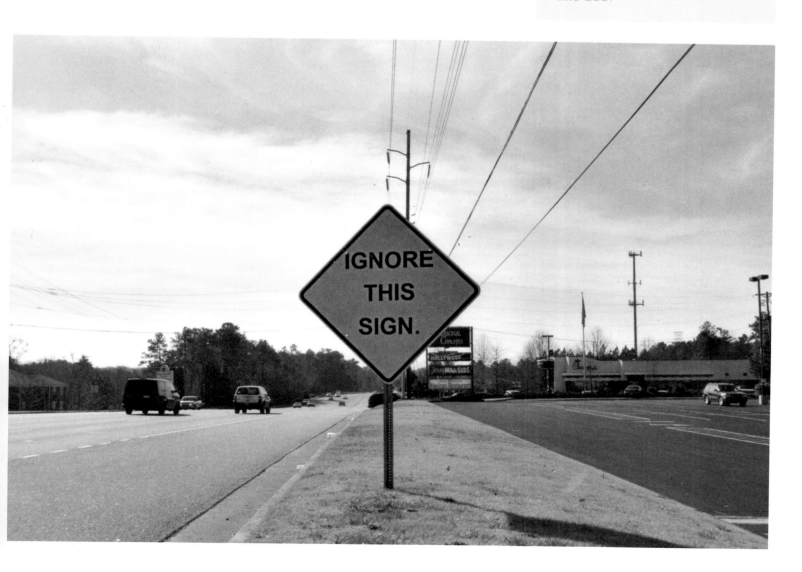

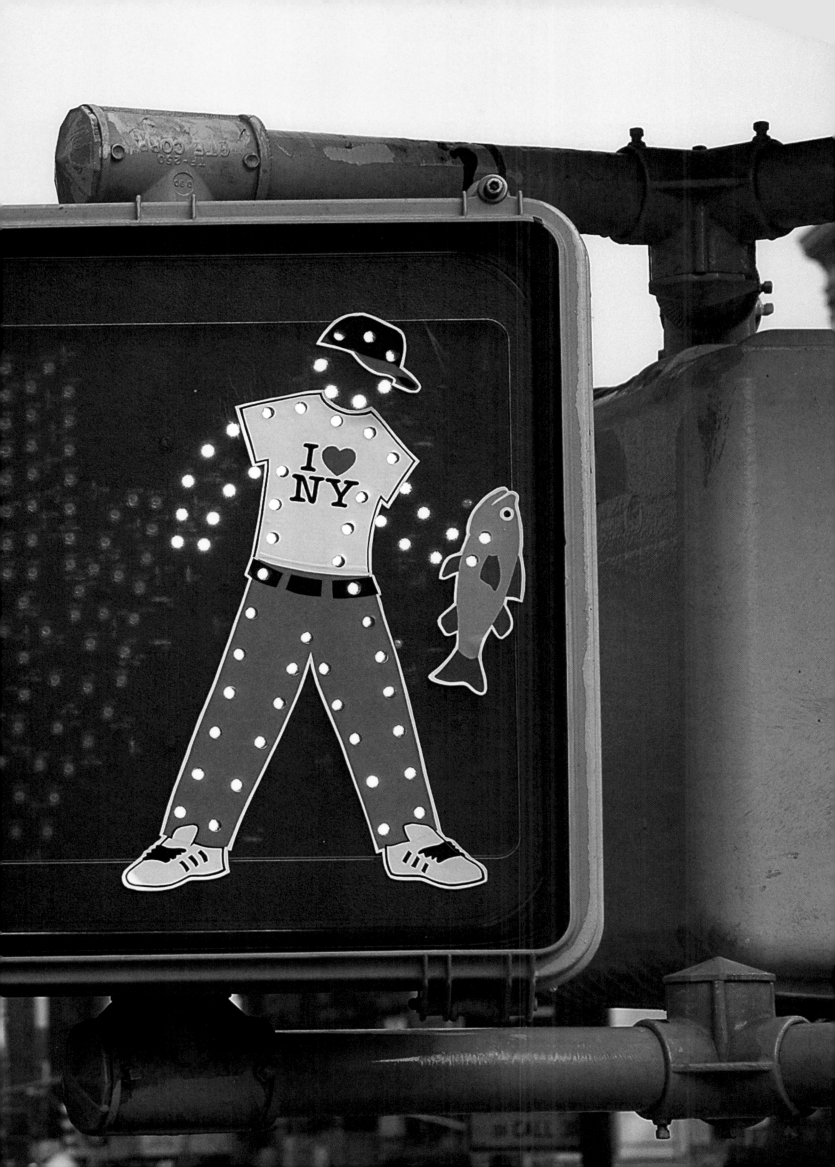

Brad Downey, *Take a Seat*
LOCATION New York City
DATE 2007
MEDIUM hipster park bench,
 metal bars, paint
PHOTO Tod Seelie
ARTIST NOTES Duration: nine days.
Special thanks to Mike Wrobel.

Jason Eppink, *Pixelator*
LOCATION New York City
DATE 2006
MEDIUM Foam core, diffusion gel
ARTIST NOTES In an attempt to
broaden the scope of New York
City MTA's video-art series,
Pixelator takes video pieces cur-
rently on display and diffuses
them into a pleasant array of 45
blinking, color-changing squares.

Roadsworth, *Male / Female*
LOCATION Baie St. Paul, Quebec
DATE 2007

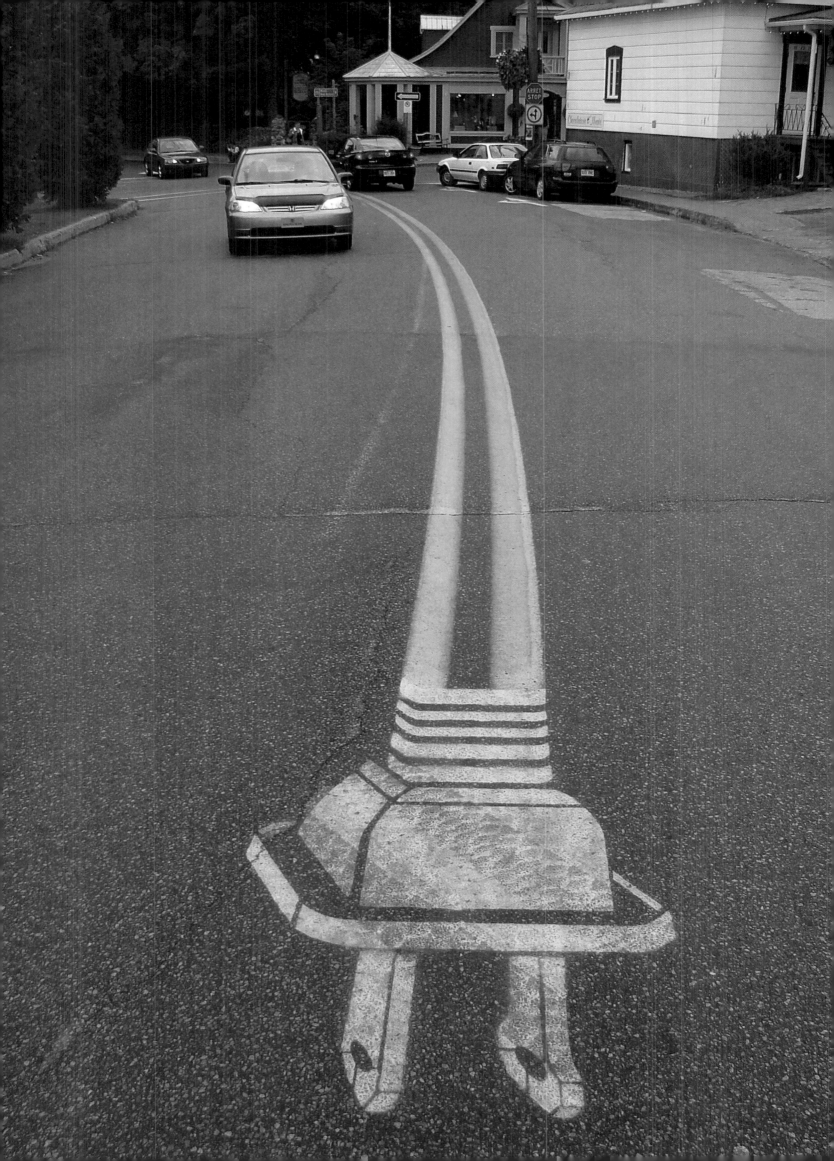

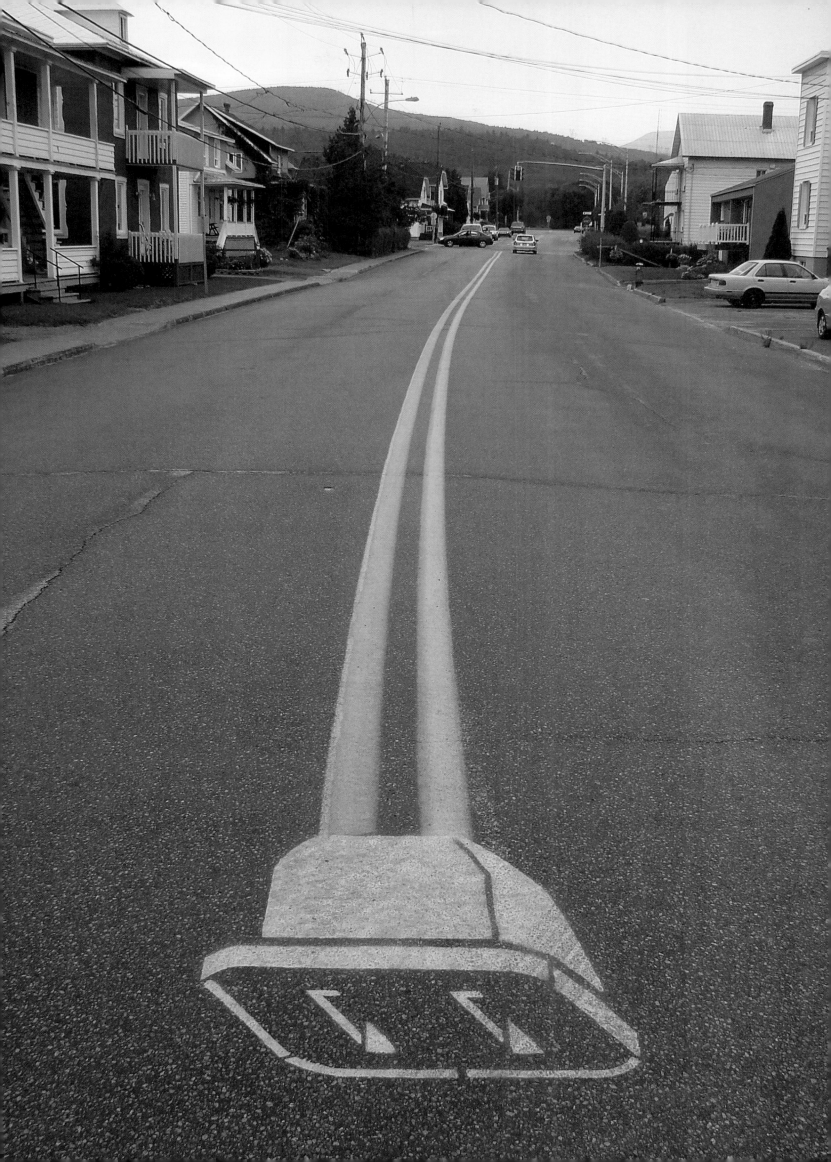

Dan Witz, *Third Man Series*
LOCATION Brooklyn, New York
DATE 2006
MEDIUM Gloves and mixed media
on iron sewer grate

Leon Reid IV, *It's All Right*
LOCATION Brooklyn, New York
DATE 2005
MEDIUM Aluminum signs, steel
poles, enamel

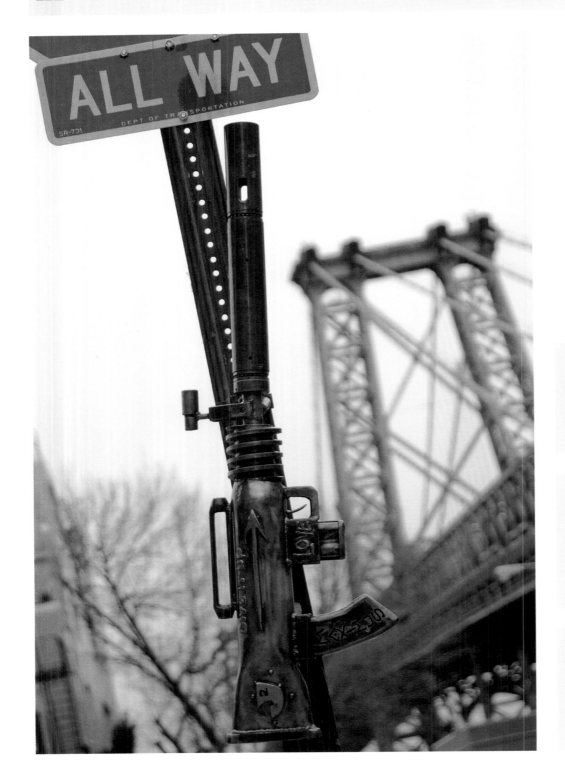

LEFT

JJ Veronis, *Love Maximus*
LOCATION Brooklyn, New York
DATE 2000
PHOTO John Messinger

OPPOSITE

Dan Witz, *Do NOT Enter Series, Ian*
LOCATION New York City
DATE 2007
MEDIUM Mixed media on plastic affixed to metal sign

PAGES 184–185

Jorge Rodriguez-Gerada, *Identity Series—Jordi / Barcelona*
LOCATION Barcelona, Spain
DATE 2003
PHOTO Ana Alvarez-Errecalde

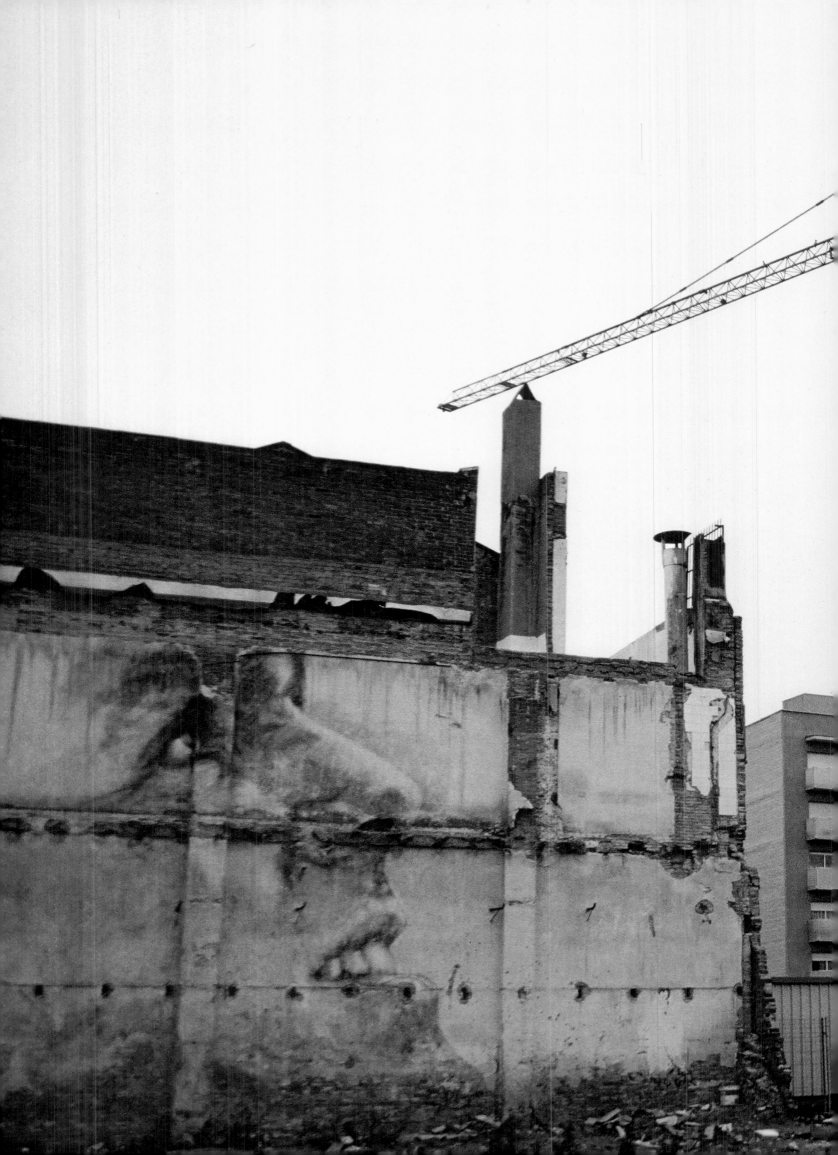

ENVIRON MENTAL. RECLA MATIONS

5

5

"These are utopian visions grafted upon the urban dystopia of alienation and disaffection."

Frances Zaunmiller (1913–1986), the celebrated rural columnist, aptly defined wilderness as the psychological expanse where "a man can walk and he is not trespassing." Already vanishing when this was written in the mid-20th Century, it is even more of a hypothetical space today, but all the more formidable in its absence. An exercise in free will against the limits of control, to trespass in the contemporary urban landscape is in many ways to conjure the possibility of a social wilderness. If we mapped the predominant topographies where art is thrown into the public—the nodal, at those hubs, meeting places, and crossroads; the interstitial, where art secretes and discretes itself in the gaps; and the abandoned, in which art comes to occupy the traumatic history of what is "left"—it would be in this latter forbidden and forgotten zone that art can really attain a pure voice unencumbered by the dialectics of an audience. Invocations of an alternative, often in the form of humanizing, personalizing, or even prettifying what is already there, these are utopian visions grafted upon the urban dystopia of alienation and disaffection. In parts practical, frequently political, and at best poetic, the intervention of some Arcadian sublime into the mundane or the postnaturalist choice to make art an environmental medium is the consequential embrace of the rapturous against reason.

OPPOSITE

Casita Garden
LOCATION New York City
DATE 1989
PHOTO Martha Cooper

The gardens were born of the urban blight that devastated many poor areas of Manhattan, Brooklyn, and the Bronx. Built within Puerto Rican communities when vacant lots in New York City were plentiful, casitas or "little houses" represented the folklore of a rural community transported into an urban environment.

PAGE 186

Adam Purple, *The Garden of Eden*
LOCATION Lower East Side, NYC
DATE 1982
PHOTO Martha Cooper

Adam Purple constructed his Garden of Eden *on a huge rubble-strewn lot that opened up when New York City razed two tenements close to his home, fertilizing his plot with manure from Central Park carriage horses, which he transported via bicycle. What began around Forsyth Street in 1974, when the city was facing bankruptcy, was considered by most residents a local treasure by the time the city bulldozed the* Garden of Eden *in 1986.*

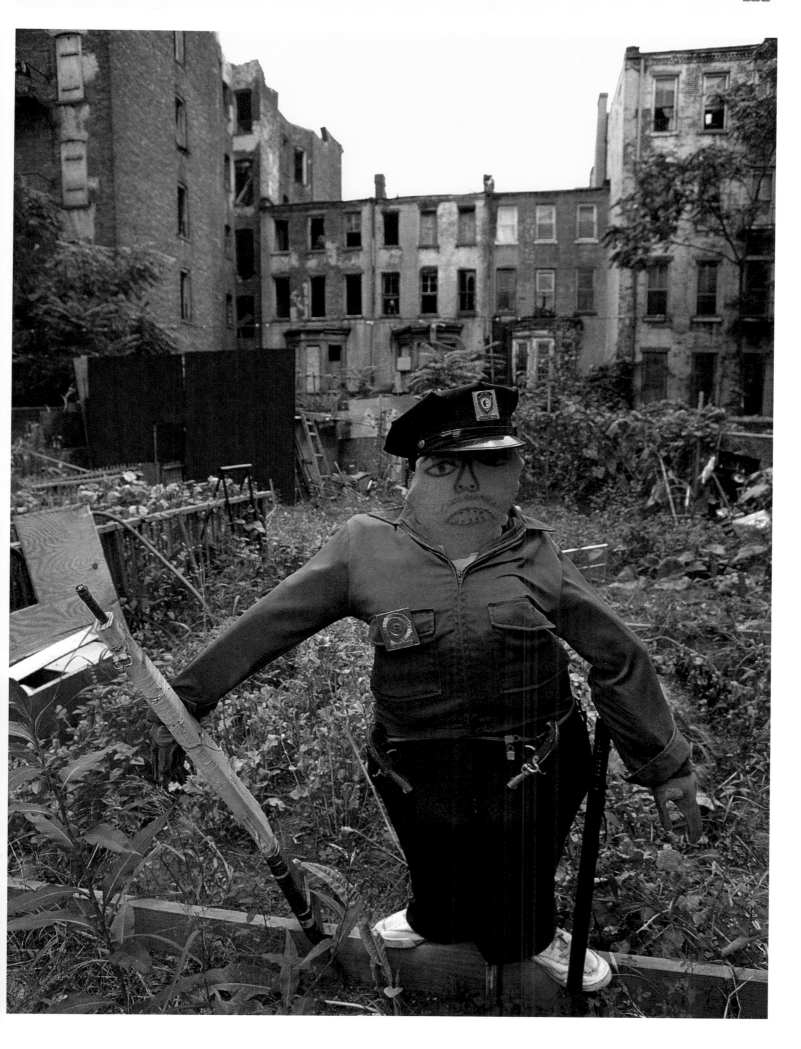

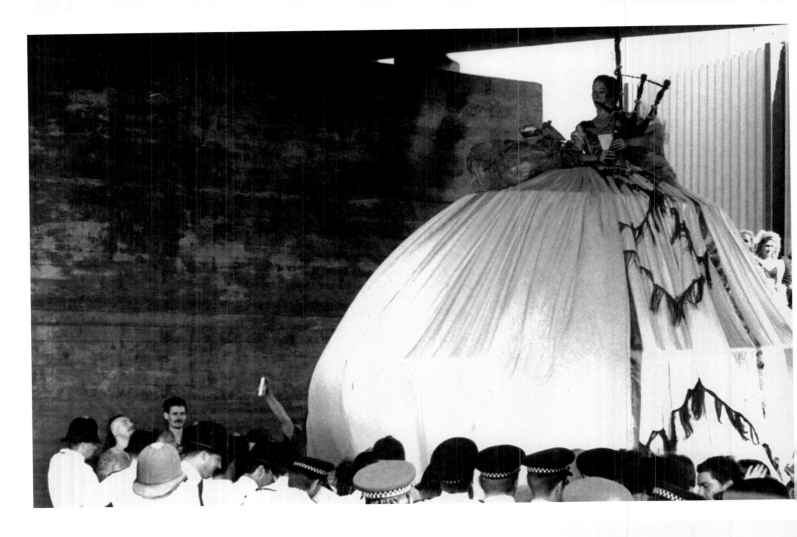

PAGES 190-191

Object Orange, *Auburndale Site #4*
LOCATION Highland Park, Michigan
DATE 2006
ARTIST NOTES In "the D," D doesn't really stand for "Detroit" but "Demolition." You'll notice a great number of buildings marked on the front with a circled D in faint chalk. Our goal is to make everyone look at not only these houses, but all the buildings rooted in decay and corrosion.

ABOVE & LEFT

Reclaim the Streets, *M41*
LOCATION London, England
DATE 1996
PHOTO Julia Guest

Under the hooped skirt, Reclaim the Streets plants trees in the fast lane of the M41 highway. Upwards of 6,000 people attended the party to state their opposition to the car-dominated transport system.

OPPOSITE

Charles Simonds, *Wisteria-planted Tenement Museum Proposal*
LOCATION East Village, New York City
DATE 1976
MEDIUM Ink on photograph

Proposal included wisteria vine and empty rooms with recordings of former tenants.

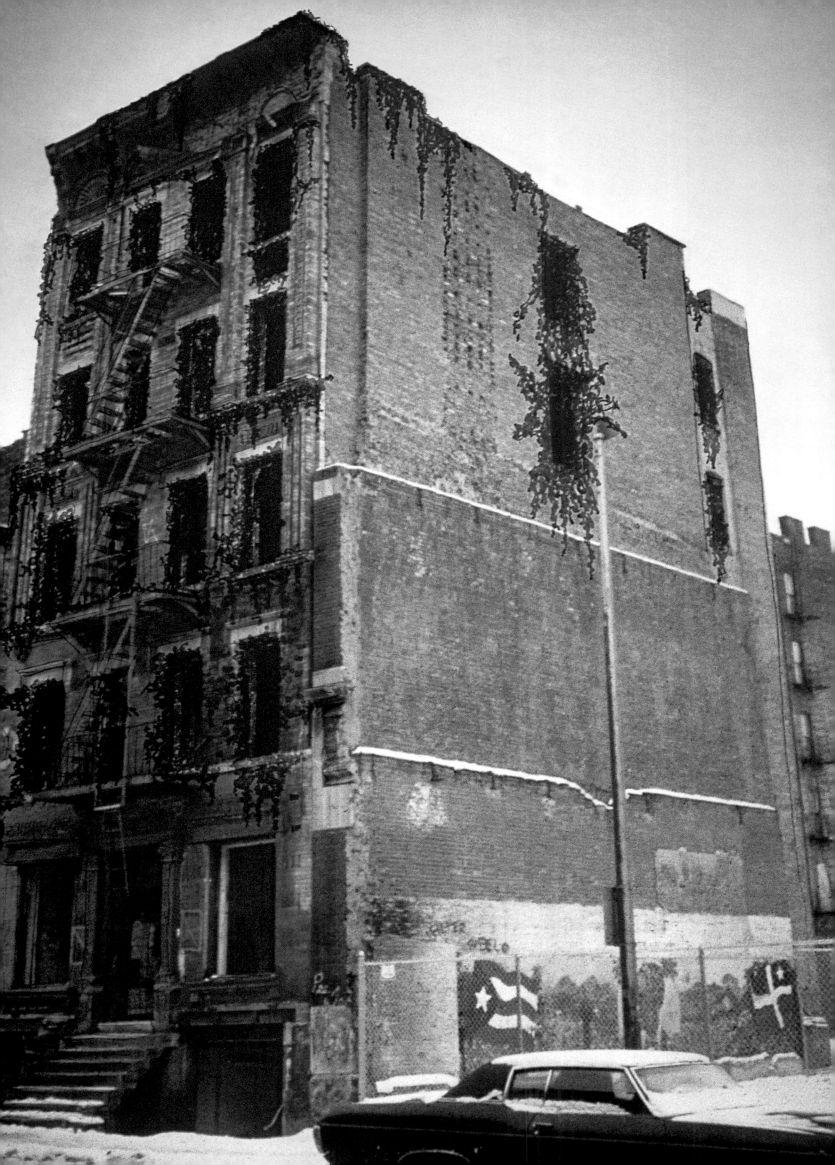

ABOVE, BELOW & OPPOSITE

Ellen Harvey, *New York Beautification Project (Details)*
LOCATION New York City
DATE 1999–2001
PHOTO Jan Baracz

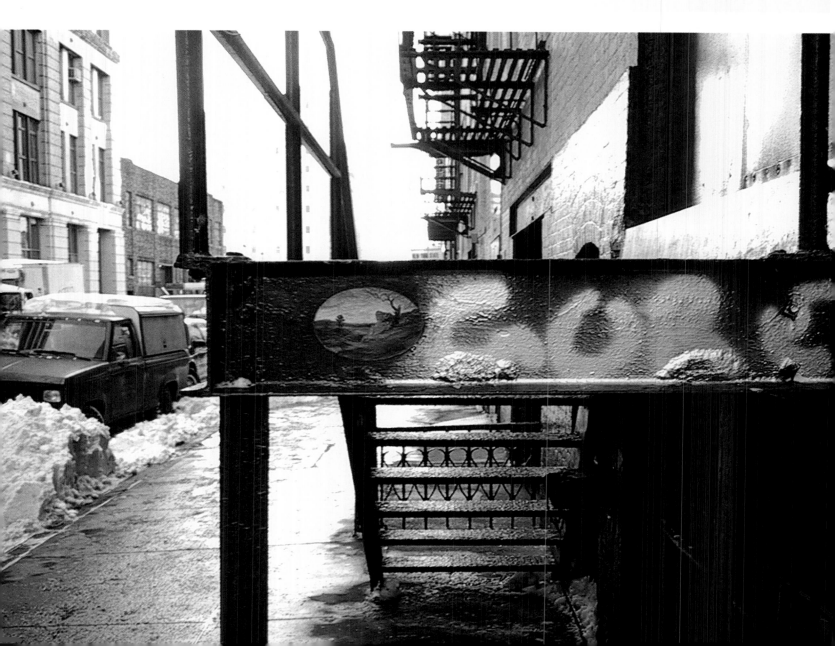

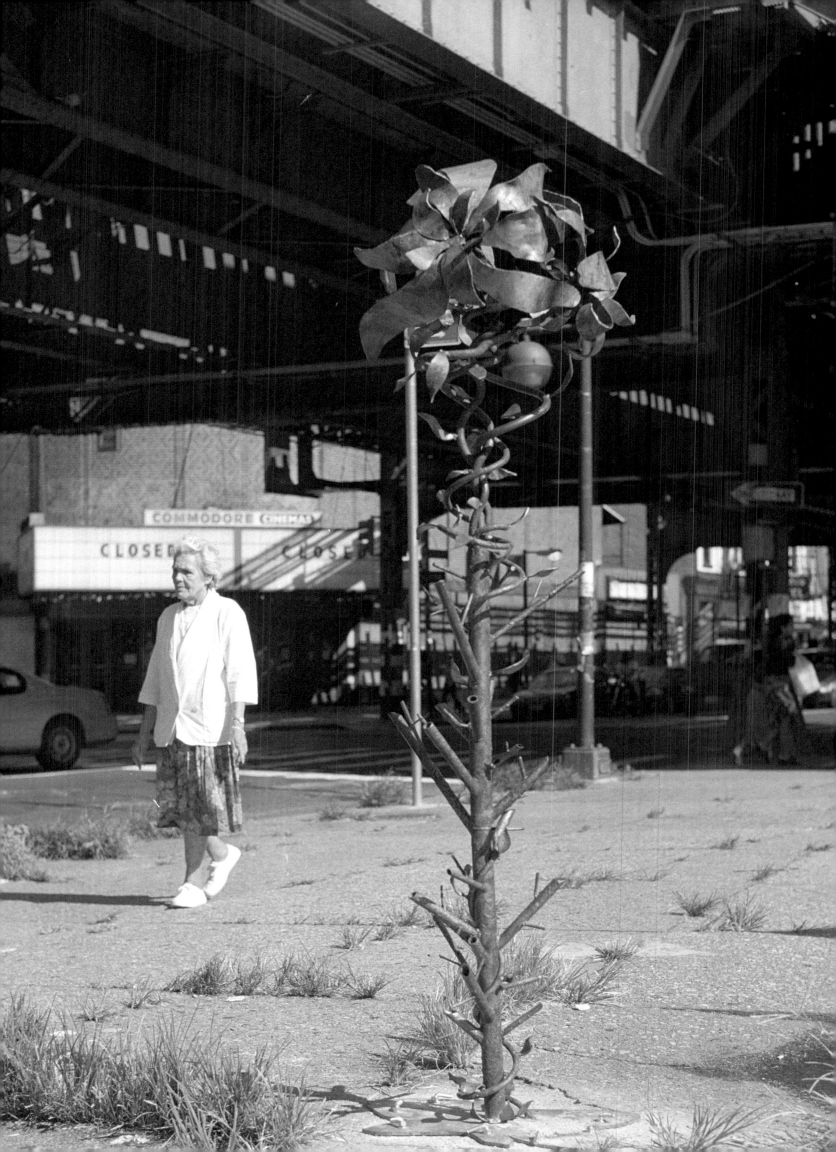

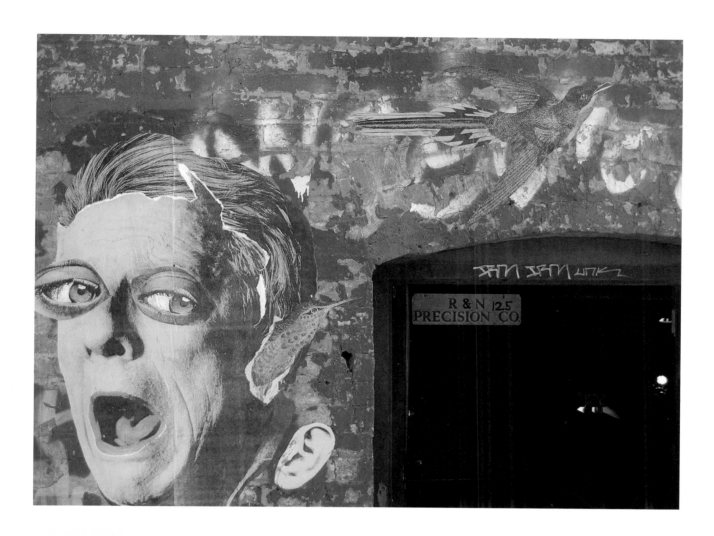

Leon Reid IV, *Fleur D'Acier #1*
LOCATION Brooklyn, New York
DATE 2002
MEDIUM Steel, enamel

Judith Supine
LOCATION New York City
DATE 2008

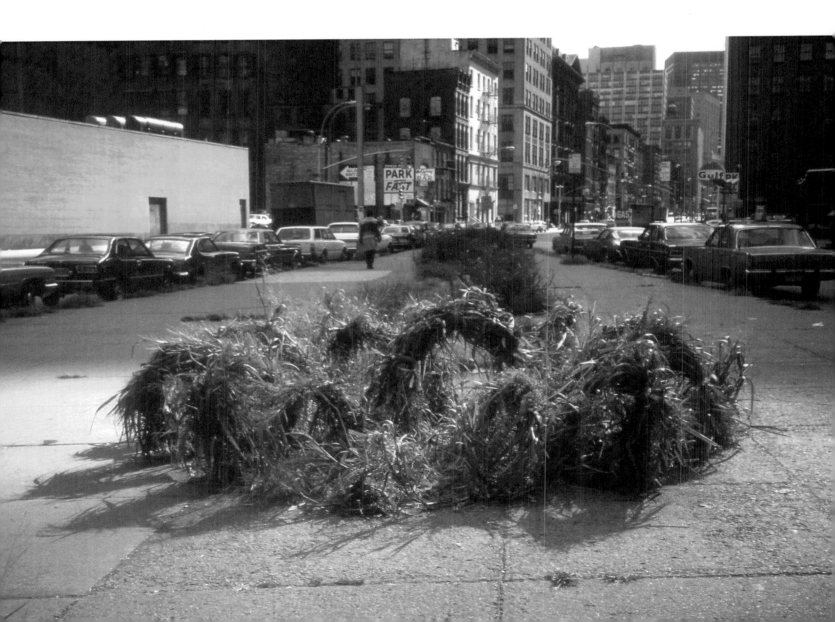

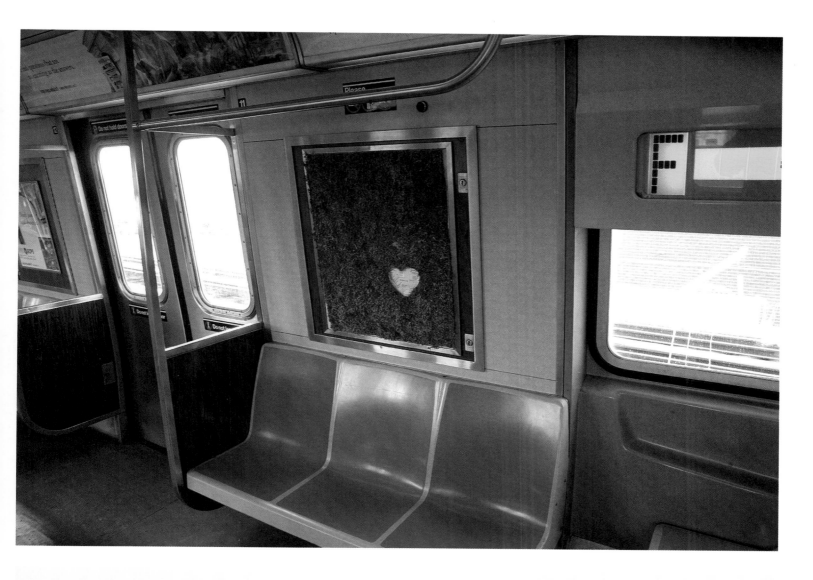

Becky Howland, *Grass Arches*
LOCATION New York City
DATE 1977
MEDIUM Grass tied with cloth strips
ARTIST NOTES *Grass Arches* is part
of a series of playful, temporary
interventions that I did on the
traffic islands in Lower Manhattan
—guerrilla public sculpture. That
same spirit of transgression led
me to become one of the princi-
pal organizers of the *Real Estate
Show*, which in turn led to the
formation of ABC No Rio.

Edina Tokodi / Mosstika,
Metro moss
LOCATION Brooklyn, New York
DATE 2008
MEDIUM Moss
PHOTO József Vályi-Tóth

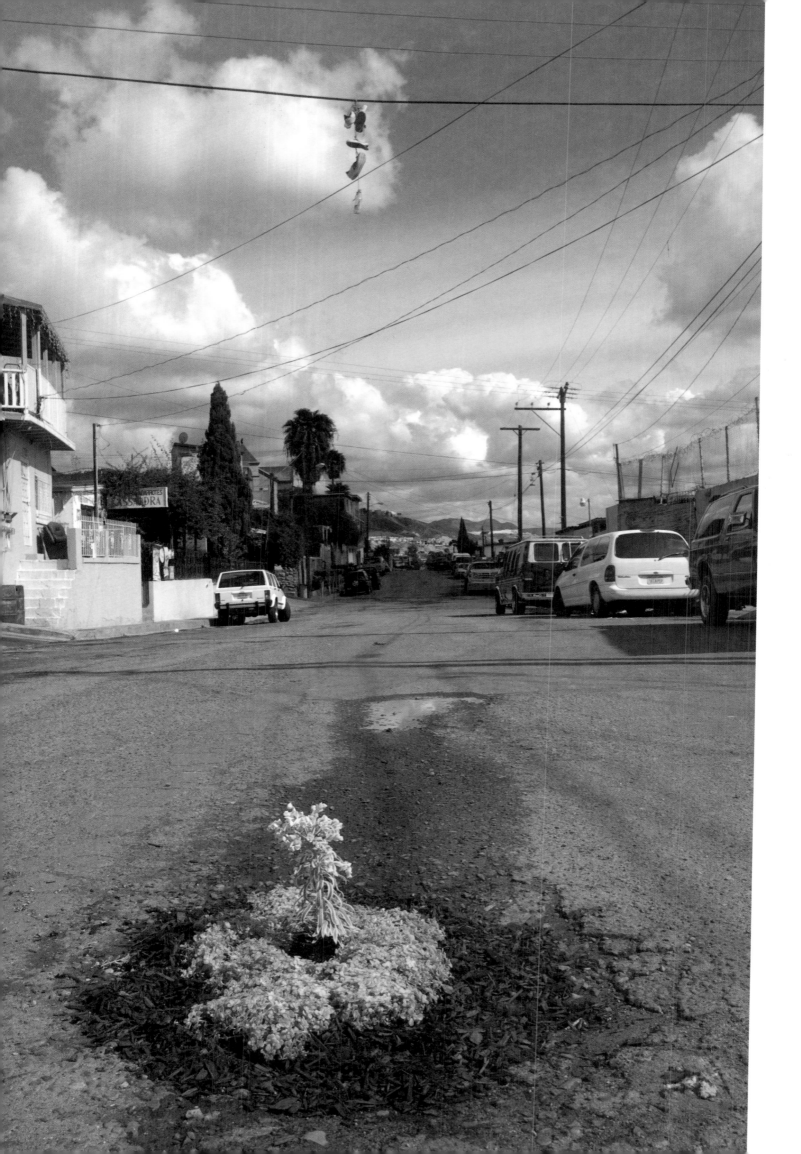

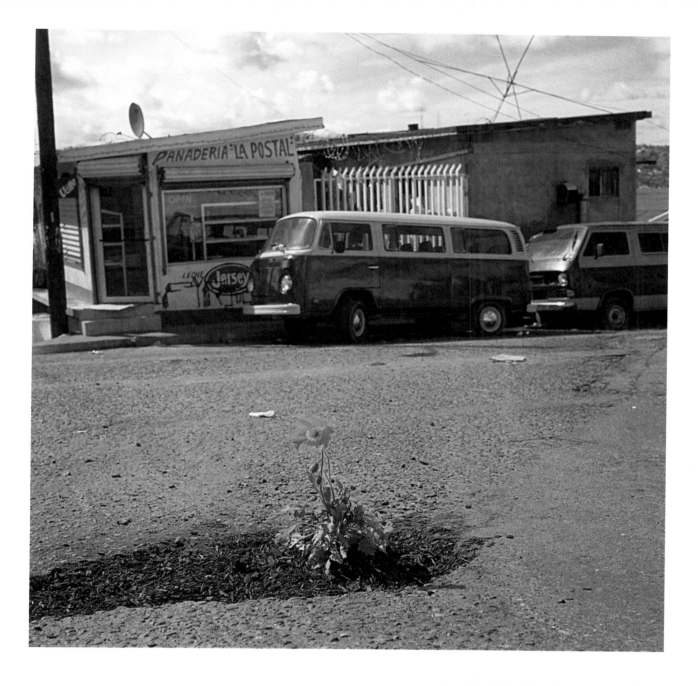

Shannon Spanhake, *A Tijuana Garden*

LOCATION Tijuana, Mexico
DATE 2005
MEDIUM Potholes, plants
PHOTO Jennifer Medlin, Deanna Erdmann, Camilo Ontiveros
ARTIST NOTES Adorning the streets in Tijuana are potholes, open wounds that mark the failure of man's Promethean Project to tame nature, and somehow surviving in the margins are abandoned buildings, entropic monuments celebrating a hyperrealistic vision of a modernist utopia linked to capitalist expansion gone awry.

ABOVE

ABOVE

Masquerade
LOCATION Stockholm, Sweden
DATE 2007

OPPOSITE

Magda Sayeg
LOCATION Mexico City, Mexico
DATE 2008
PHOTO Dan Sayeg

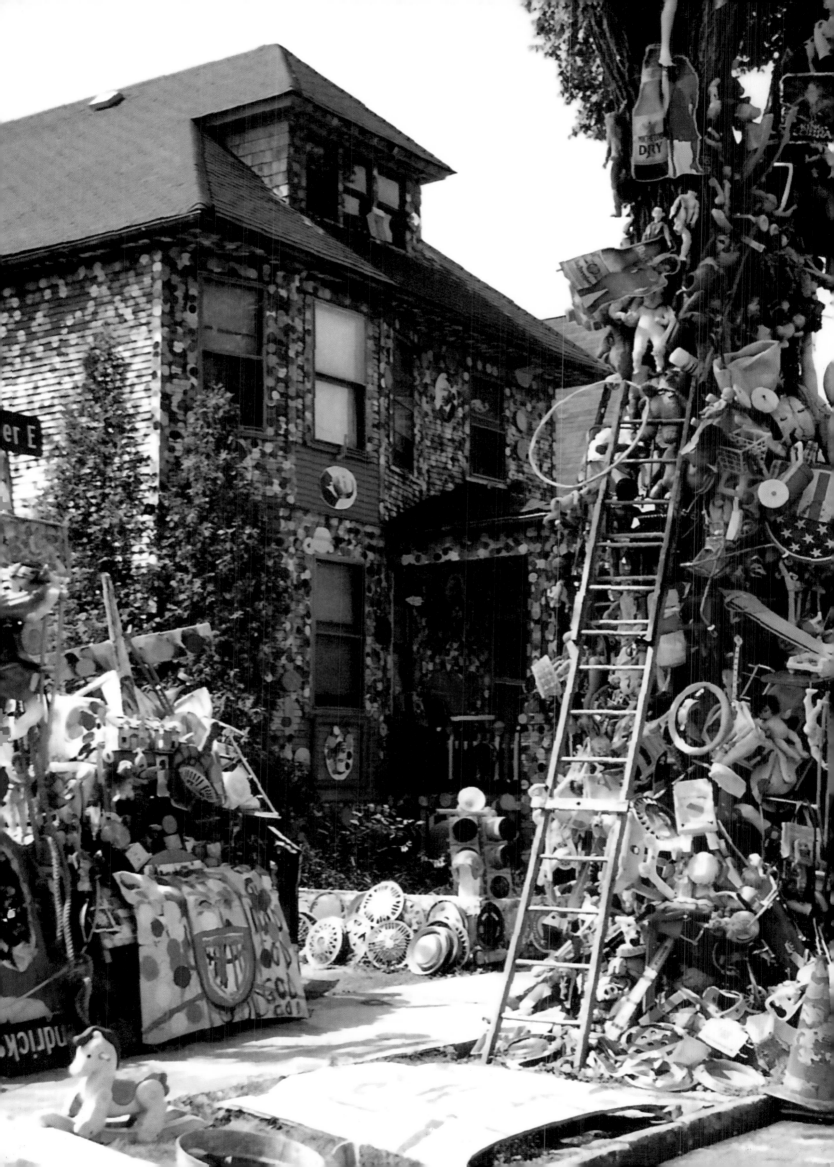

OPPOSITE

Tyree Guyton, *Heidelberg Project, Dotty Wotty*

LOCATION Detroit, Michigan
DATE C. 1992

Raised on Heidelberg Street and witness to the riots in the '60s that destroyed inner-city Detroit, Tyree Guyton redesigned a new world out of the detritus of abandonment found there in 1986. Part outsider art, part urban social intervention, the much-beloved Heidelberg Project *was inexplicably razed by the city in 1991 and again in 1999. Though it never returned to its former glory, Guyton's artistic reclamation remains today as a work in progress.*

BELOW & PAGE 206

Christy Rupp, *The Rat Patrol*

LOCATION New York City
DATE 1979

ARTIST NOTES I started pasting these up during the three-week garbage strike in May of 1979. Rats were very visible in those days where I lived in the Wall Street area, and I wanted to point out how we had created a habitat for them.

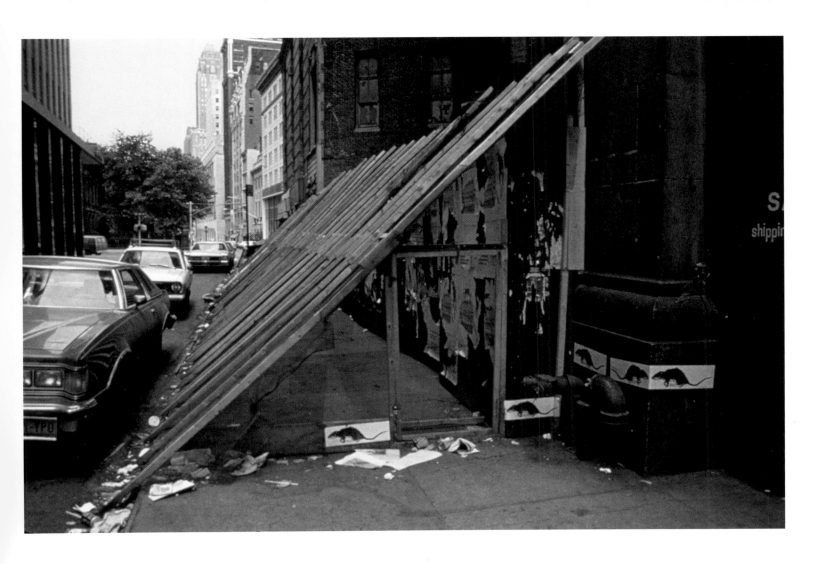

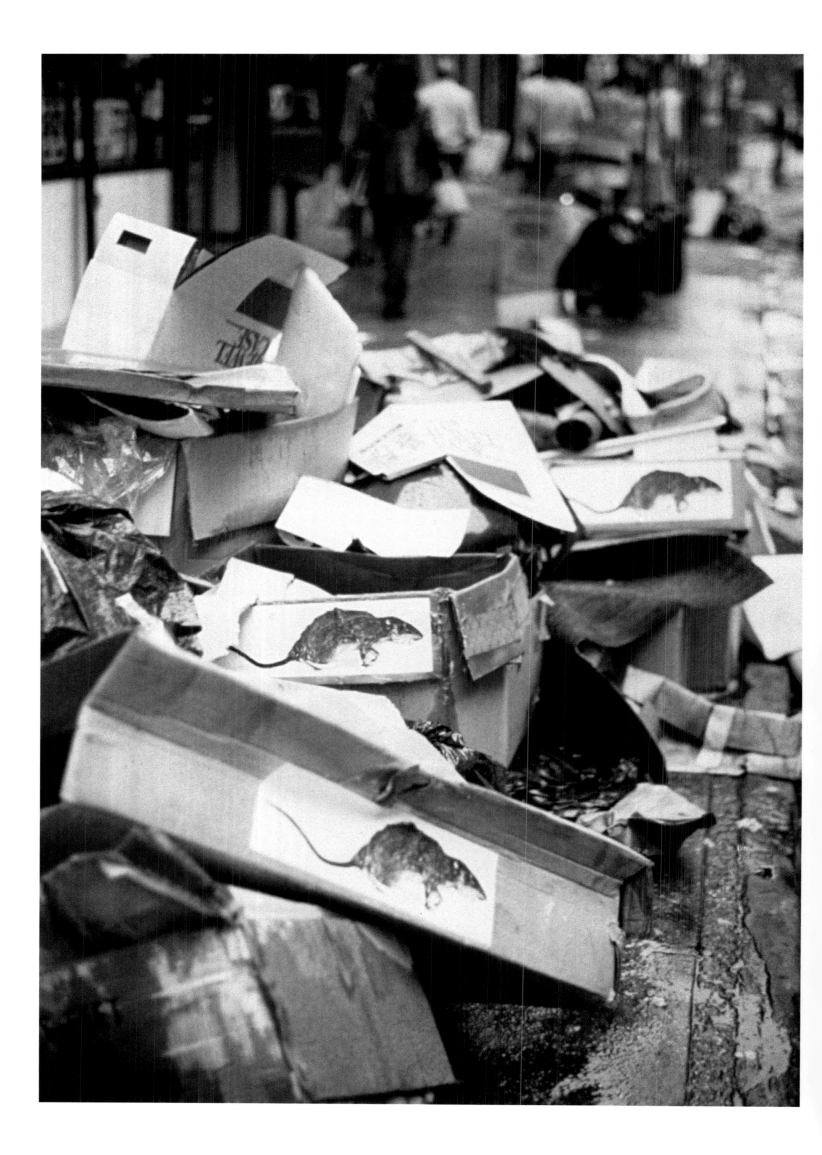

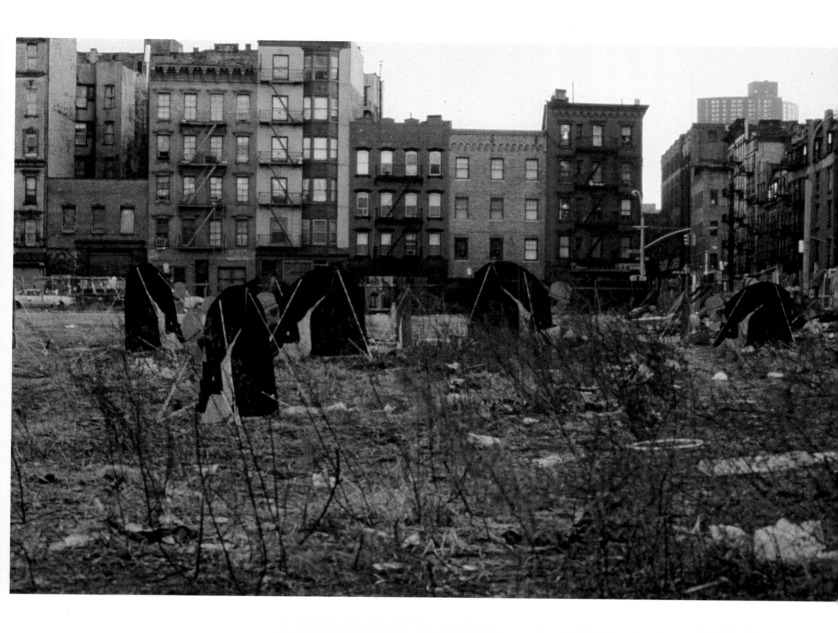

ABOVE

David Wells, *Gleaners in the Elizabeth Street Meadow*
LOCATION New York City
DATE 1980
MEDIUM Pencil and acrylic wash over shellac primer, corrugated cardboard, marine varnish, spikes, twine

PAGES 208–209

Alexandre Orion, *Art Less Pollution*
LOCATION Max Feffer Tunnel, São Paulo, Brazil
DATE 2007
MEDIUM Scraped-off soot
PHOTO Daniel Kfouri

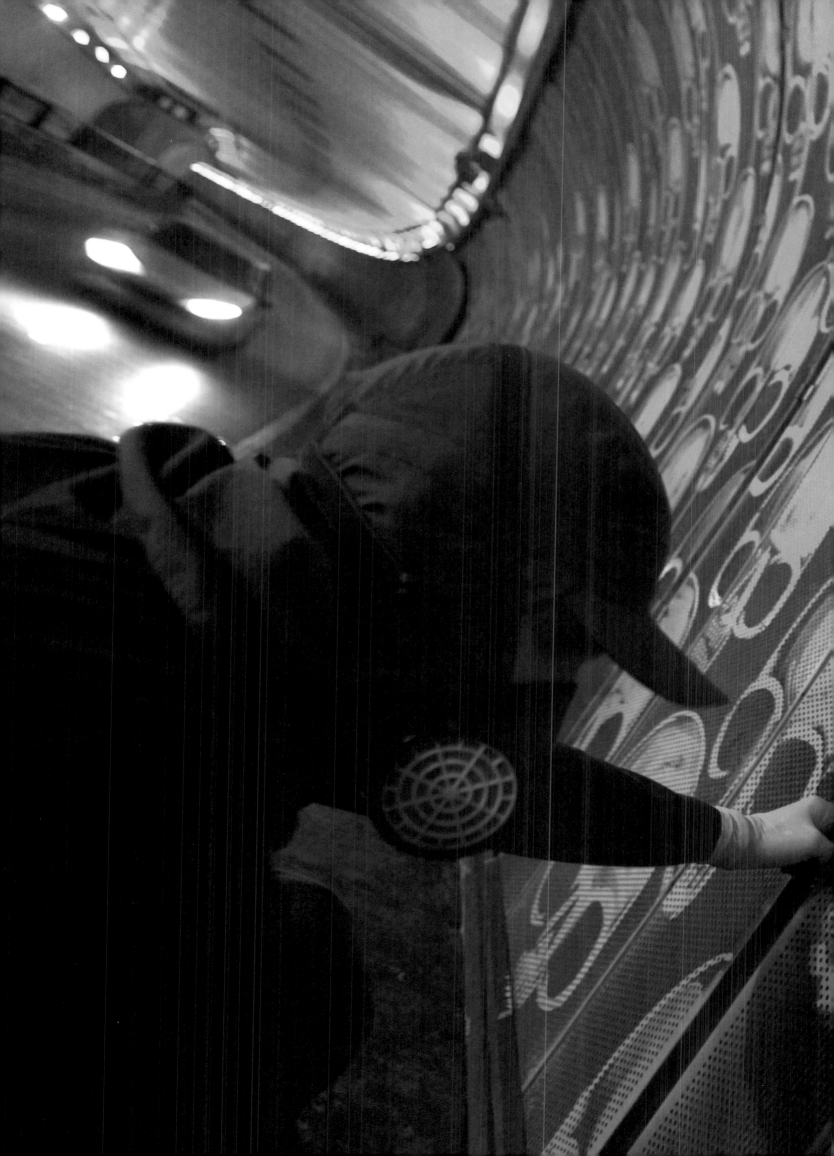

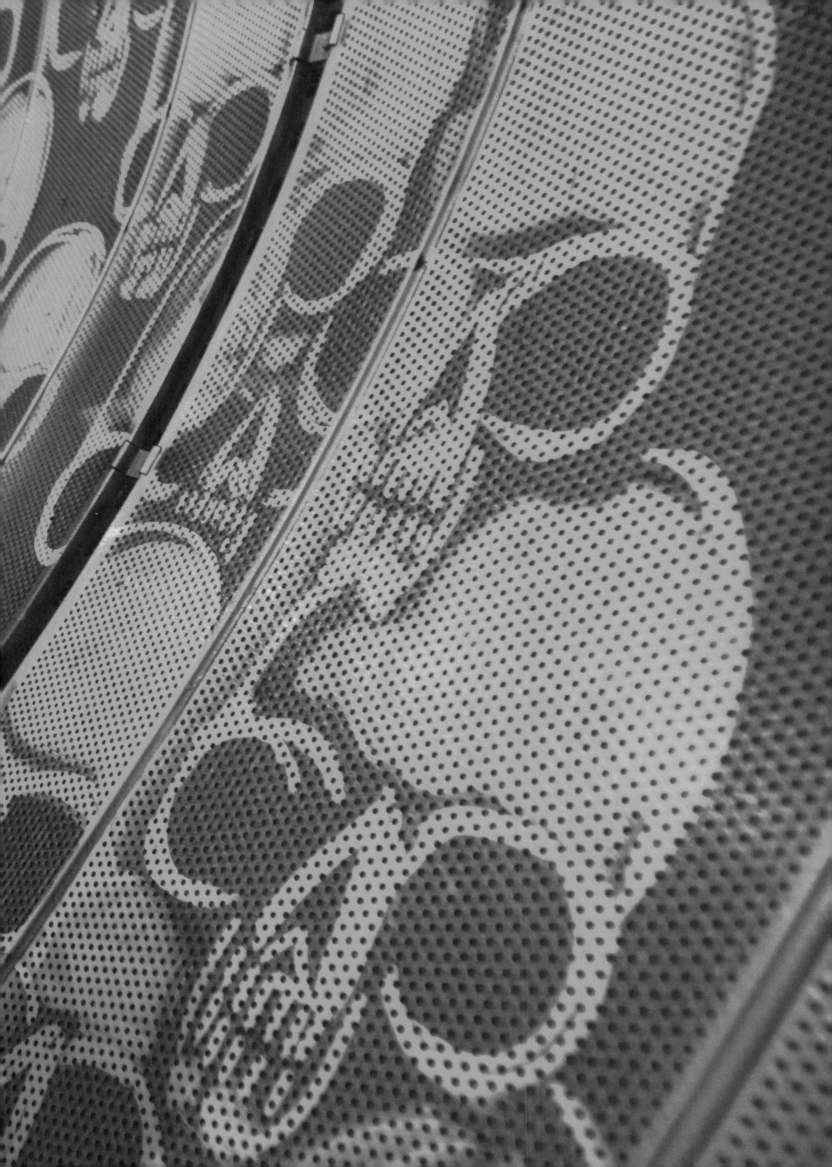

Richard Reynolds, Guerrilla
gardening sunflowers bloom
opposite the Houses of
Parliament
LOCATION London, England
DATE 2008

Richard Reynolds, Before
guerrilla gardening, Westminster
Bridge Road
LOCATION London, England
DATE 2006

Richard Reynolds, Guerrilla
gardening lavender flourishes
in the middle of Westminster
Bridge Road
LOCATION London, England
DATE 2006

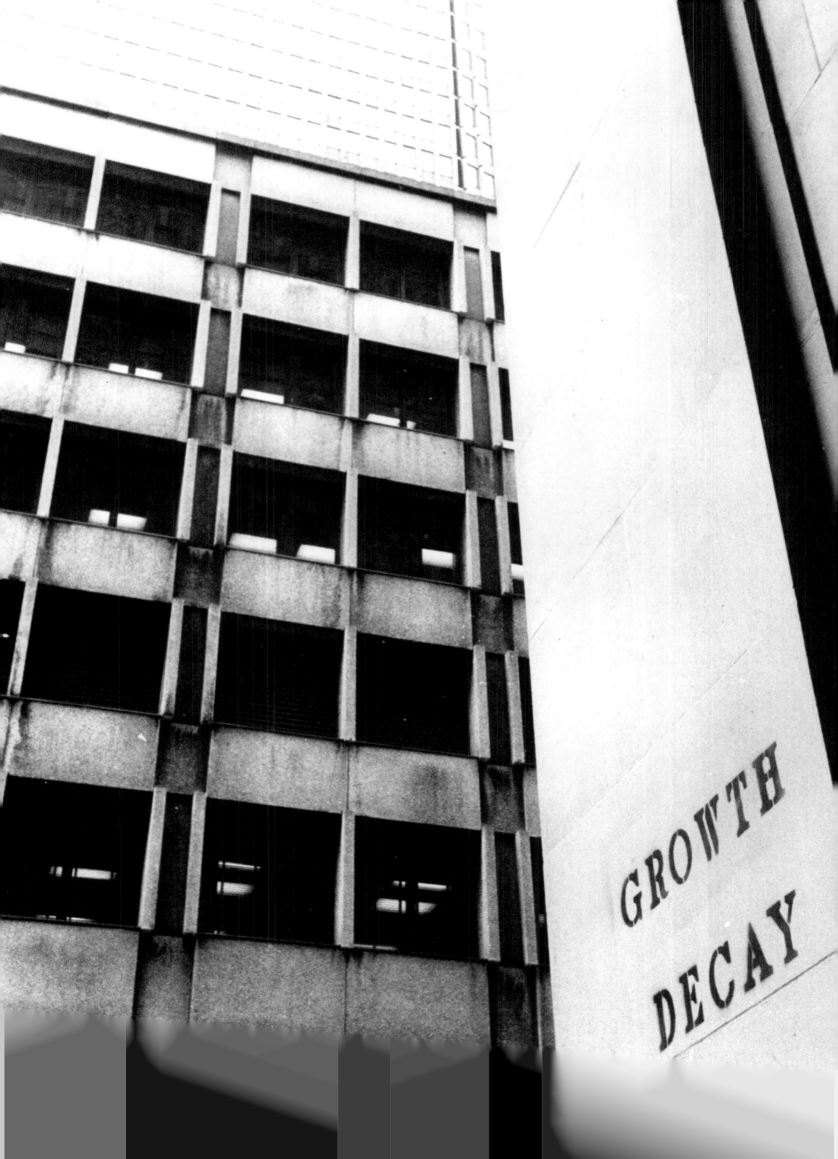

OPPOSITE

John Fekner, *Growth Decay*
LOCATION New York City
DATE 1978

ABOVE

Dan Witz, *Birds 2000 Series*
LOCATION New York City
DATE 2000

ABOVE

Anna Garforth, *Mossenger*
LOCATION London, England
DATE 2008
MEDIUM Moss
ARTIST NOTES Mossenger colonizes city walls with lyrical thoughts and positive messages. "Sporeborne" is quoted from a poem by Eleanor Stevens.

OPPOSITE

Michael De Feo *Flower*
LOCATION Providence, Rhode Island
DATE 2007

PAGES 216–217

Nele Azevedo, *Minimum Monument Project*
LOCATION National Congress, Brasília, Brazil
DATE 2003
MEDIUM Ice

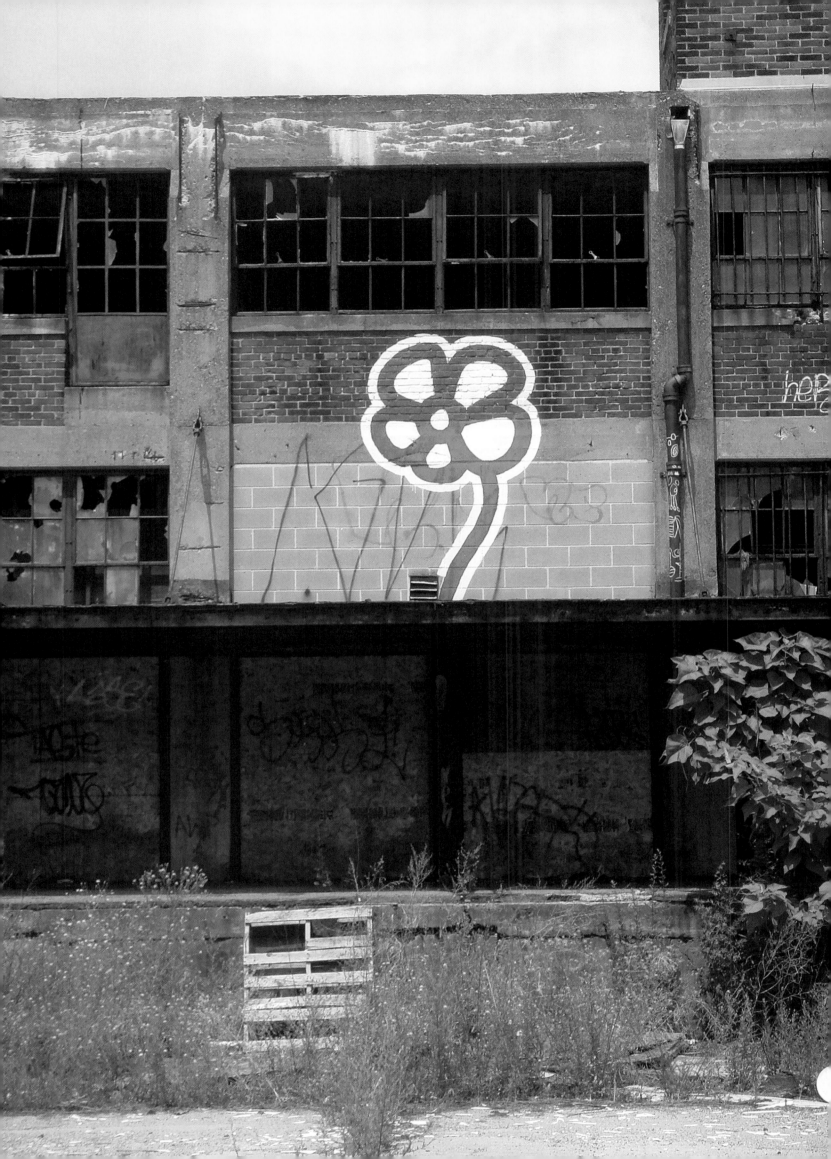

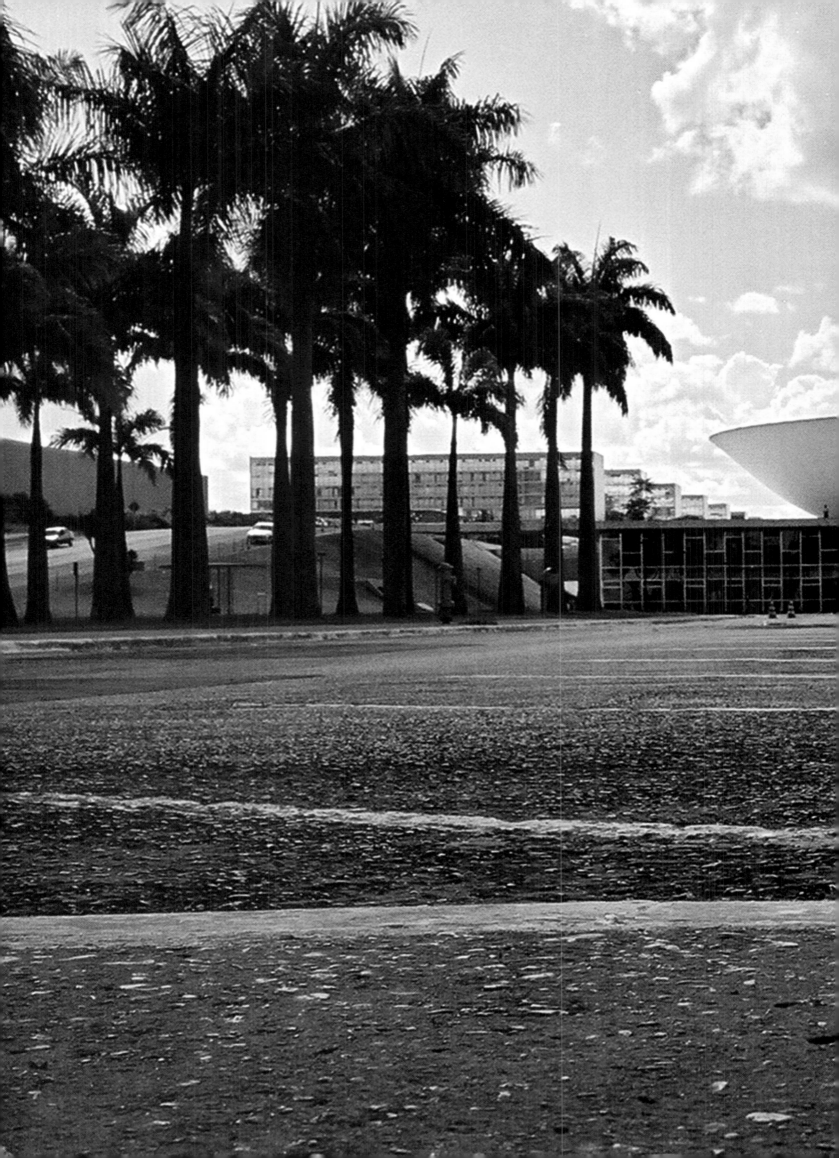

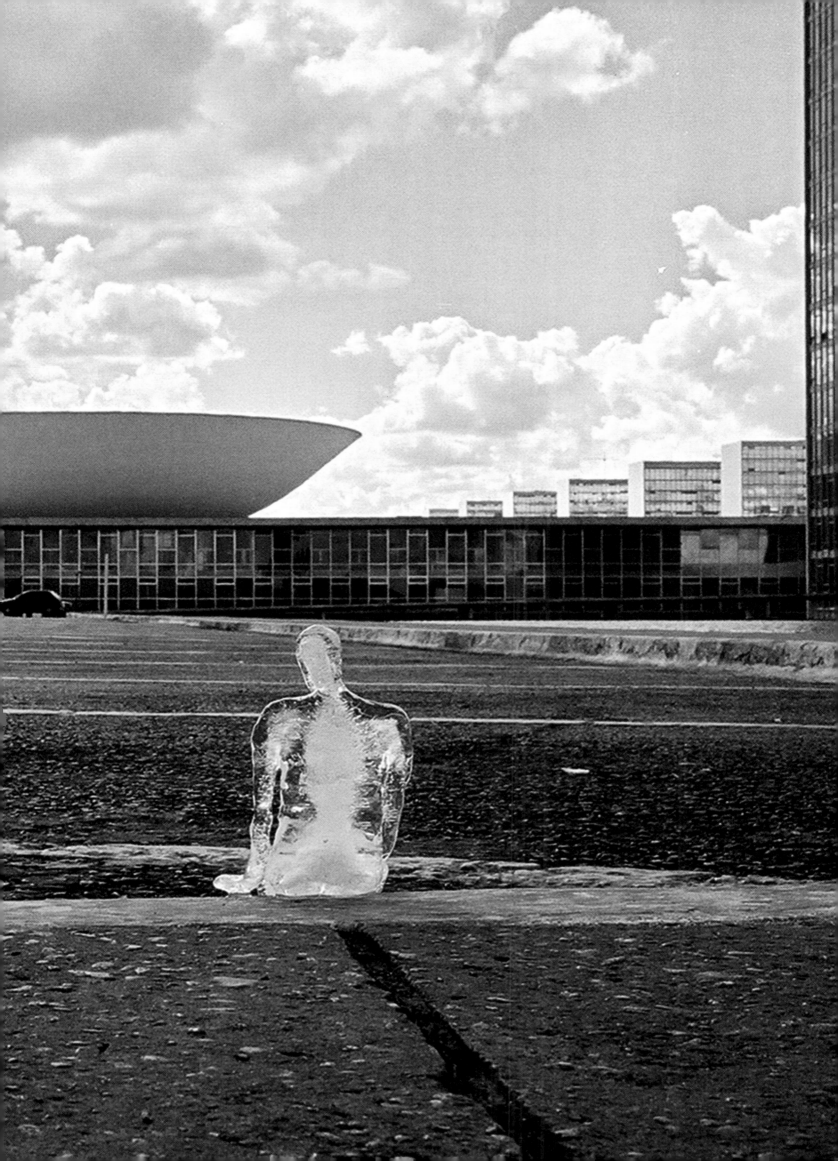

MAGICAL THINKING

"When myriad artists attack the homogeneity of the streets to conjure their own alternate realities, we do not discredit their accomplishments with the failure of their dreams but rather value them for the beauty of their vision."

Disregarded as superstitious pathology in the fields of anthropology, psychology, and cognitive science, part of the power we invest in art is in fact the magical thinking by which we make the nonscientific leap of believing in the causal effect of thoughts or totemic objects upon the world. Consider the cargo cults that emerged in the wake of World War II after America abandoned its military bases in the Pacific; Native islanders built their own airstrips and traffic-control towers, and would even post the tribal chief with a coconut-fashioned headset to conjure the great metal birds that once brought them cargo. While generally regarded as laughable, in the context of creativity the cargo cults are inspiring. When, in 1969, John Lennon and Yoko Ono put up billboards in 11 cities declaring, "WAR IS OVER! (If You Want It) / Happy Christmas from John & Yoko"; when art students fabricated their own Statue of Liberty to invoke democracy in China (1989); or when myriad artists attack the homogeneity of the streets to conjure their own alternate realities, we do not discredit their accomplishments with the failure of their dreams but rather value them for the beauty of their vision. If we are to believe in the power of ideas, as we must, we must understand that it is not in the thoughts we keep to ourselves but only in sharing them that ideas attain their potential. This is the primary reason that public space offers such a fertile tableau for unsolicited artistic expression.

OPPOSITE

Events of May–June 1968
LOCATION Paris, France
DATE 1968

Under the paving stones, the beach
—International Situationist slogan

PAGE 218

The London Police
LOCATION Amsterdam, Netherlands
DATE 2002
MEDIUM Marker pen
PHOTO Chaz
ARTIST NOTES There was nothing like the papered electricity boxes in Amsterdam in the late '90s / early noughties to provide a smooth and abundant surface for my hand-drawn characters "The Lads."

RIGHT

John Lennon & Yoko Ono,
Christmas Peace Message
LOCATION New York City
DATE 1969

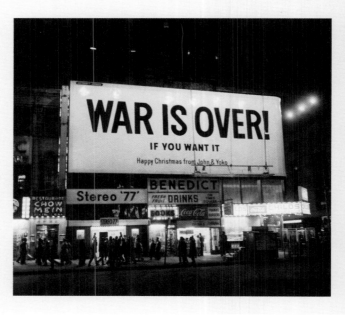

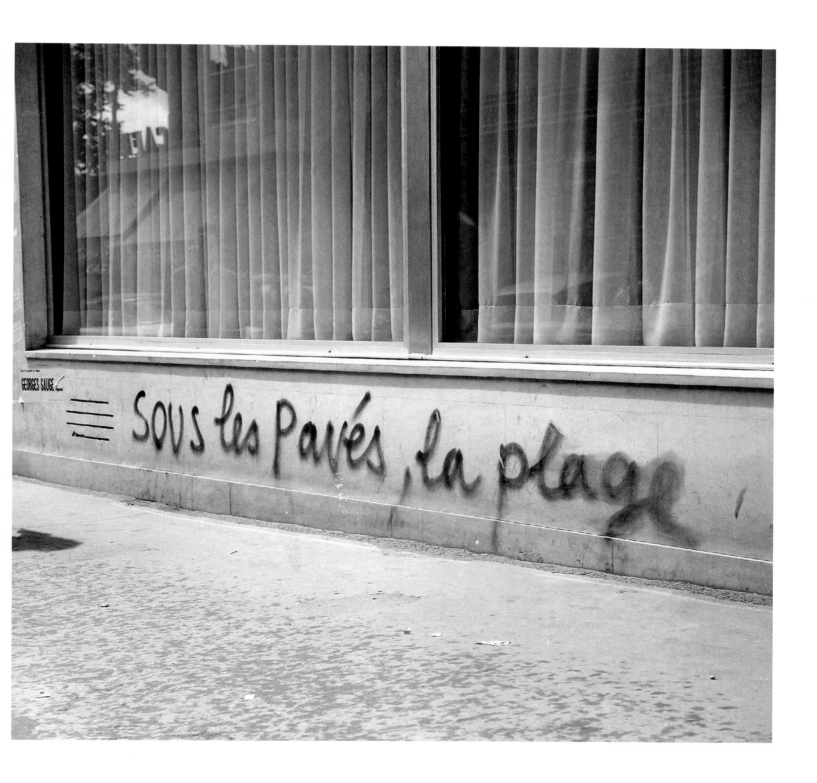

PAGES 222-223

Charles Simonds, *Dwelling*
LOCATION 98 Greene Street, NYC
DATE 1971
MEDIUM Clay, wood

BELOW

Charles Simonds, *Dwelling*
LOCATION Houston Street, NYC
DATE 1972
MEDIUM Clay, wood

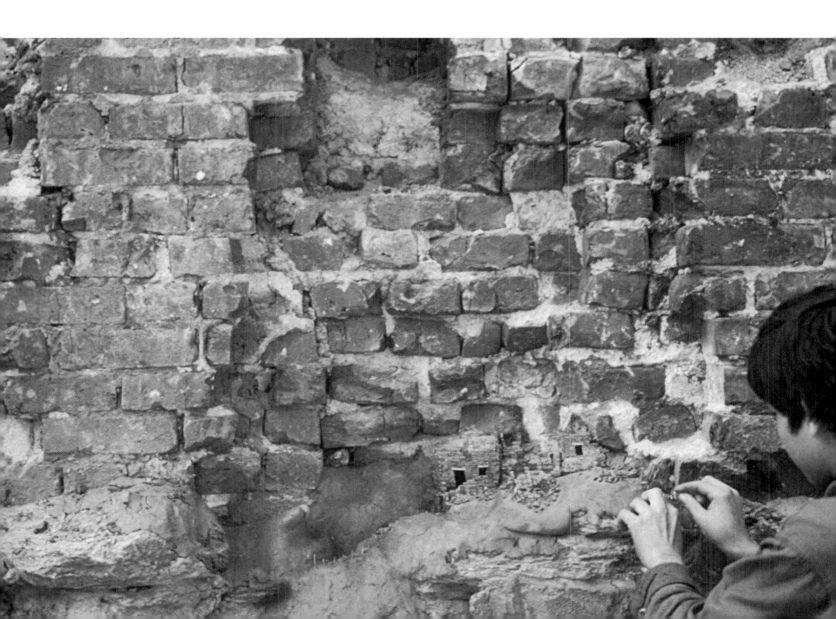

Slinkachu, *After the Storm*
LOCATION Tower Hill, London,
 England
DATE 2007

BELOW

Hans Winkler, *Un incidente in gondola (The Accident of a Gondola in Venice)*
LOCATION Venice, Italy
DATE 2002

ABOVE

Gabriel Specter, *Spacial Project*
LOCATION Toronto, Ontario, Canada
DATE 2007
MEDIUM Wood, twine, rope,
 insulation foam, latex paint

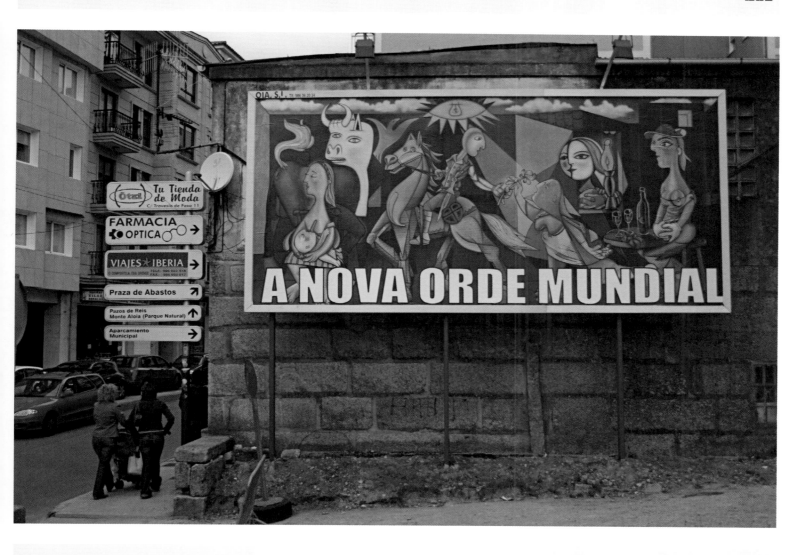

Miss Van
LOCATION Barcelona, Spain
DATE 2005

Ron English, *A Nova Orde Mundial*
LOCATION Tui, Spain
DATE 2006

The New World Order references Ron English's original painting 5 Minutes Before the Bombing, which imagines Picasso's creatures blithely unaware of the impending calamity.

BELOW

Matthias Wermke & Mischa Leinkauf, *Zwischenzeit / In Between*

LOCATION Berlin, Germany
DATE 2008
MEDIUM Video
PHOTO Mischa Leinkauf
ARTIST NOTES When a thought turns into reality, when conceived images start to exist, this is when fiction becomes reality. A handcar on the tracks of the metropolis.

OPPOSITE

Billboard Liberation Front, *LSD*

LOCATION Hillsdale Mall, San Mateo, California
DATE 1994

PAGES 234–235

Improv Everywhere, *The Human Mirror*
LOCATION New York City subway
DATE 2008
PHOTO Chad Nicholson

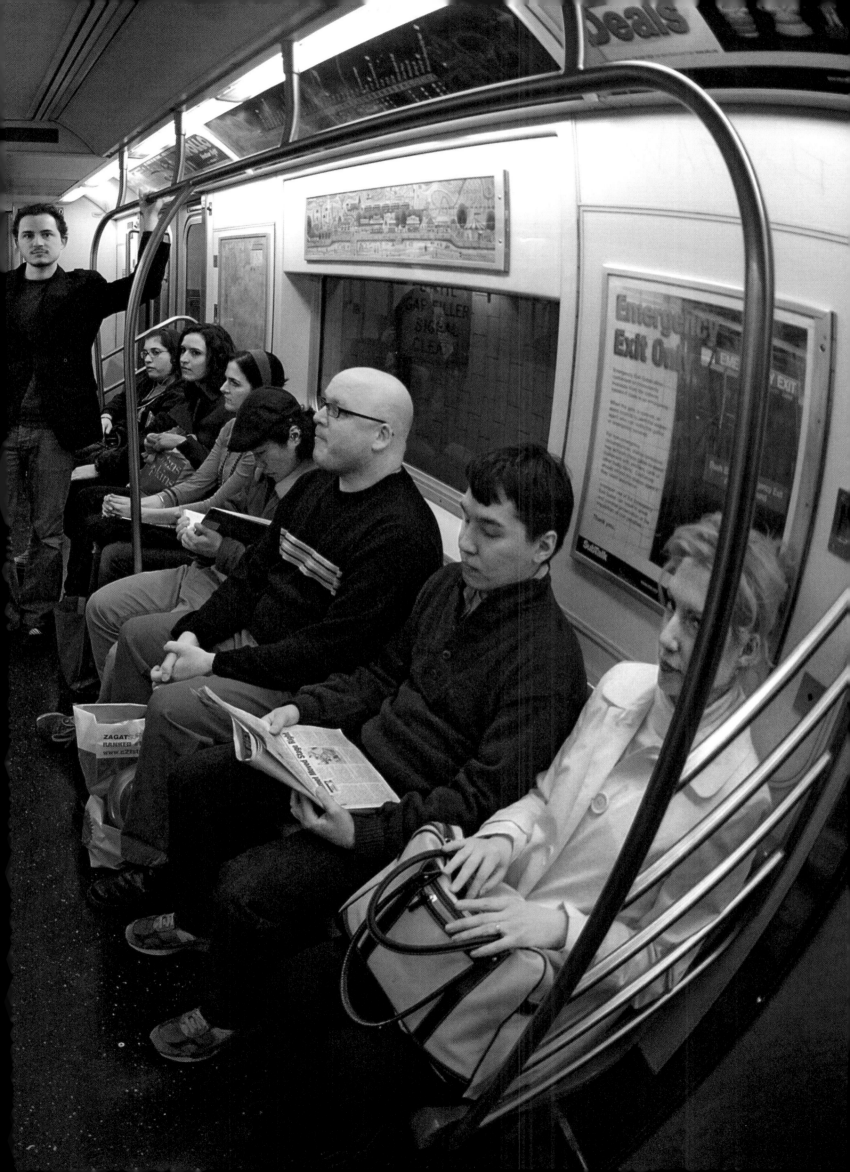

ABOVE

Paul Notzold, *TXTual Healing*
LOCATION Brooklyn, New York
DATE 2007
MEDIUM Computer, projector,
 mobile phone, text messaging,
 custom code
ARTIST NOTES Audience members
send text messages from their
phones, and the texts automati-
cally go into the bubbles.

OPPOSITE

Brennan McGaffey, *L.A.A.C.M.—*
Temporary Starscape Placement
LOCATION Chicago, Illinois
DATE 2001
ARTIST NOTES For L.A.A.C.M. (Low
Altitude Atmospheric & Civic
Modifications) rockets were

launched in the city with payloads
designed to create micro-alterations
of a city's near atmospheric envi-
ronment. Photo shows the Starscape
Placement rocket launch that dis-
persed luminescent stars into the
Chicago night sky.

ABOVE

Mariusz Waras / M-City

LOCATION Gdansk, Poland

DATE 2006

BELOW

Blek le Rat, *The Man Who Walks Through The Walls in London*
LOCATION Shoreditch, London, England
DATE 2008
PHOTO Sybille Prou

The Man Who Walks Through The Walls (TMWWTTW) series embodies the globetrotter who travels the world as if he was going through the walls. It is an ironic self-portrait of Blek going from city to city with his stencils.

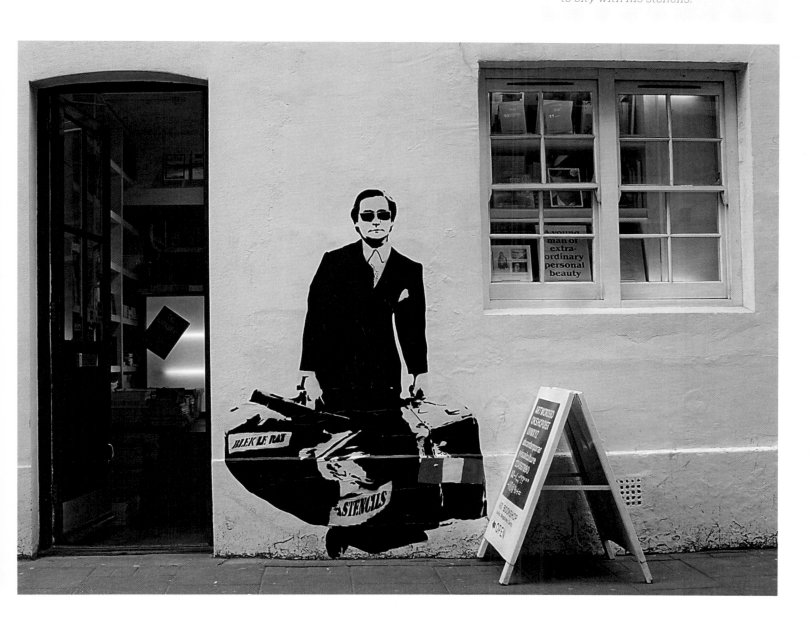

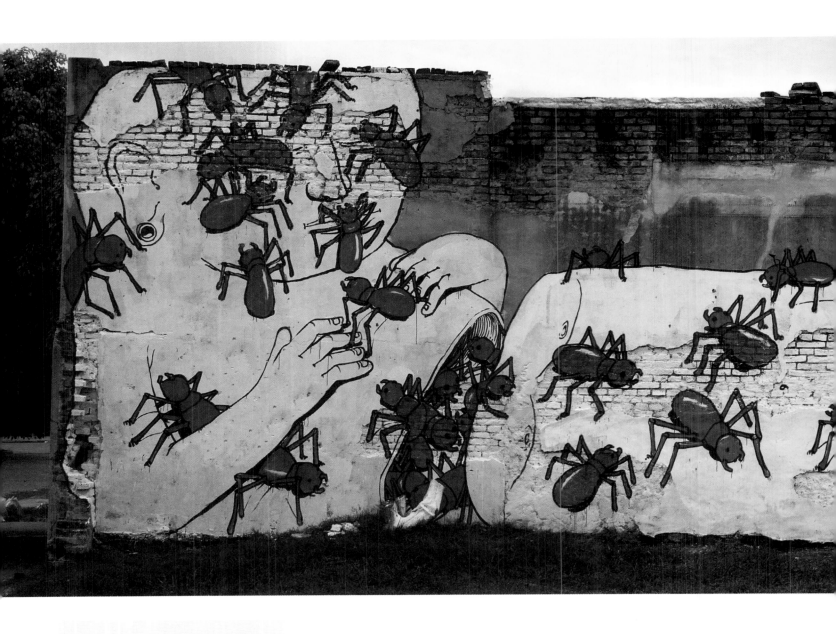

Blu
LOCATION Buenos Aires, Argentina
DATE 2006

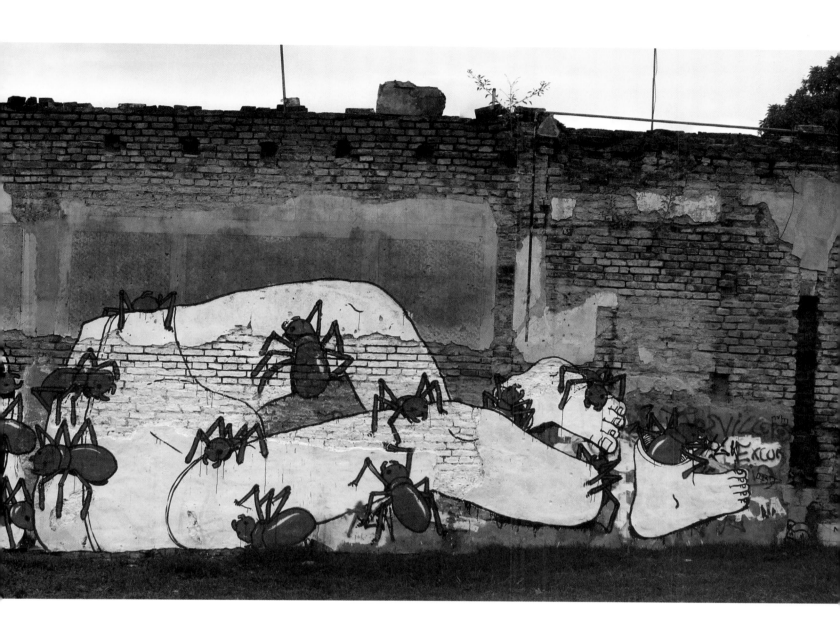

Anonymous, *Crateman in Richmond*
LOCATION Melbourne, Australia
DATE 2006
MEDIUM Milk crates
PHOTO Cornelius Brown

The first in a series of works involving a figure made of milk crates. Built facing an elevated train line in the inner city of Melbourne.

BELOW

You Are Beautiful, *You Are Beautiful*
LOCATION Chicago, Illinois
DATE 2006
MEDIUM Plywood

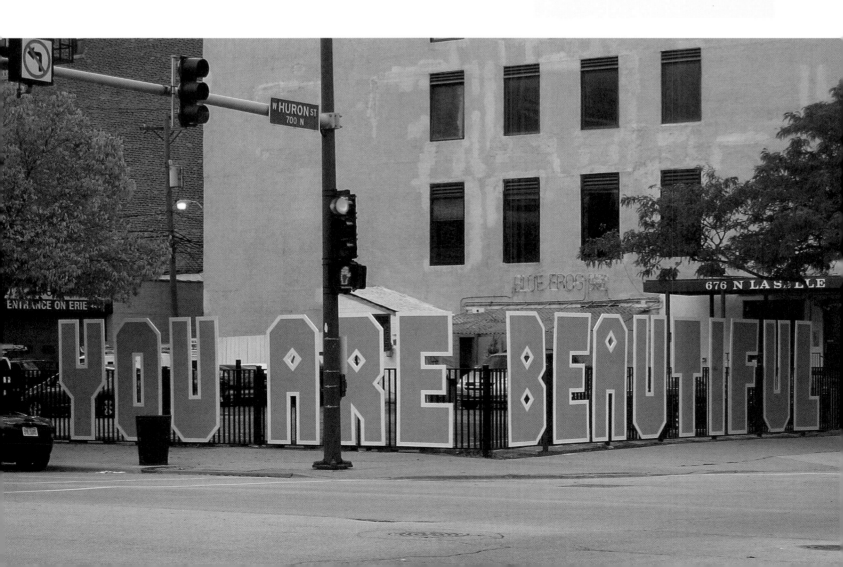

ABOVE

Alëxone, *Pokemon*
LOCATION Brussels, Belgium
DATE 2006

OPPOSITE

Fafi, *Dia de la Muerte*
LOCATION Mexico City, Mexico
DATE 2008

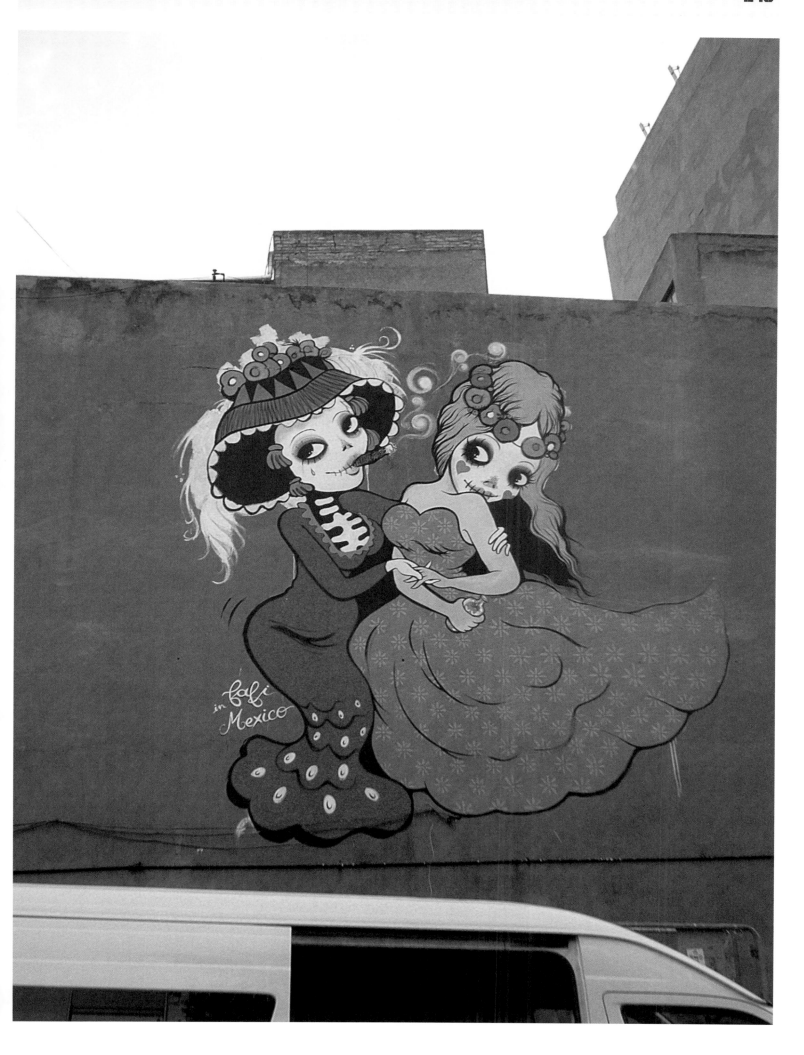

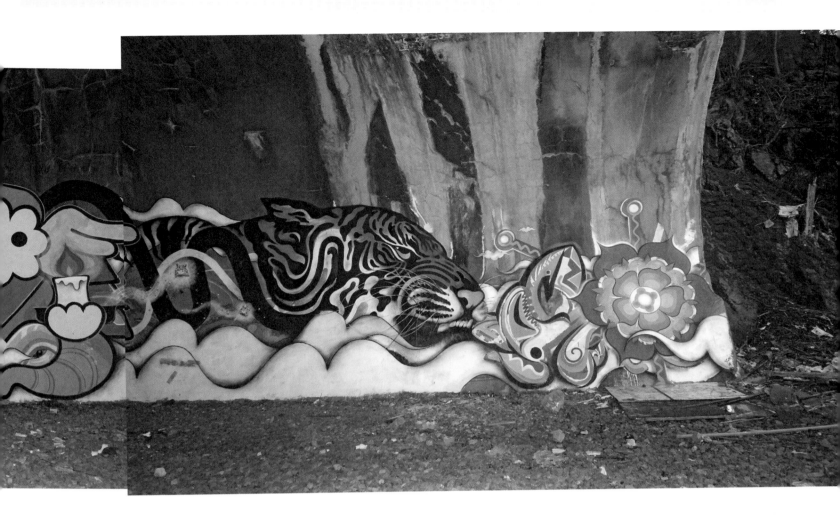

ABOVE

Hitotzuki (Kami & Sasu), *Natural Reaction*

LOCATION Wuppertal, Germany
DATE 2006
MEDIUM Brush, latex paint, spray paint
PHOTO Martha Cooper

BELOW

Sprinkle Brigade,
Strangers on a Train
LOCATION Lower East Side, NYC
DATE 2006

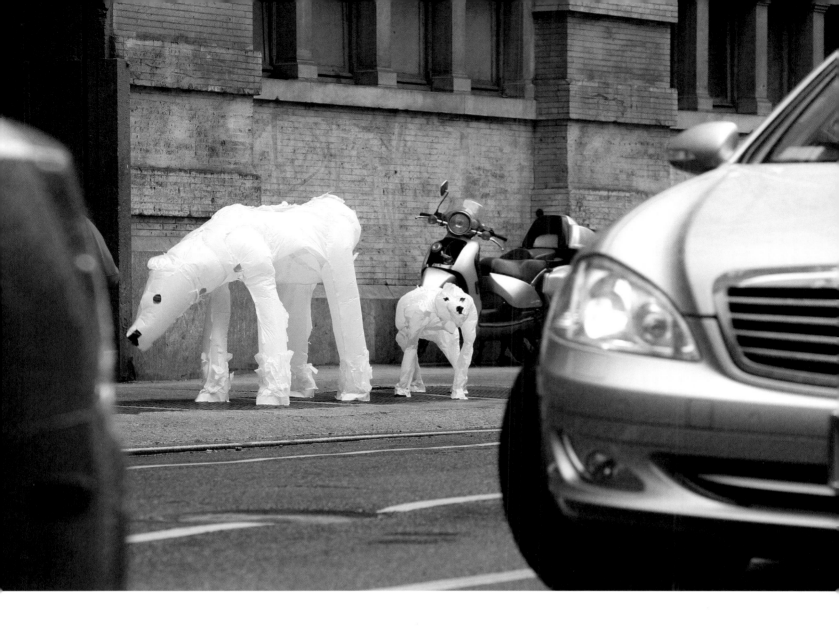

Joshua Allen Harris,
Airbear and Cub
LOCATION New York City
DATE 2008
MEDIUM Trash bags

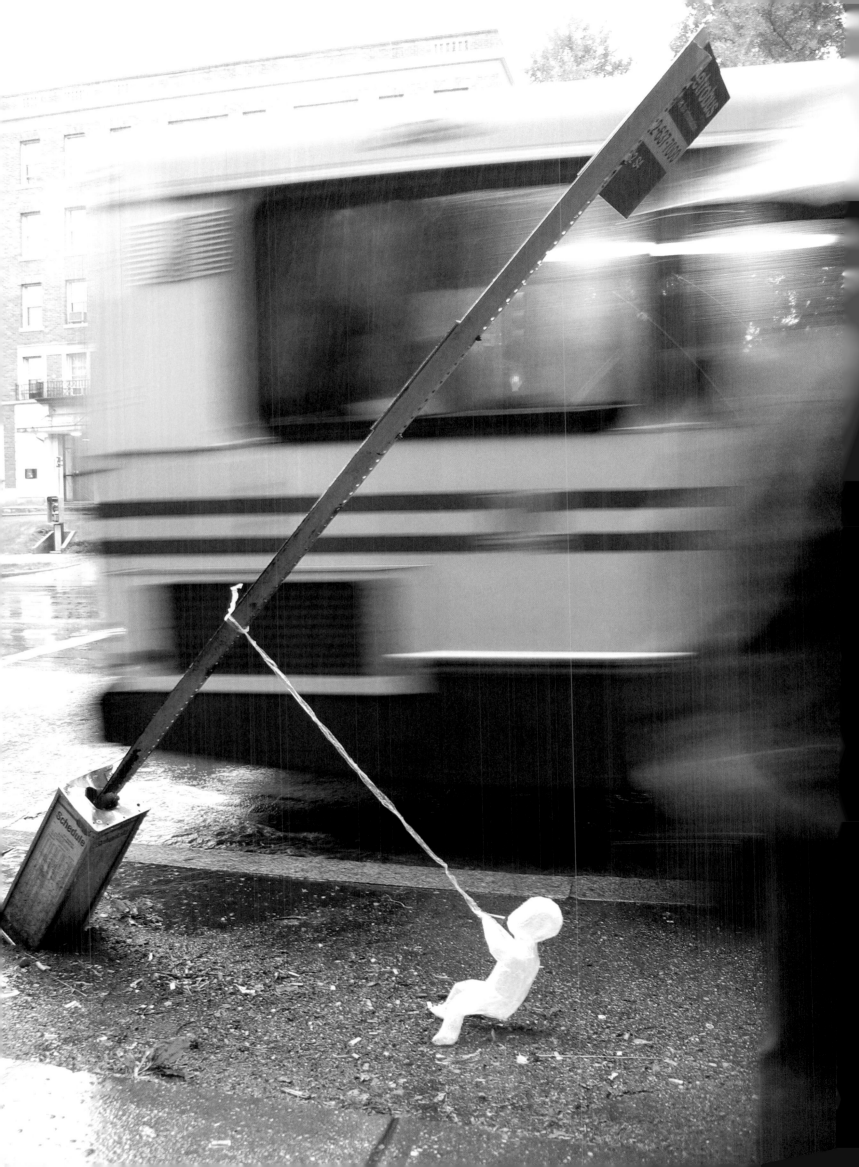

OPPOSITE

Mark Jenkins, *Storker Project*
LOCATION Washington, DC
DATE 2005

BELOW

SupaKitch, *Stop Thief!*
LOCATION Paris, France
DATE 2007
PHOTO Remy Ferante

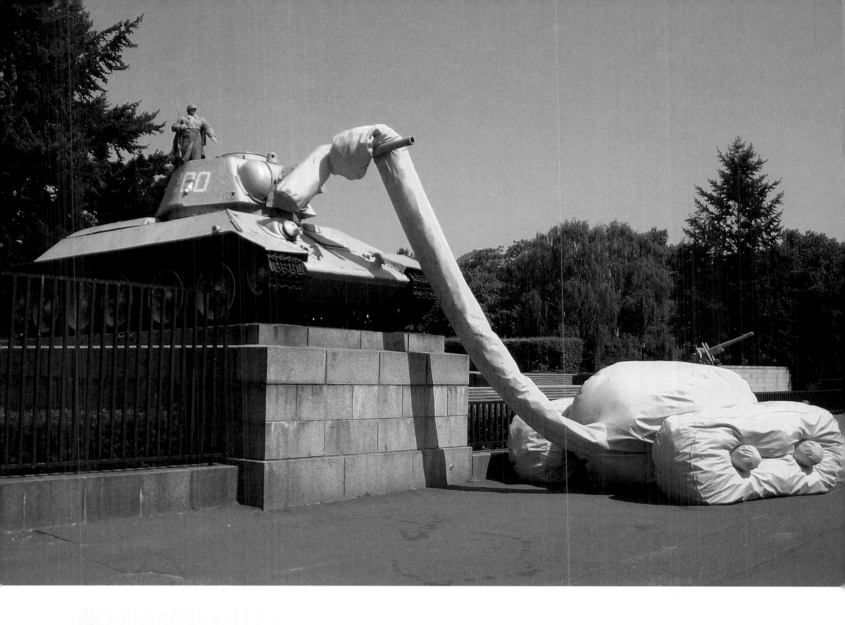

PAGES 254-255
Krink
LOCATION New York City
DATE 2005
MEDIUM Krink on enamel

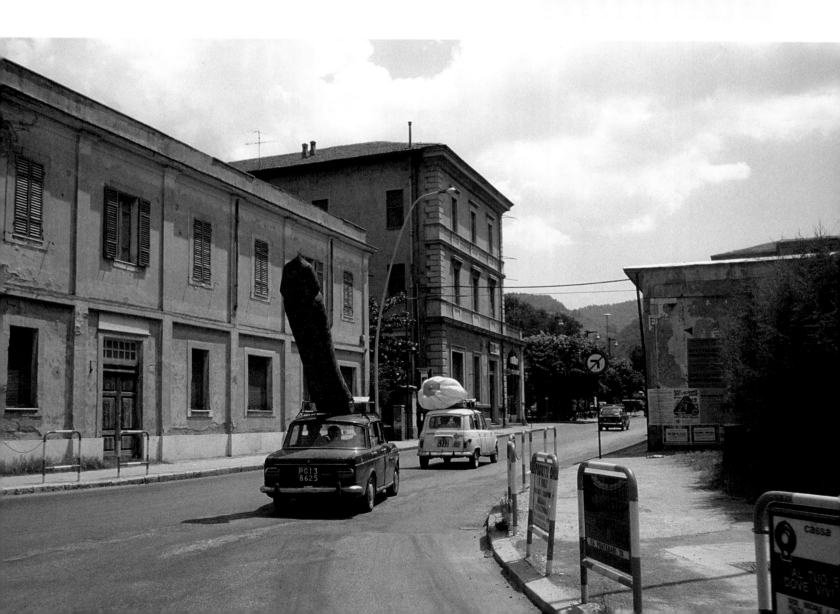

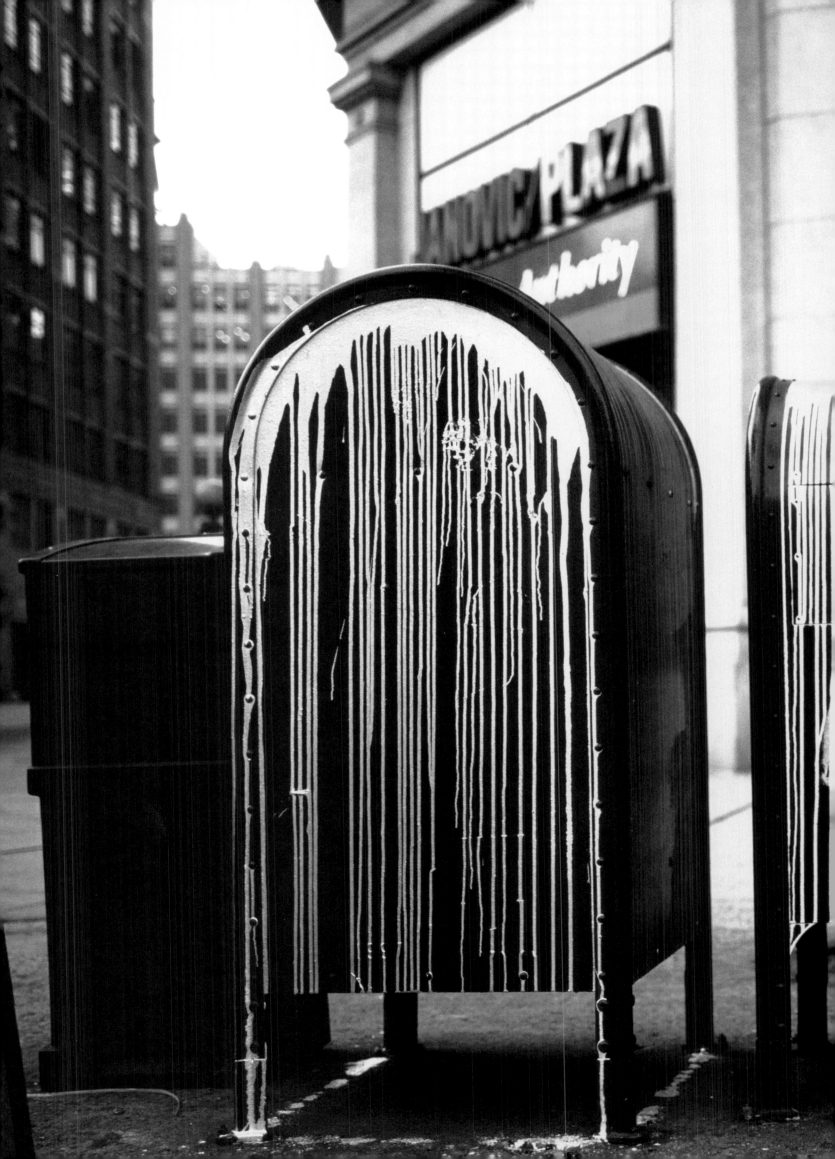

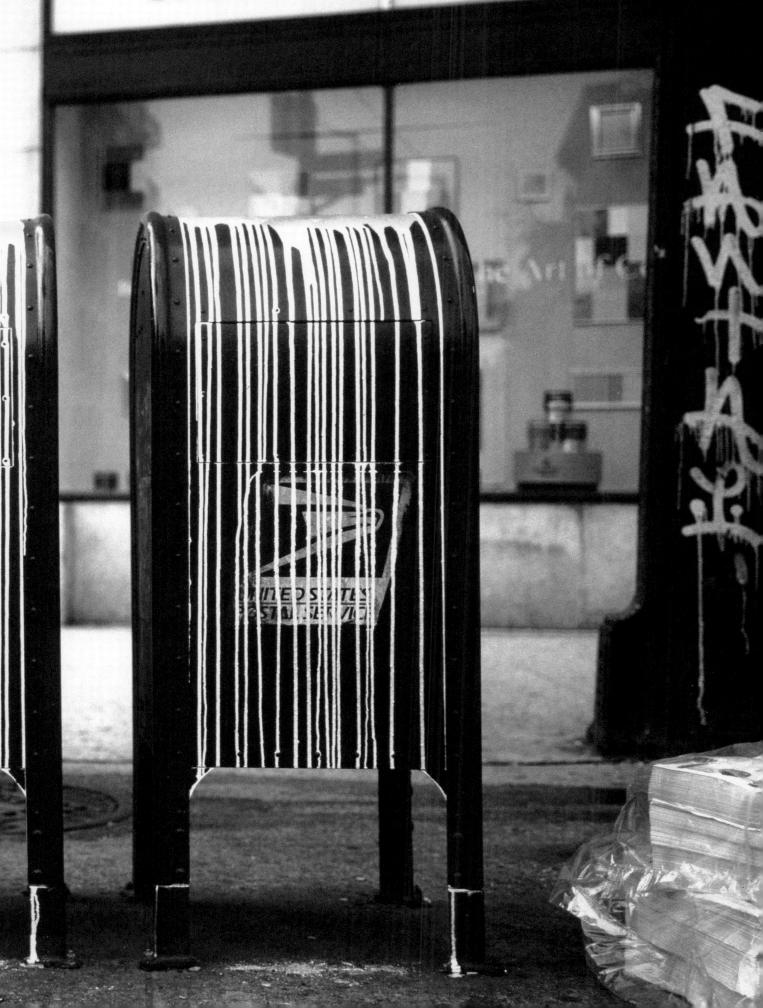

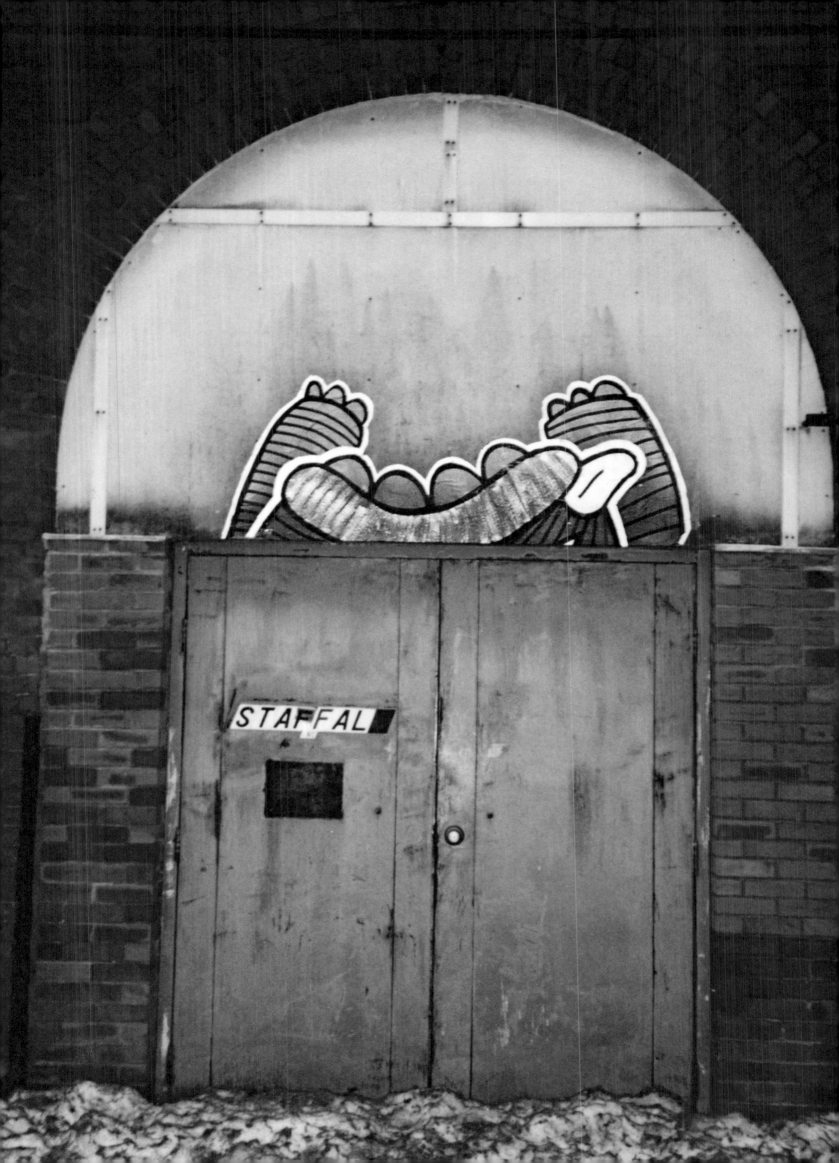

NON
FIGURA
TIVELY
SPEAK
ING

7

"Much as it seems a bit off when someone does a picture today for the mere purpose of making something pretty, the very idea of abstraction in Street Art is anathema to this medium of populist communication."

Most of the mark-making we associate with public walls has been a kind of storytelling: depictions of events, real or imaginary; caricatures, whimsies, polemics, and messages of some sort. As a textual medium, it has tried to say something, and its most common form, the name itself, has representational authority. Next time you walk down the street, try reading your surroundings and register how even our most passive gaze is fraught with messages: where and when to walk, a plentitude of driving instructions, lots of "do not" missives to remind us of socially acceptable behavior, and an endless stream of images, logos, and slogans to coerce us into loving/wanting/needing an innumerable multitude of products. No need to get all heavy with the semiotics here, but it is not so hard to see why the language of the street is just that, language—word- and picture-based and ultimately directed at figurative representation and narrative. Much as it seems a bit off when someone does a picture today for the mere purpose of making something pretty, the very idea of abstraction in Street Art is anathema to this medium of populist communication, a reversion to a painting practice that has not held much currency with youth since the advent of Pop nearly 50 years ago. Perhaps no more than an oddity on the urban landscape, a cul-de-sac in the history of *Trespass*, by very virtue of its obtuse relationship to the ways in which we read the walls and signs about us, it is worth celebrating the domain of abstraction.

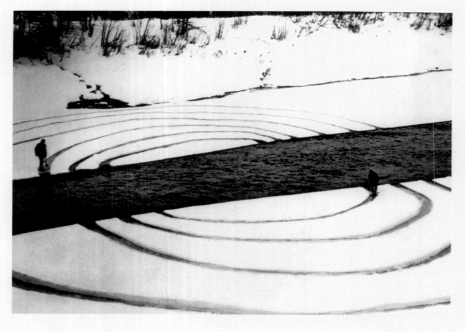

PAGE 256

Monster Project Team
LOCATION Providence, Rhode Island
DATE 2001

LEFT

Dennis Oppenheim, *Annual Rings*
LOCATION USA/Canada boundary
at Fort Kent, Maine, and Clair,
New Brunswick
DATE 1968, USA 1:30 pm;
Canada 2:30 pm
ARTIST NOTES Schemata of annual rings severed by political border

OPPOSITE

Gordon Matta-Clark, *Day's End (Pier 52)*, (Diptych, Detail)
LOCATION New York City
DATE 1975
MEDIUM Silver dye bleach print
(Cibachrome)

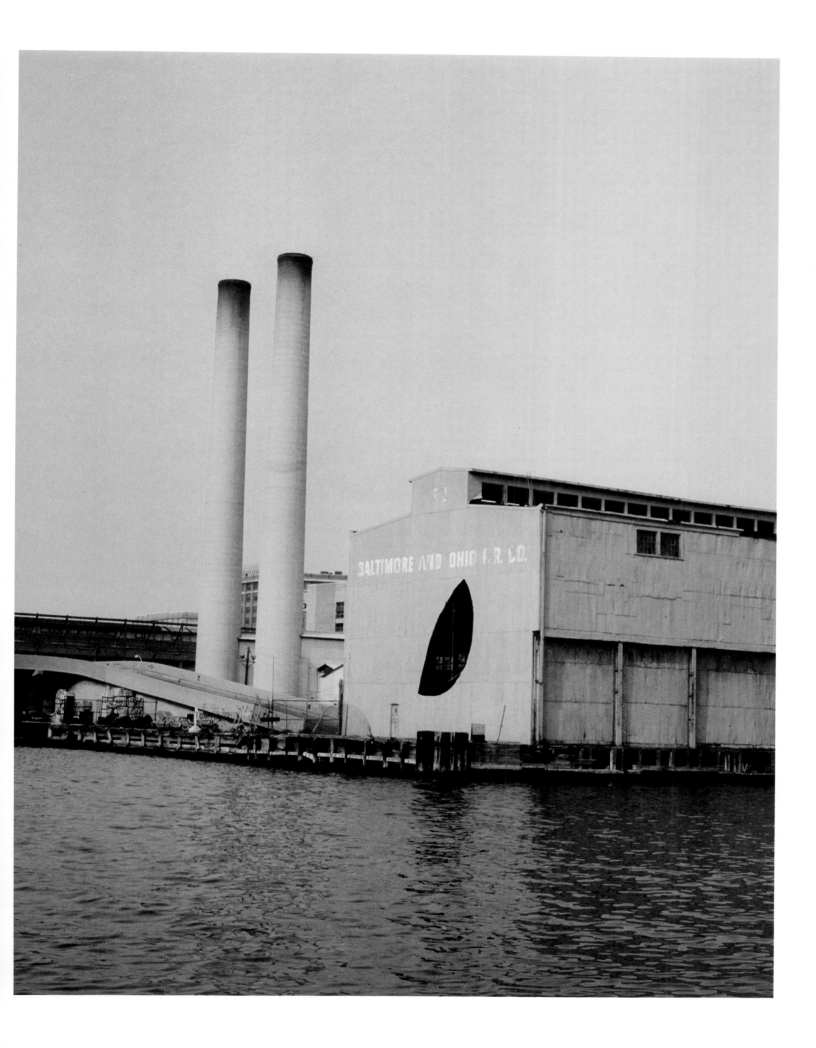

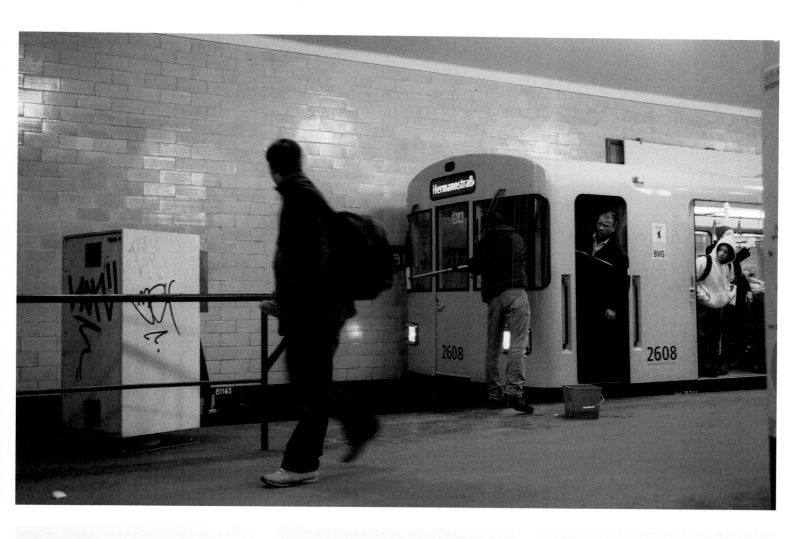

OPPOSITE

C. R. Stecyk, *Street Rod Series*
LOCATION El Camino Real,
 Los Angeles, California
DATE 1972
MEDIUM Polychromed cast
 aluminum poles bolted to
 the ground

ABOVE

**Matthias Wermke & Mischa
Leinkauf,** *Trotzdem Danke /
Thanks Anyway*
LOCATION Berlin, Germany
DATE 2006
MEDIUM Video
PHOTO Thomas Krüger

*Giving train windows a cleaning,
free of charge.*

PAGES 260–261

Gordon Matta-Clark, *Window
Blow-out*
LOCATION New York City
DATE 1976

*Matta-Clark's series of black-and-
white photographs of vandalized
housing projects in the Bronx were
conceived for a 1976 show at the
Institute of Architecture and Urban
Studies in Manhattan. His photo-
graphs of smashed windows testified
to the failed social and architectural
policies of 1970s New York. To un-
derscore his point, he crept into the
gallery late one night and blasted
out several windows with an air rifle.*

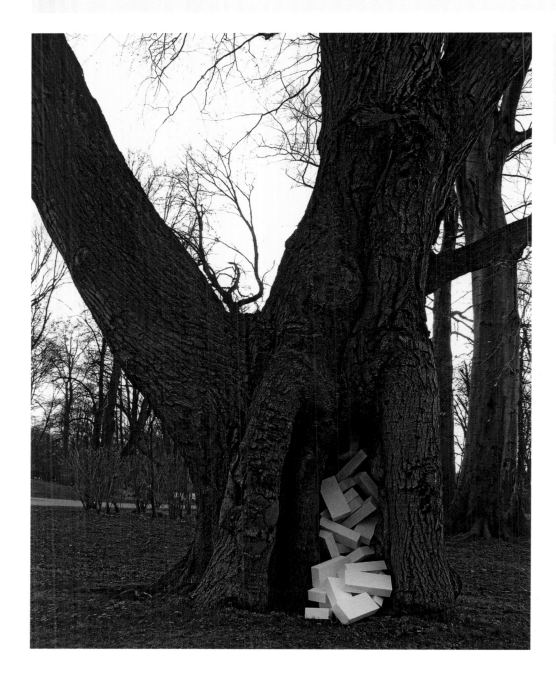

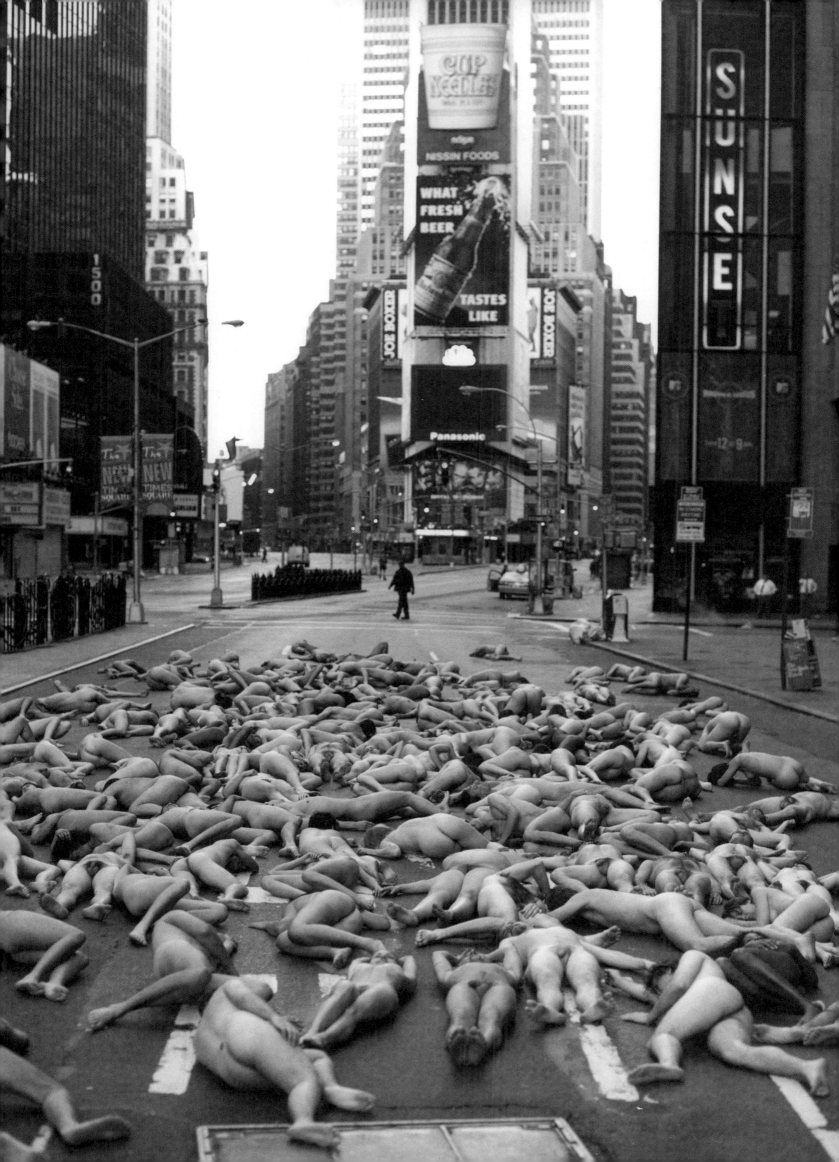

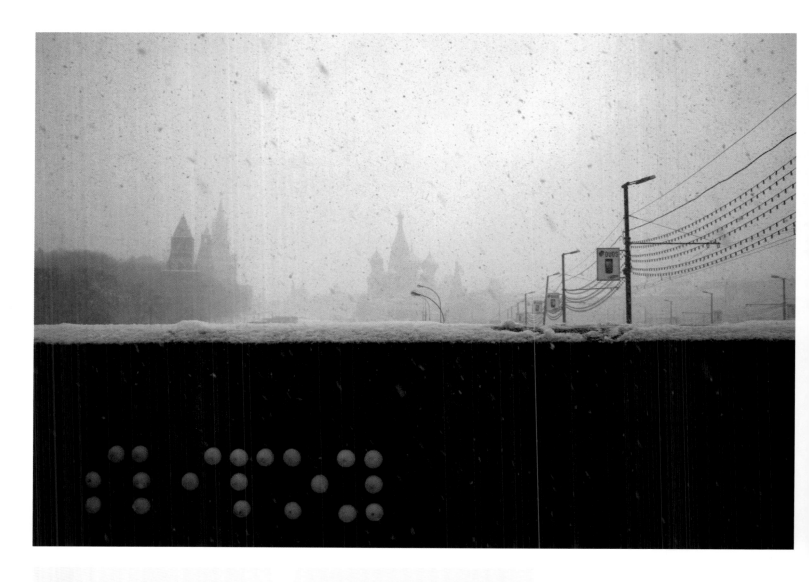

Blind, *Slipoy (Blind)*

LOCATION In front of the Red Square in Moscow, Russia

DATE 2007

PHOTO Guillaume Jolly

ARTIST NOTES Painting during the day in front of the red square was not easy, especially in a city like Moscow where you see a soldier every two minutes ... I had to wait for a snow storm surrounded by tourists pretending to make a photo to hide myself.

Blind, *Blind City*

LOCATION Pripyat, Ukraine

DATE 2007

PHOTO Guillaume Jolly

ARTIST NOTES We all know what happened in Chernobyl in 1986 but governments still continue to use bad energy.

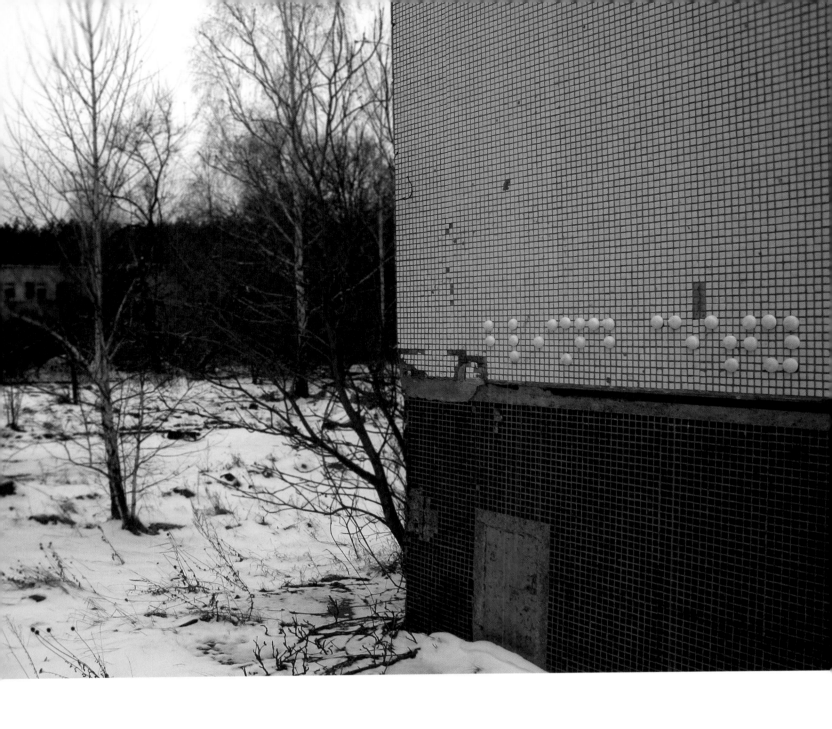

PAGES 268-269

Kami
LOCATION Tokyo, Japan
DATE 2004
MEDIUM Brush, latex paint

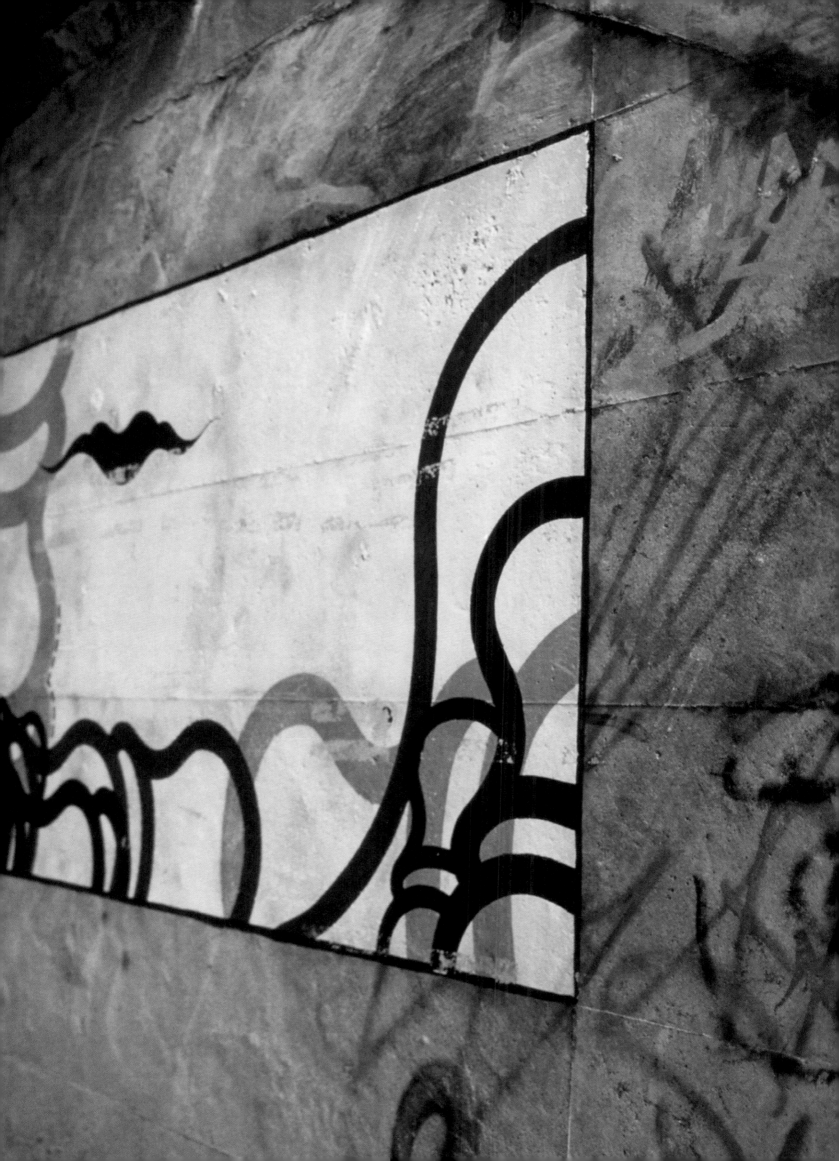

BELOW

Zezão
LOCATION Estação da Luz,
 central train station in
 São Paulo, Brazil
DATE 2008

OPPOSITE

Nuria Mora, *Falet Series*
LOCATION Favela "Falet," Rio de
 Janeiro, Brazil
DATE 2008
MEDIUM Acrylic paint

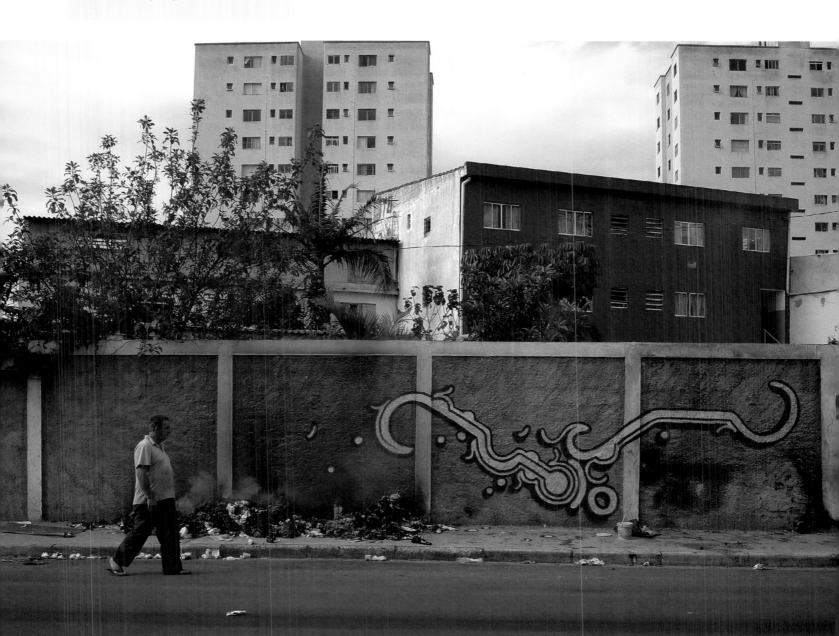

PAGES 272-273

Eltono
LOCATION Bogota, Colombia
DATE 2008
MEDIUM Vinyl paint, masking tape

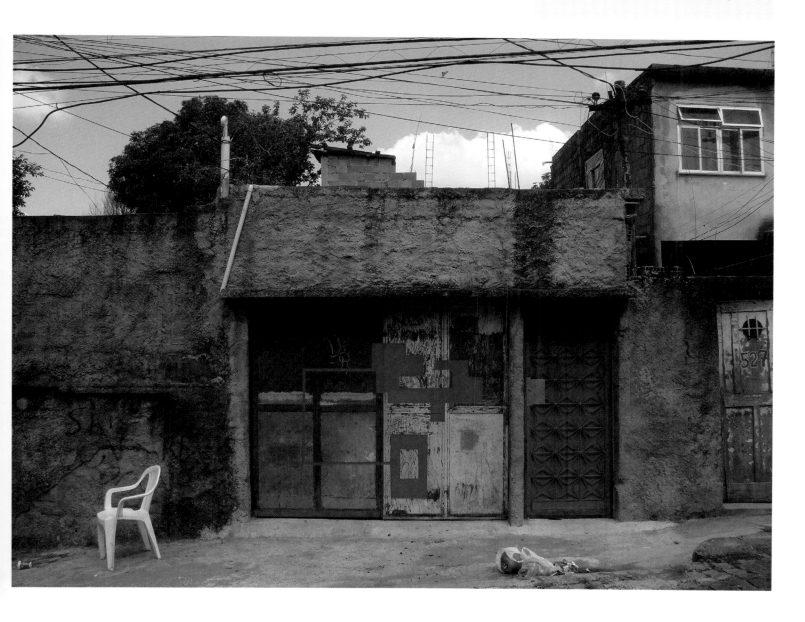

ABOVE & LEFT

ZASD, *Arrow Pieces—Tickling Centrum Chodov Reactions*

LOCATION Centrum Chodov shopping center, Prague, Czech Republic

DATE 2008

MEDIUM Handmade wooden arrows, 12mm diameter, 1000mm long, mixed colors

ZASD uses a bow and handmade arrows to shoot at buildings and break through their layers of plaster and heat insulation.

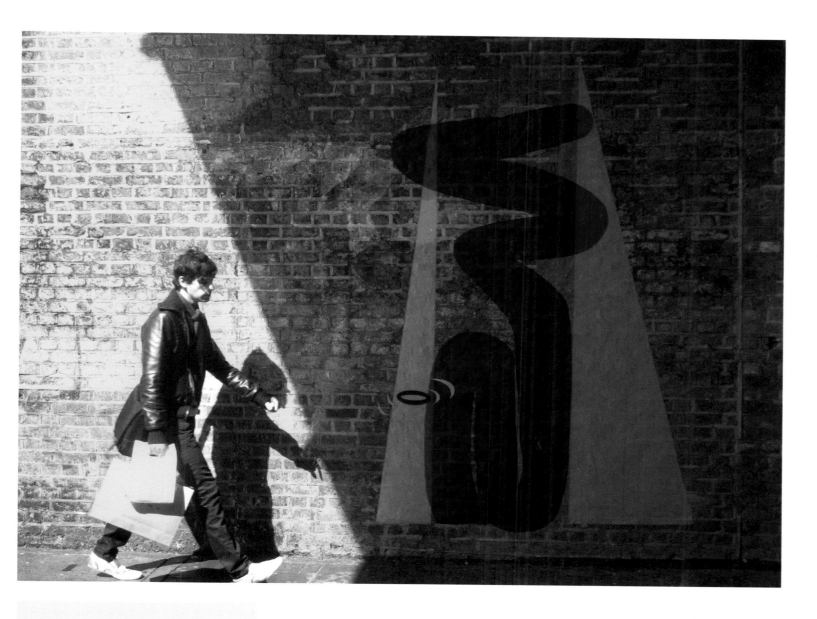

MOMO
LOCATION London, England
DATE 2008
MEDIUM Collage, paper

PAGES 276–277

ESPO
LOCATION Los Angeles, California
DATE 2002

In a subtle misappropriation of a municipal program run by the city of Los Angeles to combat graffiti, in which concerned citizens are given permission to paint over offending graffiti, artist Steve Powers used his residency in Nike's Blue House to initiate his own plan of buffing out bad graffiti in ways that discreetly spelled out his own tag, ESPO.

PAGES 278–279

Harald Naegeli, *Death Series*
LOCATION Cologne, Germany
DATE 1980
PHOTO Hubert Maessen

Known as the "Sprayer of Zürich," Harald Naegeli fled to Düsseldorf and Cologne after being sentenced to jail in Switzerland for his prolific wireframe graffiti. Death Series was his reaction when his works were immediately removed by the city cleaning department in this more "liberal" town.

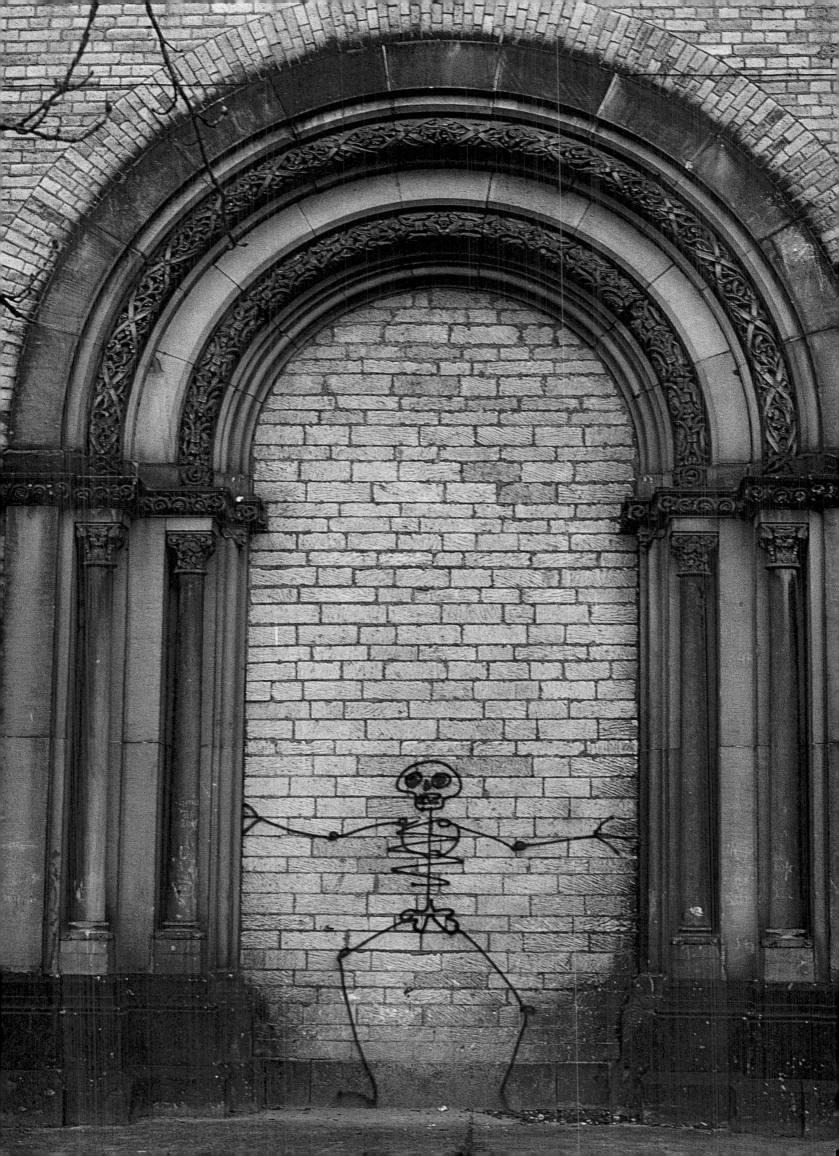

URBAN FOLK

8

"In a form based on immediacy, accessibility, and directness, that which is simple, rudimentary, rude, and even barbarous often trumps the nuances of civility."

Regardless of "style wars" and beyond the orthodoxies by which many ratify some expressions on the street over others, graffiti as a mode of aesthetic intervention is not a style; it is an act. Just as certain musical genres, from blues to punk, have perpetuated themselves beyond their specific moments of origin, the voice behind spontaneous public art is of a self-sustaining urban folk art. By no means limited to creations by self-taught artists—DIY in spirit, counterintuitive towards market and career considerations, low-budget, ephemeral, and community-centric—work done on the streets is often far closer to a folkloric tradition than to the formalisms of fine art. Take the lesser-known history of hobo freight-train art largely lost in its original

Depression-era context, which was brought back as retro-nostalgia by contemporary practitioners with a folkloric formalism equivalent to that of other resuscitated mediums. Highly personal and more beholden to issues of primacy than to the particularities of craft, there is a shamanic outlaw element to the art of trespass that is called for in conjuring sensibilities outside the mainstream of progress. Though the language around primitivism is loaded with condescension— there is something indeed troubling about the way Brassaï's fascination with kids' graffiti has the taint of a mystified savage Other—we may fairly enjoy the primitive and crude vernacular of some street art without too much grief or guilt. There is too much evidence to the contrary for anyone to dismiss the full scope of uncommissioned public art as artless criminal vandalisms. Shy of such ignorant reactionary proclamations, we must also appreciate that in a form based on immediacy, accessibility, and directness, that which is simple, rudimentary, rude, and even barbarous often trumps the nuances of civility.

PAGE 280

Harald Naegeli, *Death Series*
LOCATION Cologne, Germany
DATE 1981
PHOTO Hubert Maessen

LEFT

Brassaï, *Graffiti Series VIII, Magic*
LOCATION Paris, France
DATE c. 1935–1950

OPPOSITE

Barry McGee (Twist)
LOCATION San Francisco, California
DATE 1993
PHOTO Krink

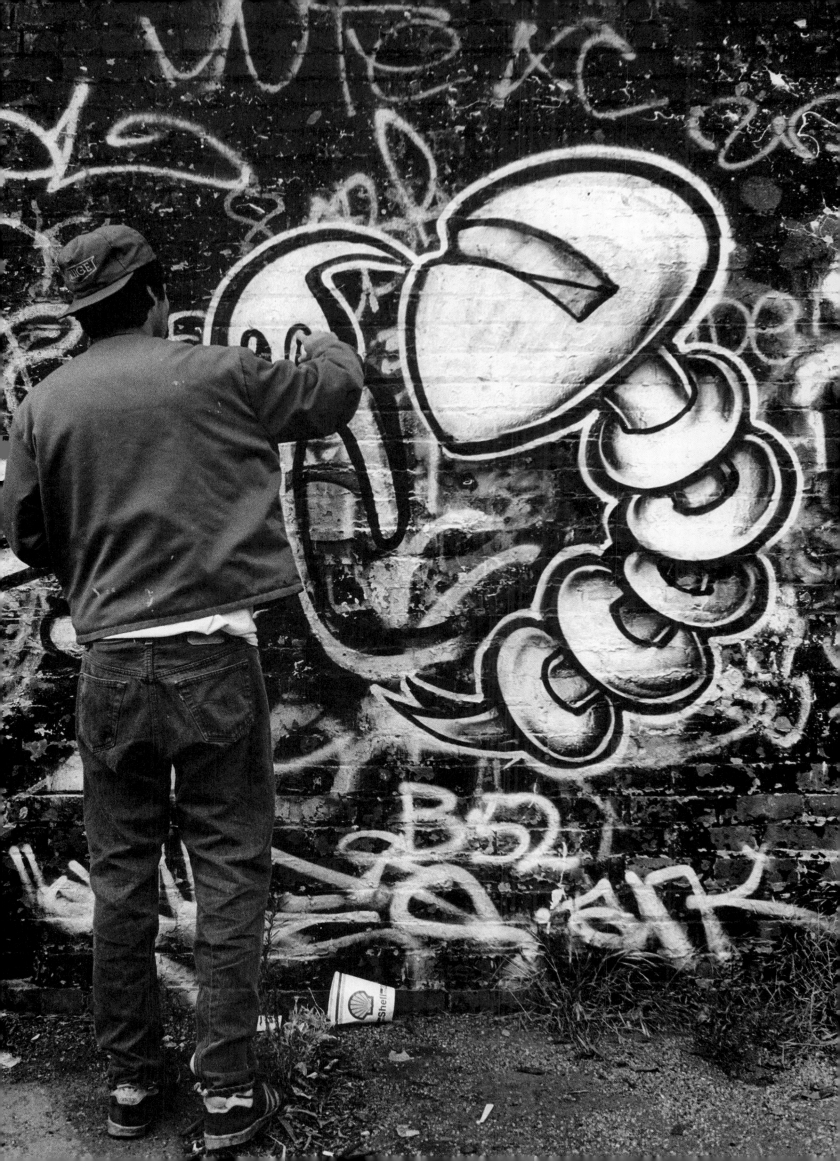

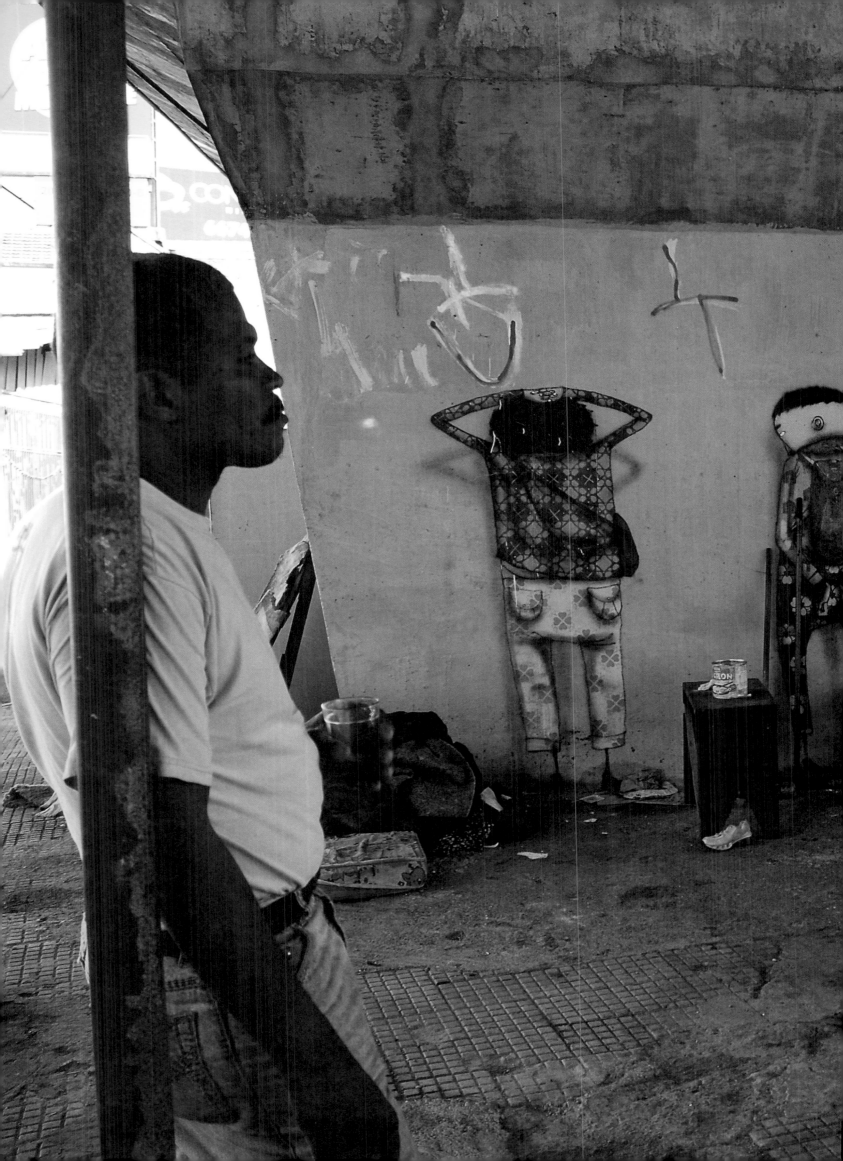

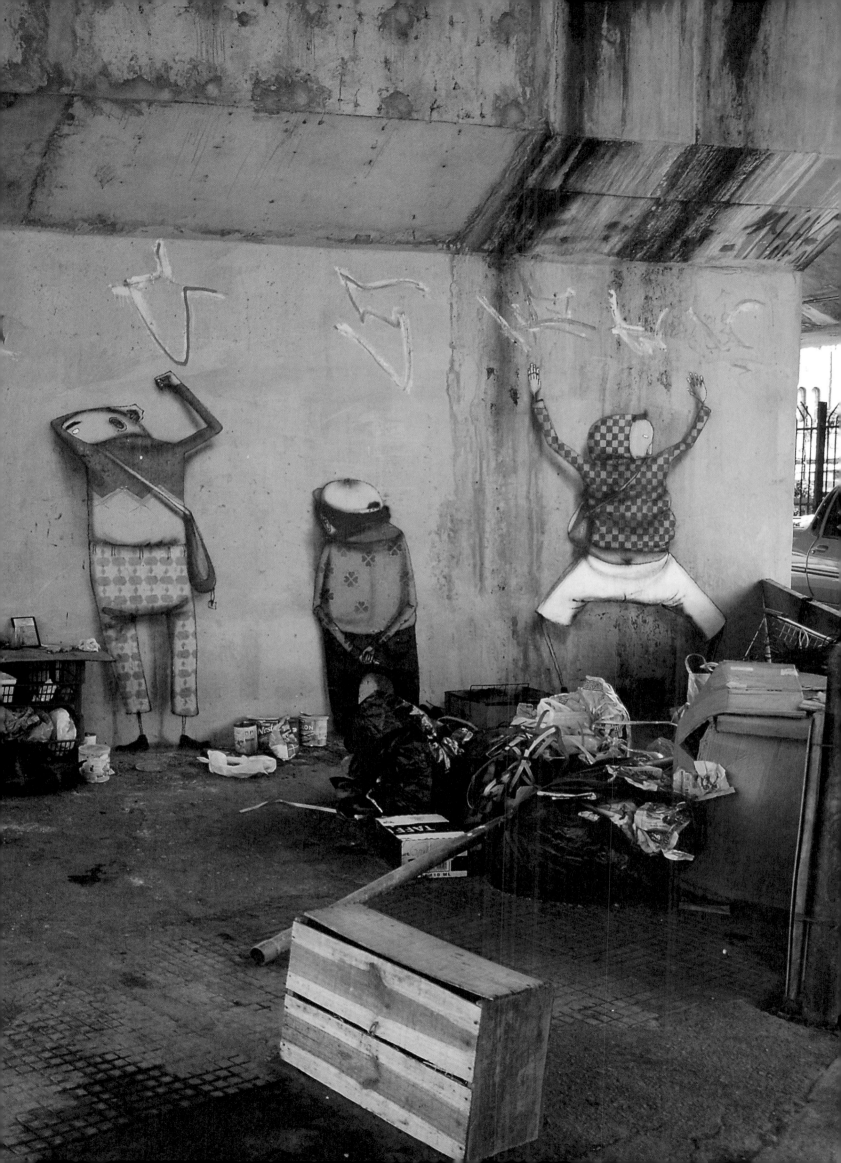

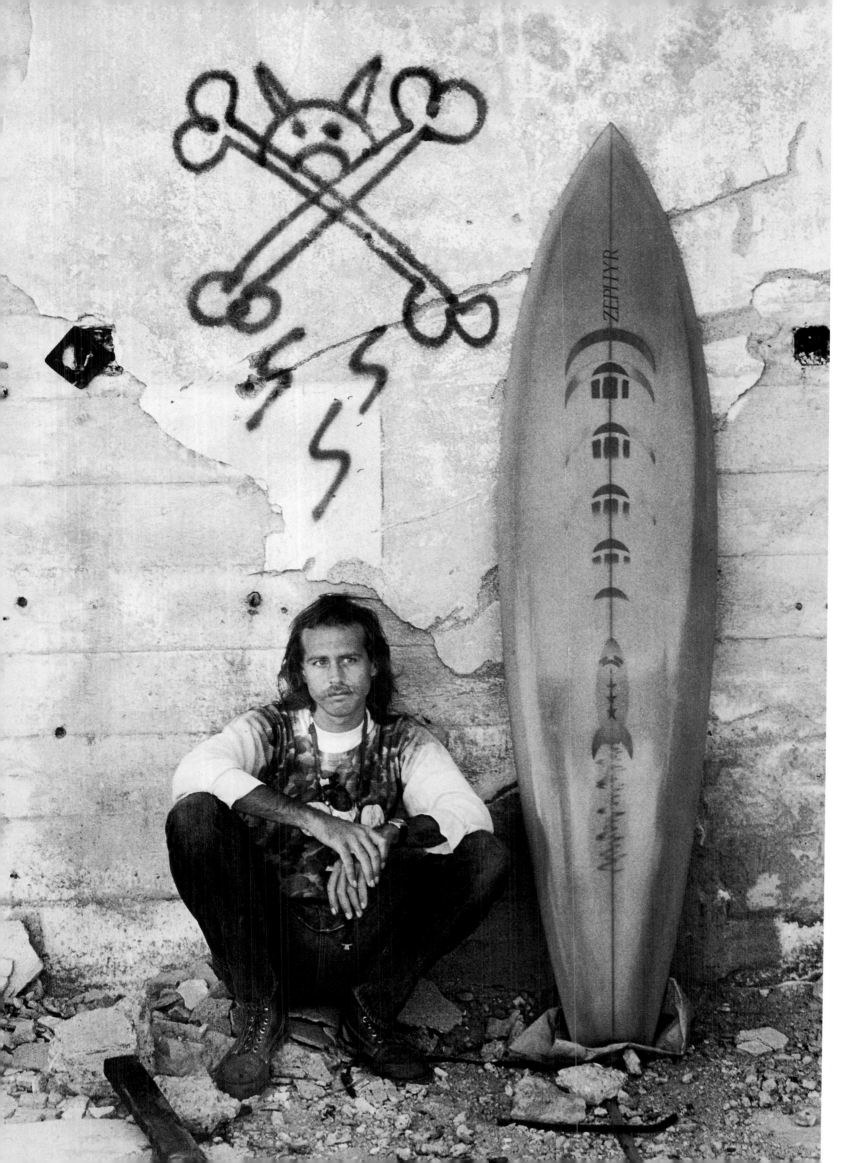

PAGES 284-285

Os Gêmeos
LOCATION São Paulo, Brazil
DATE 2008

OPPOSITE

C. R. Stecyk with his graffiti tag
LOCATION Ocean Park, California
DATE 1974
PHOTO Anthony Friedkin

ABOVE

C. R. Stecyk, *Calavera Series*
LOCATION Sepulveda Canyon,
 Los Angeles, California
DATE 1986
MEDIUM One-off poster, mixed media
 with letterpress ink and lacquer,
 oil, acrylic-based paints

BELOW

Miss.Tic
LOCATION Paris, France
DATE 1992

All complete / except the desire
 —Miss.Tic

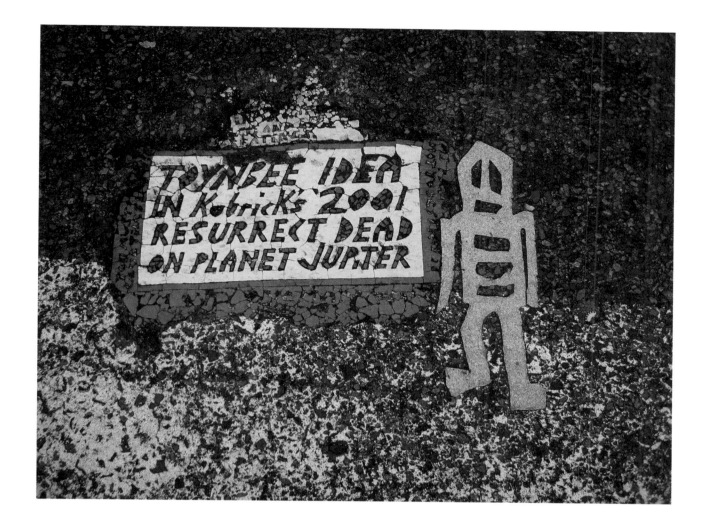

stikman, *Red, Yellow, White*
LOCATION Philadelphia,
Pennsylvania
DATE 2007
MEDIUM Paint, adhesive, tile

*Stikman appears with Toynbee tile
of mysterious origin, embedded in
asphalt.*

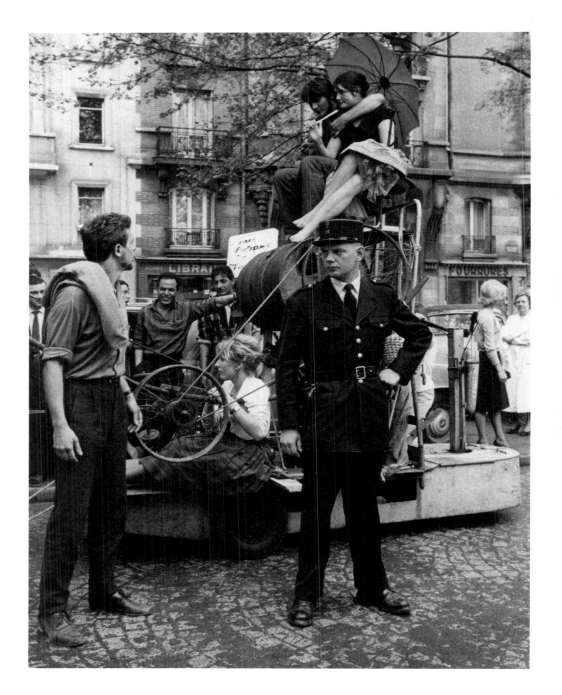

Jean Tinguely
LOCATION Paris, France
DATE 1960
PHOTO Christer Christian

When Tinguely's parade of machines, from his studio at Impasse Ronsin to the Galerie des 4 saisons, was stopped, he allowed himself to be arrested so the parade could continue.

OPPOSITE

Linus Coraggio, *Gas Station*
LOCATION East Village, NYC
DATE 1994
PHOTO Nick Kuskin

Open-air studio with installations made of welded steel. Linus Coraggio's sculptures made of scavenged metal bolted onto city signs were recognized as 3-D graffiti.

ABOVE

Jean-Michel Basquiat (SAMO)
LOCATION New York City
DATE 1982
PHOTO Martha Cooper

OPPOSITE

buZ blurr aka Colossus of Roads
LOCATION San Francisco, California
DATE 1993
PHOTO Bill Daniel

A third-generation rail worker in small-town Arkansas, buZ blurr engaged in the practice of boxcar drawing and mail art from the early '70s.

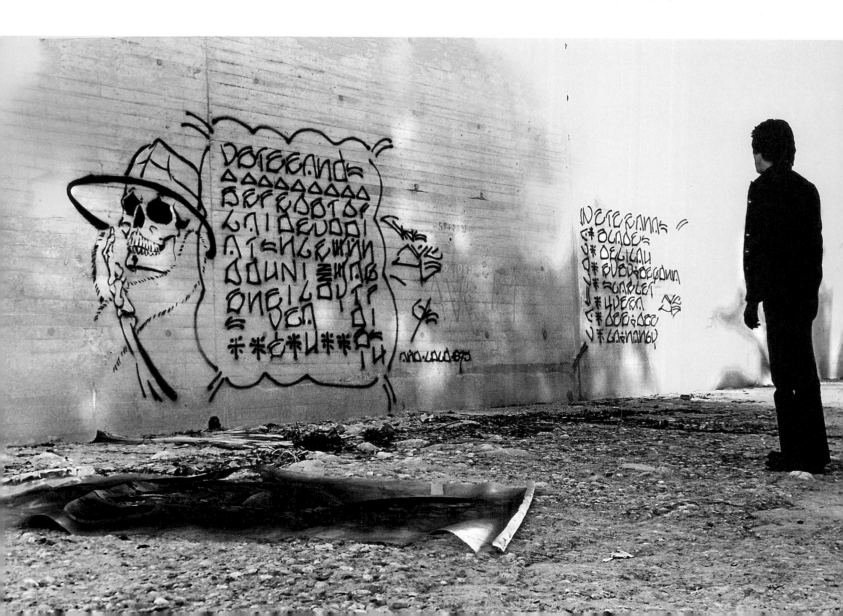

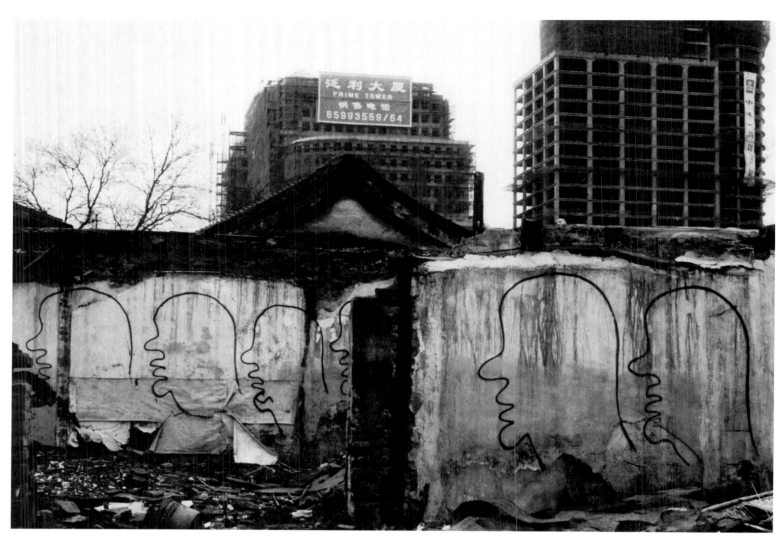

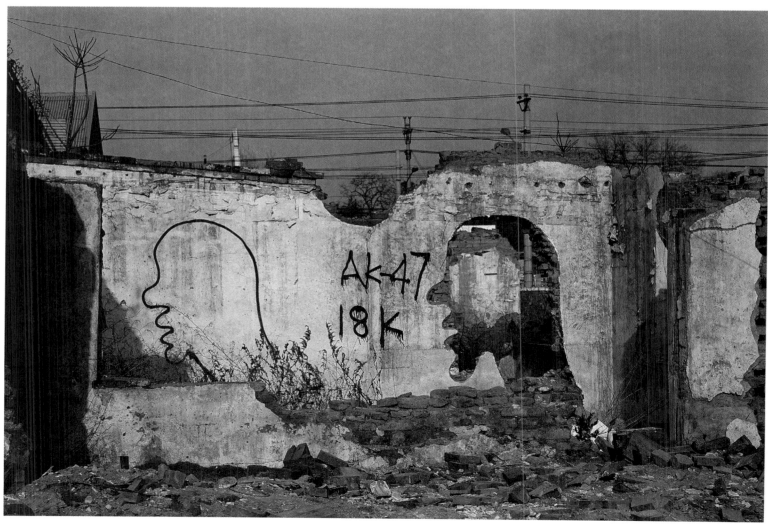

OPPOSITE, TOP & BOTTOM

Zhang Dali, *Dialogue and Demolition Series*
LOCATION Beijing, China
DATE 1998

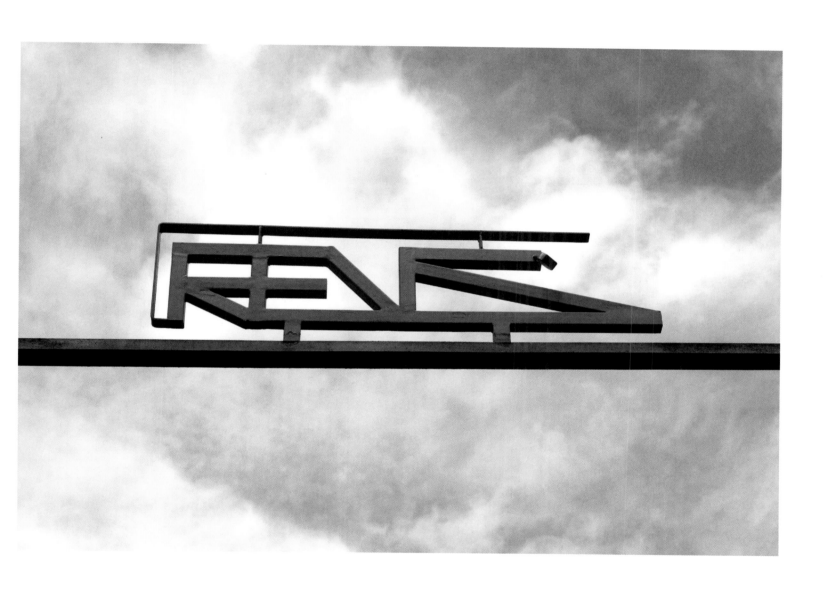

ABOVE

REVS
LOCATION New York City
DATE 2006
PHOTO Jake Dobkin

Once the most prolific and visible graffiti artist of his era in New York—using wheatpasted posters and extended paint rollers to get his art up high and on a big scale—REVS now conquers the city with metal sculptures.

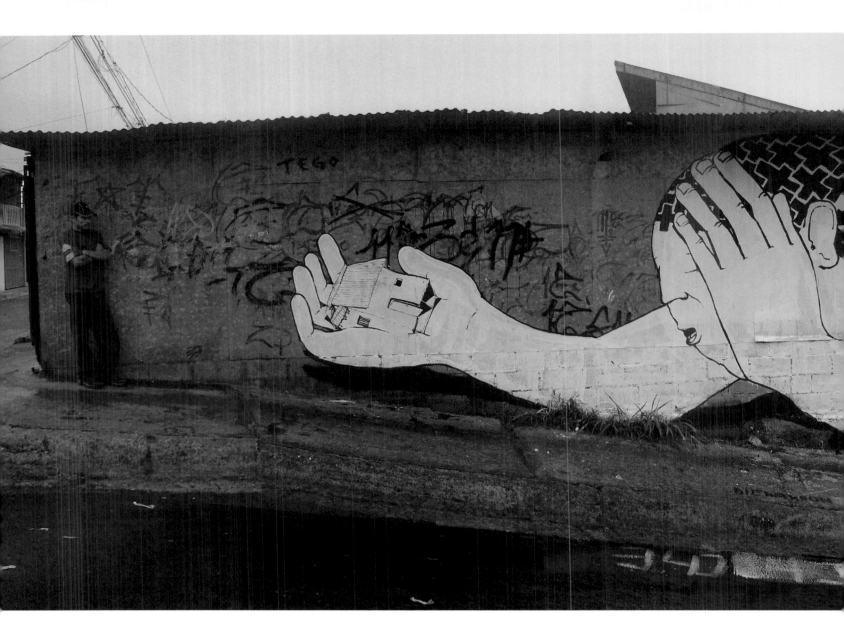

ABOVE

Blu
LOCATION San Jose, Costa Rica
DATE 2006

OPPOSITE

Mr A
LOCATION Paris, France
DATE 2000
PHOTO Sybille Prou

ABOVE

DAVe Warnke, *4-Eyed Guy* with
You Are Beautiful
LOCATION Oakland, California
MEDIUM Highlighter marker, sticker

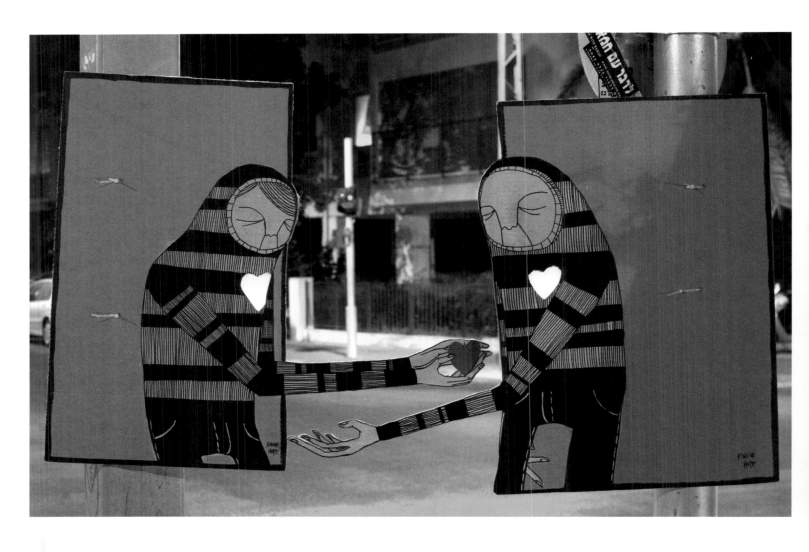

ABOVE

Know Hope, *Lend yr. Heart*
LOCATION Tel Aviv, Israel
DATE 2007
PHOTO Guy Pitchon

OPPOSITE

Keith Haring, *Houston Street Mural*
DATE 1982
PHOTO Martha Cooper

PAGES 304-305

The Bruce High Quality Foundation, *The Gate: Not the Idea of the Thing, But the Thing Itself*
LOCATION New York City
DATE 2005

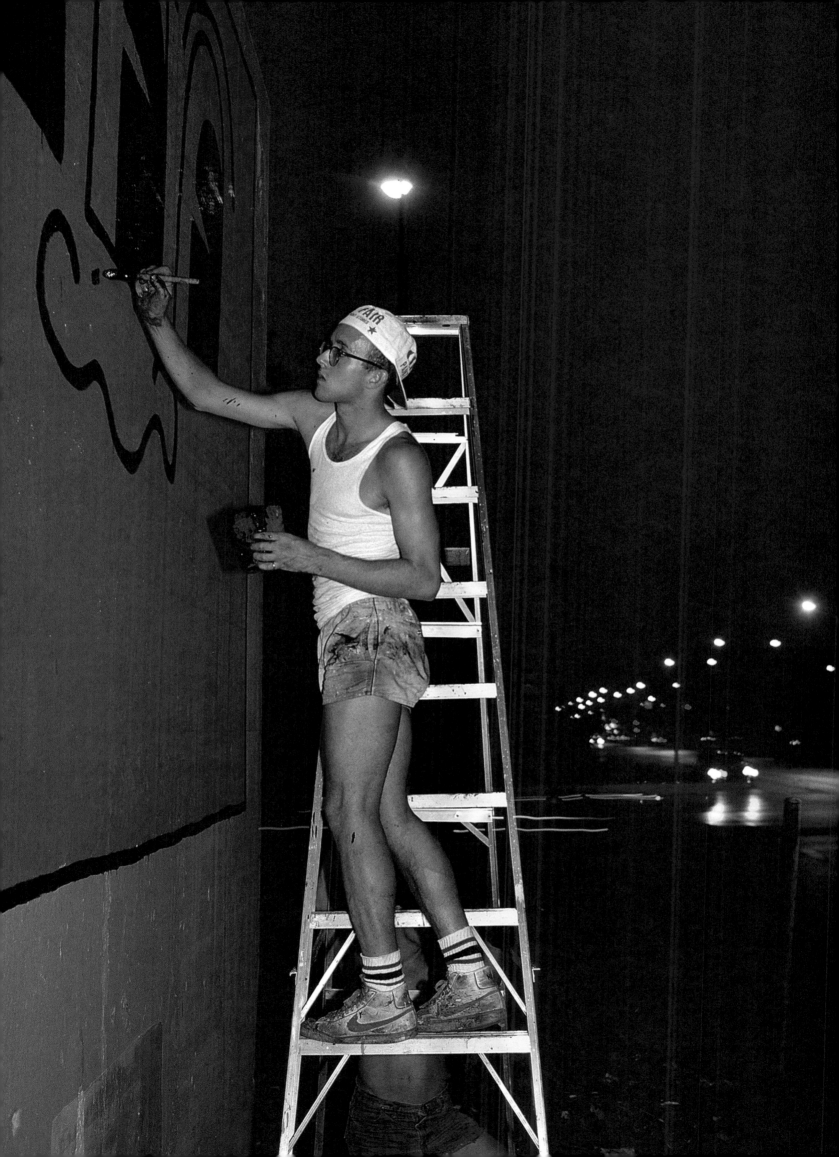

A Miniature Gate in Hot Pu

of a Miniature Central Park

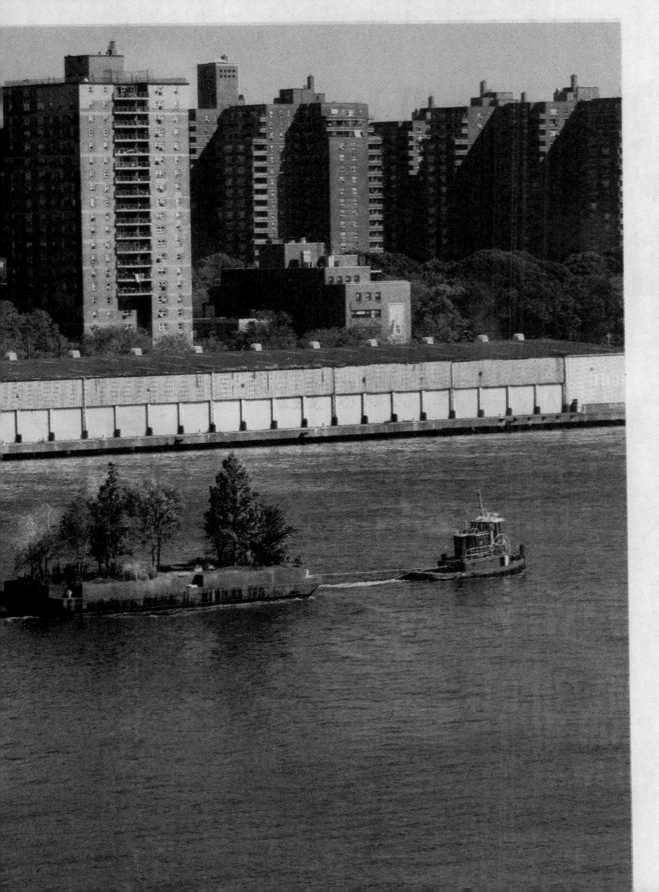

JUST DO IT

Let me begin with a disclaimer: I detest the term *public art*. Why? Because there is no creative pursuit that can be categorized as public art. It is not a movement like Abstract Expressionism, Minimalism, Pop Art, or graffiti, for example, that can be defined stylistically or conceptually. Let's be honest: the term *public art* conjures ideas of banal, even dreadful, permanent displays in municipal buildings from airports to courts. Most official opportunities to create public art are encumbered by graffiti-resistant, child-safe, family-friendly, provocation-adverse rules, which guarantee that any commissioned artwork will be bland at best.

Let us keep in mind, however, that there are multiple approaches to art in the public realm—from memorial tributes to lives lost and monuments of heroes on horseback, to land art in remote destinations and celebrated transformations of urban plots; from spectacular to modest, permanent to temporary, beautiful to badass. Surely there could be no one way to produce great art in the public realm, but one thing is certain: when artists are burdened with limitations to their creative process, the results cannot be good—let alone great. Instead, it is those artists who are unencumbered, and more often than not those who freely trespass into the everyday world to provoke ideas, embrace the unpredictability of public life, reclaim the streets, and take profound social action, who are the best poised to create some of the most compelling art experiences.

Since art is at its best when artists are free to take control of their own destiny, uncommissioned work, or "interventionist art," is sometimes the most successful in the public realm. Just think about it. Some of the greatest art of the 20th Century was uncommissioned, from Allan Kaprow's *Happenings* in the late 1950s and '60s, in which he created impromptu experimental events with fellow visual and performing artists in unlikely public spaces, to Gordon Matta-Clark's illegal slicing of a neglected municipal building on Manhattan's waterfront, turning it into a temple of light and air in *Day's End* (1975).

Interventionist art, a term coined by the influential writer and curator Nato Thompson, describes the work of artists who trespass into the everyday world to critique, lampoon, disrupt, and agitate in order to create social awareness and even advocate for social change. In the process, they activate our urban spaces as places for democracy, keep our cities alive with creativity and powerful ideas, and engage new

"Since art is at its best when artists are free to take control of their own destiny, uncommissioned work, or 'interventionist art,' is sometimes the most successful in the public realm."

audiences. Every day innumerable artists are creating provocative interventions in cities around the world. Just think of how many times you have been confused, delighted, and moved by these interventions, from a strange occurrence happening during your daily commute, to fallen branches cleverly arranged along the riverfront, or misplaced construction objects curiously obstructing a pathway.

One of my heroes is the little-known, oft-times homeless Vietnam veteran Jim Power. For decades Power has been creating mosaics from discarded porcelain dishes and home-renovation debris to transform New York City's East Village traffic lights, signposts, and planters from the banal into objects of brightly colored wonder. Ellen Harvey, another urban romantic, shared her love affair with historic European and American landscape painting by illegally painting her own intimate renditions on the surfaces of 40 derelict sites, from tenement buildings to dumpsters, from the Bronx to Brooklyn, in her *New York Beautification Project* (1999–2001).

Urban artists activate public space as a place for beauty, bold actions, and wonder. While graffiti artists wow us with bold stylings and daredevil feats to tag sites where no one else has gone, street artist Swoon has taken a different approach as she beautifies the urban funk with her intricate paper cut-outs portraying urban dwellers in everyday actions with dignity and grace. Another young artist, Chris Stain, also employs fresh Street Art techniques in the noble effort of elevating citizens to the scale of the billboard giants that dominate our cities, with a humane eye toward their daily struggle.

Prankster artists also keep our cities alive with provocation, humor, and even a healthy measure of perversity. Just imagine, for example, you are a morning commuter rushing to work, and you notice a young man outside a subway entrance setting up a desk complete with telephone, computer, and penholder. He then undresses, hangs his clothes on a coat rack, and proceeds to type away at his computer while taking phone calls. It is business as usual for artist Zefrey Throwell, who captured his intervention on film. The Neistat Brothers, aka Casey and Van, also capture their urban hoaxes on film, which are seen on the Internet by an international following.

Fascinated with the "unclaimed frontiers on the edge and inside overdeveloped urban areas, and their unsuspected autonomy," artist Duke Riley took his homemade Revolutionary War–inspired submarine into the Brooklyn Harbor, where he blocked the progress of the Queen Mary 2 and pissed off the U.S. Coast Guard at a time of heightened security in New York's post-9/11 reality. Annoyed by this act of creative trespass, the Coast Guard rammed the submarine in an effort to sink it and end its journey. Yet it lives on in memory and urban mythology thanks to the media, which covered the event and brought the artist's effort to millions of readers. This was no shallow media stunt. Rather, Duke reminded us of the incredible struggle for freedom our founding fathers endured as our government drastically restricts those hard-earned freedoms today.

The artist collective of Bruce High Quality Foundation also took to the waters as they

"These projects of deep social and political import radically challenge notions of the artist's role in society, advocate meaningful exchanges with diverse publics, and promote ideas for real social change."

chased Robert Smithson's *Floating Island* (2005) in an old motor boat waving a faux orange gate à la Christo and Jeanne-Claude as part of their ongoing public assault on art-world elitism.

Among the most radical of the public interventionists are surely Andy Bichlbaum and Mike Bonanno, aka The Yes Men. Striving to call mass media attention to the unethical practices of multinational corporations, The Yes Men create clever media spectacles by impersonating executives of such companies as Dow Chemical, Exxon, and Halliburton to undermine their corporate goals and highlight their public abuses. Most recently The Yes Men joined forces with artists, writers, and activists to create and distribute one million fake issues of the *New York Times* blazing headlines such as "Nation Sets Its Sight on Building Sane Economy" and "Iraq War Ends" (2008).

Consider that some of the most legendary large-scale artworks, such as Robert Smithson's *Spiral Jetty* (1970) in Utah's Great Salt Lake and Michael Heizer's *Double Negative* (1969–70) in the Nevada desert, were visions the artists spent years digging away at. There was no single institution behind them, no big foundation, and no instant gratification—just personal determination and a ton of hard work.

Artists continue to undertake incredibly ambitious projects on their own, though the hardcore drive it takes makes these artists the exception and not the rule. Mel Chin, a big-thinking visionary, has taken on societal ills and environmental problems with interventionist projects that confront genocide in Rwanda and land-art

installations that actually heal heavy metal toxic land sites in his now-legendary *Revival Field* (1990–present).

Likewise, a young artist fresh out of college, Rick Lowe, decided to transform the predominantly African-American Third Ward neighborhood of Houston, Texas, in founding *Project Row Houses* (1993). For one of the most profoundly political art projects of our times, Lowe acquired two blocks of derelict shotgun houses ready to be torn down by the city and brought them back to life. This was no ordinary intervention. Lowe mobilized neighbors, friends, and city activists to create housing for teen mothers and their children as well as space for health care, day care, artist studios, and vegetable gardens.

These projects of deep social and political import radically challenge notions of the artist's role in society, advocate meaningful exchanges with diverse publics, and promote ideas for real social change. These artists do not wait for others to realize their ideas. They do it on their own, investing in deep research, building relationships with community residents, initiating fresh partnerships, sharing their passions, and bravely reclaiming the public domain as a place for creativity and free expression. Interventionist artists are everywhere. Thank goodness they insist on making their dreams a reality.

OPPOSITE

The Yes Men, Steve Lambert / The Anti-Advertising Agency, *The New York Times Special Edition*
LOCATION New York City
DATE 2009
PHOTO Conway Liao

GRAFFITI AND U.S. LAW

*"Government considers graffiti a 'blight,'
'detrimental to property values,' and 'visual
pollution' in a wholly one-sided, off-balance,
and alarmist perspective."*

In recent decades in the United States, a battle has been waged under the banner of law enforcement between the property rights of the masses and the moral rights of the artist. The battlefield is on so-called graffiti, vandalism. City, county, and federal jurisdictions have promulgated multifarious forms of legislation to eradicate this alleged art form. The following is typical of the findings that underlie the eradication movement:

> *San Francisco Public Works Code article 23 1303(a)(1994) stipulates: Graffiti is detrimental to the health, safety, and welfare of the community in that it promotes a perception in the community that the laws protecting public and private property can be disregarded with impunity. This perception fosters a sense of disrespect of the law that results in an increase in crime; degrades the community and leads to urban blight; is detrimental to property values, business opportunities, and the enjoyment of life; is inconsistent with the City's property maintenance goals and aesthetic standards; and results in additional graffiti [...] in visual pollution and is hereby deemed a public nuisance. Graffiti must be abated as quickly as possible to avoid detrimental impacts.*

It can be readily seen that the rationale underlying the so-called war on graffiti is vicious, dogmatic, and mean-spirited. Government considers graffiti a "blight," "detrimental to property values," and "visual pollution" in a wholly one-sided, off-balance, and alarmist perspective. New York accords in its declarations:

> *The legislature hereby finds and declares that graffiti vandalism poses a serious problem for urban*

> *centers and especially the city of New York. [...] The legislature also finds that when unchecked, graffiti presents the image of a deteriorating community, a community that no longer cares about itself, a community that shows evidence of urban blight. Not only is graffiti an assault upon individual sensibilities, it is another reason for people to leave the city prompting a further downward spiral of economic and social conditions with severe consequences for the city of New York.*

Many cities have sought to encourage more arrests and prosecutions of graffiti artists under laws applicable to vandalism, criminal mischief, malicious mischief, intentional destruction of property, or criminal trespass statutes, associating graffiti with gangs, community decline, and rising crime. Complainants are usually governments, transit authorities, and neighborhood groups. Private property owners spend millions of dollars and hours every year to stem its tide. They paint over it, outlaw it, try to catch "them" at it, sue parents over it, and increase their security against it.

Because graffiti costs the nation $4 billion to $5 billion a year, it is understandable why graffiti has been the focus of much debate. Legislators have responded by inundating the system with various solutions to the issues, to no avail. Vandalism enforcement teams have been created for graffiti removal; property owners have been legally coerced into paying for obliterating it; jail sentences, fines, and community-service sentences have been mandated for offenders. Revoking drivers licenses has also been employed, as well as giving a property owner a civil claim against a graffiti writer or his or her

*"Graffiti endures, and outlawing graffiti
is not an effective solution."*

parents; controls on sales to minors of spray paint, felt-tip markers, and other potential graffiti instruments; and even curfew restrictions for under-18-year-olds.

Yet graffiti endures, and outlawing graffiti is not an effective solution. Its persistence is complex. All subcultures that feel in any way repressed by the dominant culture find an avenue by which to manifest their artistic creativity and their protest mentality. Graffiti is an outcome of psychological, intellectual, social, and political needs of a subculture, and broadly speaking, it is a symbol of the dissent by a minority faced with multiple forms of First Amendment repression.

Most state and local penal codes criminalizing graffiti make no distinctions when defining it in relationship to its artistic merit, subject matter, artistic intent, or location. The proscription usually goes along the following lines:

> *New York City, Graffiti prohibition: It shall be unlawful for any person to apply graffiti on any public or privately owned structures located on public or privately owned real property located within the area of the metropolitan government.*

> *California Penal Code, Graffiti defined: As used in this section, the term "graffiti or other inscribed material" includes any unauthorized inscription, word, figure, mark, or design, that is written, marked, etched, scratched, drawn, or painted on real or personal property.*

The over-broadness of such criminal codes creates an impediment to artistic freedoms and unduly criminally punishes the artist.

Removing graffiti conflict to the judicial process, as with most social protest movements, dissolves the impetus to continue the activity; criminal judicial process has been used in the United States to create dysfunction and to abate all forms of public protest, dissent, and demonstration. Making artists felons, incarcerating them, subjecting them to projects that efface the graffiti art, are all calculated to destroy this movement and its form of free speech.

Obviously, there are many dimensions subsumed by the generic noun *graffiti* and multiple states of mind creating it, and it is important to distinguish between graffiti writers who are driven by artistic expression and those who are driven primarily by the desire to deface property. These differing motivations form the basis of the argument between graffiti proponents and opponents. Vandalism is a crime; graffiti can be art. The solution is not to try to prevent graffiti, but rather to try to prevent vandalism. In equating all graffiti with vandalism, statutes and policies ignore the fact that graffiti and vandalism are not mutually inclusive. The distinction between graffiti and vandalism needs to be drawn more clearly in the laws, in public debate, and by the art community.

A recent case that this writer participated in arose in Berkeley, California, where an anti-pollution activist stenciled on many of the red street STOP signs: DRIVING. He was prosecuted on multiple counts of criminal vandalism, faced significant jail time, and attracted significant media attention. In this particular case, Berkeley's activist community gave full

and vigorous support to the defendant, resulting in multiple press conferences and media outreach, and the case became more important than the graffiti in conveying the philosophy of the defendant. With such visible support, prosecution is less likely because the artist's ultimate ideology becomes more prevalent in the community.

The Federal Visual Artists Rights Act of 1993 sought to instill primary enforceable moral rights for the artist of mural motifs. This act was the only U.S. gesture toward counterbalancing the aggressive legislation toward invited or uninvited publicly posted art activity. It has been a dismal failure in its application. It is gravely limited in scope; the visual work must be of "recognized stature"; and the artist must hire an attorney to bring the protracted litigation. The act has not played any role in the adjudication of distinctions between graffiti art and graffiti vandalism.

The real solution lies in a candid application of the First Amendment. Graffiti falls under the realm of symbolic speech and, therefore, should be afforded First Amendment protection and be subject to the rights and limitations of freedom-of-speech precedents. Most so-called graffiti is created without criminal intent. To potentially imprison the artist is a greater detriment to a free society than the invasive presence of a graffiti production. Unfortunately, art and artists have no special prerogatives from the perspective of law and law enforcement, which emanates from that portion of social consciousness that for the most part is insensible to aesthetic values.

BELOW

Cornbread
LOCATION Philadelphia, Pennsylvania
DATE 1972

Cornbread had already received enough media attention for his graffiti in 1972.

PAGES 314–315

Jean-Michel Basquiat (SAMO)
LOCATION New York City
DATE C. 1980
PHOTO Lisa Kahane

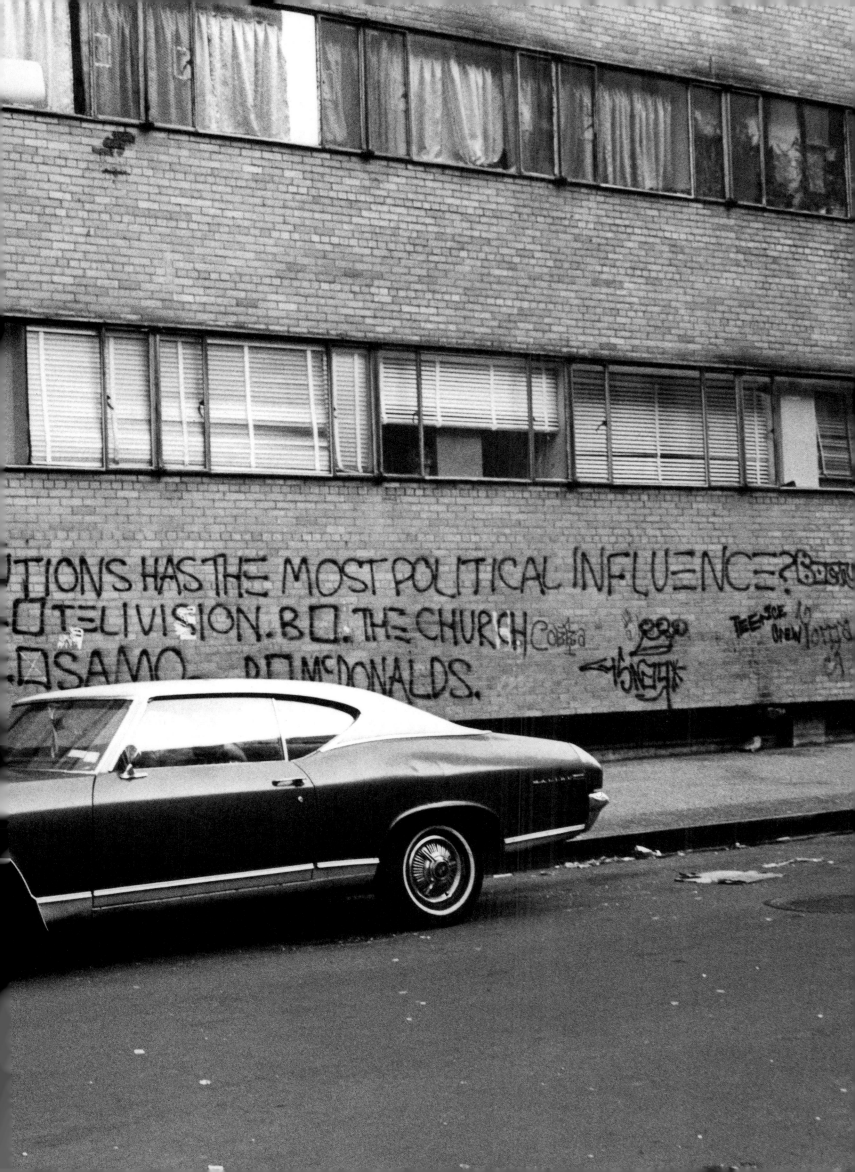

A very special "thank you" goes out to all the artists, photographers, writers, and friends who inspired, contributed to, and assisted in the formation of this book, including Banksy, Anne Pasternak, and Tony Serra. This important project could not have been done without you. And to the countless others whose names would overflow this page—your interest in the title, knowledge, and social spirit towards art have kept *Trespass* alive.

Ethel Seno extends a sincere "thank you" to Martha Cooper for her guidance and commitment; to Aiko Nakagawa, Hans Winkler, and Duke Riley for sharing their inspiration; to Dinah Martinez Seno for her veritable faith; Dian Hanson for having been an extraordinary mentor; and to all those from TASCHEN who supported the making of this book.

Carlo McCormick extends his gratitude to Thomas Solomon, Martha Wilson, Martha Cooper, Charlie Ahearn, Jeffrey Deitch, Jonathan Levine, Marvin Taylor, Nancy Barr, Jeanette Ingberman, Pedro Alonzo, Alan Moore, Jack Napier, Jon Savage, Mike Osterhout, Ulli Rimkus, Erik Foss, Larry Ratso Sloman, Melissa Harris, Monica LoCascio, Julie Martin, and the entire staff of Creative Time. His dearest and most personal thanks extend to those who formed the basis of his education: Henri Peyre, Diana Festa, Linda Nochlin, Tessa Hughes-Freeland, Leonard Abrams, Walter Robinson, Ingrid Sischy, David Hershkovits, Kim Hastreiter, and to Tristan Hughes-Freeland above all others.

Marc & Sara Schiller extend their special thanks to all those who went out of their way to locate and provide material for this title, including Wiley Aker, Erin Gilligan, Lauren Kantro, Holly Cushing, Patrick Nguyen, Andy Phipps, Jake Dobkin, Jeroen Jongeleen, KR, Geoff Hargadon, Brett Bloom, Adeline Jeudy, Paul Harfleet, WK, Sybille Prou, and Sabrina Gschwandtner.

Photography Credits

ALL PHOTOGRAPHS COURTESY THE ARTIST WITH THE EXCEPTION OF THE FOLLOWING: COURTESY AIKO: 165; © ANTONIO AMENDOLA: 125; © THE ASSOCIATED PRESS: 133; COURTESY JULIE AULT: 112; © JANETTE BECKMAN: 76; © BETTMAN/CORBIS: 220; © BPK/KUPFERSTICHKABINETT, SMB/JÖRG P. ANDERS: 23; © JEAN-LOUIS BLONDEAU/POLARIS IMAGES: 24/25; BRASSAÏ, *GRAFFITI SERIES VIII, MAGIC,* C. 1935-1950, PARIS, MUSÉE NATIONAL D'ART MODERNE – CENTRE GEORGES POMPIDOU © ESTATE BRASSAÏ – RMN © COLLECTION CENTRE POMPIDOU, DIST. RMN/ADAM RZEPKA: 282; © MARTHA COOPER: 17, 18/19, 44, 48, 186, 189, 246/247, 292, 303; © BILL DANIEL: 293; © JAKE DOBKIN: FRONT AND BACK ENDPAPERS, 57, 163, 297; © JOHN FEKNER RESEARCH ARCHIVE: 86/87, 138, 212; © ANTHONY FRIEDKIN: 28, 286; © JULIA GUEST: 192; © GEOFF HARGADON: 62/63; COURTESY HEIDELBERG PROJECT ARCHIVES: 204; © 2010 JENNY HOLZER, VG BILD-KUNST, BONN: 91, 159; © COR JARING: 149; © LARRY E. JONES: 96; © JR-ART.NET: 46/47, 97; © LISA KAHANE: 104, 314/315; COURTESY PAUL KOTULA PROJECTS: 190/191; © KRINK: 283; © NICK KUSKIN: 291; COURTESY GALERIE LELONG, NEW YORK: 37; COURTESY GALERIE L.J., PARIS: 244; © HUBERT MAESSEN: 278/279, 280; COURTESY THE ESTATE OF GORDON MATTA-CLARK AND DAVID ZWIRNER GALLERY, NEW YORK, GENERALI FOUNDATION COLLECTION, WIEN © 2010 VG BILD-KUNST, BONN: COVER, 260/261; COURTESY THE ESTATE OF GORDON MATTA-CLARK AND DAVID ZWIRNER GALLERY, NEW YORK © 2010 VG BILD-KUNST, BONN: 259; © ANN MESSNER: 55; © 1982 MUNA TSENG DANCE PROJECTS INC., NEW YORK: 8; © THE NEW YORK TIMES/REDUX/LAIF: 32/33; © CHAD NICHOLSON: 234/235; © FRANC PALAIA: 27; © CLAYTON PATTERSON: 30; © SYBILLE PROU: 124, 239, 300; © ROGER-VIOLLET, PARIS: 221; COURTESY GREGORY SHOLETTE: 144; © 1982 TEHCHING HSIEH, COURTESY THE GILBERT AND LILA SILVERMAN COLLECTION, DETROIT, AND THE SEAN KELLY GALLERY, NEW YORK: 77; COURTESY JACK TILTON GALLERY, NEW YORK: 148; COURTESY MUSEUM TINGUELY, BASEL: 290; © ADAM WALLACAVAGE: 156/157; COURTESY OF THE ESTATE OF DAVID WOJNAROWICZ AND P.P.O.W. GALLERY, NEW YORK: 41

COVER

Gordon Matta-Clark, *Window Blow-out*
See page 263

FRONT COVER FLAP

Roadsworth, *Male*
See page 177

BACK COVER FLAP

ZEVS, *Liquidated McDonald's*
See page 124

ENDPAPERS

Bast
LOCATION Furman Street, Brooklyn, New York
DATE C. 2001
PHOTO Jake Dobkin

OPPOSITE

Rebar, *Park(ing) Day*
LOCATION San Francisco, California
DATE 2005
PHOTO Andrea Scher
ARTIST NOTES We identified a site in an area of downtown San Francisco that is underserved by public outdoor space and is in an ideal, sunny location between the hours of noon and 2 p.m. There we installed a small, temporary public park that provided nature, seating, and shade.

PAGE 320

Evereman
LOCATION Intersection of Peachtree St. and Piedmont Rd., Atlanta, Georgia
DATE 1984
SOURCE *Beat Atlanta*
ARTIST NOTES This billboard is one of the many things that kept me doing Street Art. Over the years, folks, after learning I was behind that billboard, have expressed the impact it had on them. One fellow had just come back to Atlanta. He saw the billboard and it gave him new hope for our city and his place in it.

Text © 2010 by Banksy, Carlo McCormick, Anne Pasternak, Marc & Sara Schiller, J. Tony Serra

Photographs © 2010 and courtesy the artists except where otherwise credited

© 2010 TASCHEN GmbH
Hohenzollernring 53, D-50672 Köln
www.taschen.com

EDITED BY Ethel Seno, Clear Designs, Los Angeles and New York
EDITORIAL COORDINATION Florian Kobler and Martin Holz, Cologne
DESIGN Josh Baker, Los Angeles
PRODUCTION Stefan Klatte, Cologne

TO STAY INFORMED ABOUT UPCOMING TASCHEN TITLES, PLEASE REQUEST OUR MAGAZINE AT WWW.TASCHEN.COM/MAGAZINE OR WRITE TO TASCHEN AMERICA, 6671 SUNSET BOULEVARD, SUITE 1508, LOS ANGELES, CA 90028, USA; CONTACT-US@TASCHEN.COM; FAX: +1-323-463-4442. WE WILL BE HAPPY TO SEND YOU A FREE COPY OF OUR MAGAZINE, WHICH IS FILLED WITH INFORMATION ABOUT ALL OF OUR BOOKS.

Printed in China
ISBN 978-3-8365-0964-0

Imagine the surprise at *Turner Corporate Headquarters* when they saw one of their billboards with an added "graphic approach." This *Nike* billboard got a bit more notice with a new steel pole and some red paint. The artist involved with the re-design isn't confessing, but they did mail us this picture in a plain brown envelope.